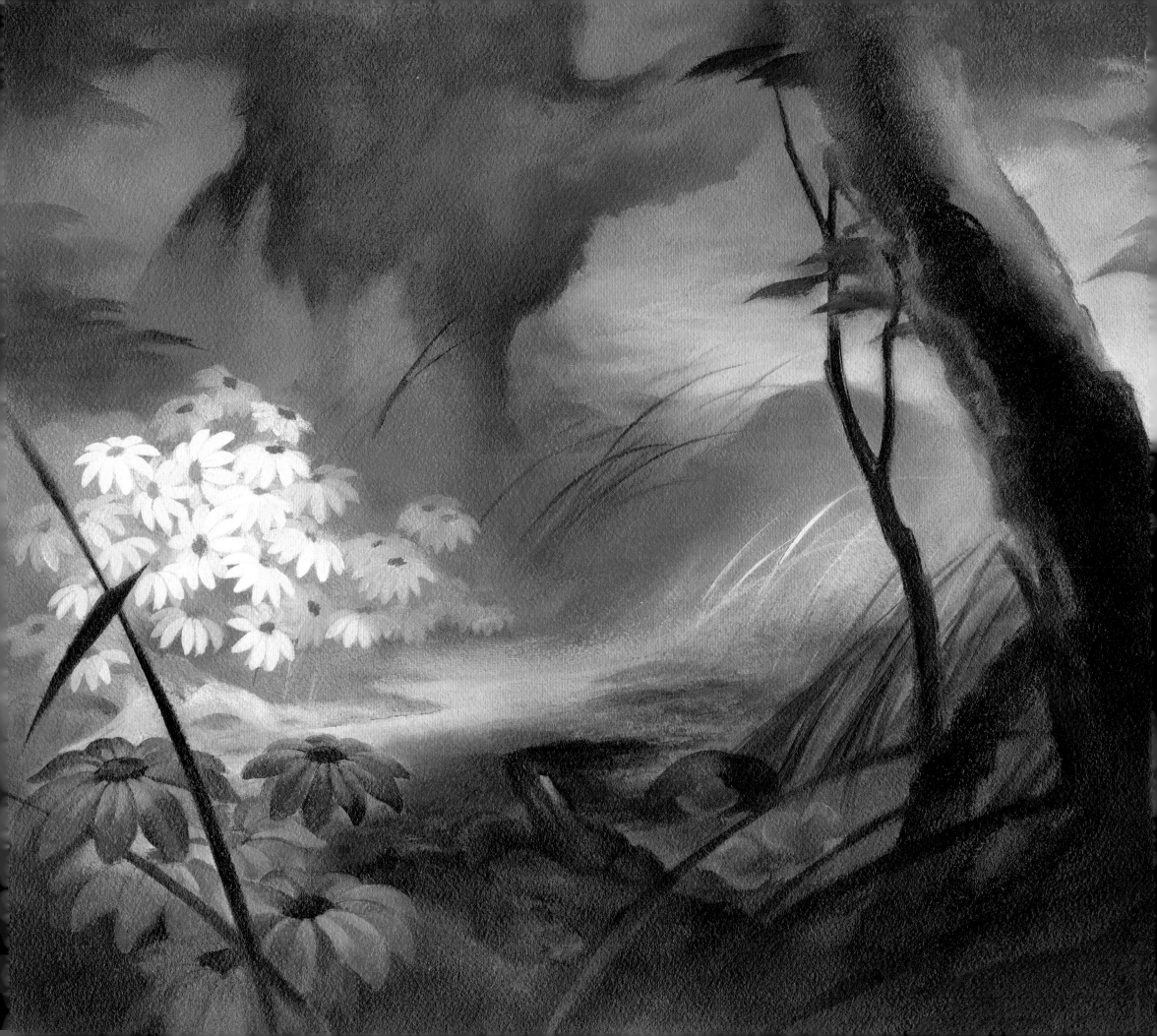

WALT DISNEY ANIMATION STUDIOS

The Archive Series

LAYOUT & BACKGROUND

DISNEY EDITIONS

NEW YORK

PREVIOUS SPREAD: **BAMBI** 1942

Also from

Walt Disney Animation Studios: The Archive Series

STORY

ANIMATION

DESIGN

For information address Disney Editions, 114 Fifth Avenue, New York, New York 10011-5690.

Printed in Malaysia

First Edition
10 9 8 7 6 5 4 3 2

ISBN 978-1-4231-3866-2
H106-9333-5-12278
This book is printed on a paper from a sustainable source

Designed by Hans Teensma, Impress, Inc.

THE BAND CONCERT 1935

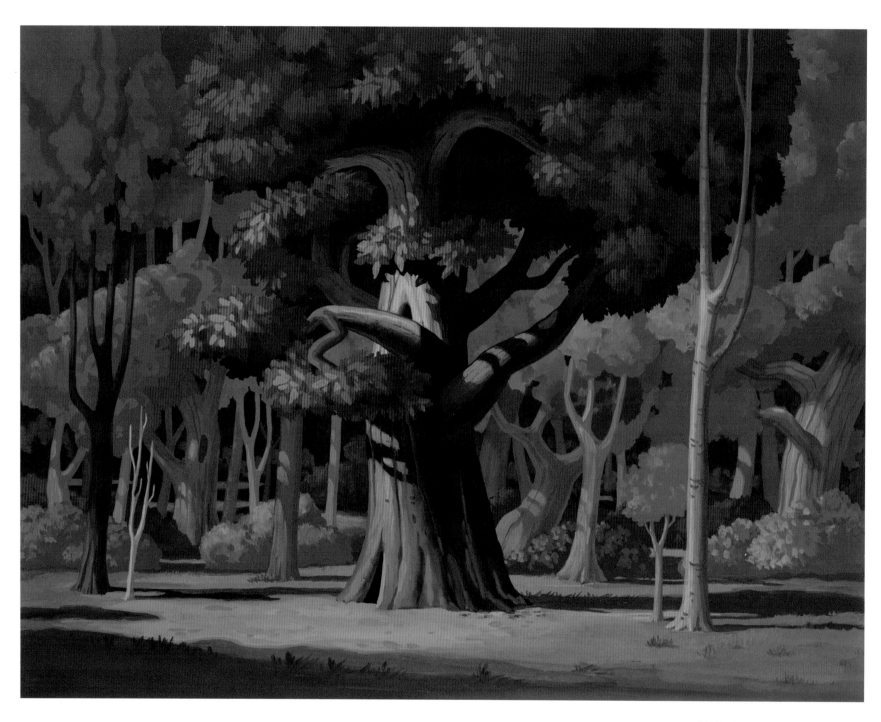

WINTER STORAGE 1949

SETTING THE STAGE

BY JOHN LASSETER

ONE OF THE THINGS Walt Disney did so well was take an audience into the world of a story. Watch any Disney movie, and you'll immediately be carried away to another time and place, whether it's a forest clearing, the cluttered attic of a London townhouse, or King Louie's jungle throne room. (You can also see the same expertise at work in the many lands of Disneyland.) From the start, the artists working on the Disney animated films did an incredible job creating beautiful, detailed, and appealing worlds; worlds you want to be in.

In an animated film, the backgrounds and layouts are what create these worlds. Character design and animation understandably get most of the attention when discussing the art that goes into a film. But it's the carefully designed — and often amazingly beautiful — backgrounds that show us where all the action takes place and help us understand the unspoken rules affecting the characters' behavior by establishing the look and feel and scale of the worlds they navigate.

Layouts are the planning images that help the filmmakers work out the precise details of how an environment will look as a character and the camera moves through it, while backgrounds are the environments that appear

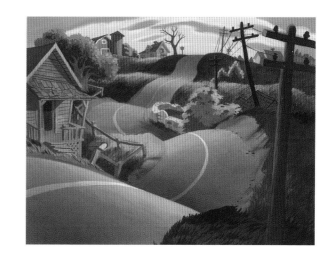

SUSIE, THE LITTLE BLUE COUPE 1952

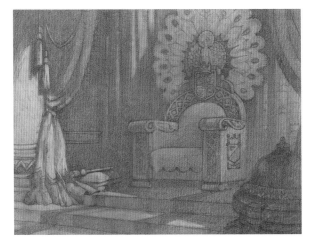

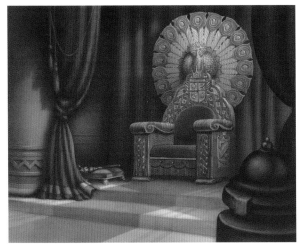

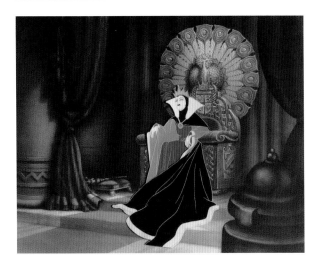

SNOW WHITE AND
THE SEVEN DWARFS 1937

in the film itself. In classic, hand-drawn animation, backgrounds are individual pieces of art that incorporate all the constant elements of a scene; everything except the characters and the props those characters interact with. Computer-animated films use paintings as well — matte paintings are used to fill in faraway vistas — but since the regular "backgrounds" in these films are really sets composed of many individual elements, we've chosen characteristic stills to represent the backgrounds from these projects. No matter how they've been created, though, the attention to detail and thoughtful planning that go into each environment are the same.

In the best movies, every element works together to support the story. Color, along with music, is one of the most effective ways to communicate the underlying emotion of a scene, and color and lighting can tell you a tremendous amount about the mood of a particular moment. When the color and lighting harmonize with the action and dialogue, they powerfully reinforce what's taking place with the characters. When they're different from the explicit action, they signal change and tension. In every case, the background can tell you the emotion of a scene at a glance.

Backgrounds can also tell you more about a place — and more convincingly — than dialogue ever could. Neverland's caricatured, fantastical settings contrast beautifully with the film's elegant but more serious London,

and perfectly create the feeling of a giant playground where Peter Pan and the Lost Boys would want to stay forever and never grow up. The clever and intricate toys that fill Geppetto's workshop show the incredible care and skill he's put into his craft over the years, while the humble surroundings show us that he's done it not for riches or glory, but for the sake of the work itself.

The genius of these backgrounds is that they do all this work without ever calling attention to themselves or interrupting the flow of the story. They work seamlessly with all the other parts of the film to let you focus on just being with the characters, being in the story.

It's not often that you get the chance to look at a background or layout by itself, and that's a big part of what makes this book such a treat. Being able to take your time with these pieces lets you fully appreciate the level of artistry that goes into them, and understand what an important role they play in the films we love.

Looking through this book I see page after page of places that were as real to me as a kid — and now as a filmmaker — as any I'd ever read or heard about or seen in real life. It's wonderful to finally be able to give them the spotlight they deserve.

John Lasseter

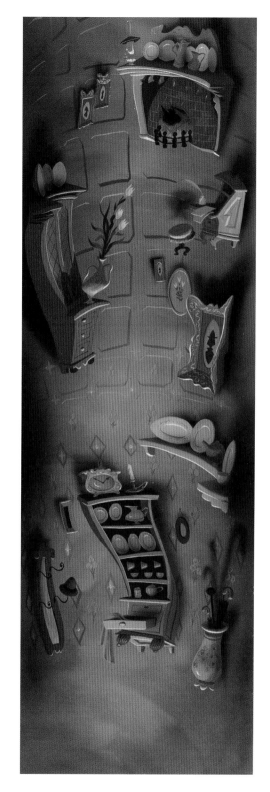

ALICE IN WONDERLAND 1951

FOLLOWING SPREAD: **PLUTO AND THE ARMADILLO** 1943

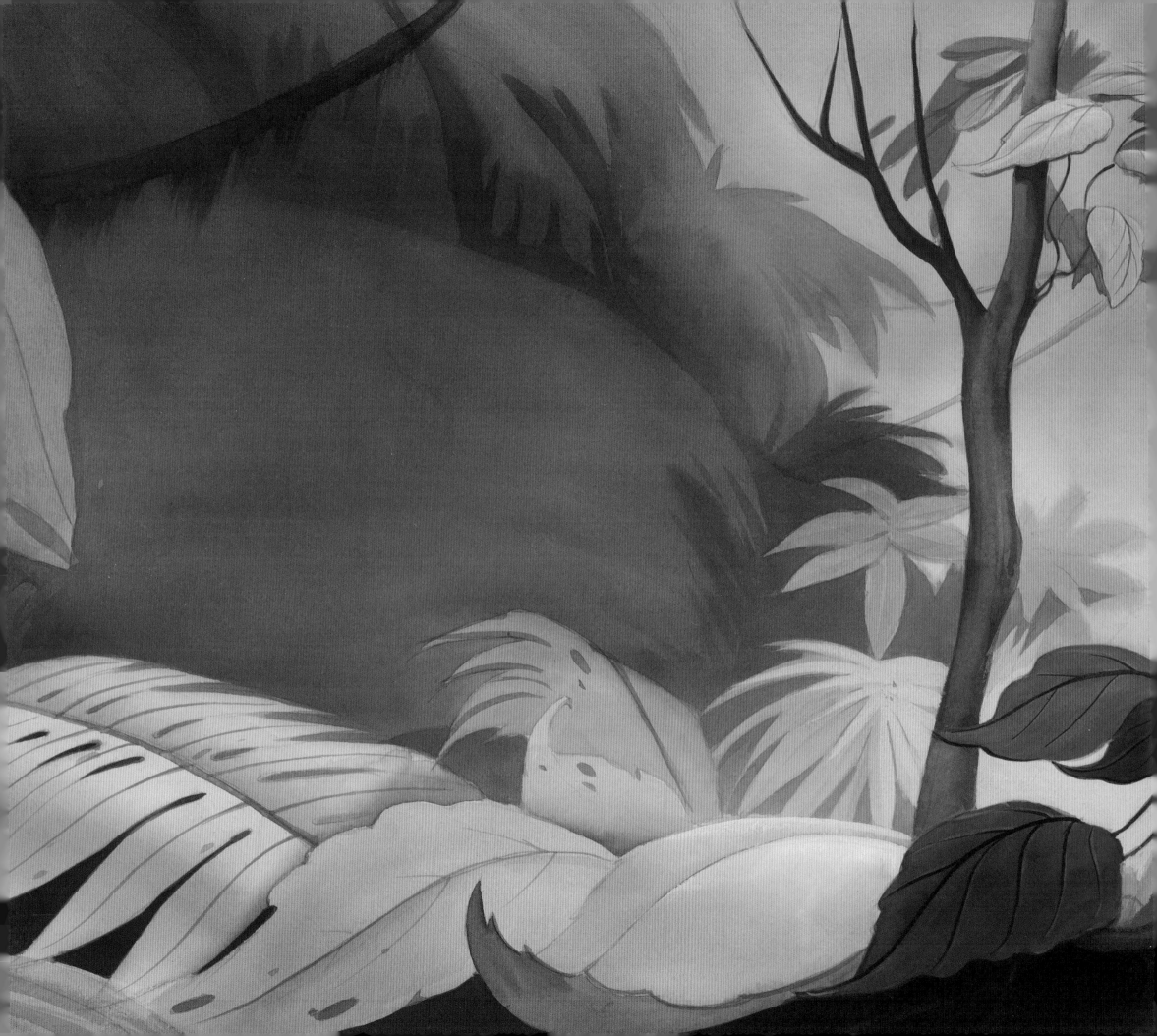

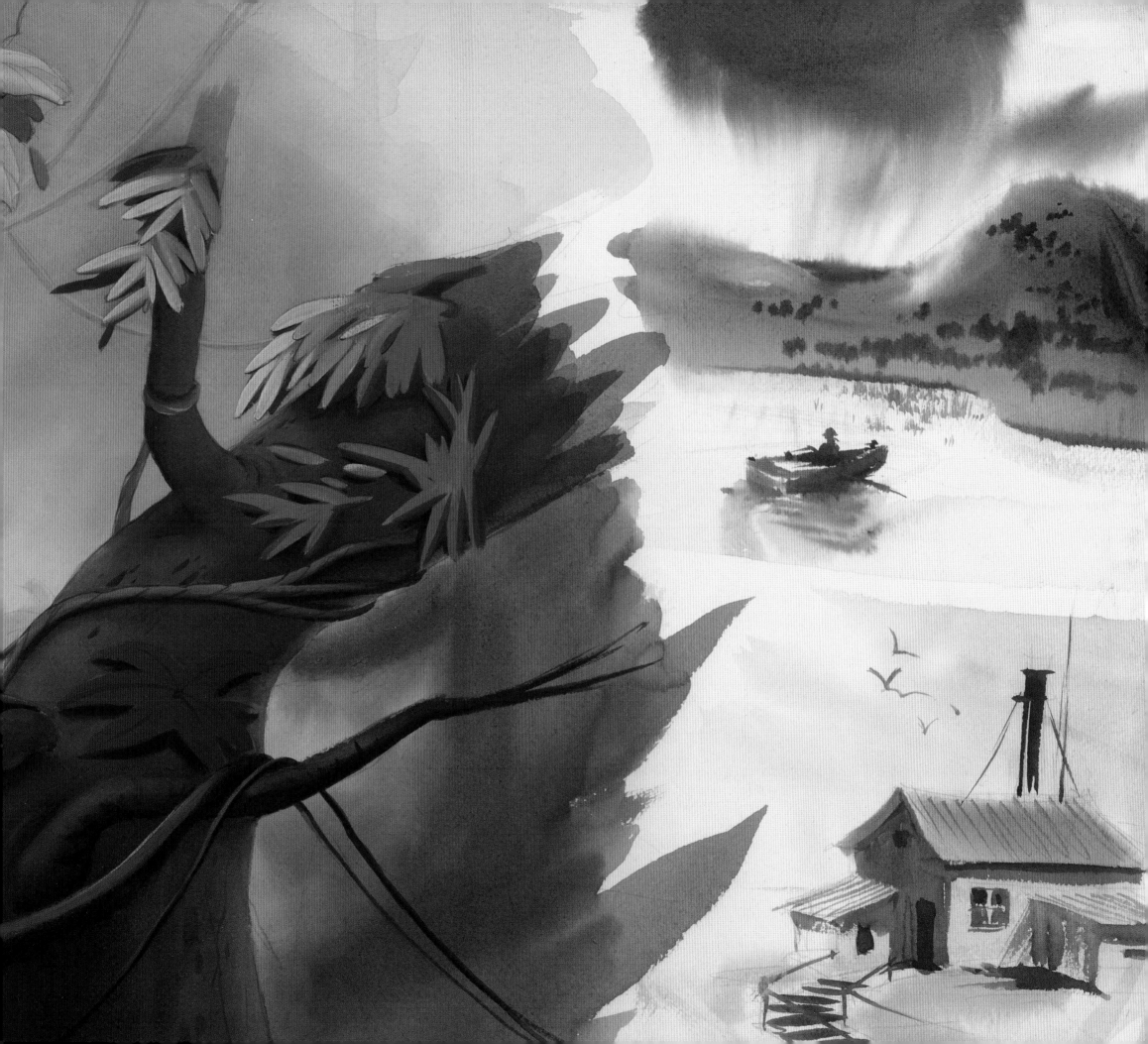

BRIGHT LIGHTS 1928

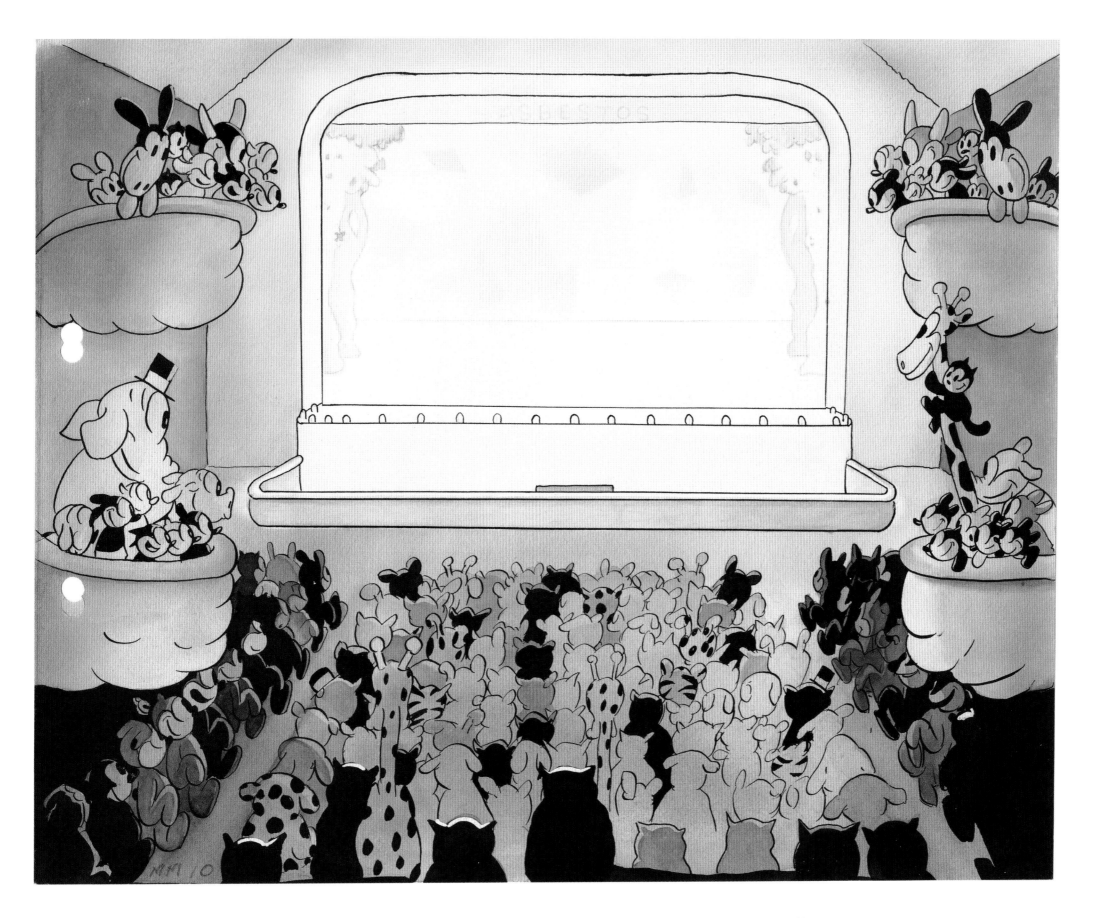

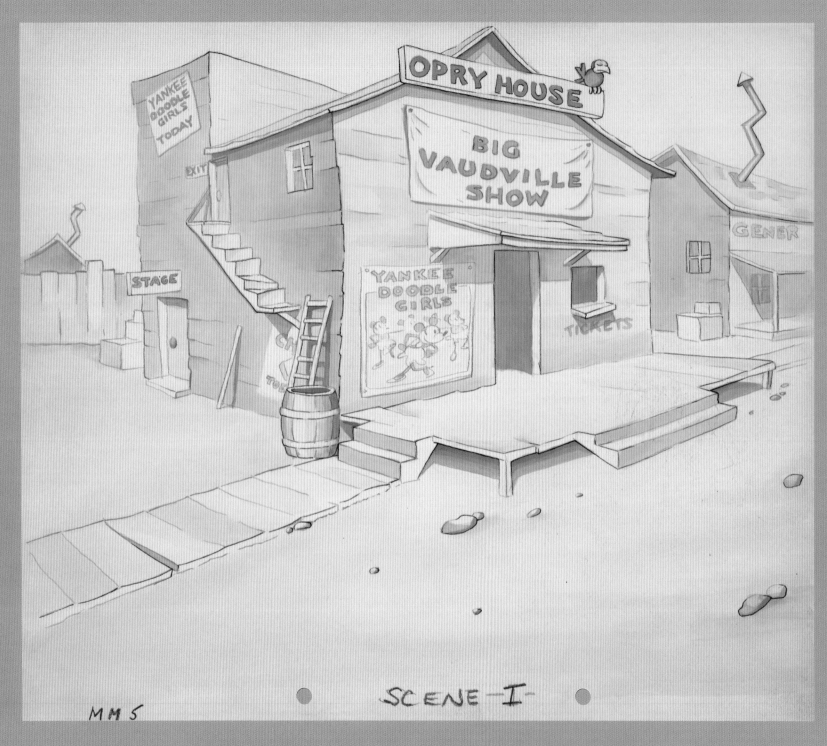

THE OPRY HOUSE 1929

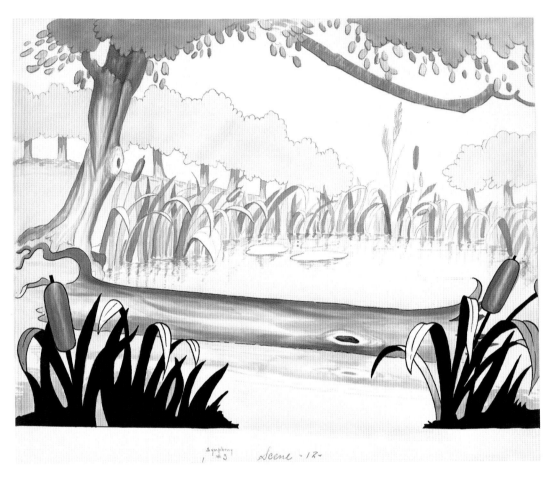

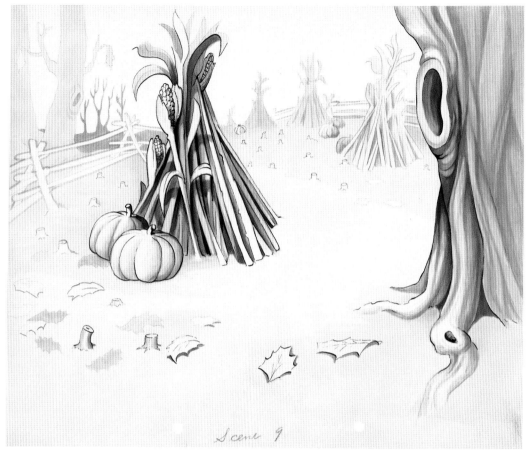

SPRINGTIME 1929 AUTUMN 1930

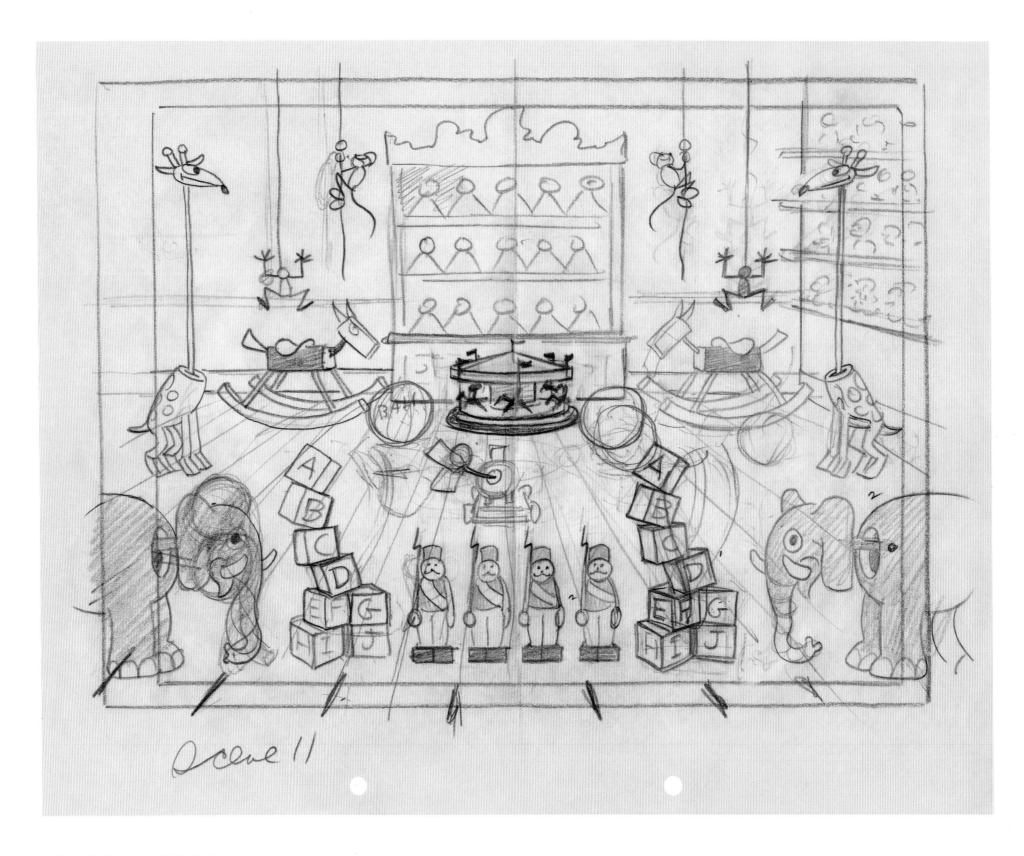

MIDNIGHT IN A TOY SHOP 1930

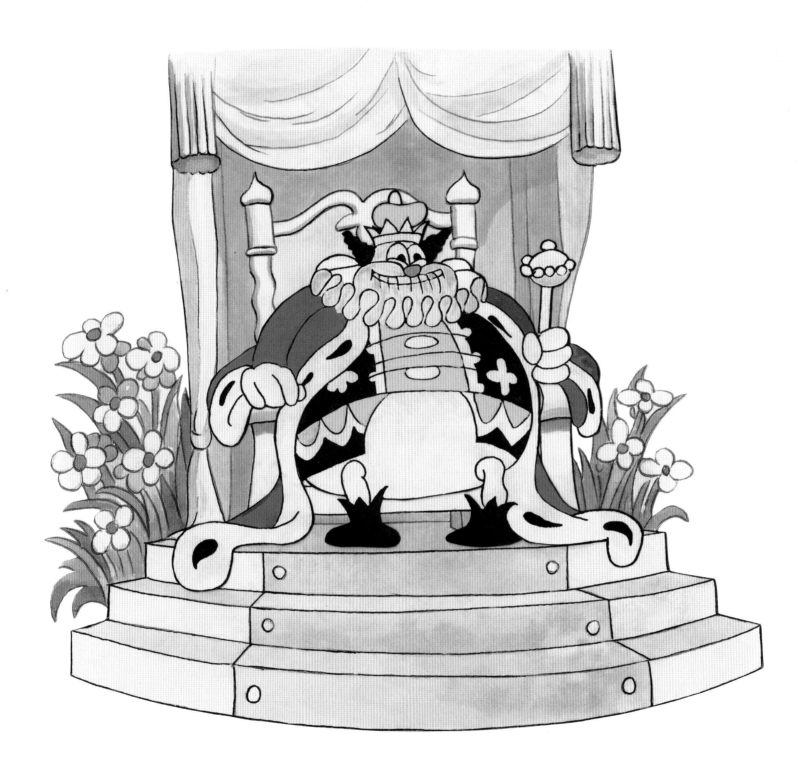

MOTHER GOOSE MELODIES 1931

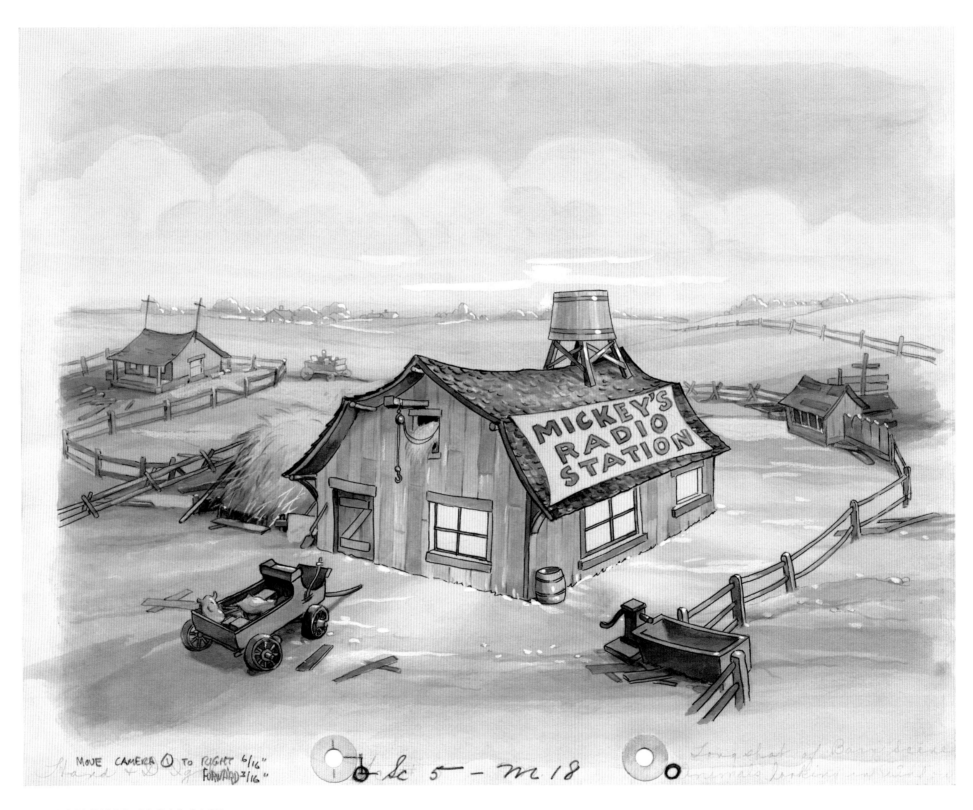

THE BARNYARD BROADCAST 1931

LAYOUT & BACKGROUND

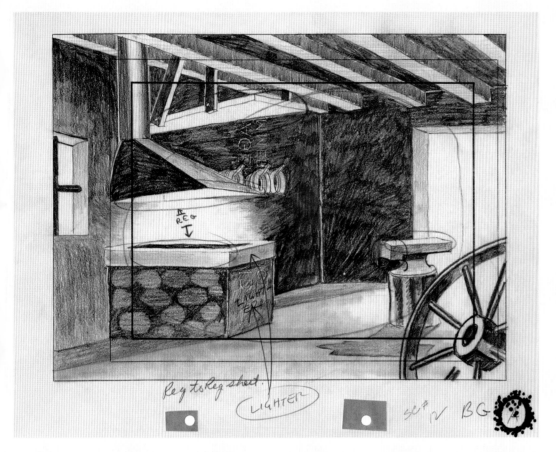
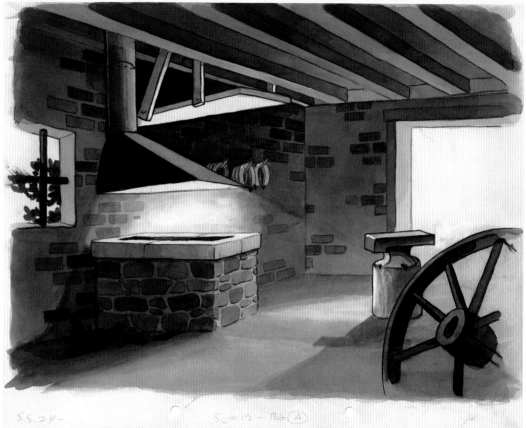

THE FOX HUNT 1931

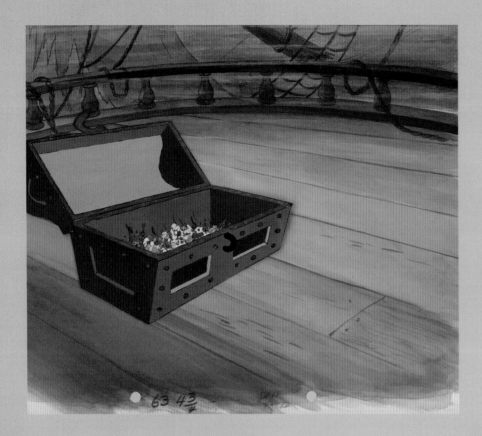

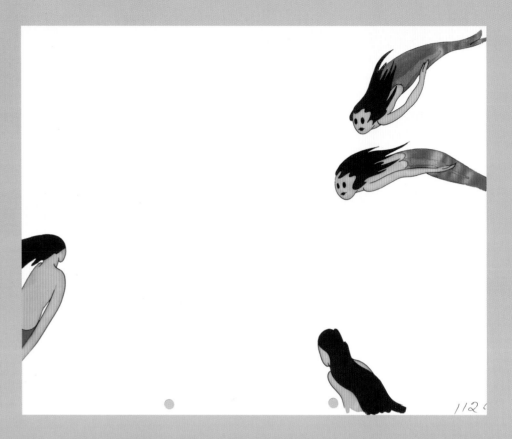

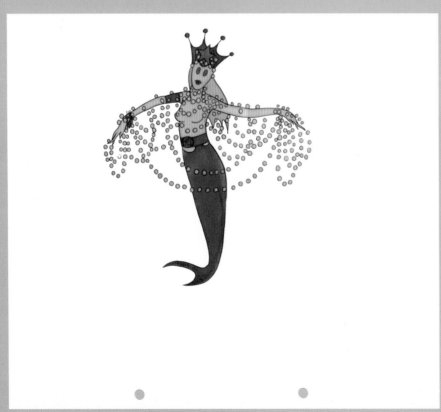

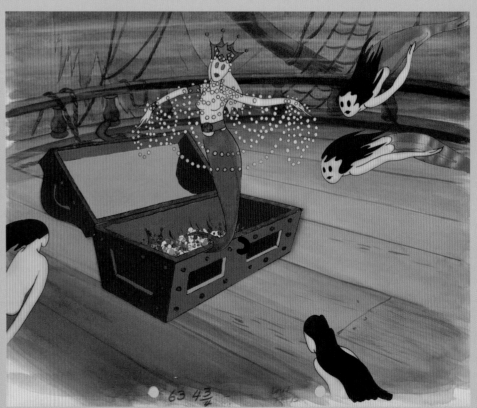

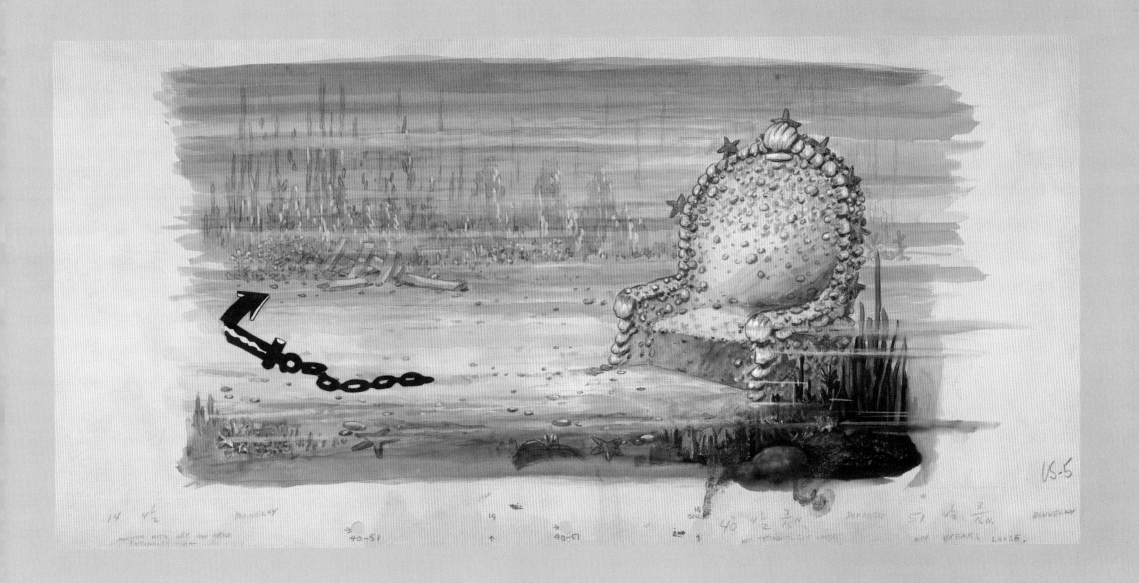

KING NEPTUNE 1932

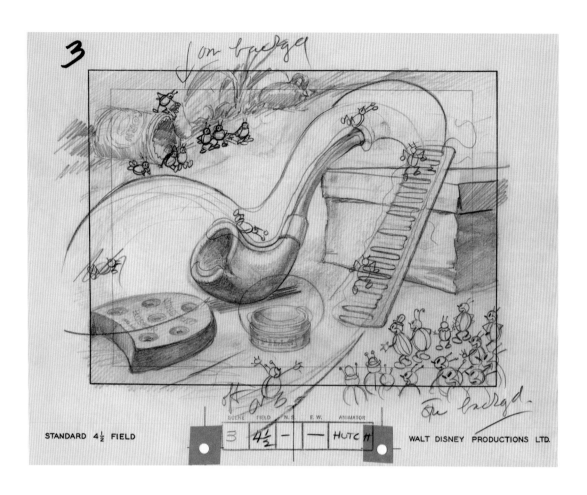

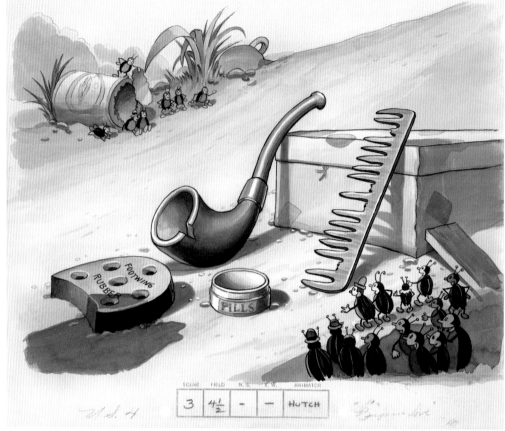

BUGS IN LOVE 1932

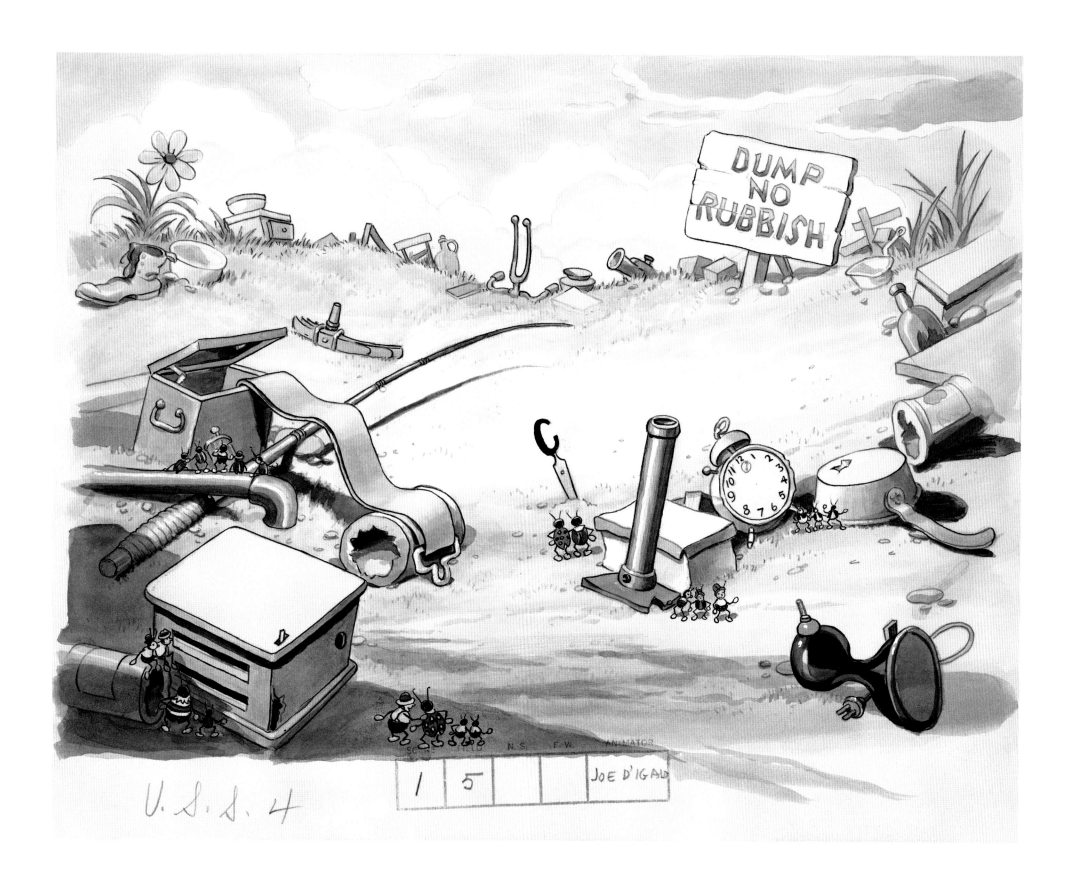

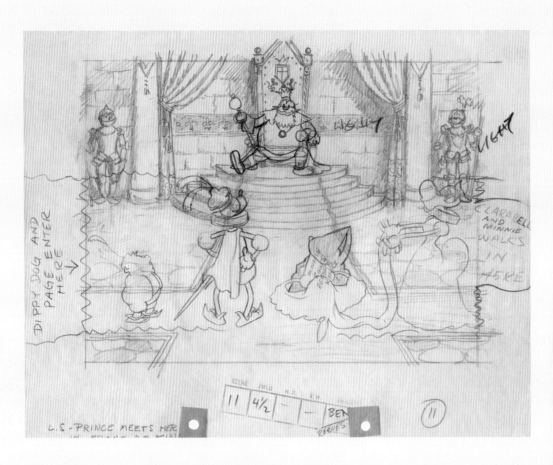

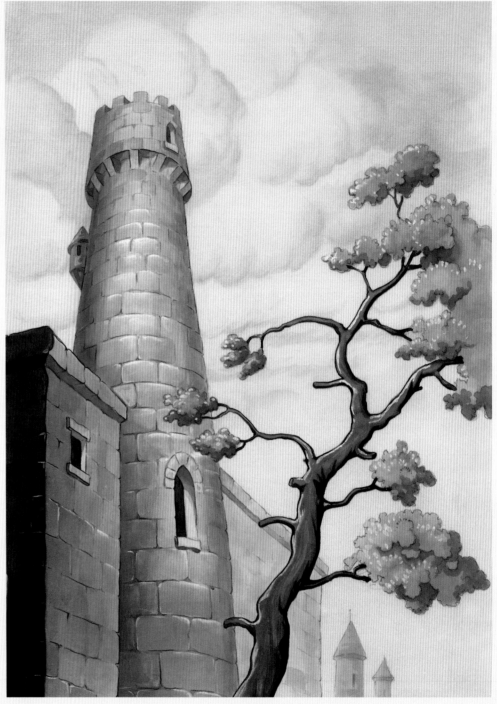

YE OLDEN DAYS 1933

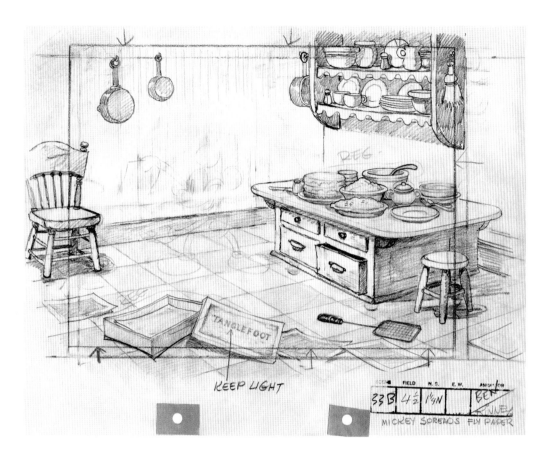

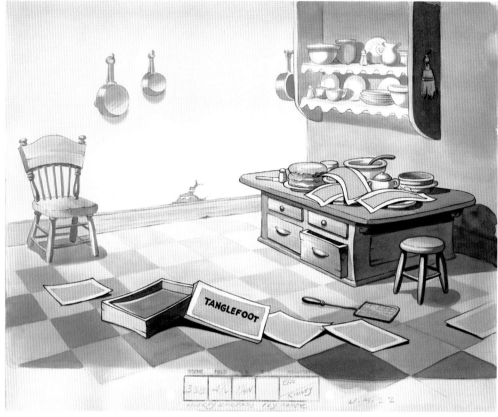

PLAYFUL PLUTO 1934

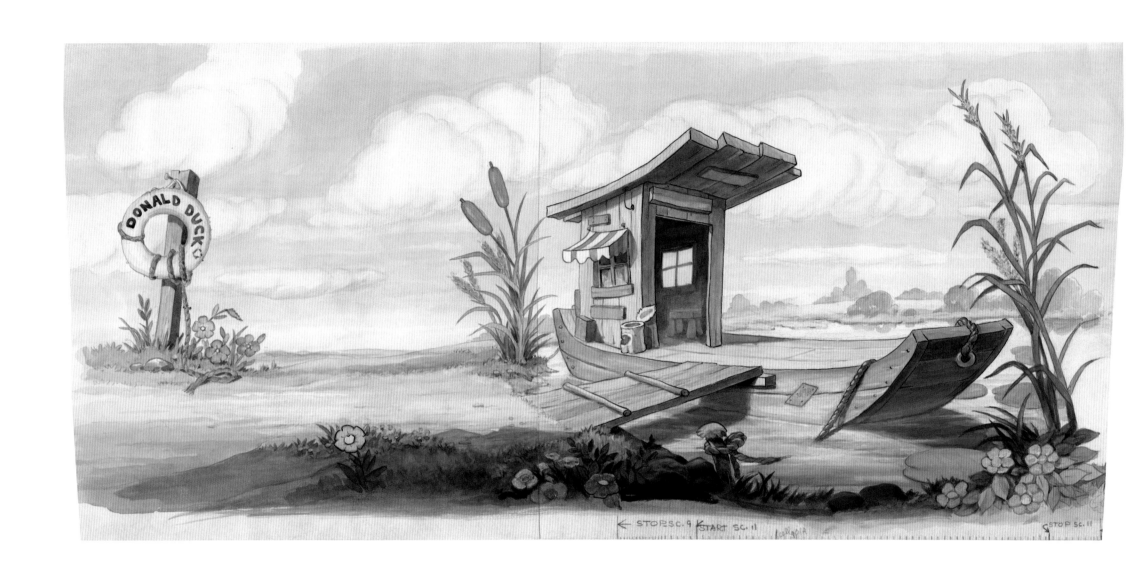

THE WISE LITTLE HEN 1934

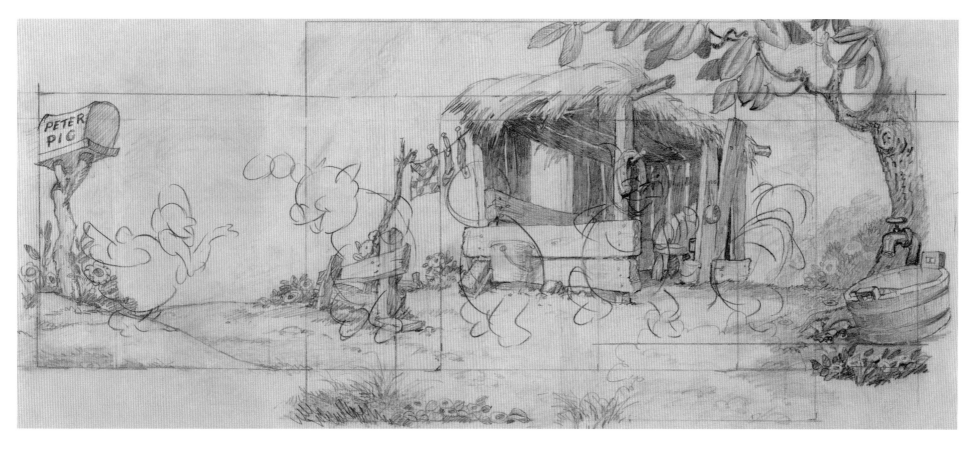

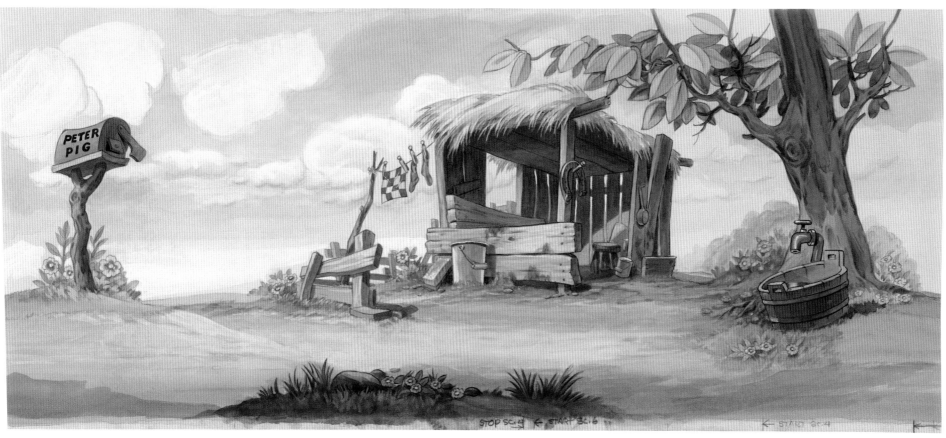

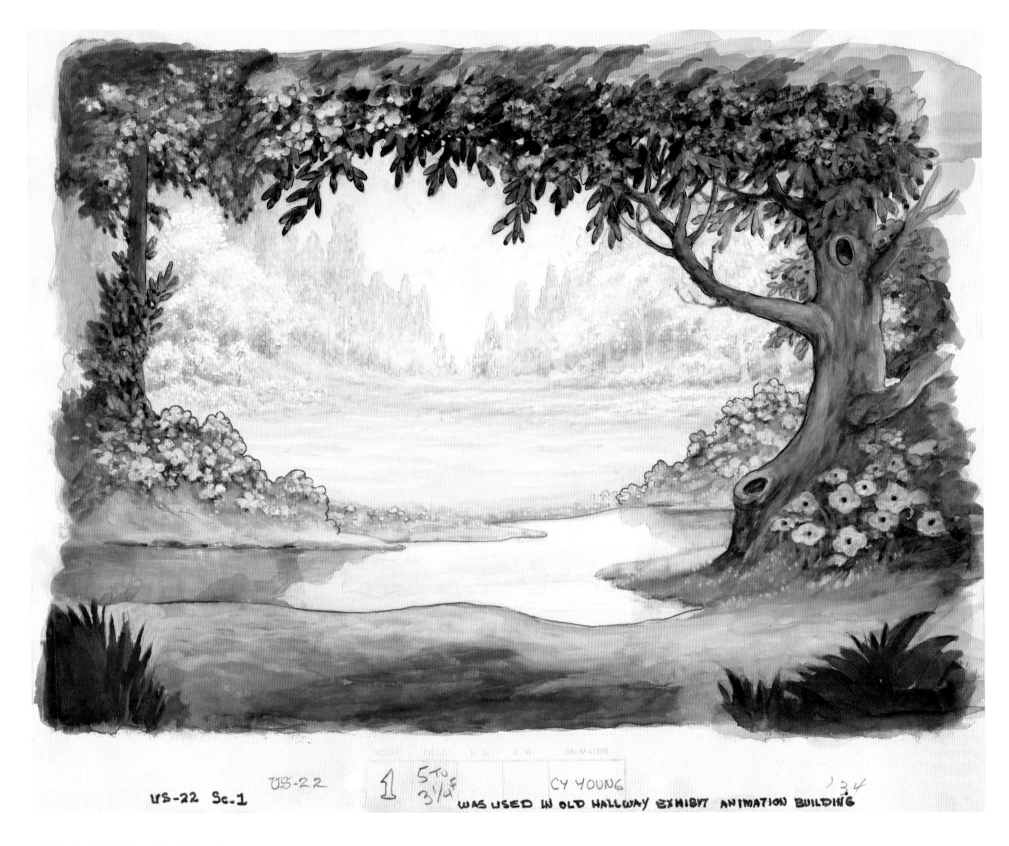

US-22 Sc.1 US-22 1 STO 3¼ CY YOUNG '34
WAS USED IN OLD HALLWAY EXHIBIT ANIMATION BUILDING

THE GODDESS OF SPRING 1934

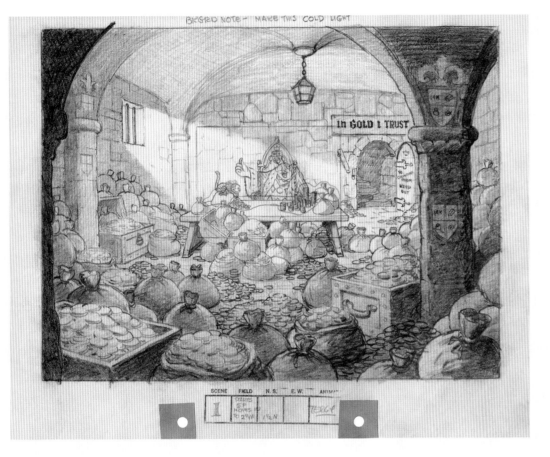

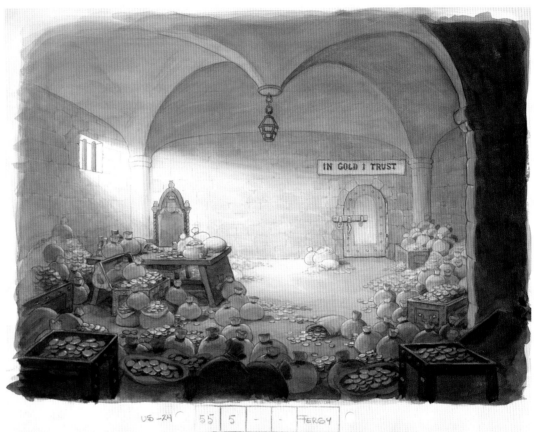

THE GOLDEN TOUCH 1935

PLUTO'S JUDGEMENT DAY 1935

LAYOUT & BACKGROUND

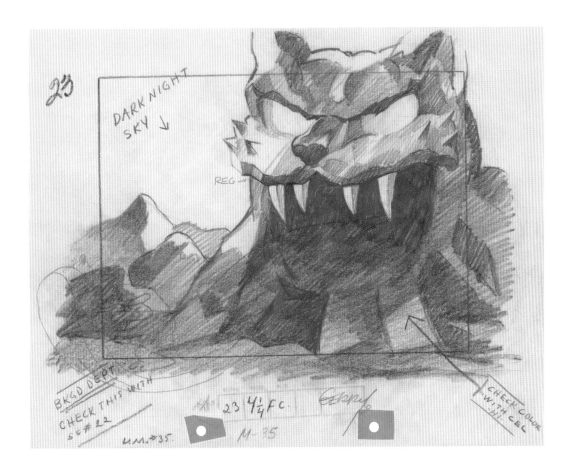

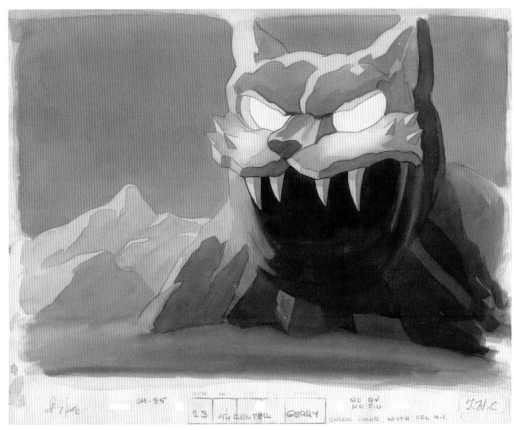

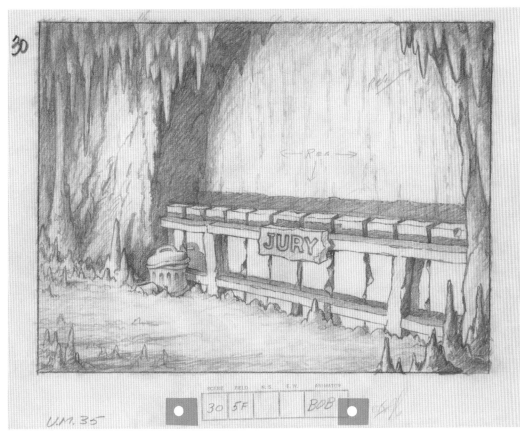

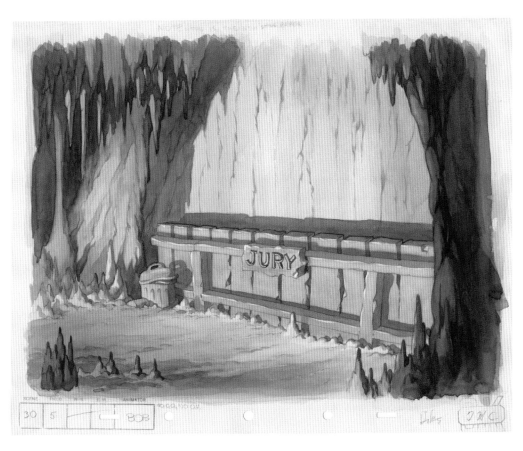

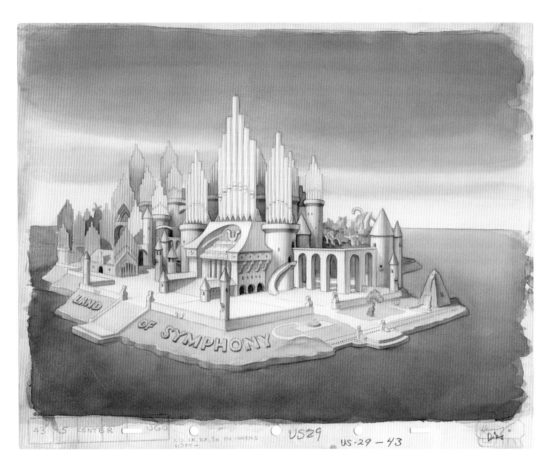

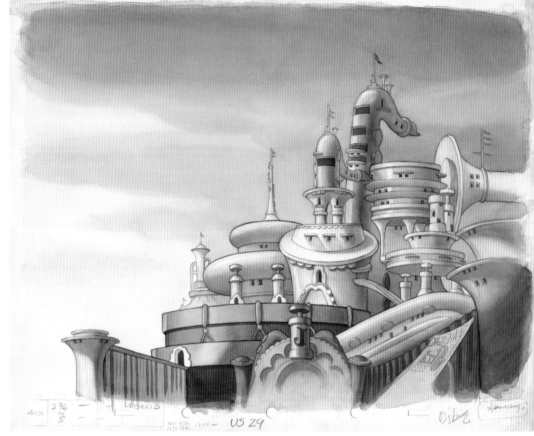

MUSIC LAND 1935

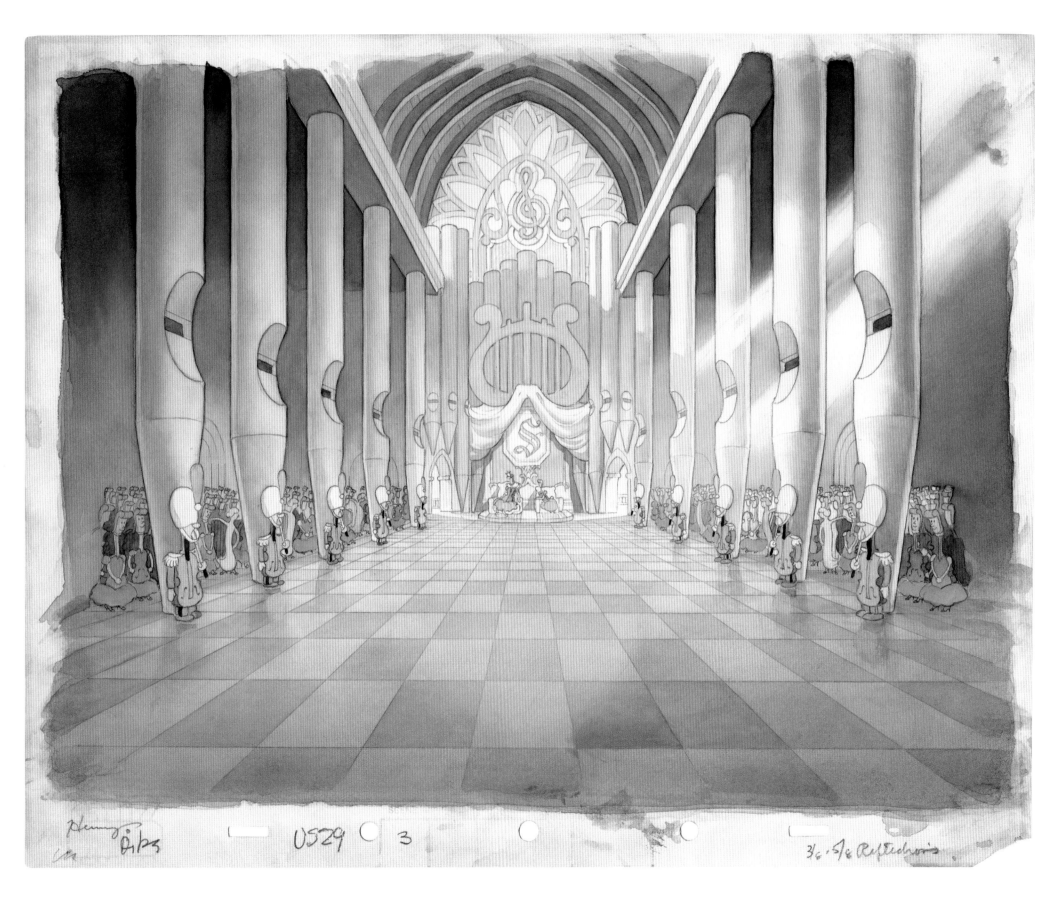

Henry
Pips US29 3 3/6 · 5/6 Reflections

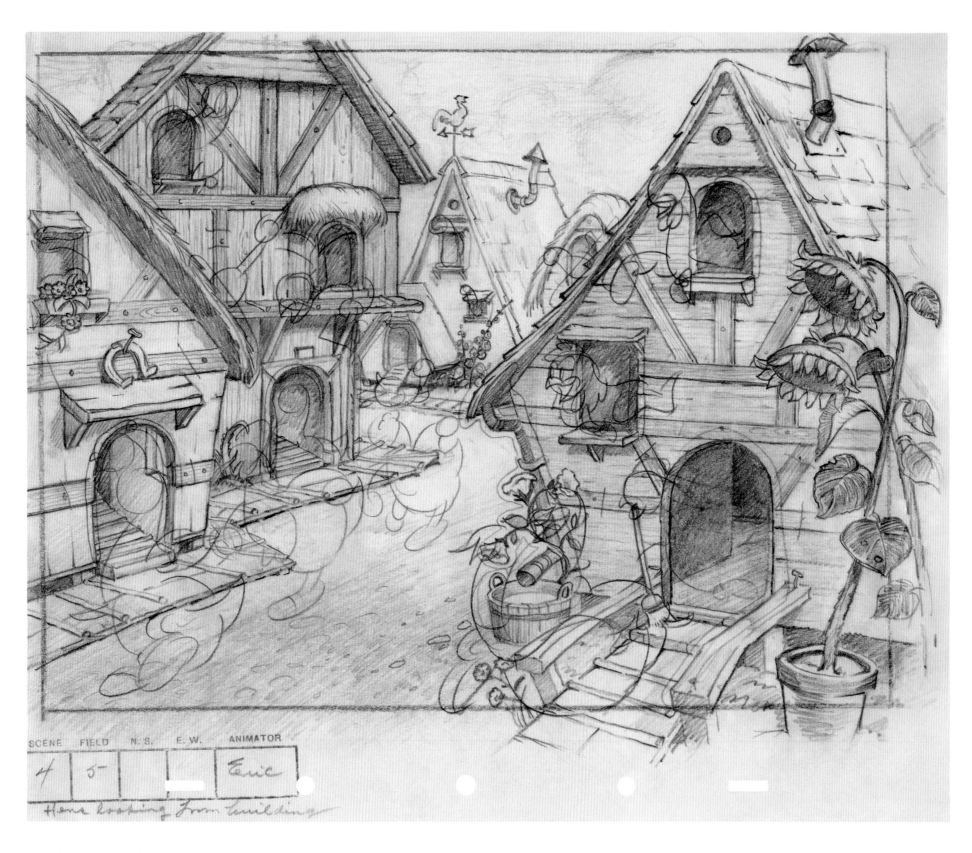

COCK O' THE WALK 1935

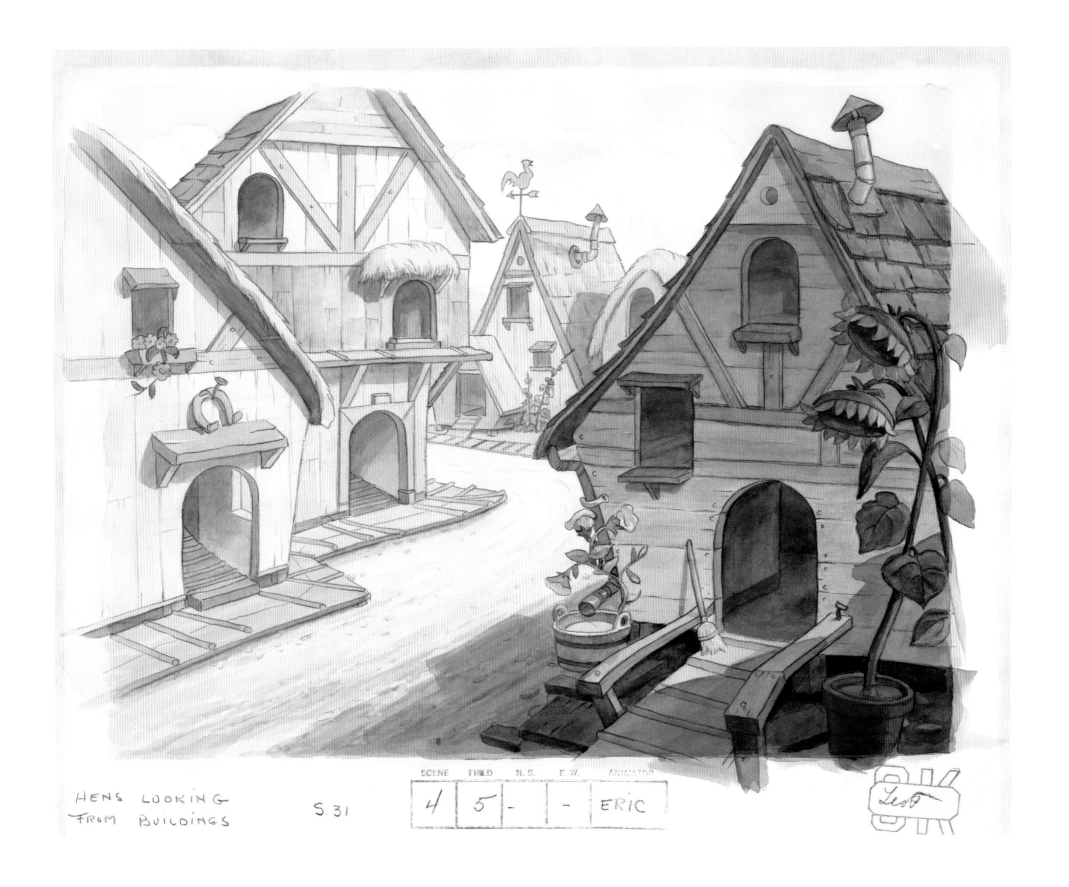

HENS LOOKING
FROM BUILDINGS

S.31

SCENE	FIELD	N.S.	E.W.	ANIMATOR
4	5	-	-	ERIC

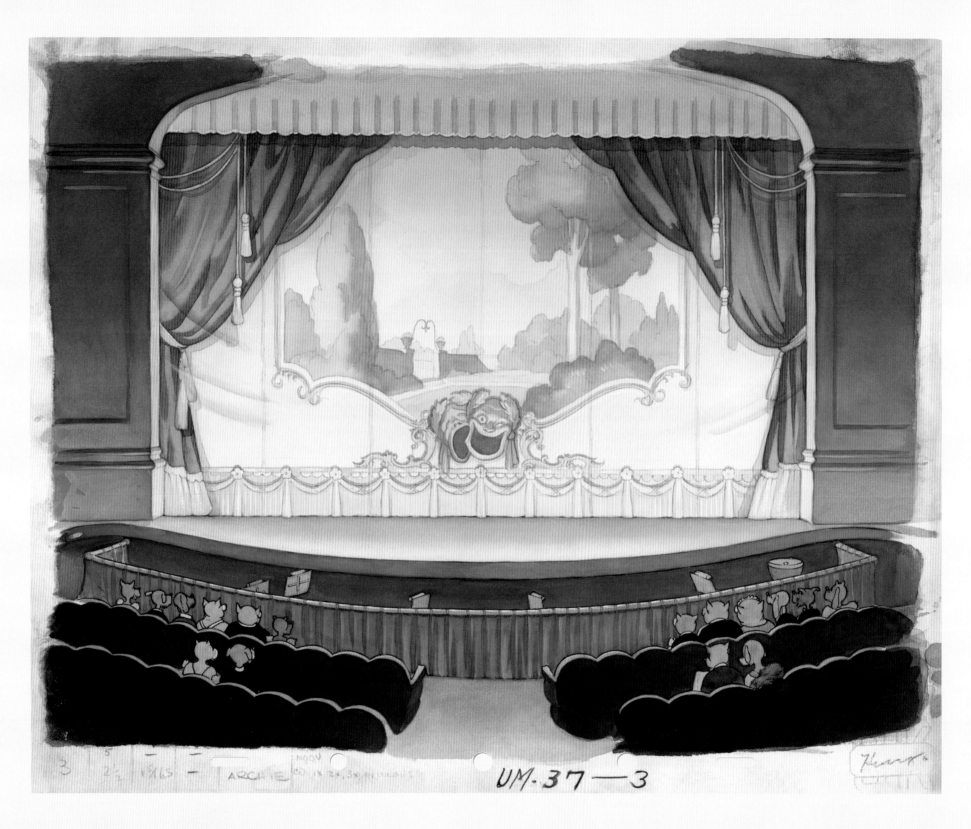

MICKEY'S GRAND OPERA 1936

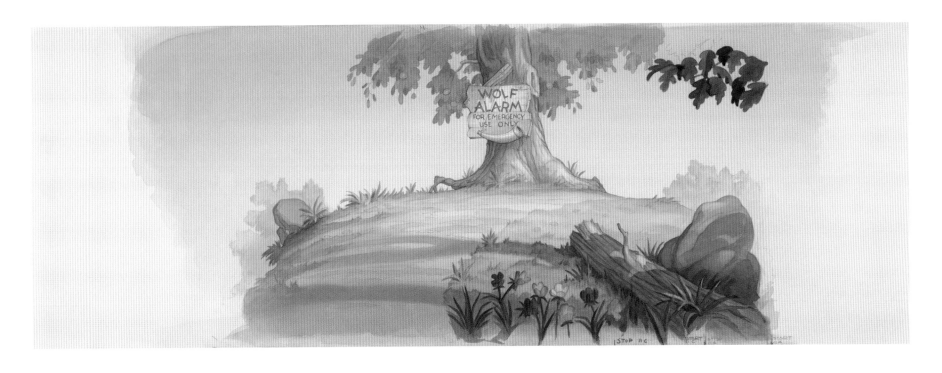

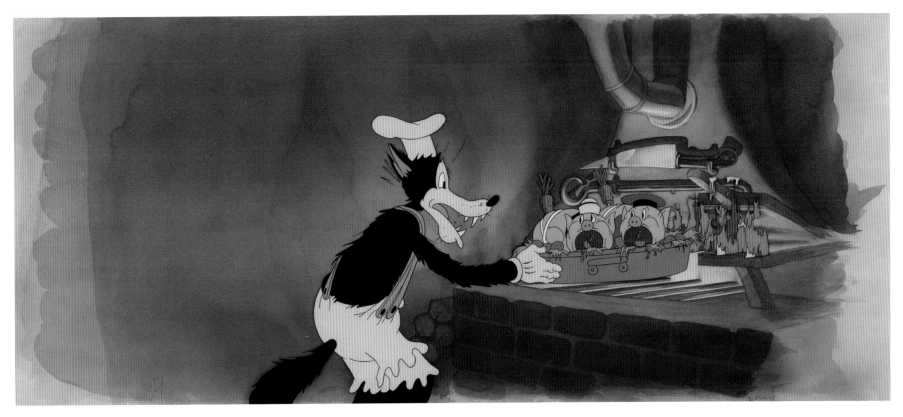

THREE LITTLE WOLVES 1936

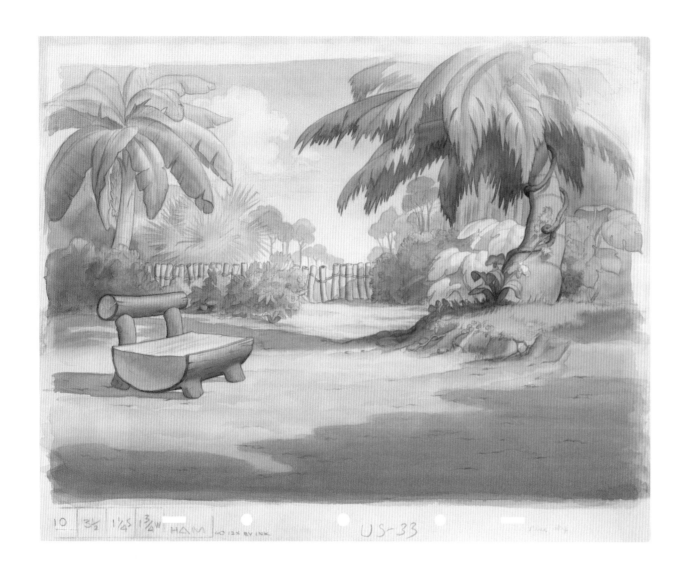

ELMER ELEPHANT 1936

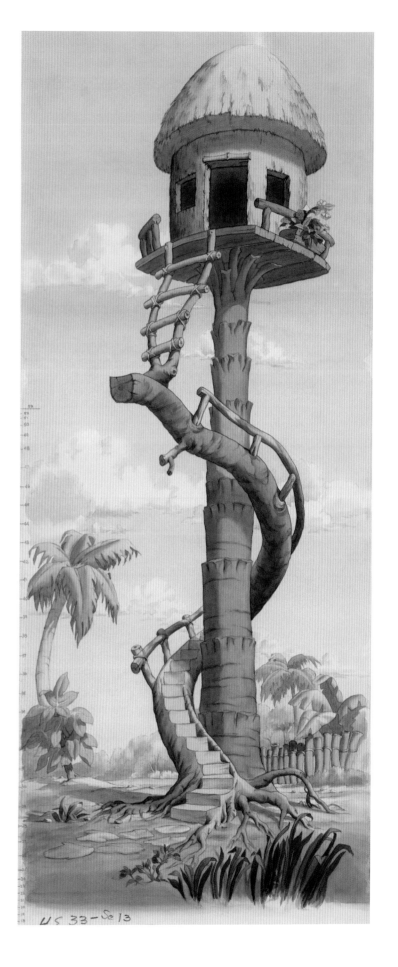

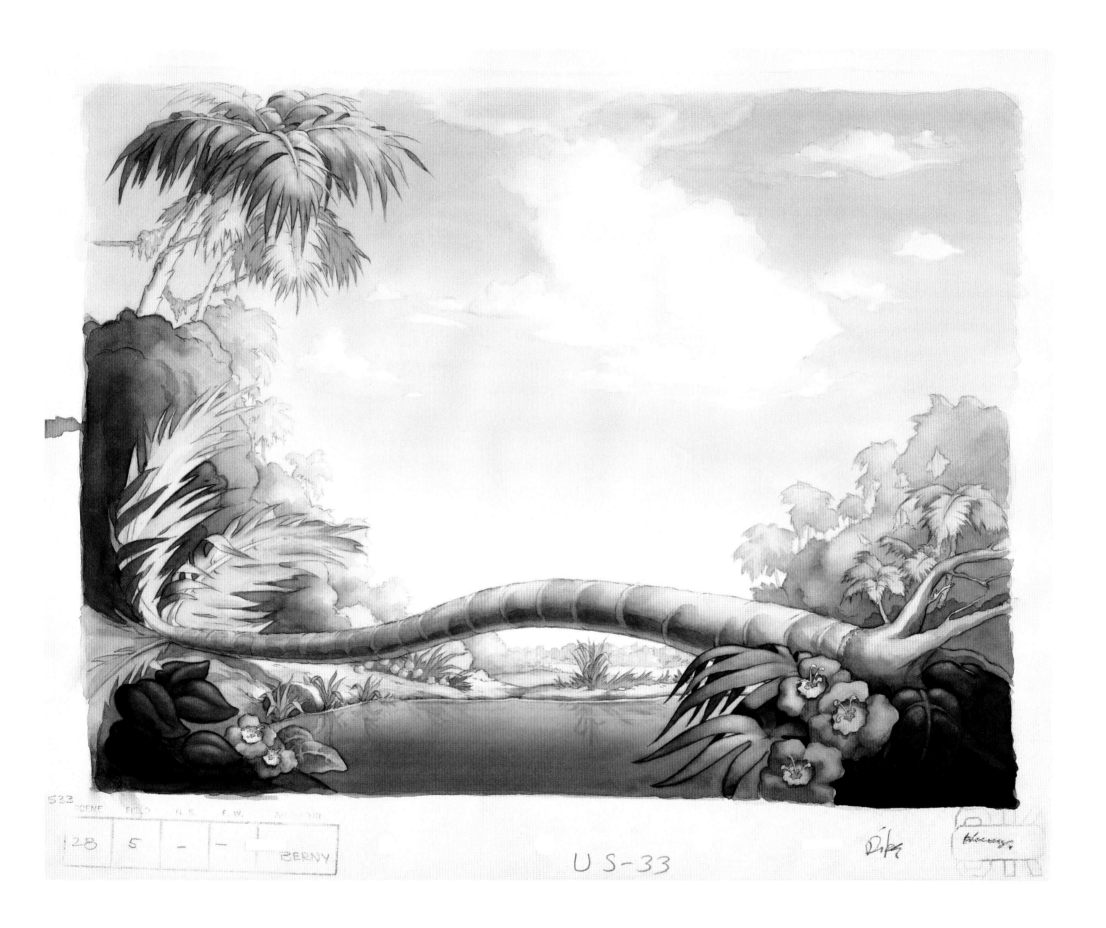

US-33

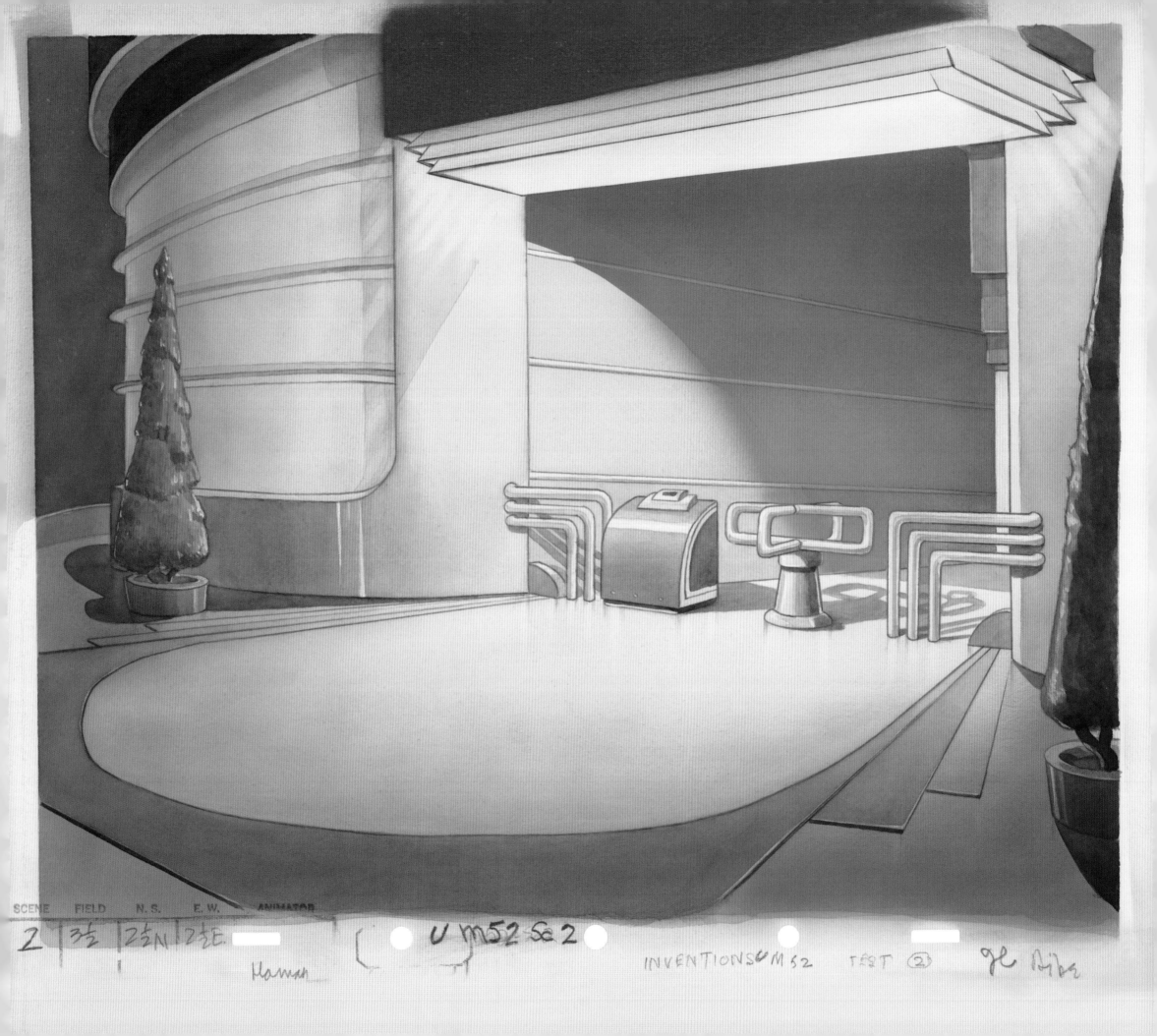

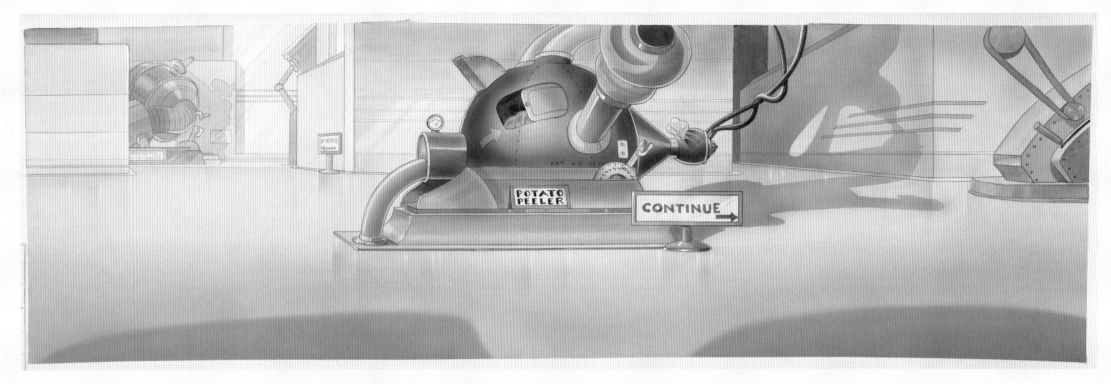

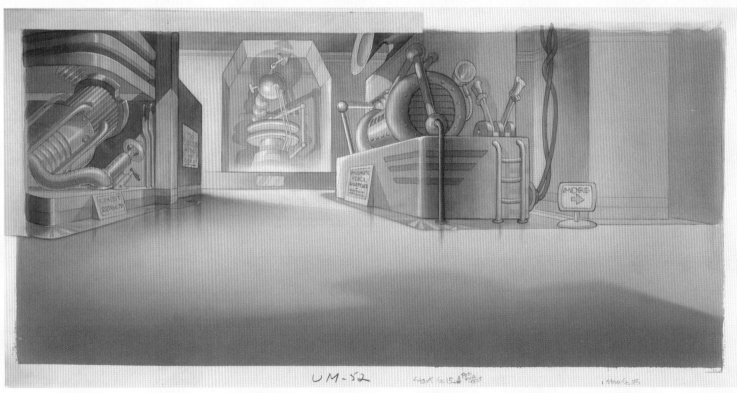

MODERN INVENTIONS 1937

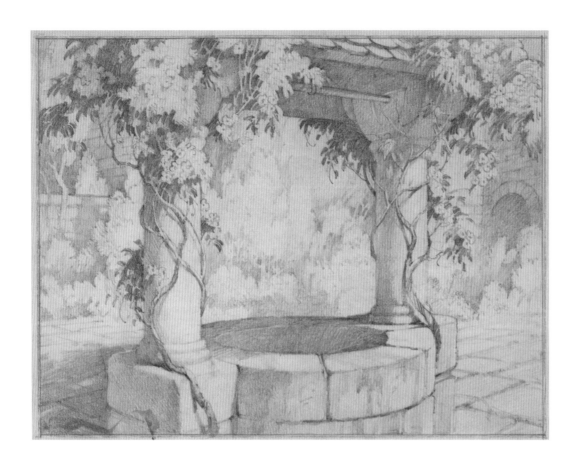
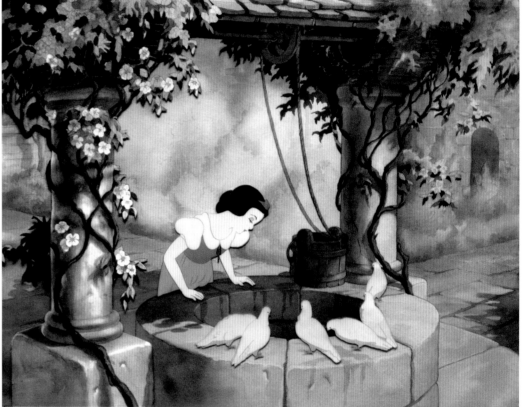

SNOW WHITE AND THE SEVEN DWARFS 1937

LAYOUT & BACKGROUND

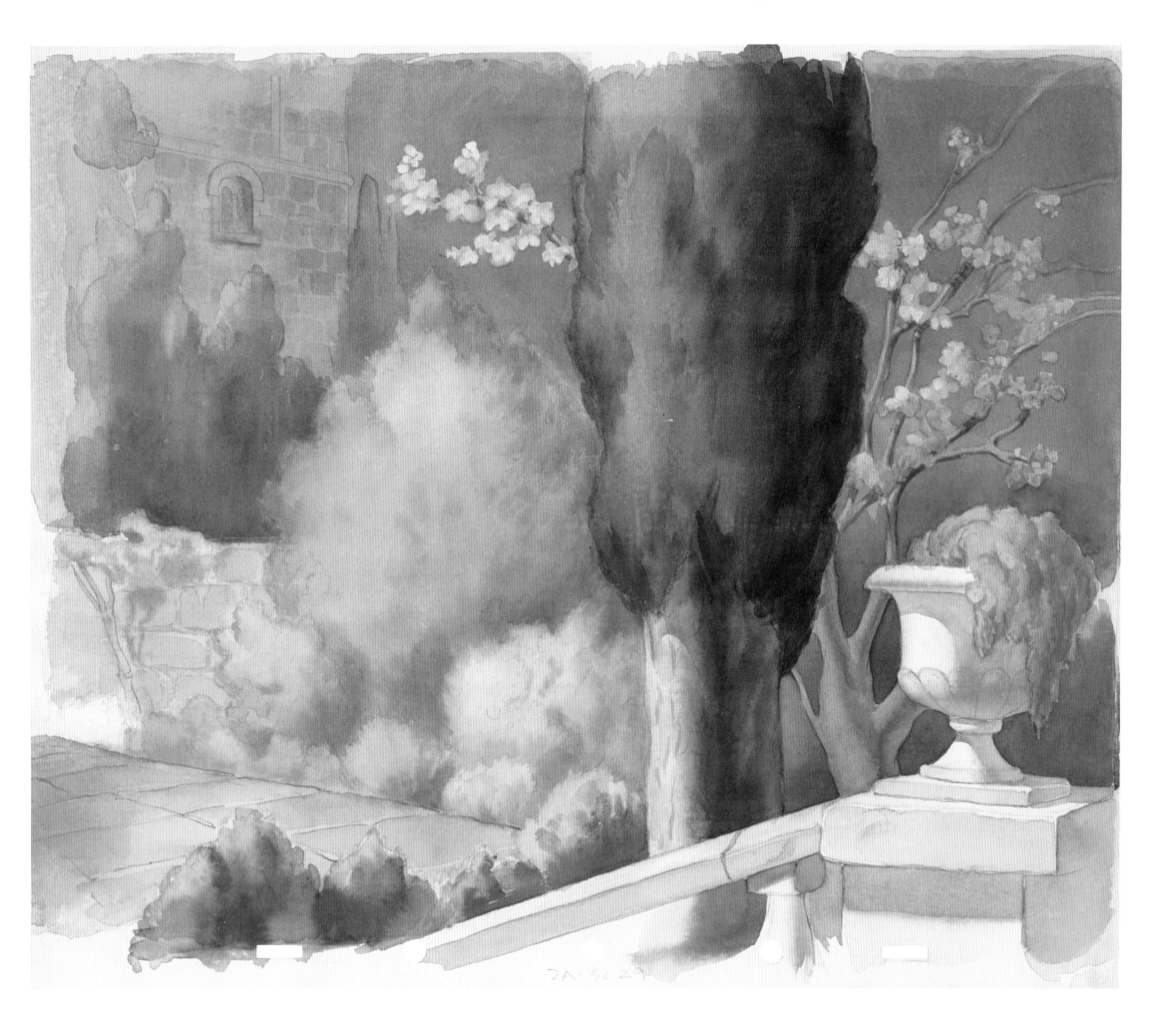

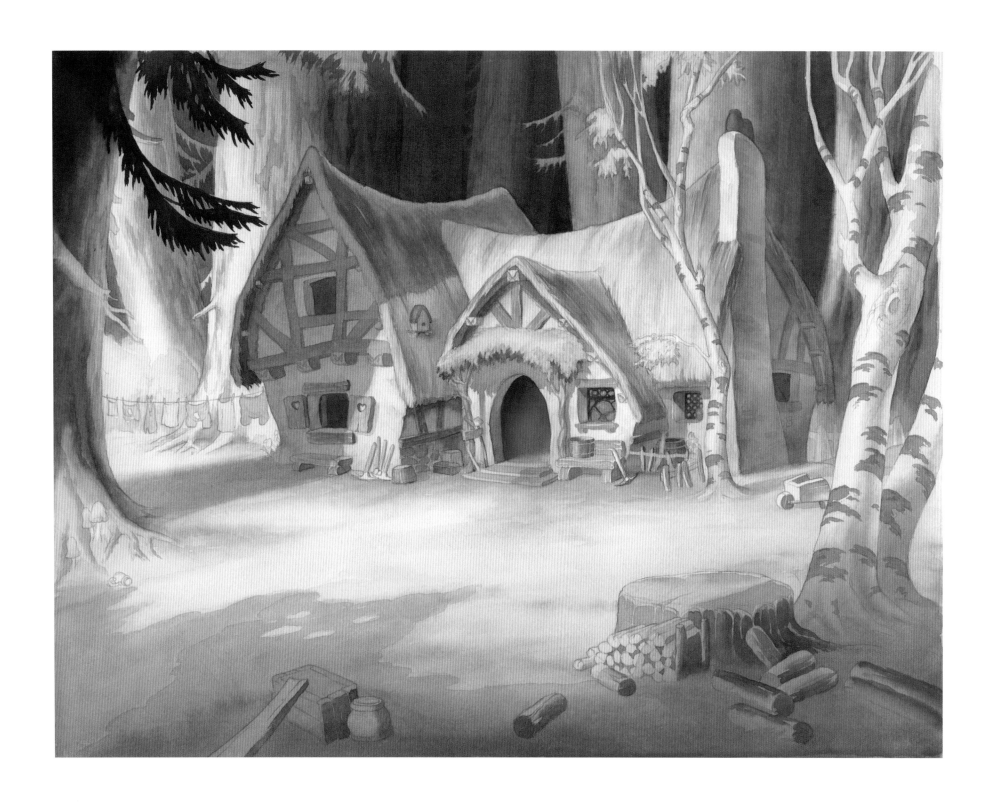

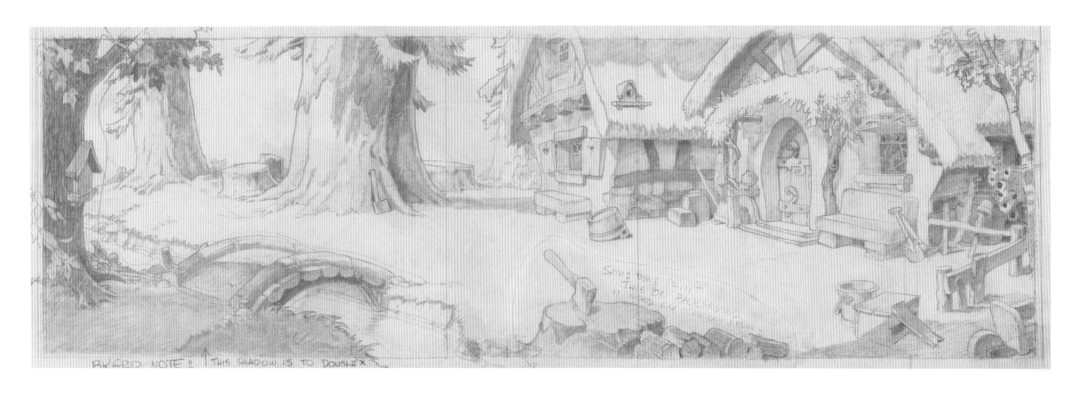

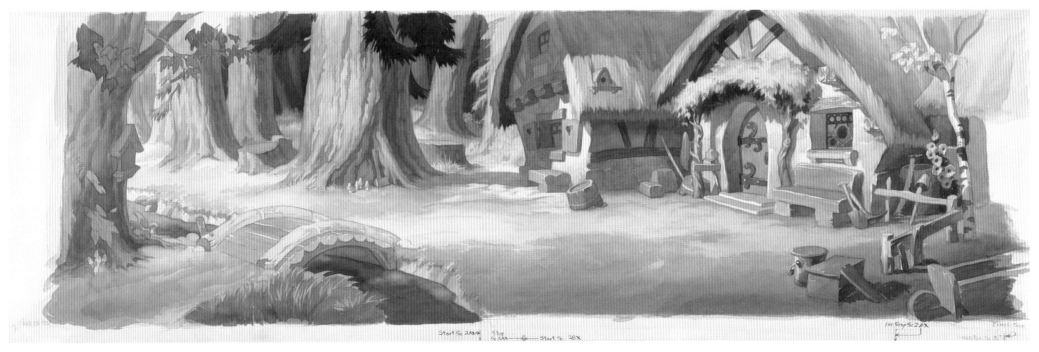

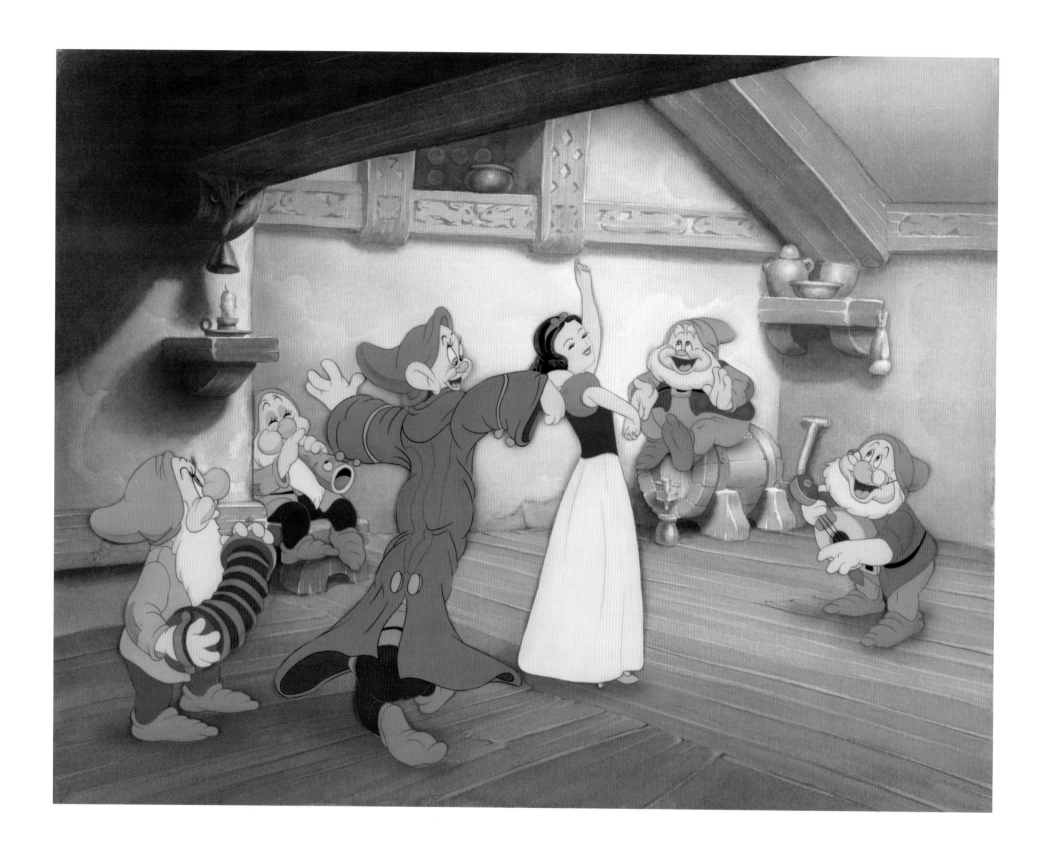

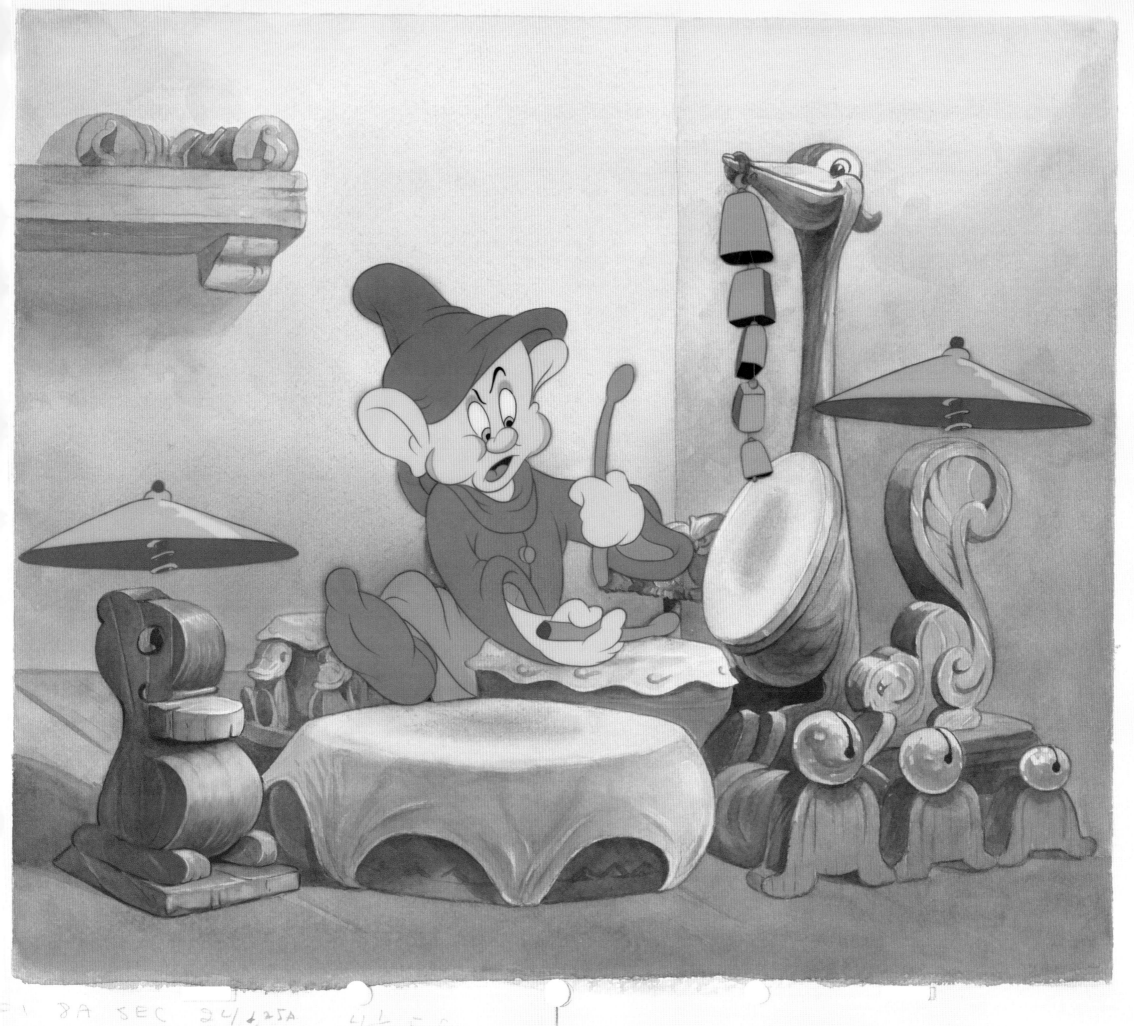

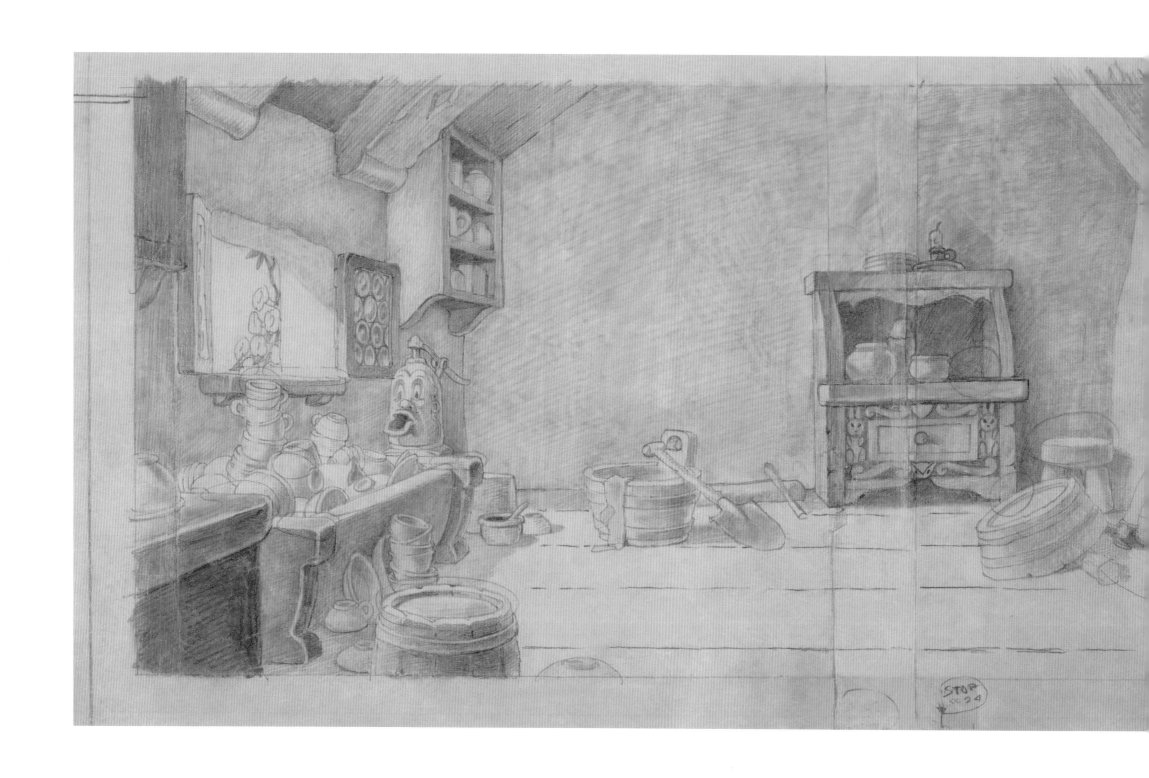

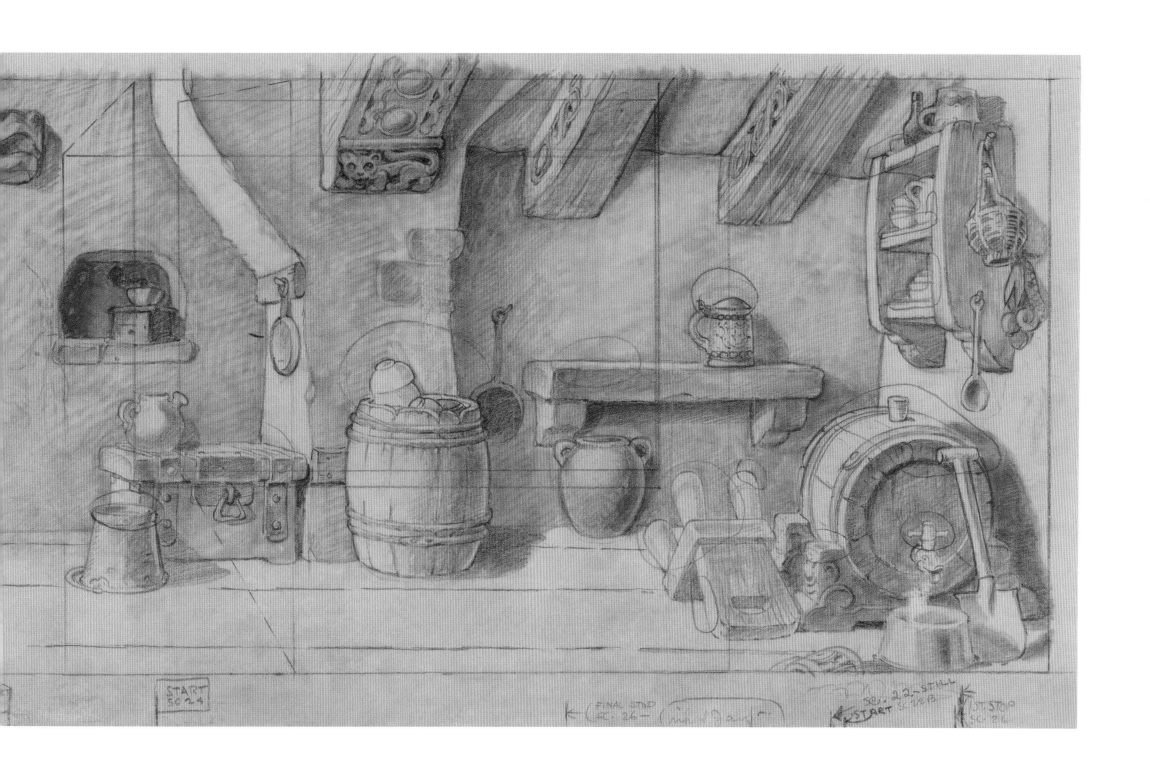

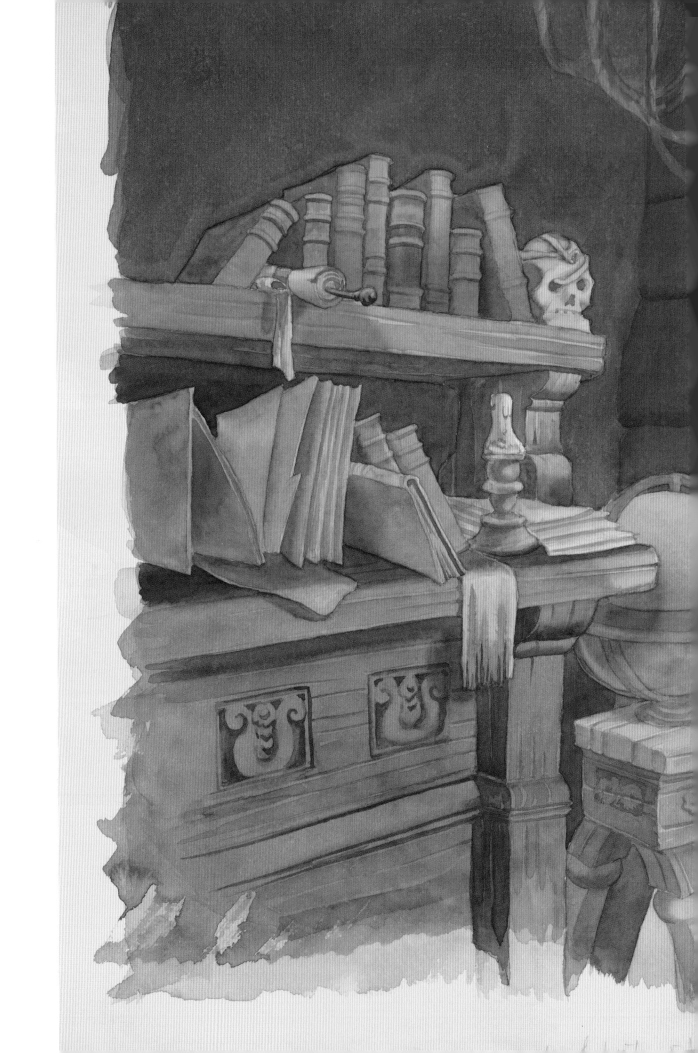

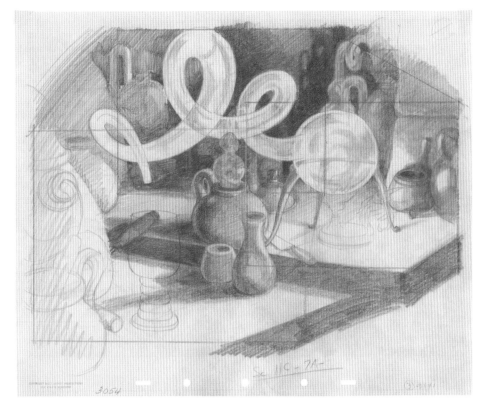

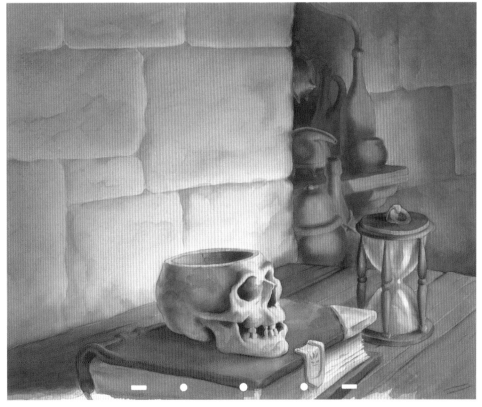

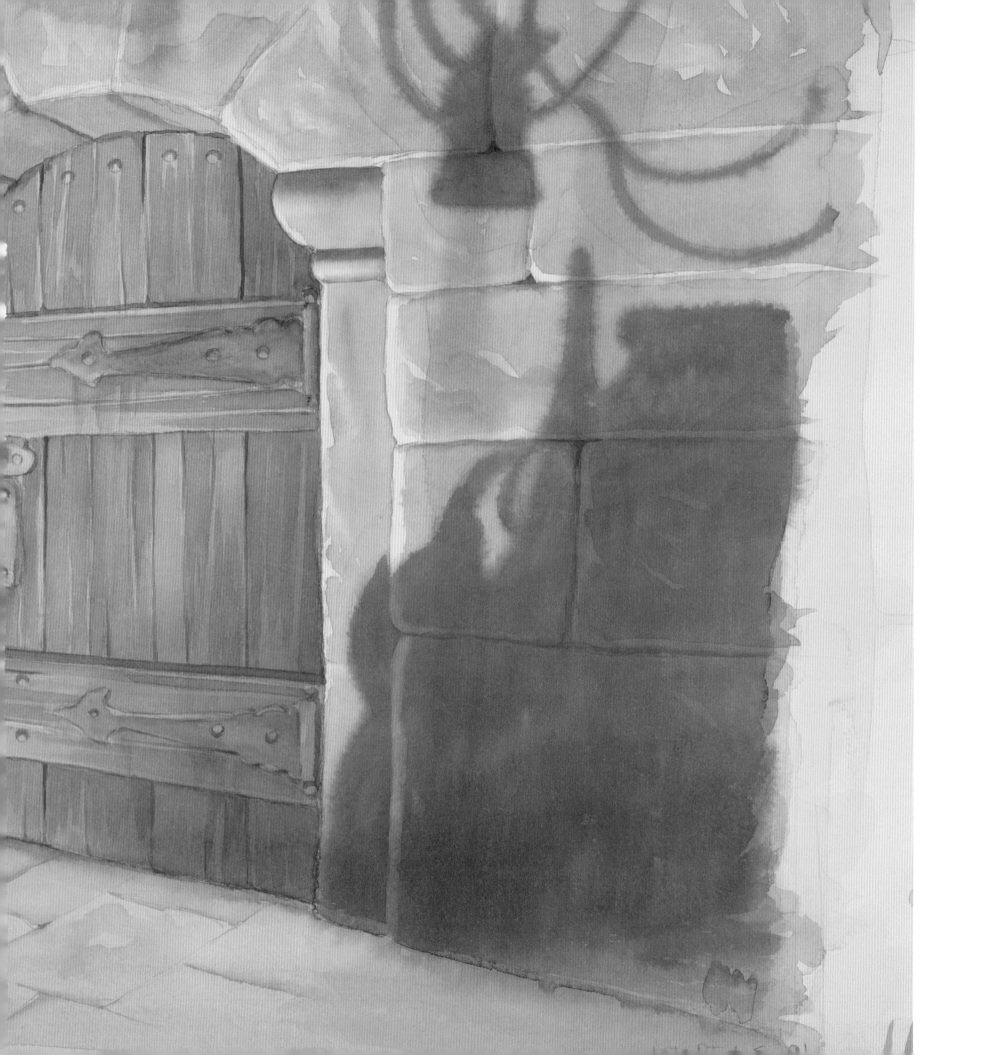

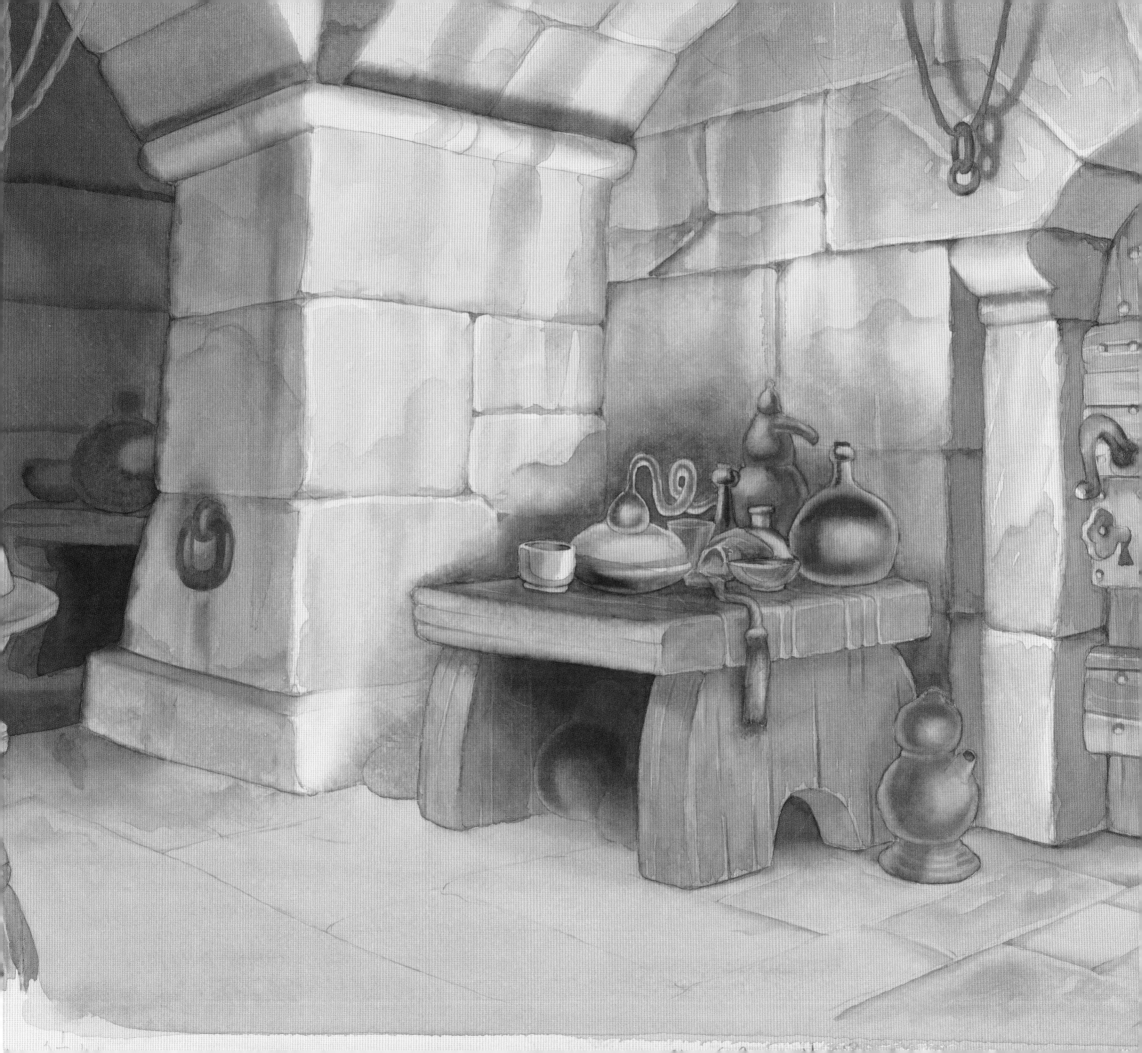

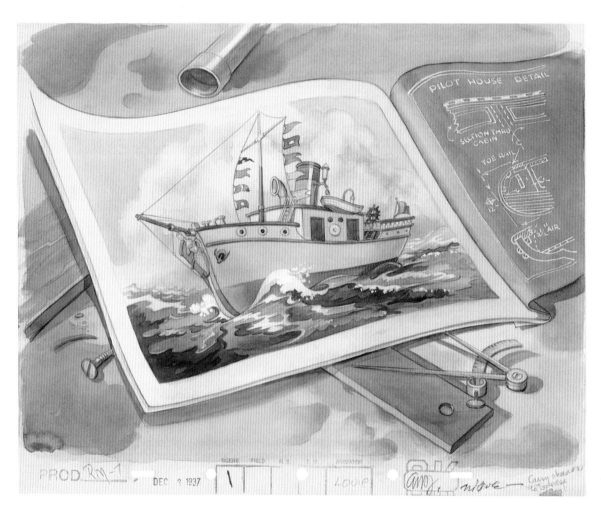

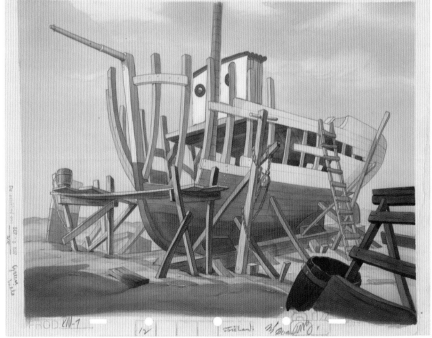

BOAT BUILDERS 1938

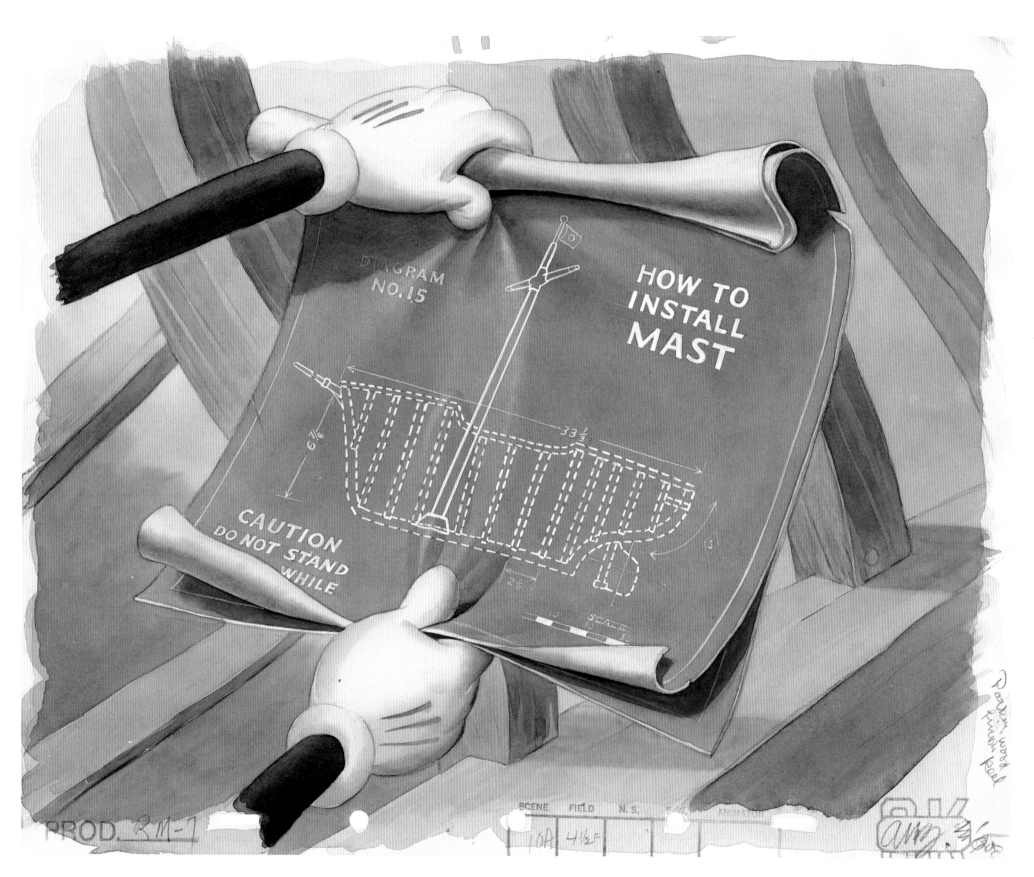

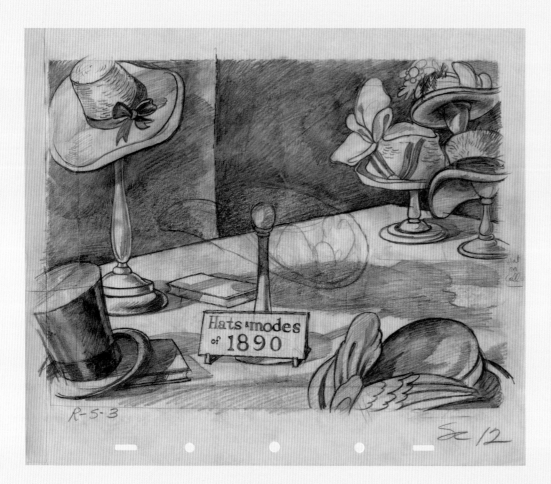

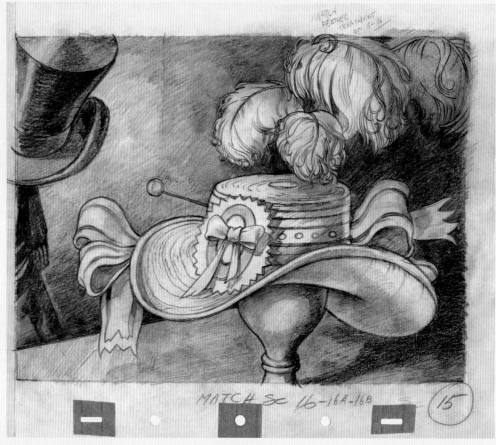

MOTH AND THE FLAME 1938

FOLLOWING SPREAD: **BRAVE LITTLE TAILOR** 1938

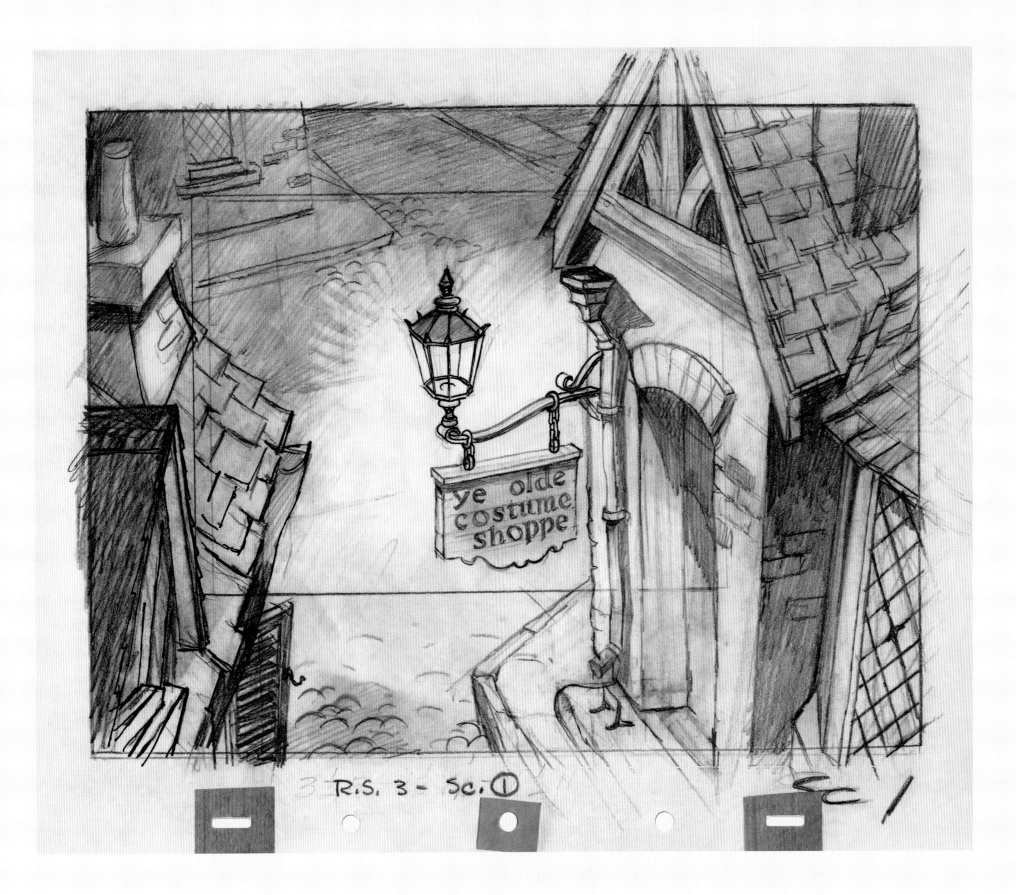

3 R.S. 3 - Sc. ① Sc. 1

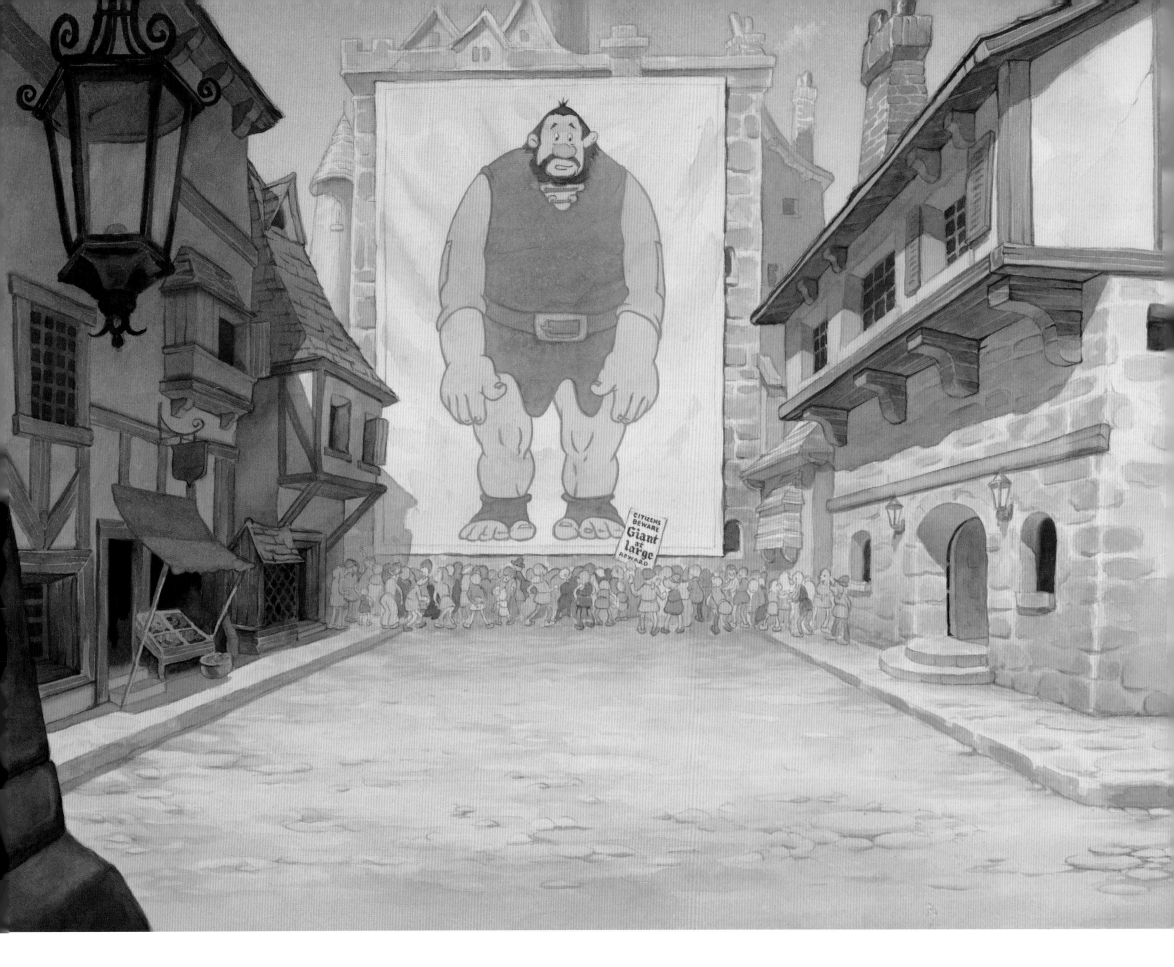

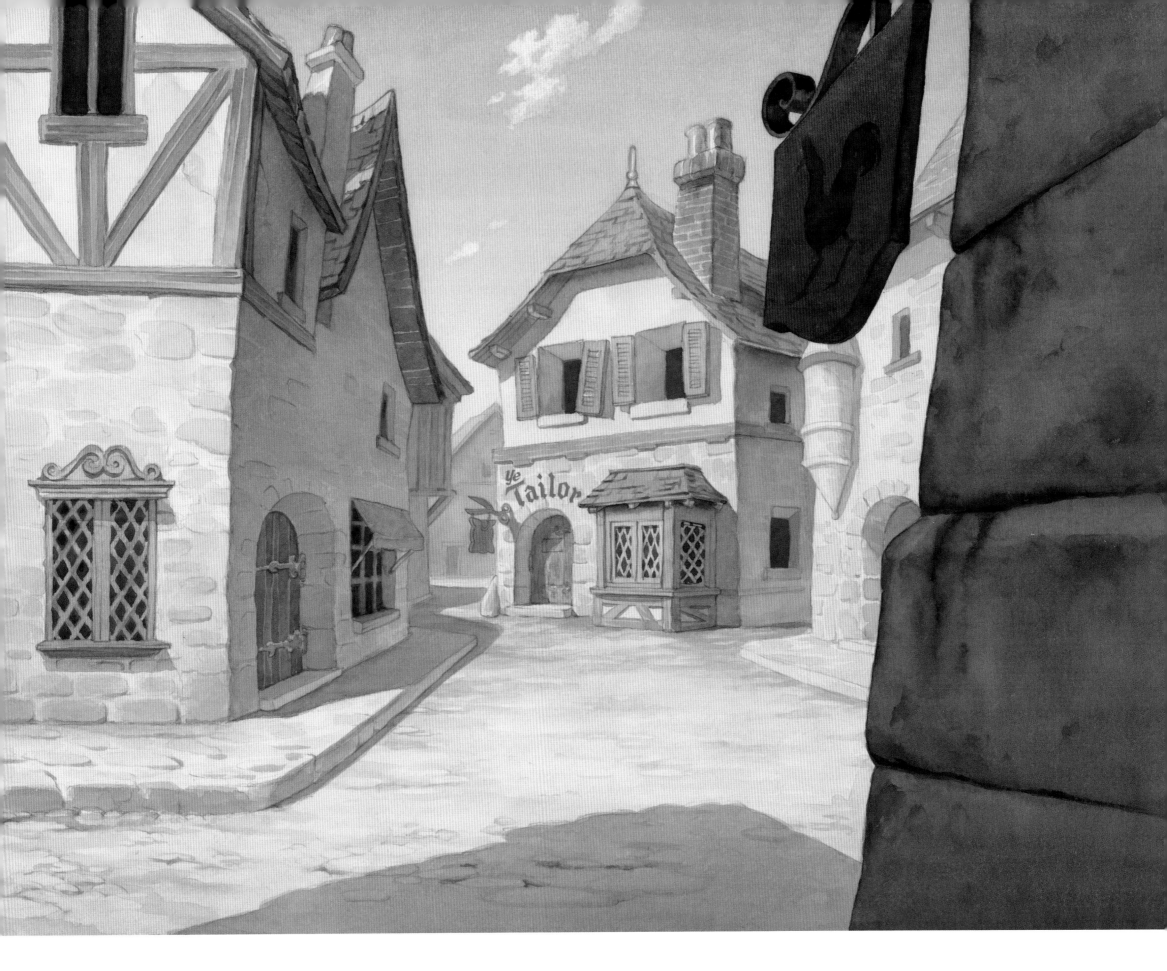

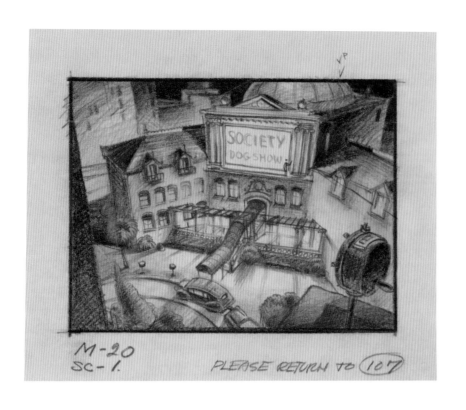

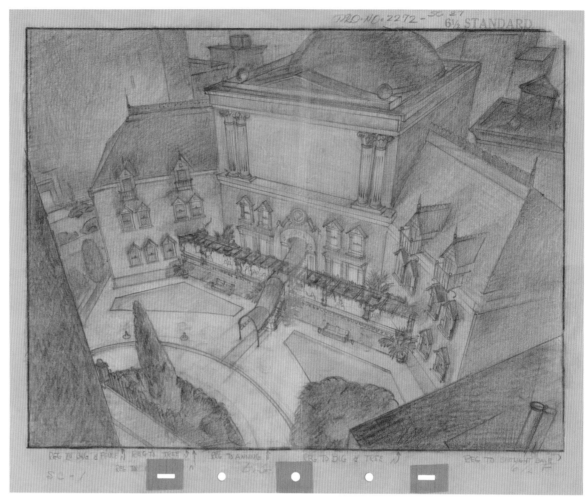

SOCIETY DOG SHOW 1939

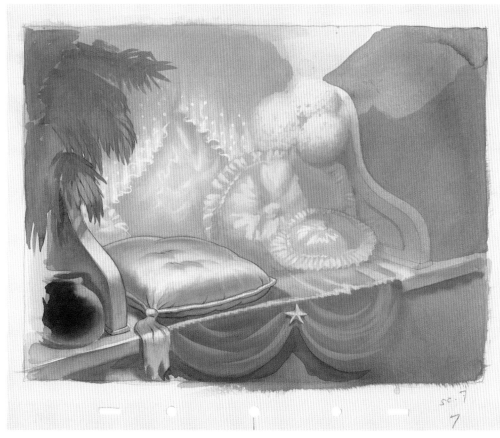

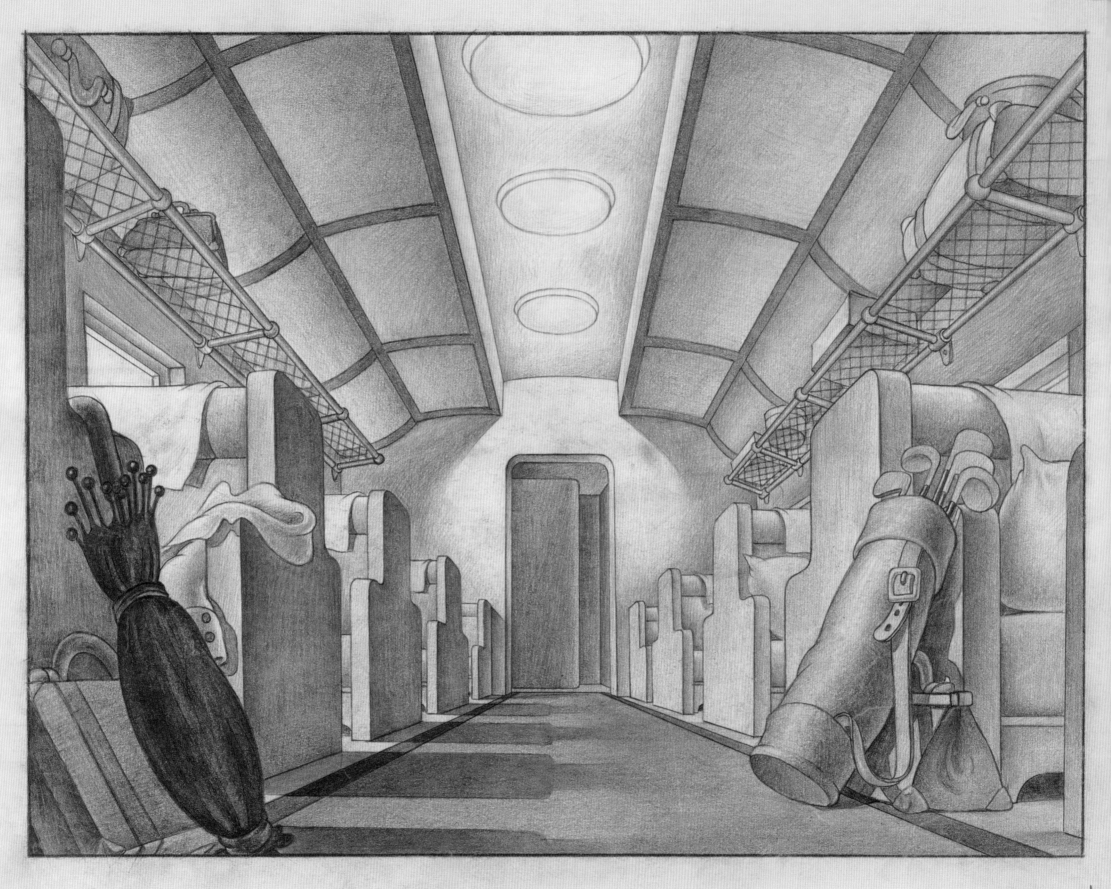

C-2

SC 21
B.6

"0 54"
SCENE 54
2242

SCENE 54
2242

MR. MOUSE TAKES A TRIP 1940

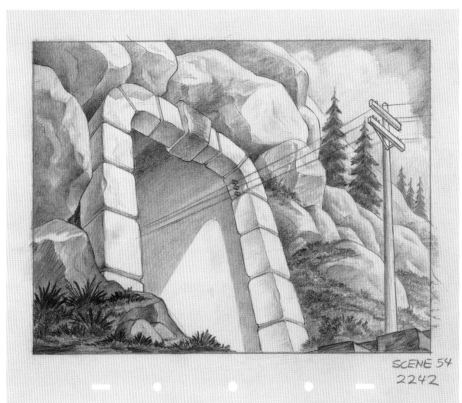

SCENE 54
2242

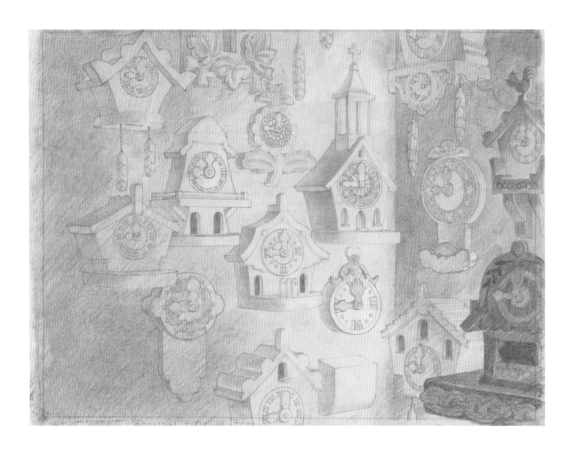

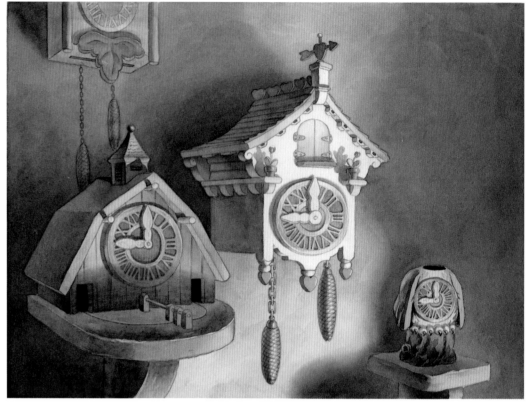

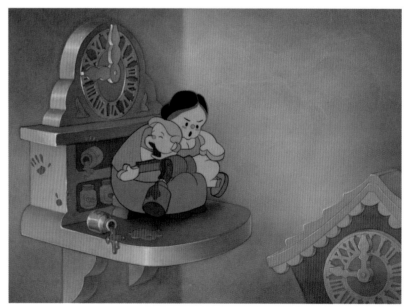

PINOCCHIO 1940

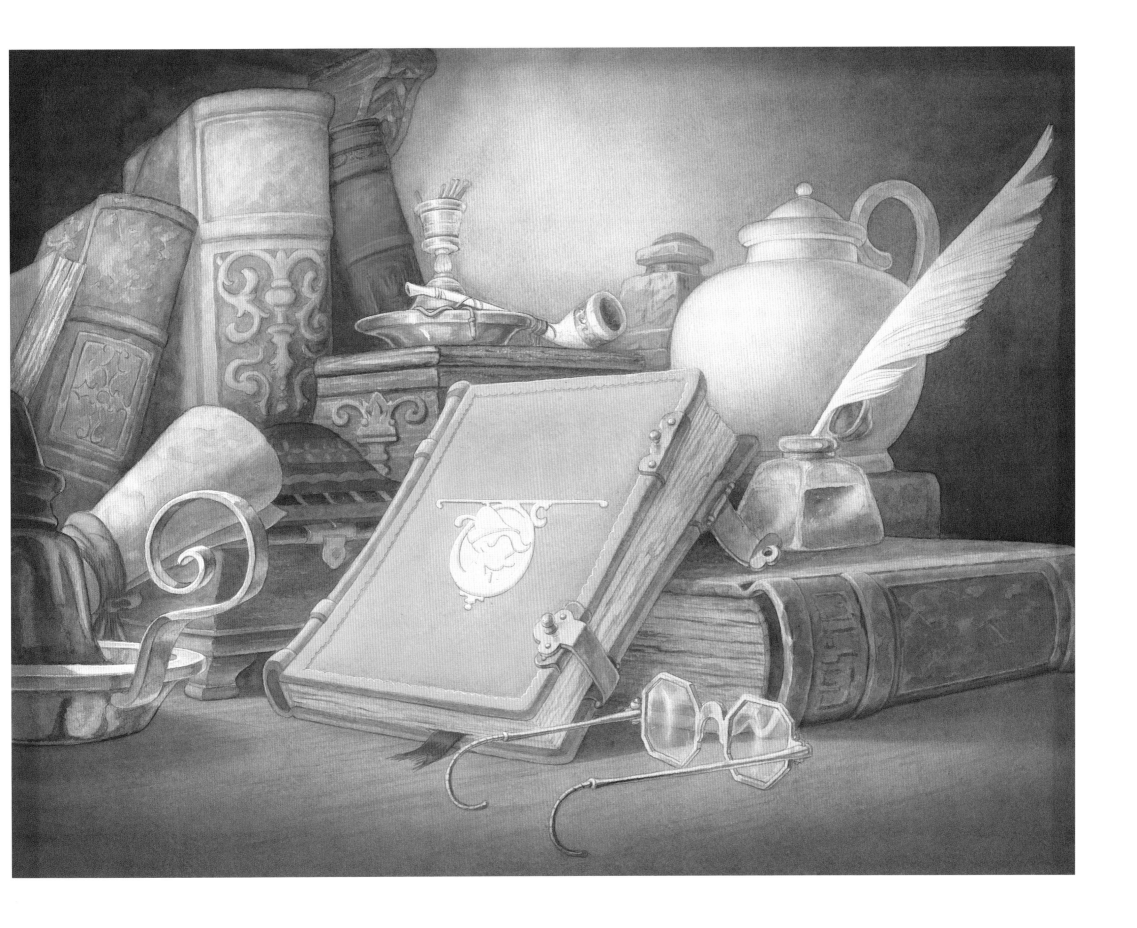

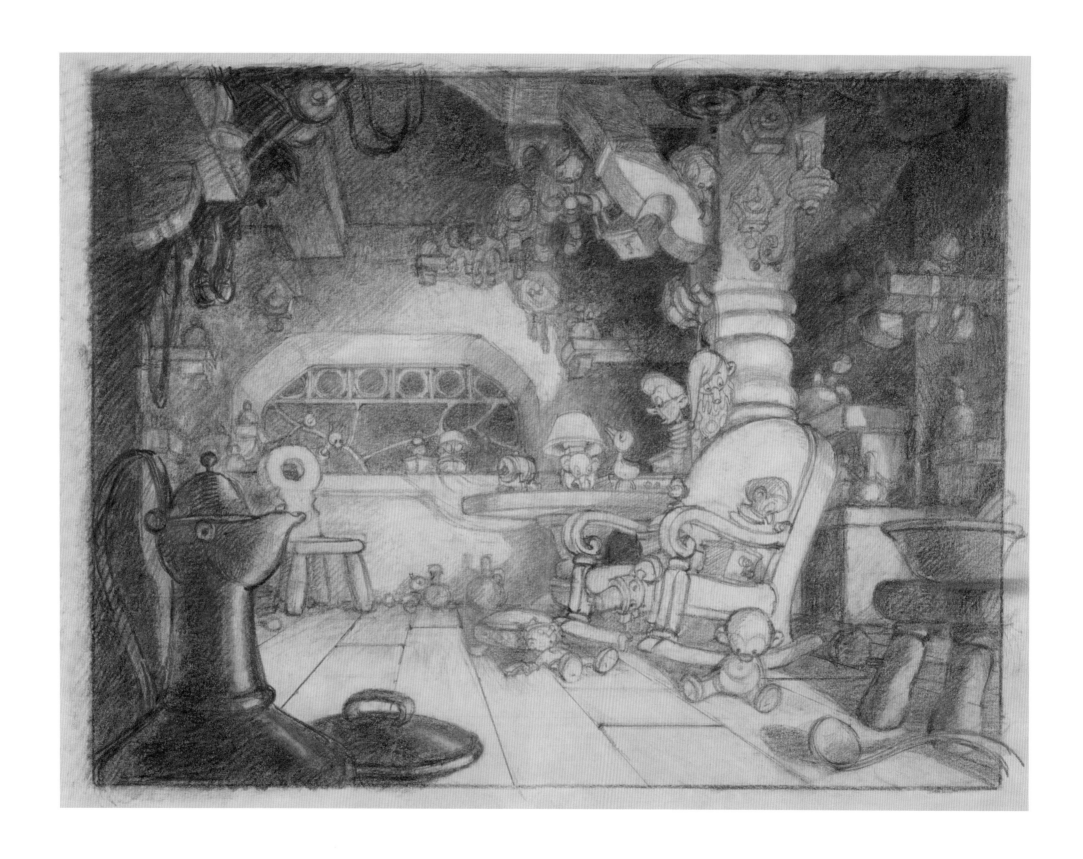

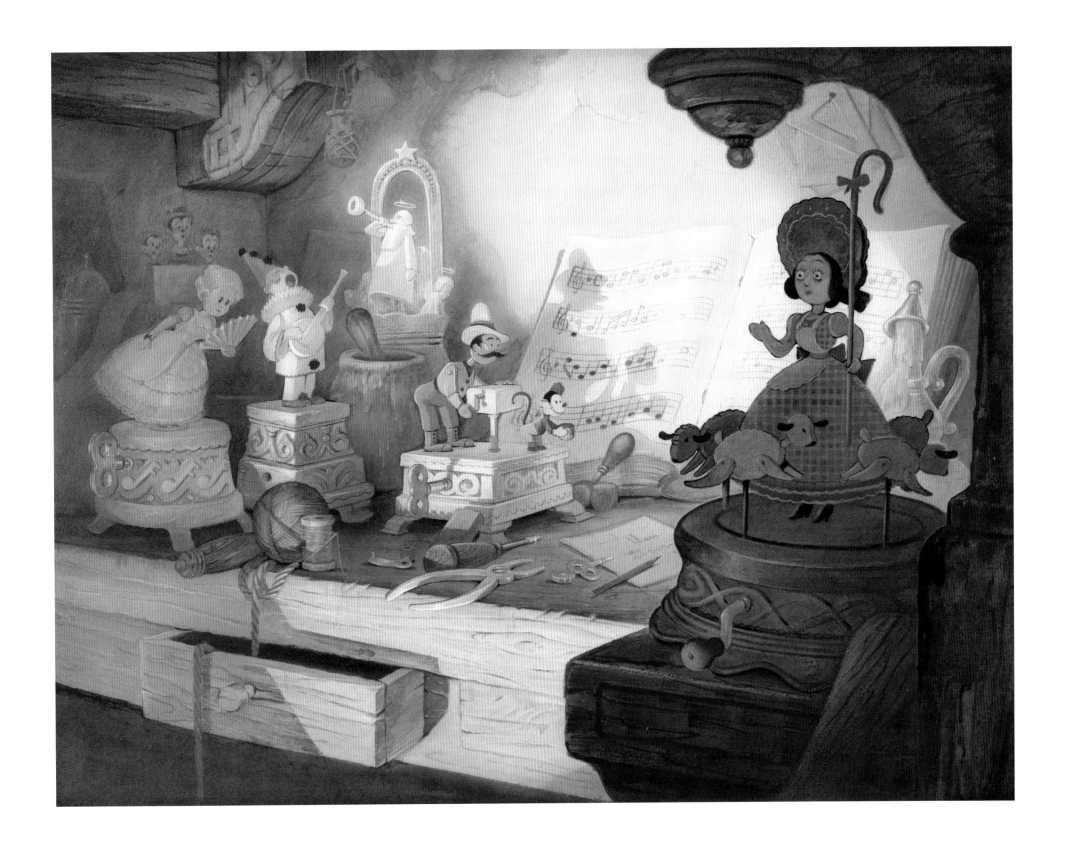

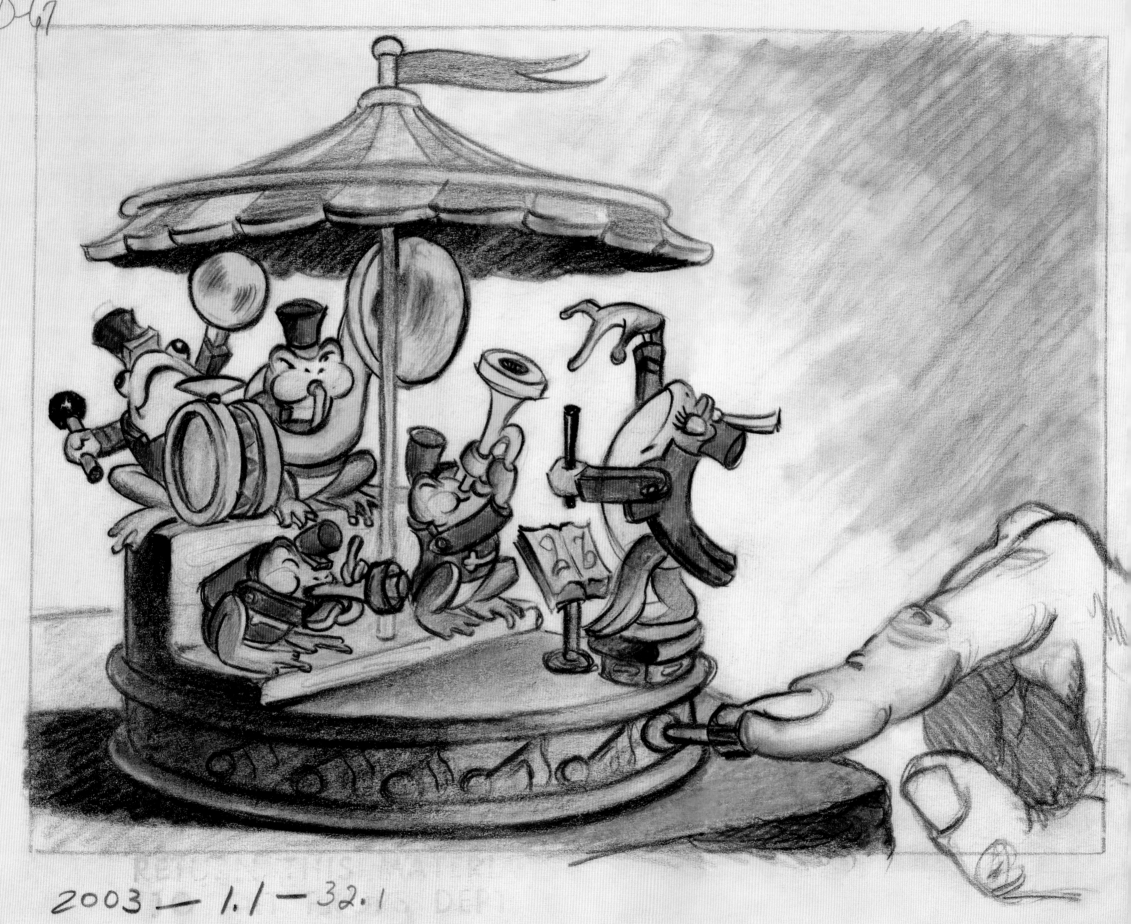

2003 — 1.1 — 32.1

MUSIC BOX

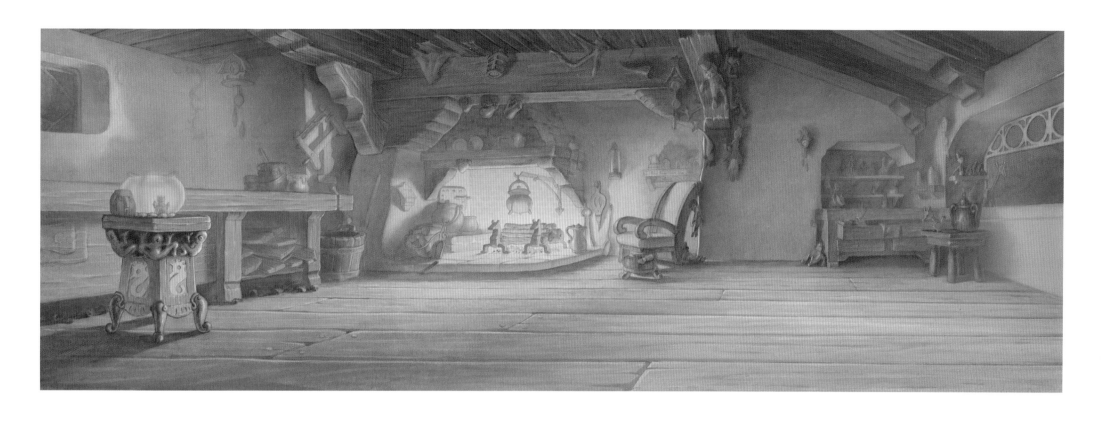

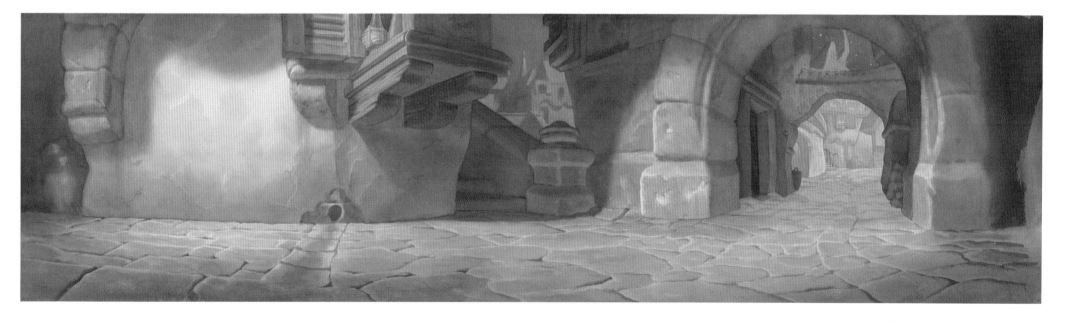

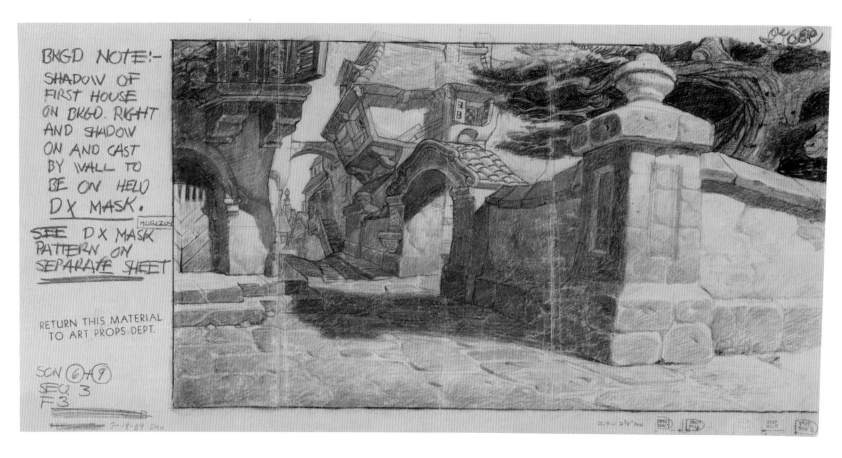

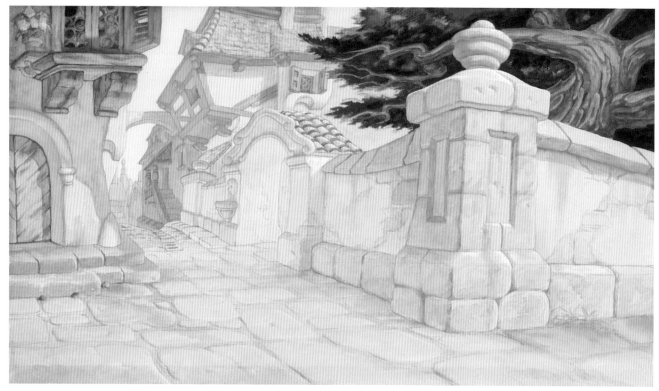

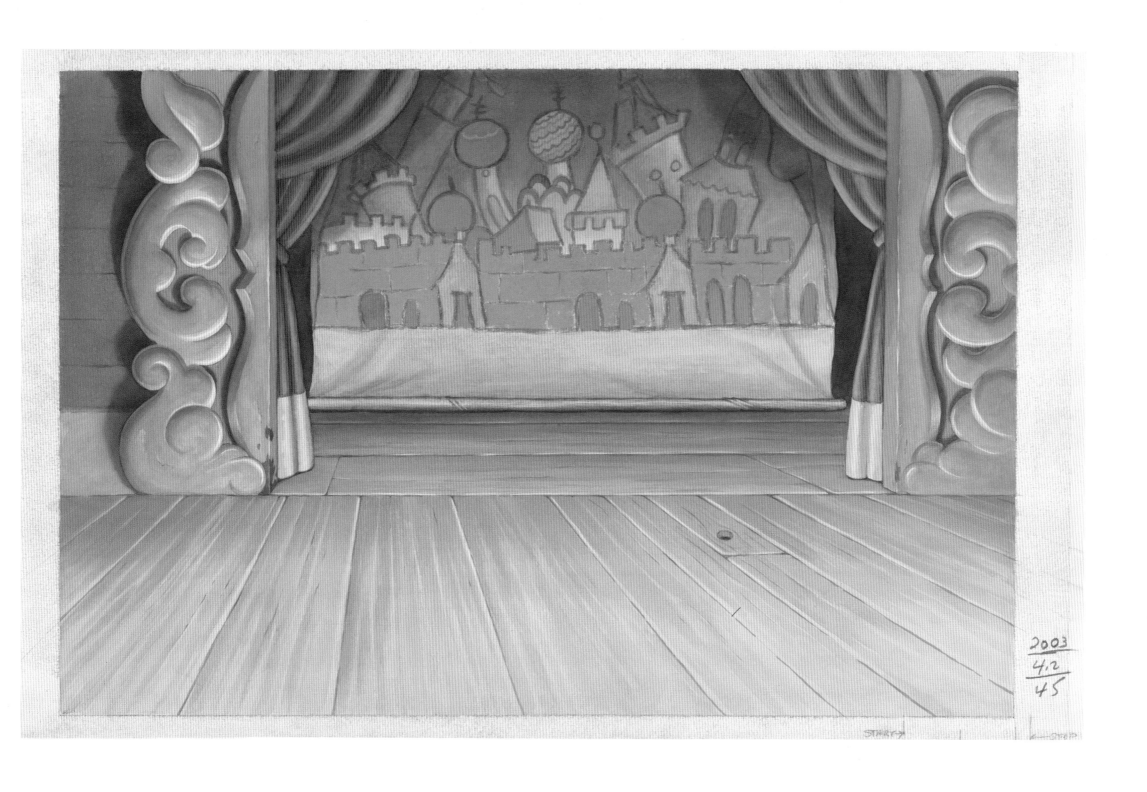

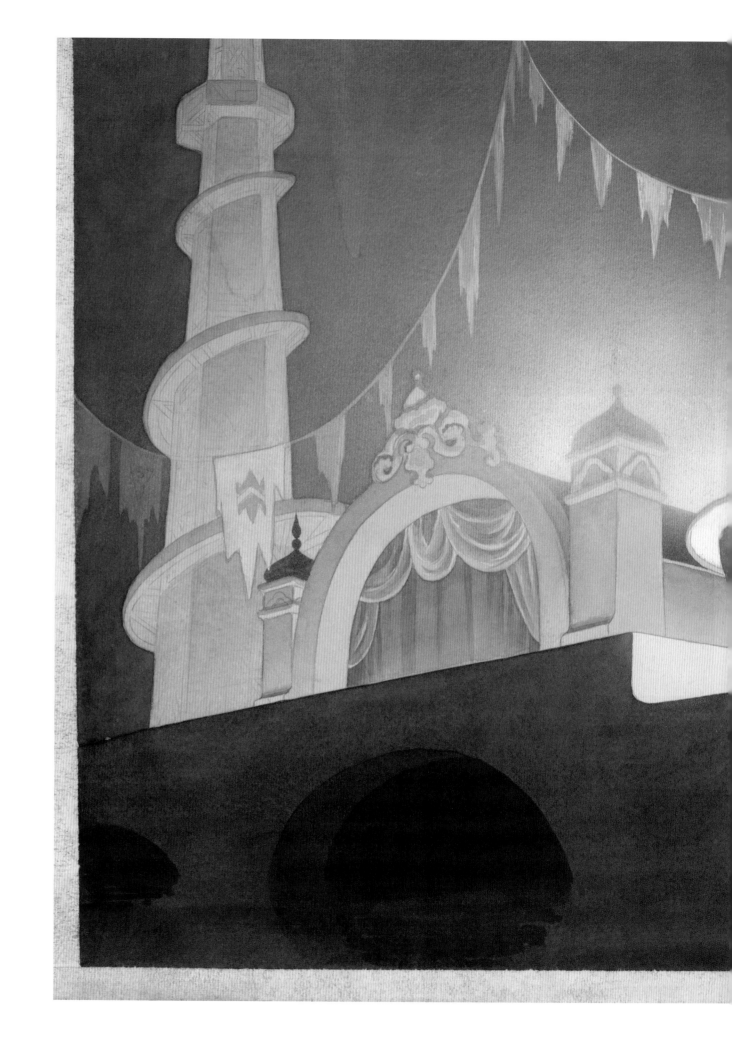

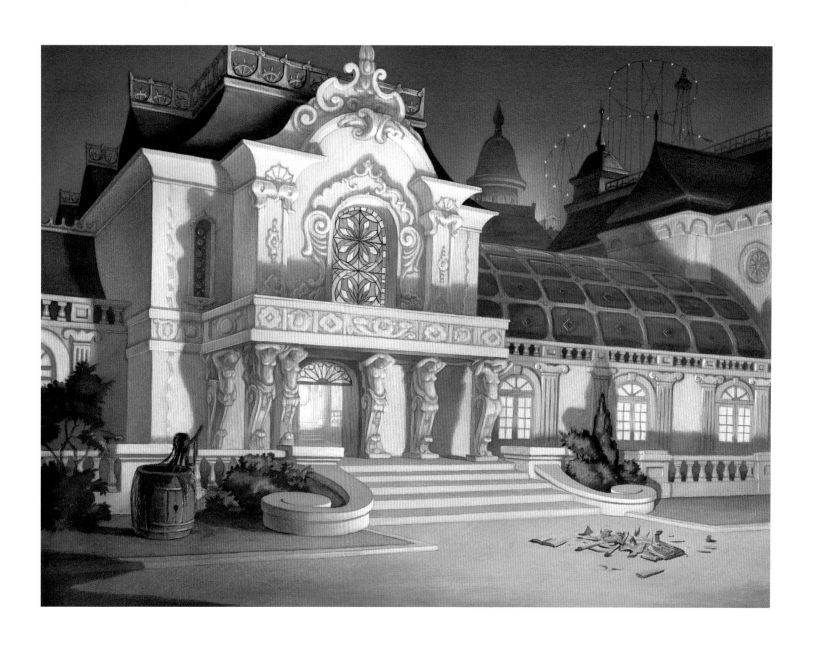

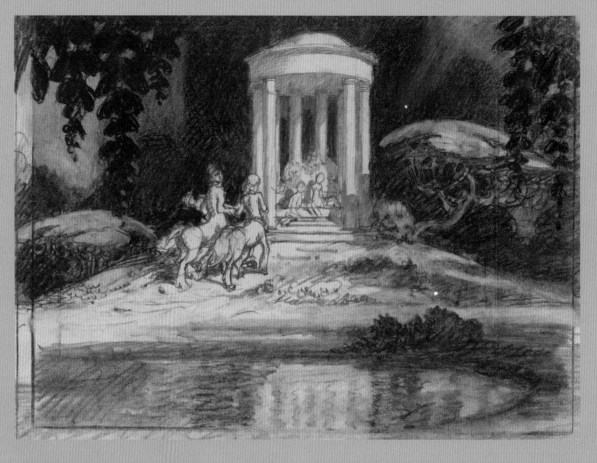

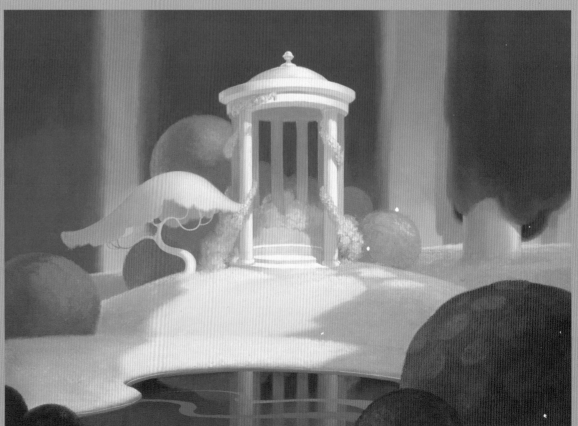

FANTASIA, "THE PASTORAL SYMPHONY" 1940

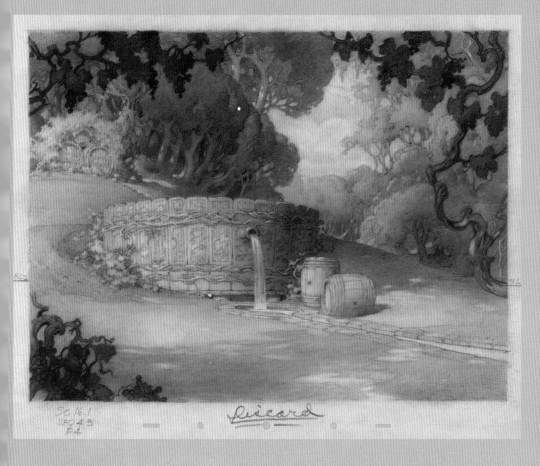

Puscard

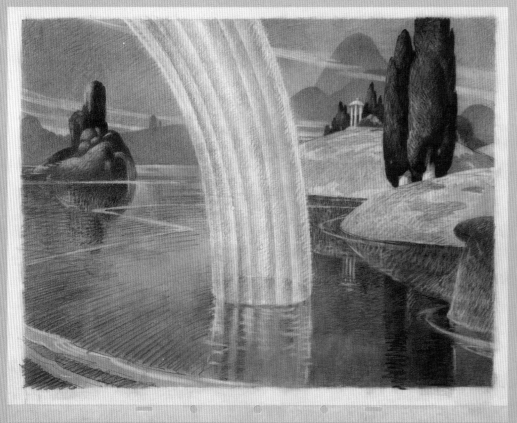

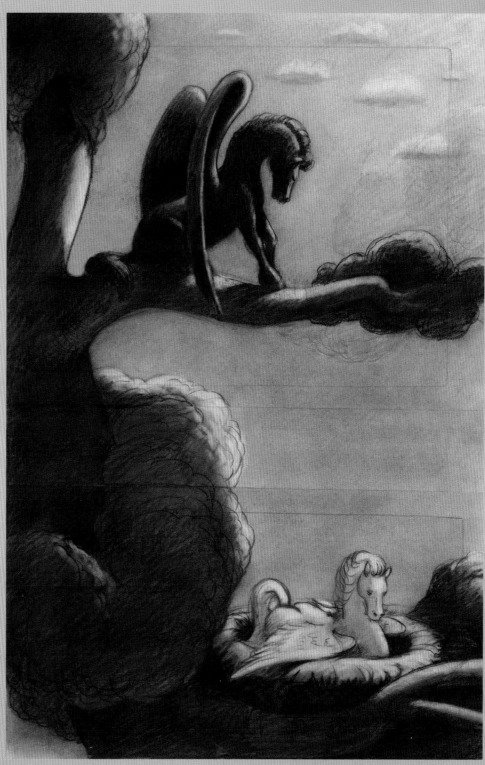

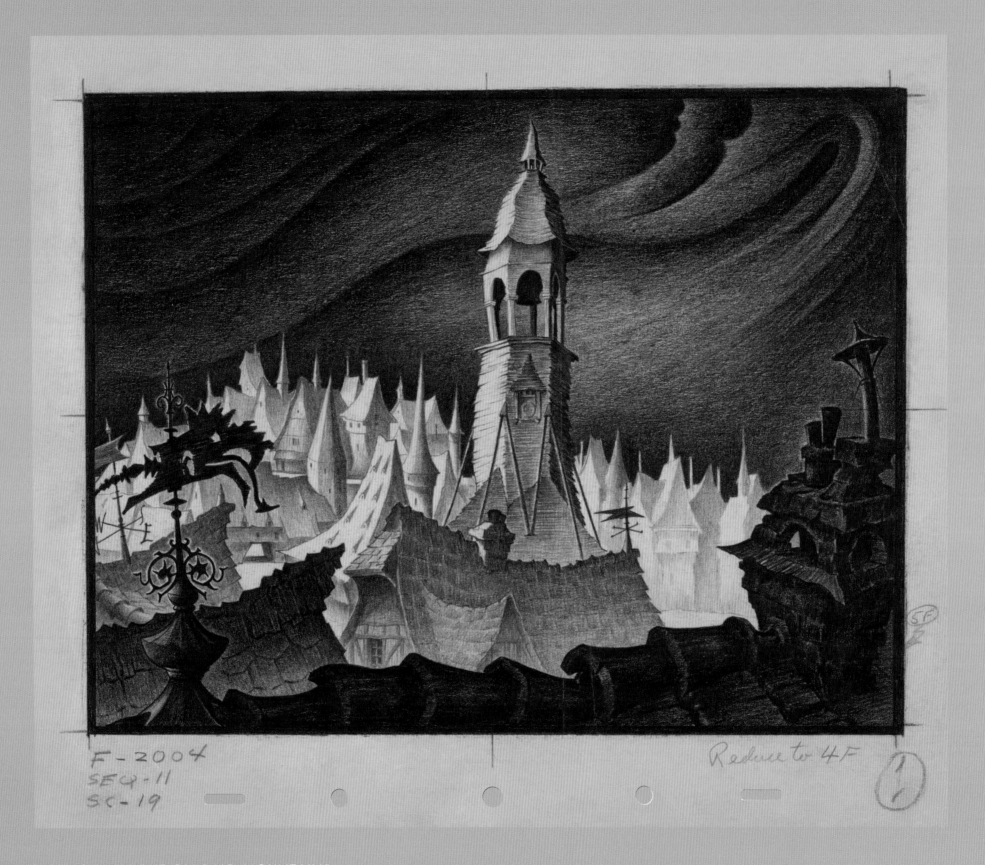

F-2004
SEQ-11
SC-19

Reduce to 4F

FANTASIA, "NIGHT ON BALD MOUNTAIN" 1940

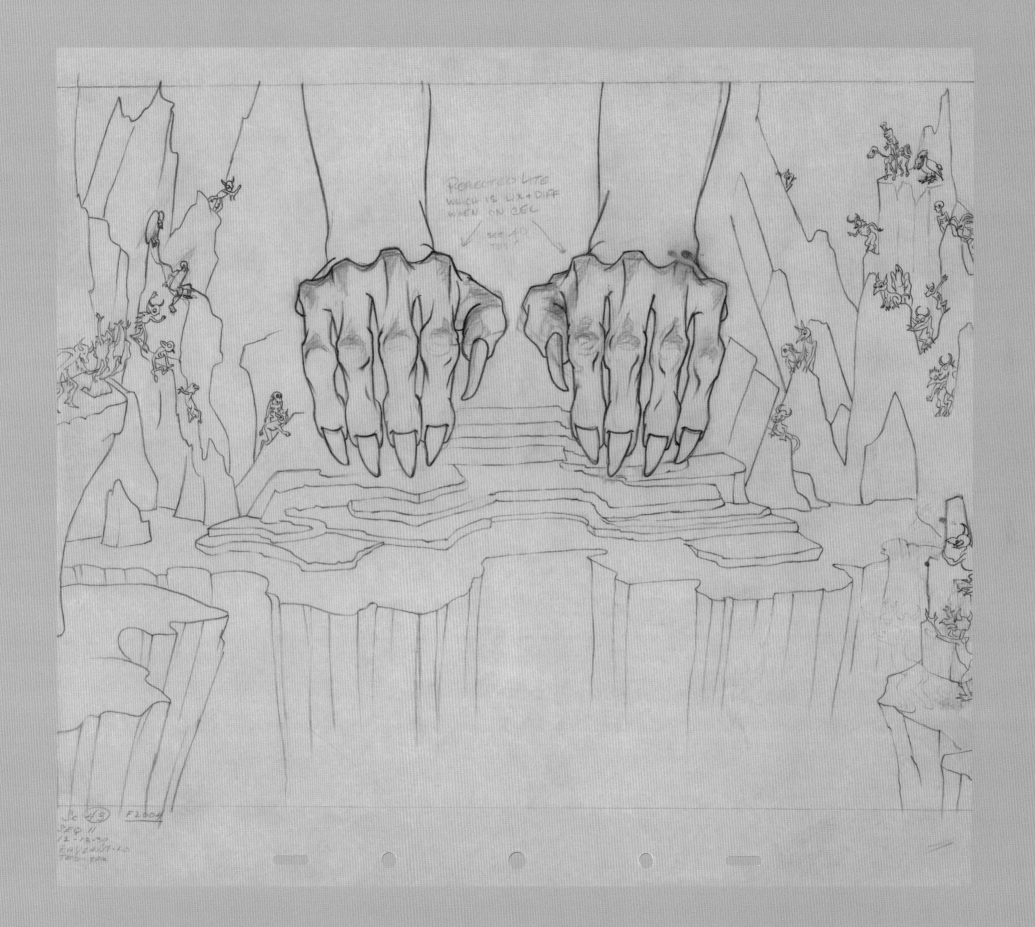

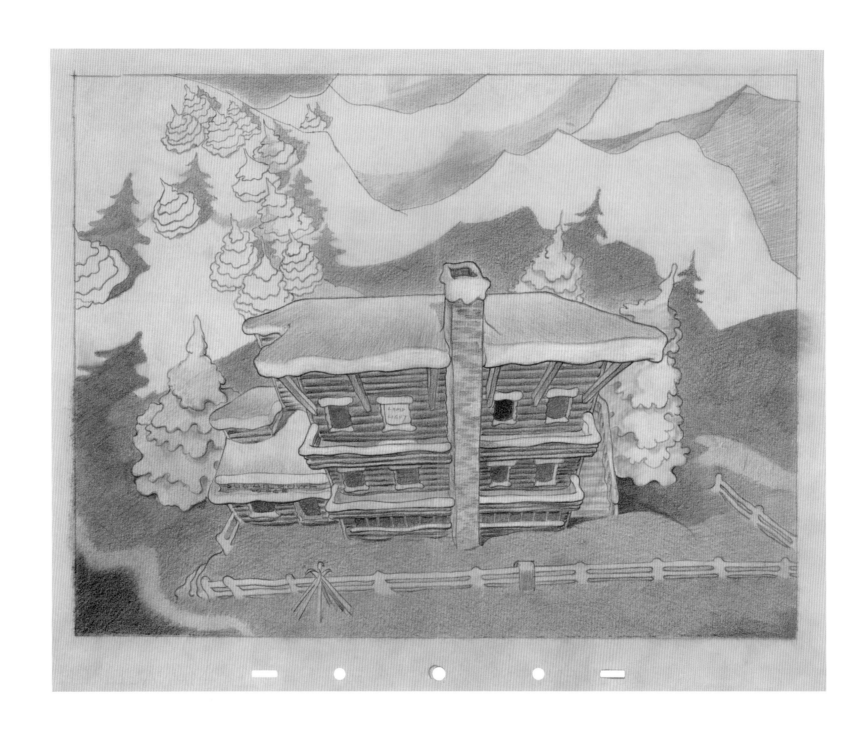

THE ART OF SKIING 1941

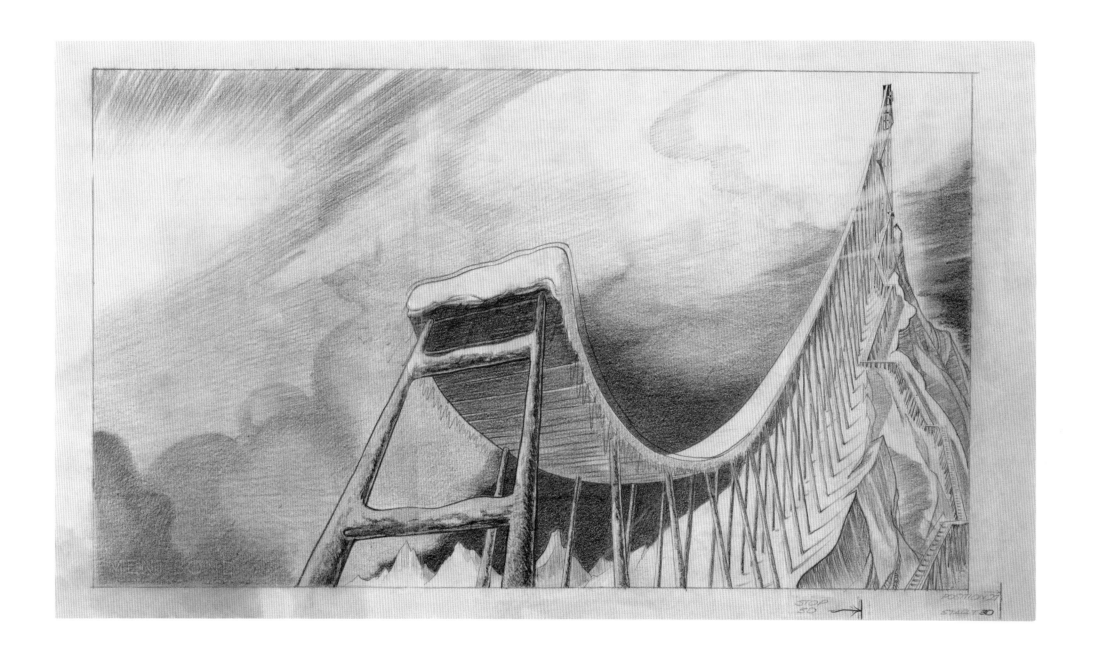

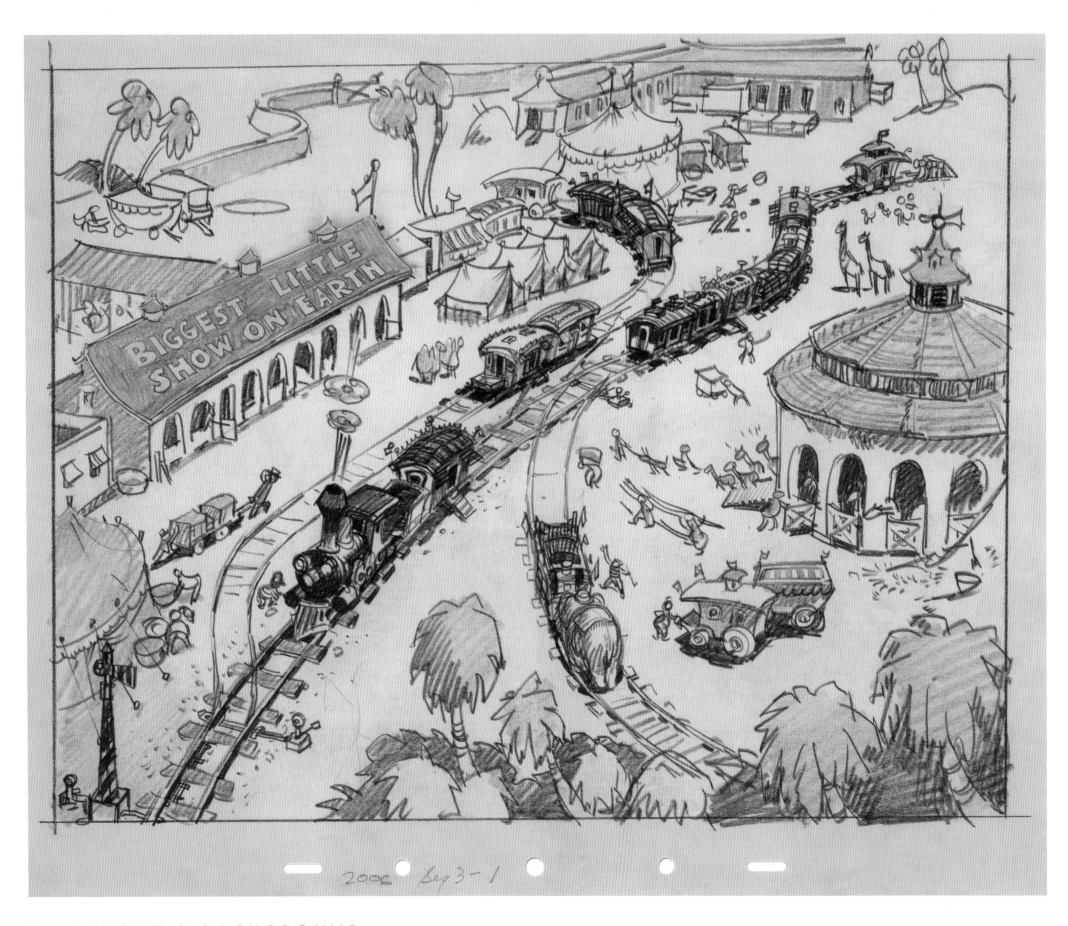

BIGGEST LITTLE SHOW ON EARTH

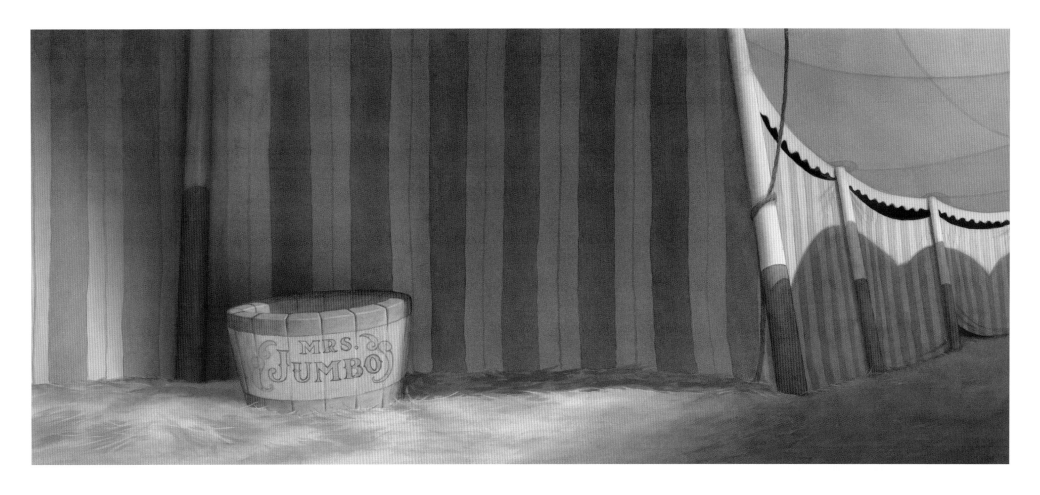

DUMBO 1941

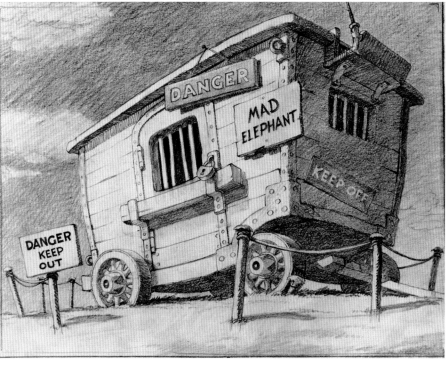

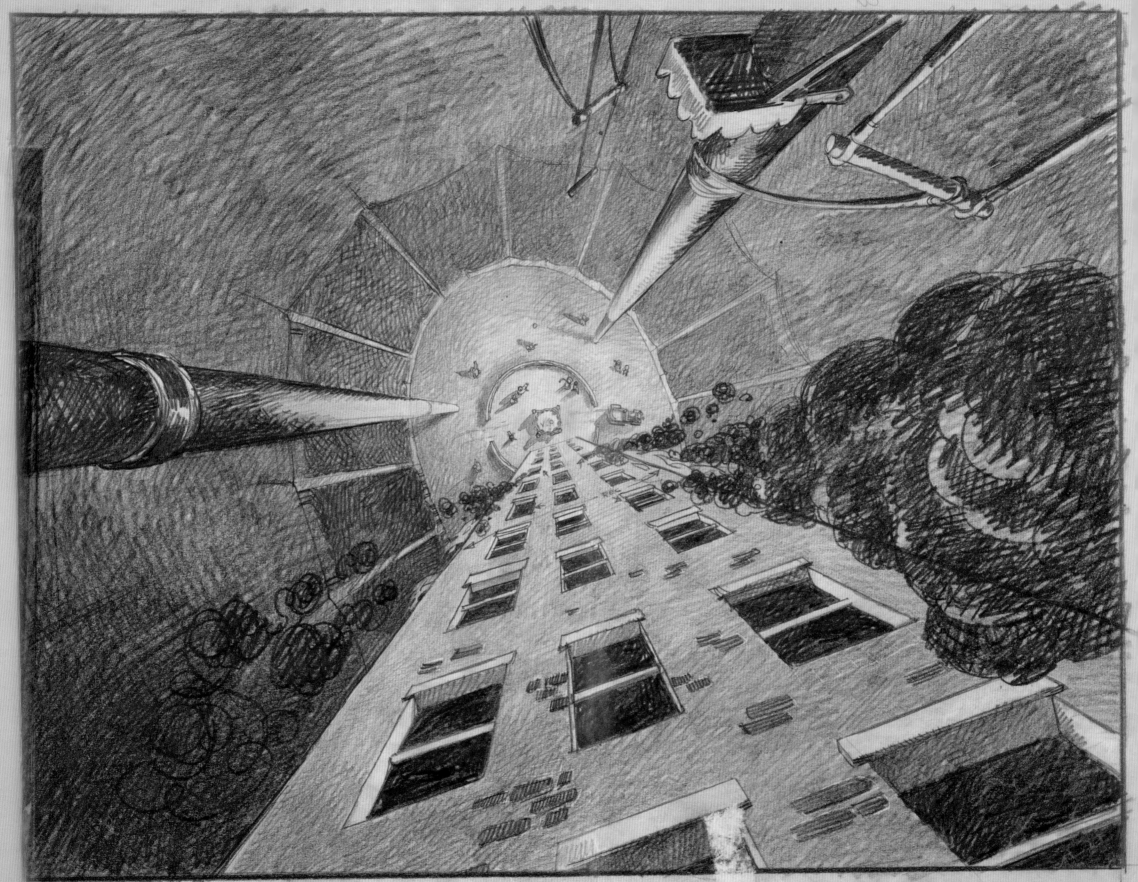

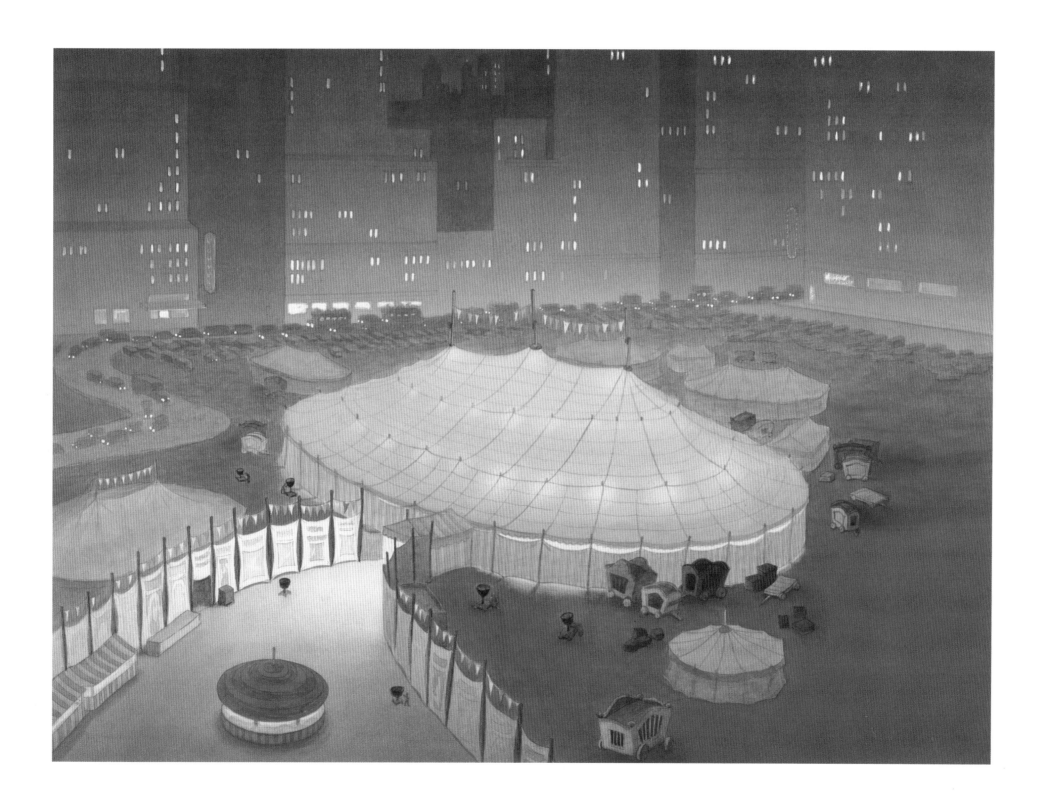

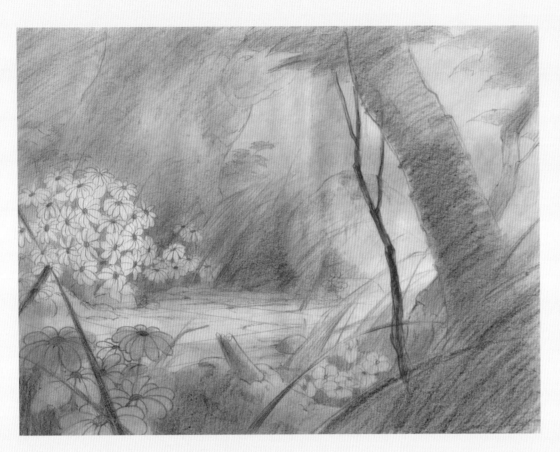
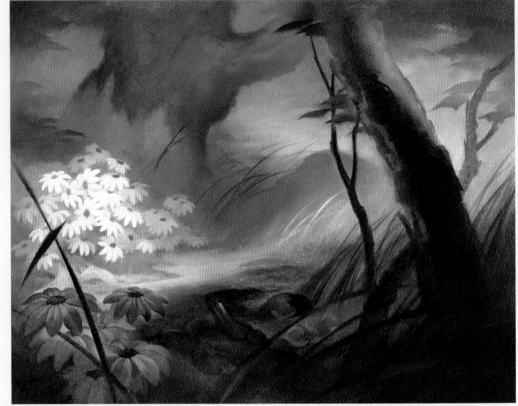

BAMBI 1942

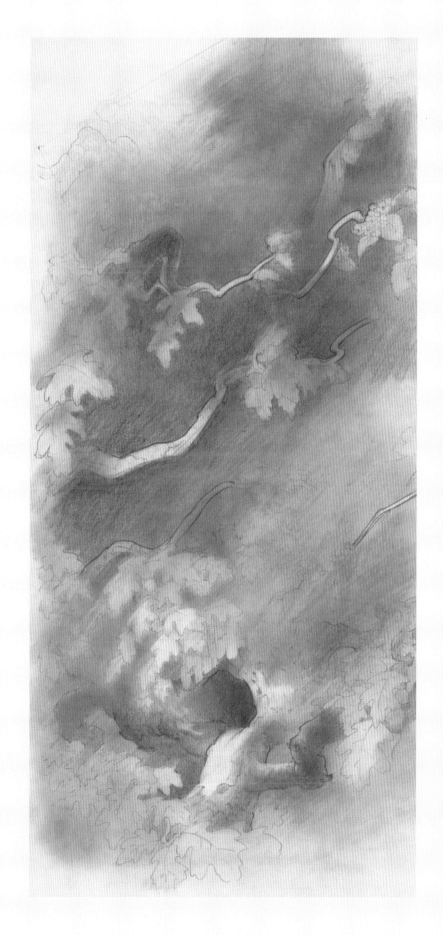
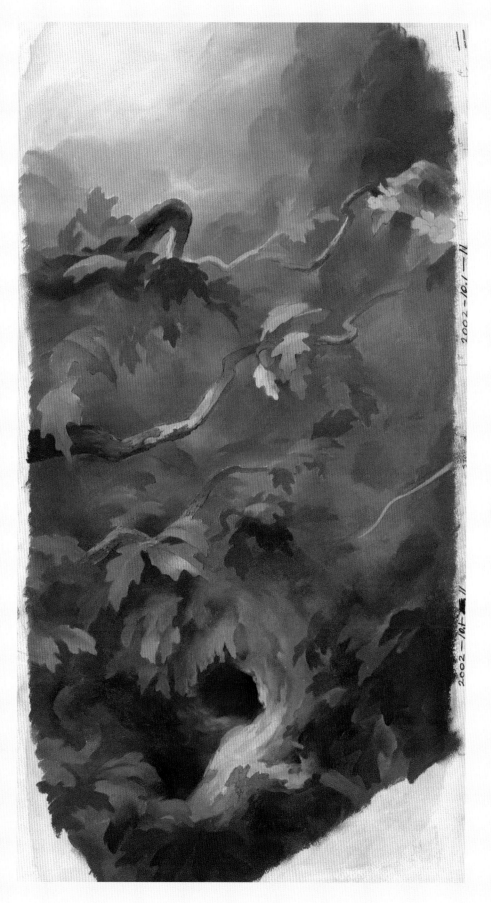

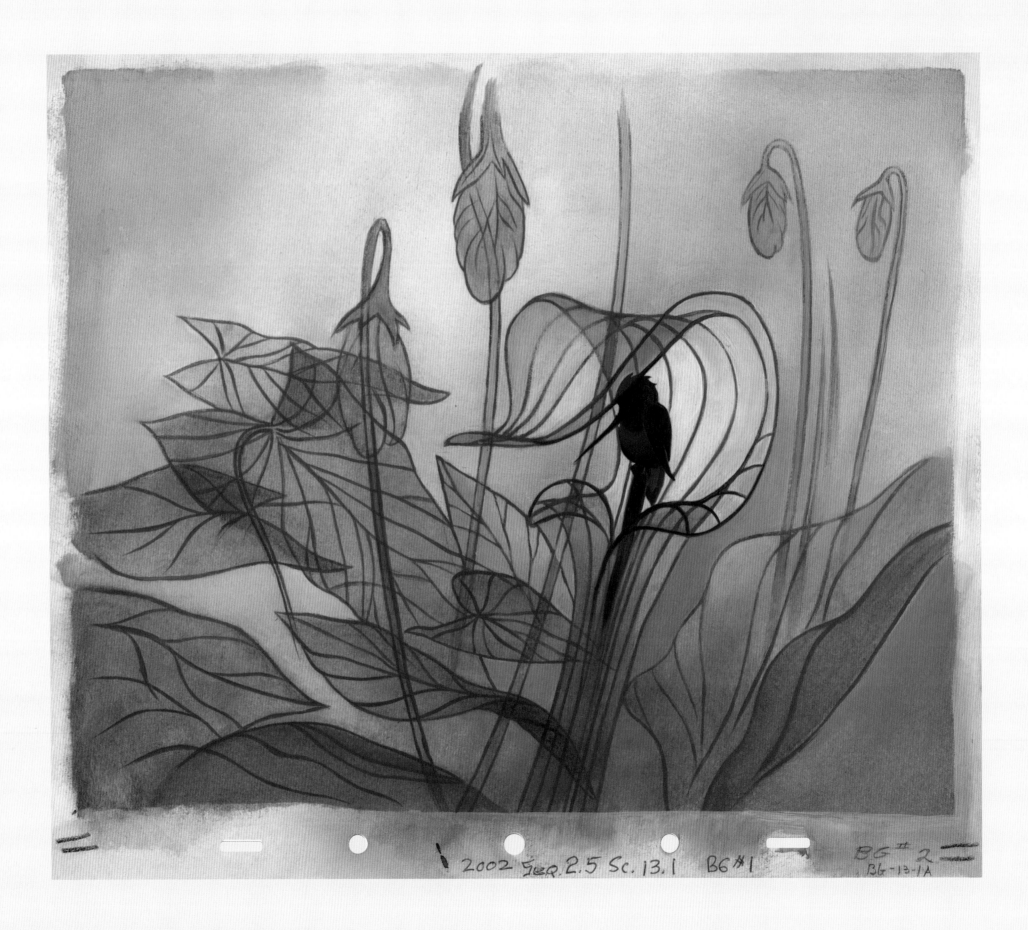

2002 SEQ 2.5 Sc. 13.1 BG#1 BG#2 BG-13-1A

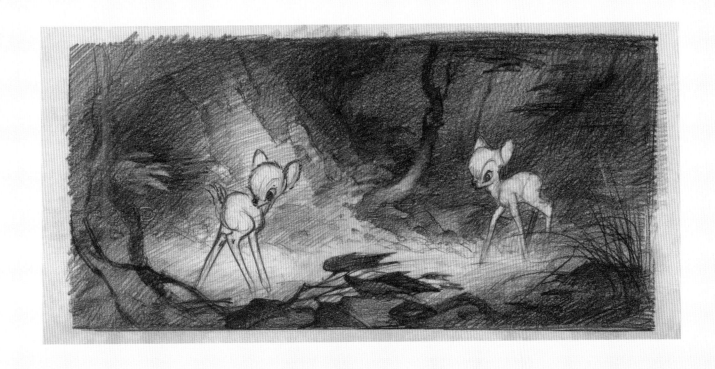

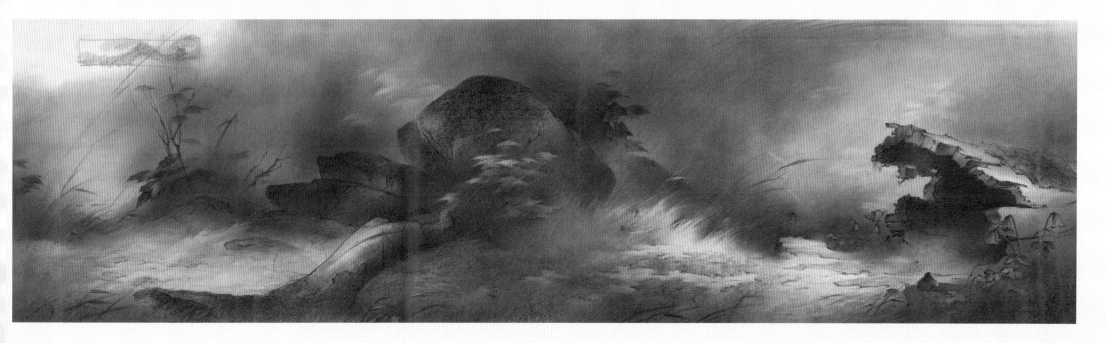

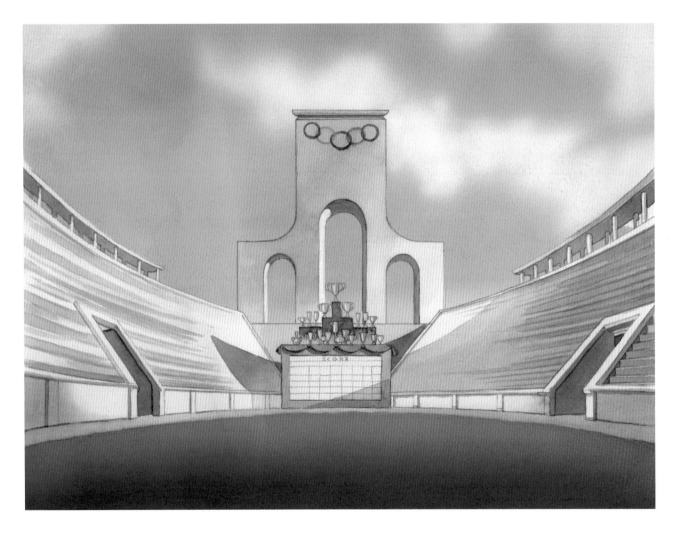

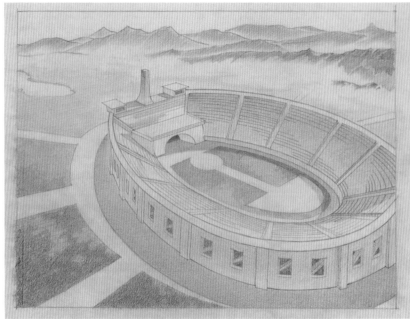

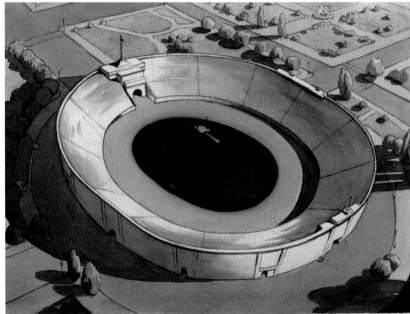

THE OLYMPIC CHAMP 1942

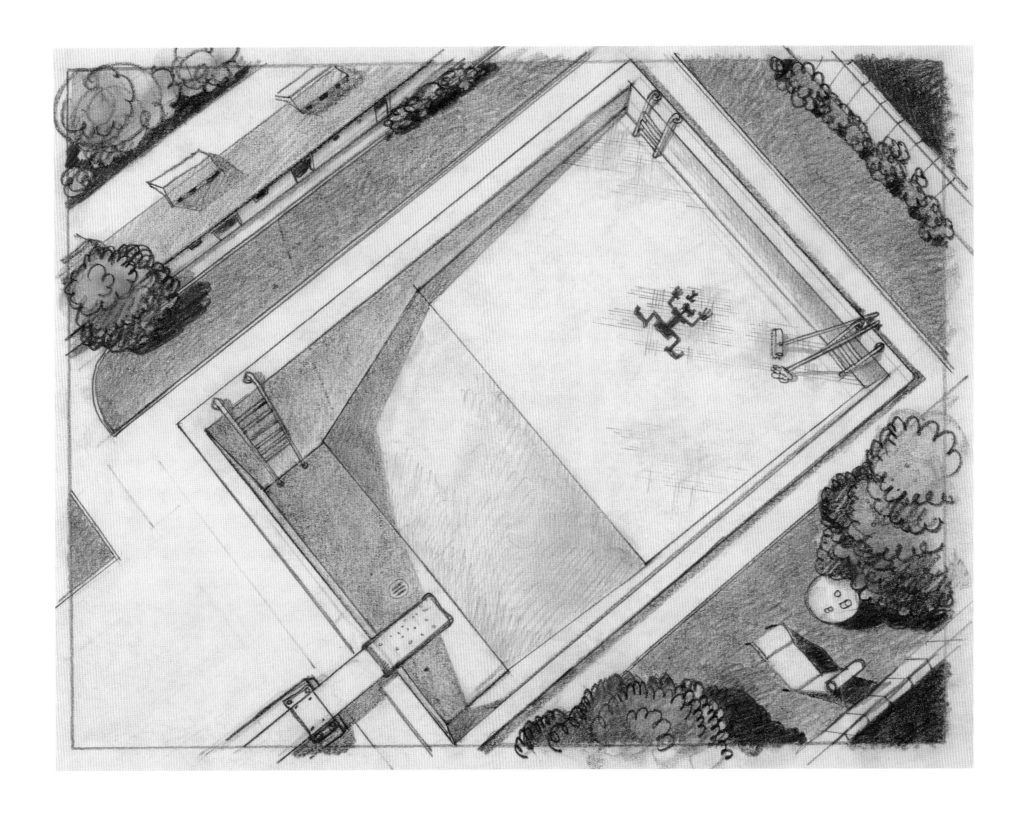

HOW TO SWIM 1942

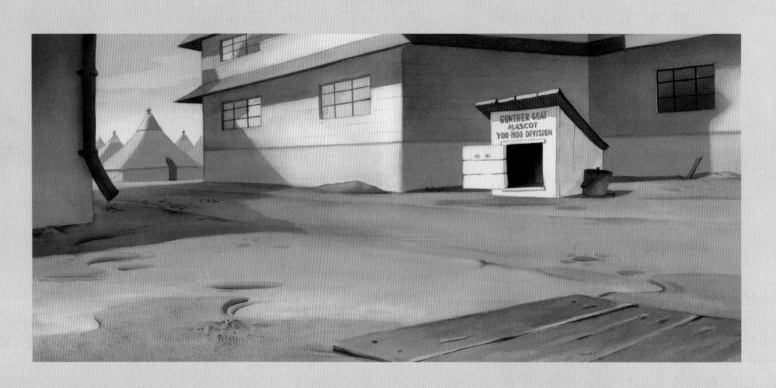

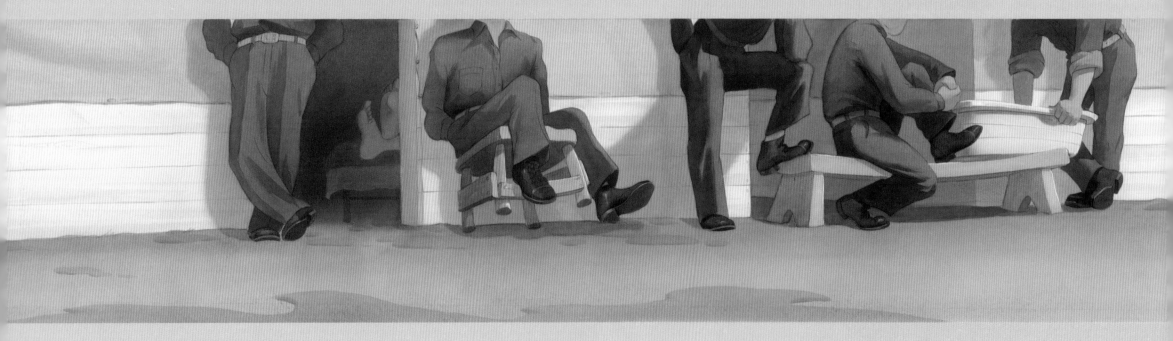

THE ARMY MASCOT 1942

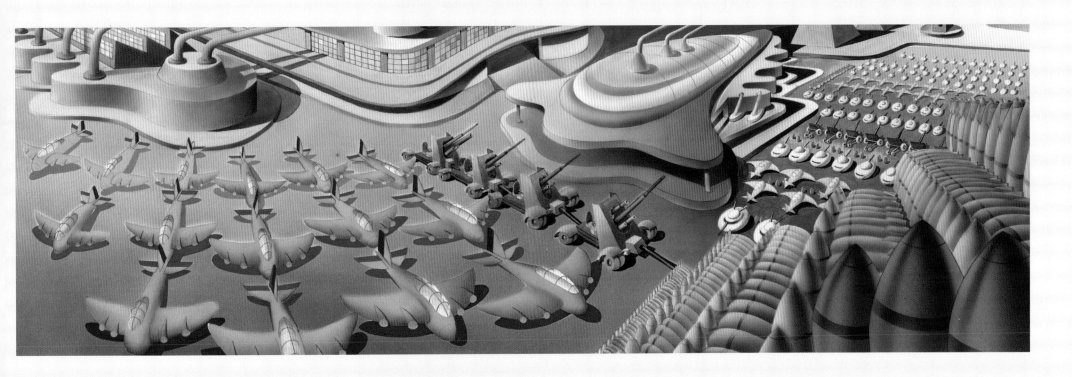

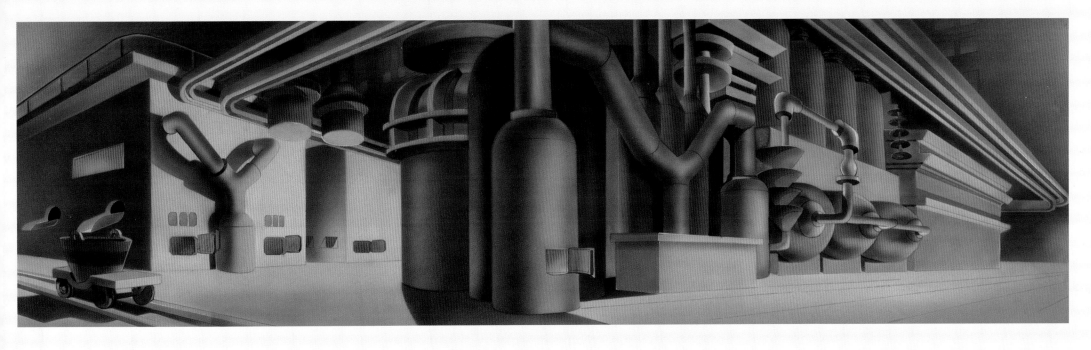

DEFENSE AGAINST INVASION 1943

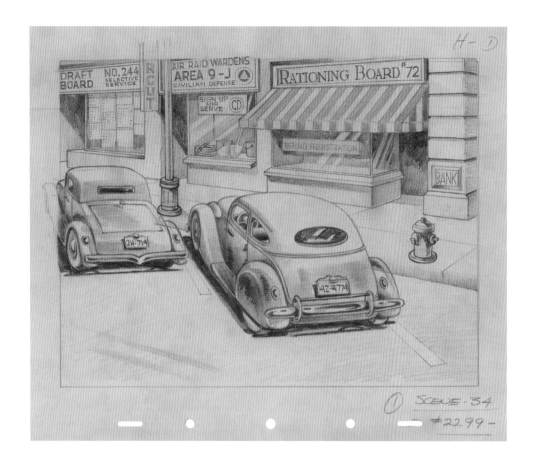

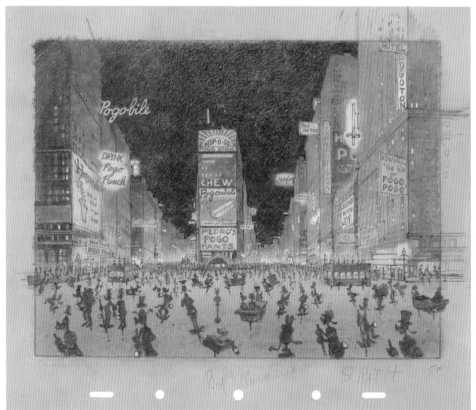

VICTORY VEHICLES 1943

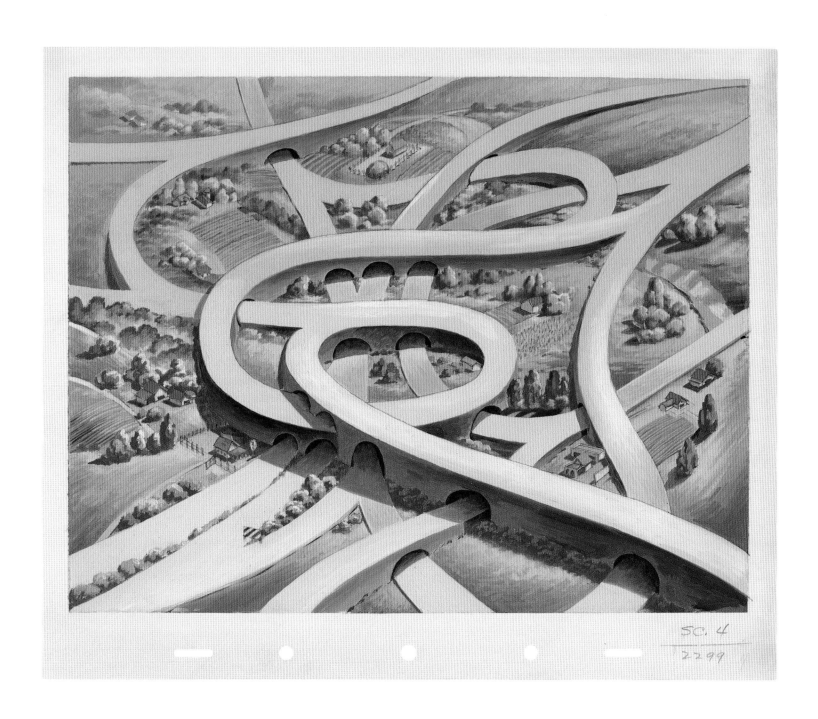

SC. 4
2299

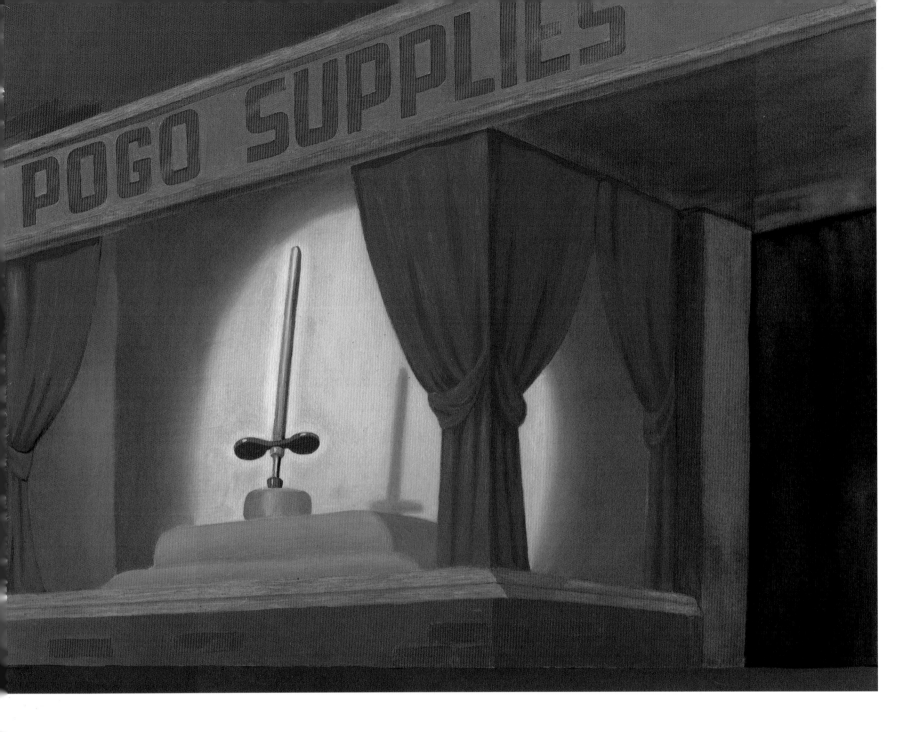

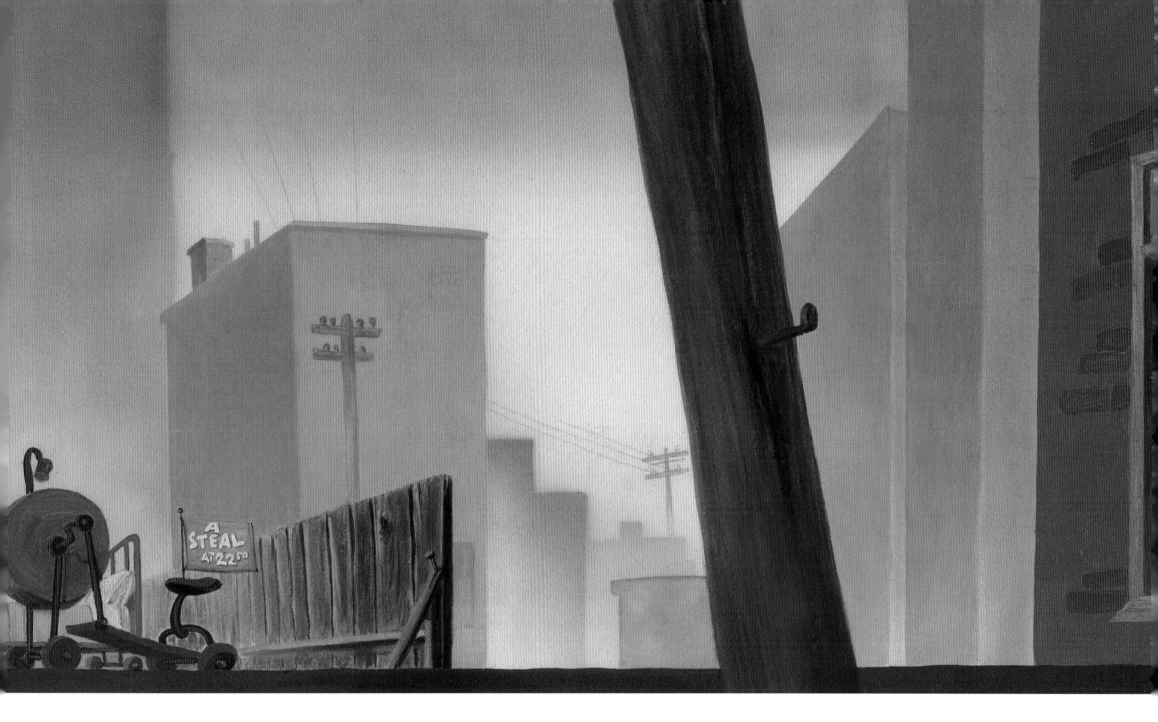

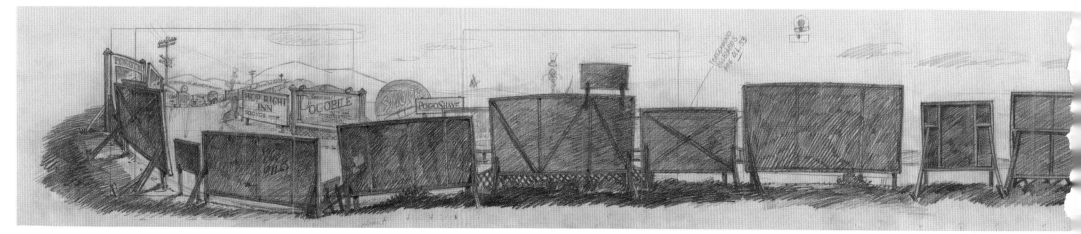

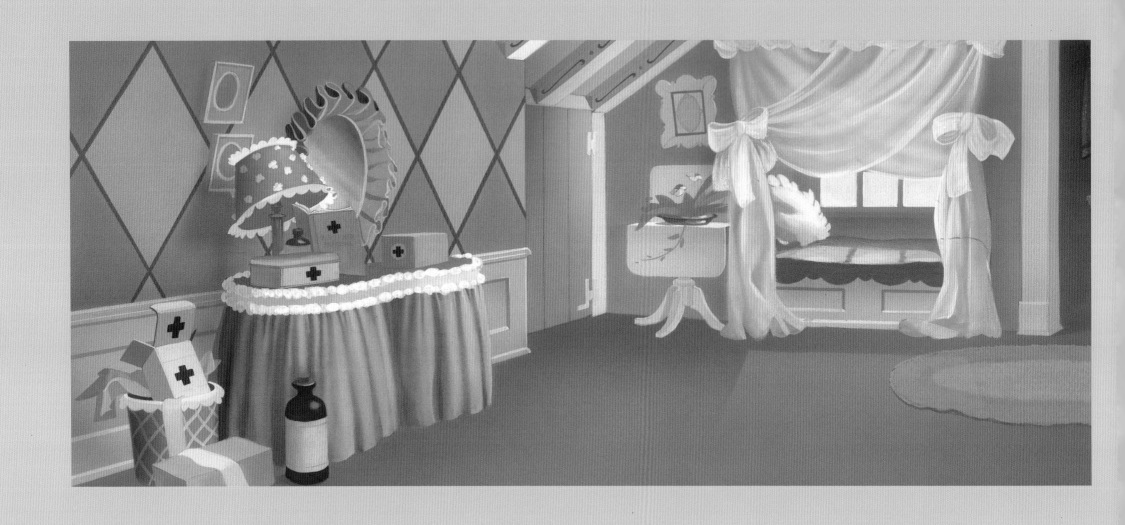

FIRST AIDERS 1944

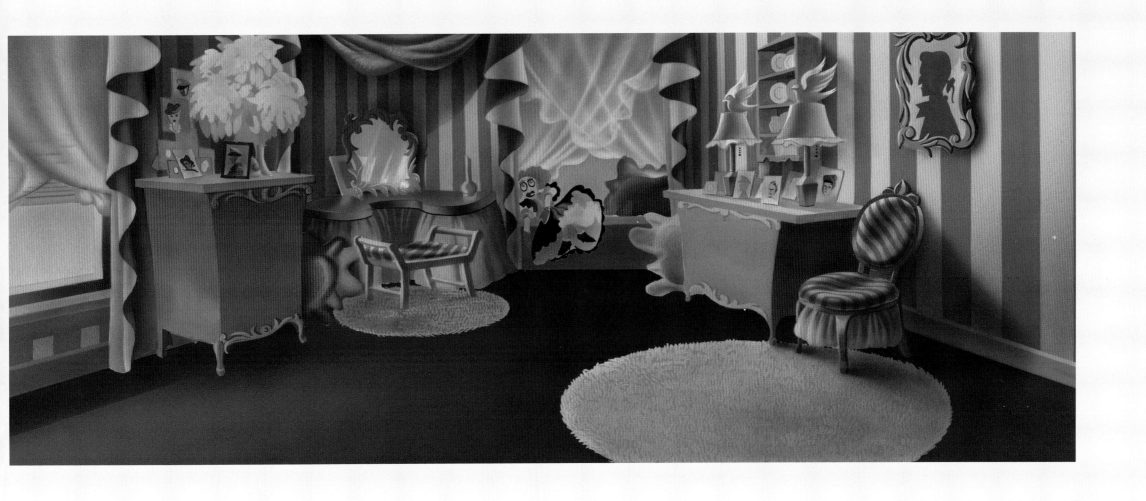

DUCK PIMPLES 1945

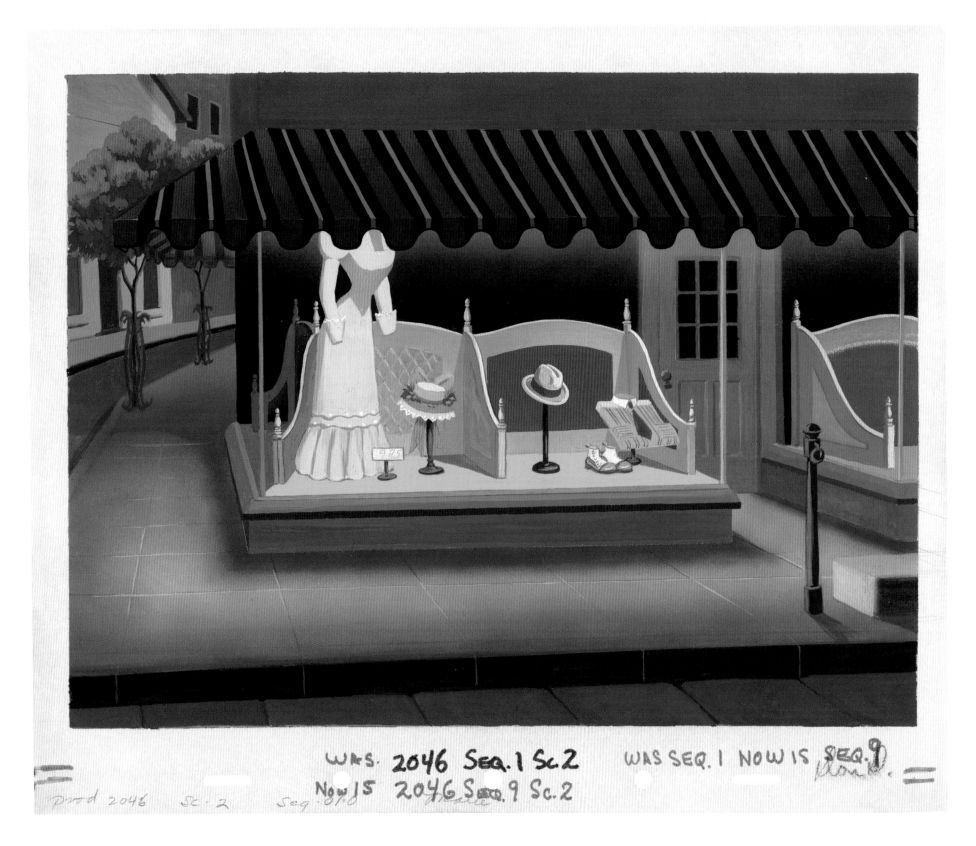

MAKE MINE MUSIC, "JOHNNIE FEDORA AND ALICE BLUEBONNET" 1946

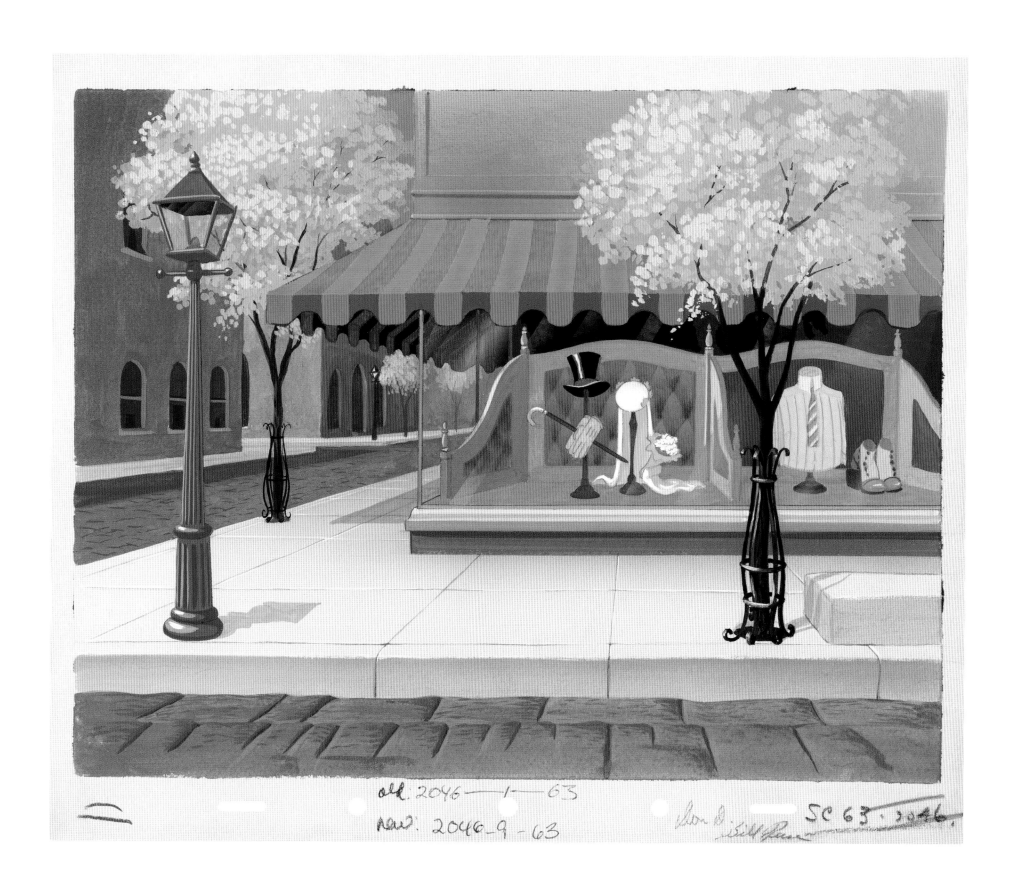

old. 2046 — 1 — 63
new. 2046 - 9 - 63

SC 63 · 2046.

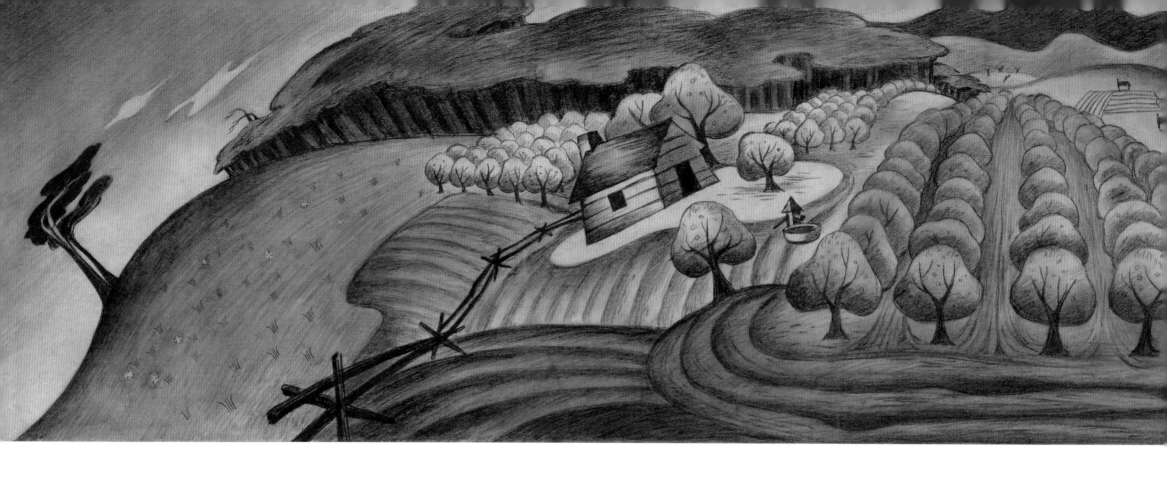

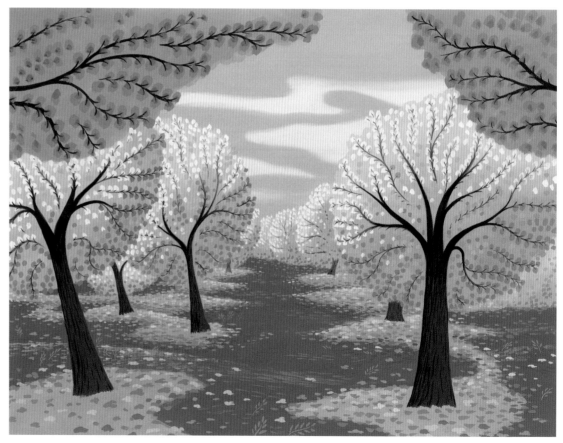

MELODY TIME, "JOHNNY APPLESEED" 1948

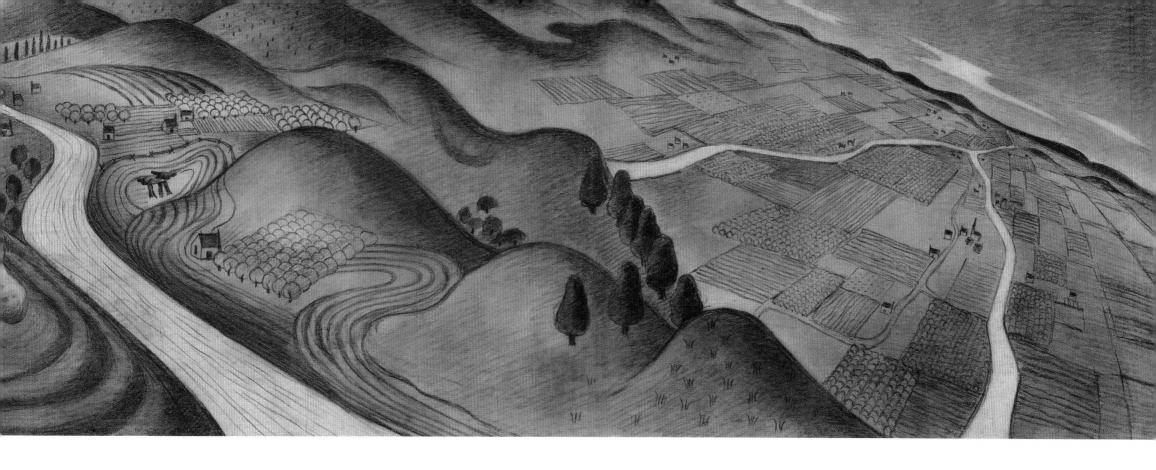

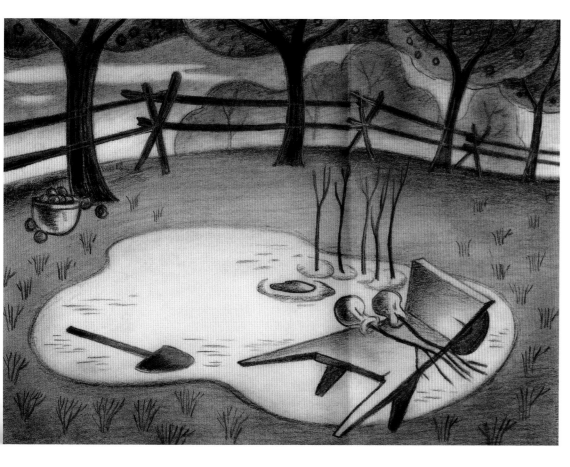

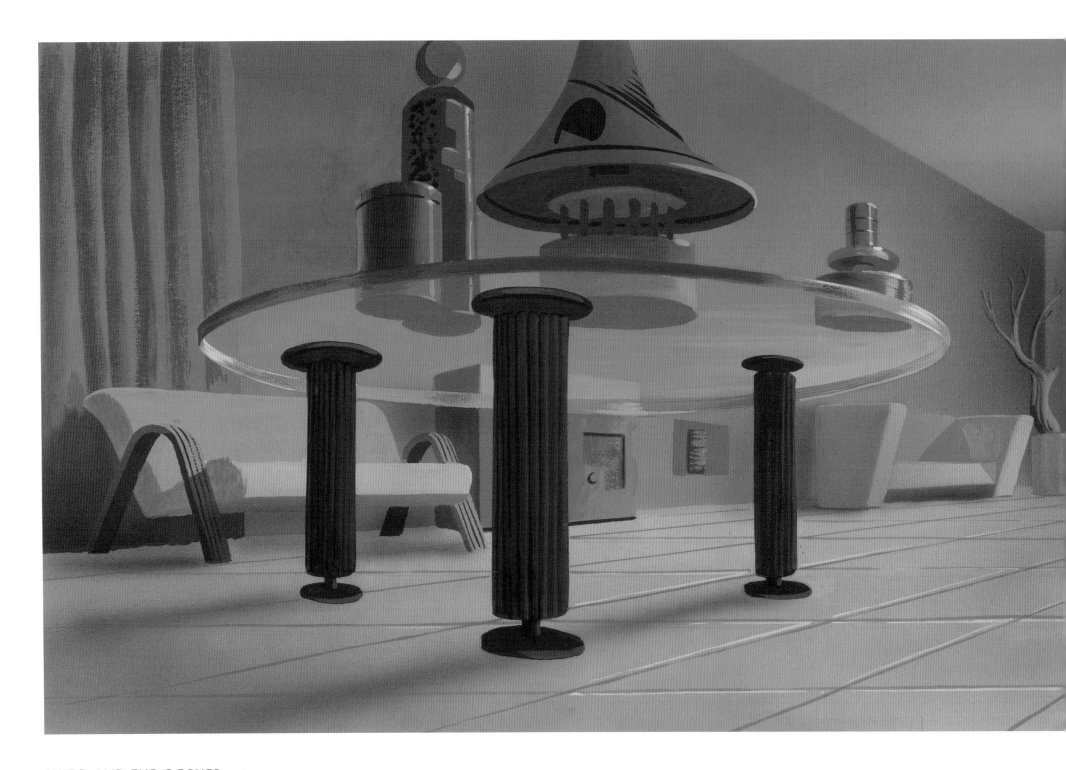

PLUTO AND THE GOPHER 1950

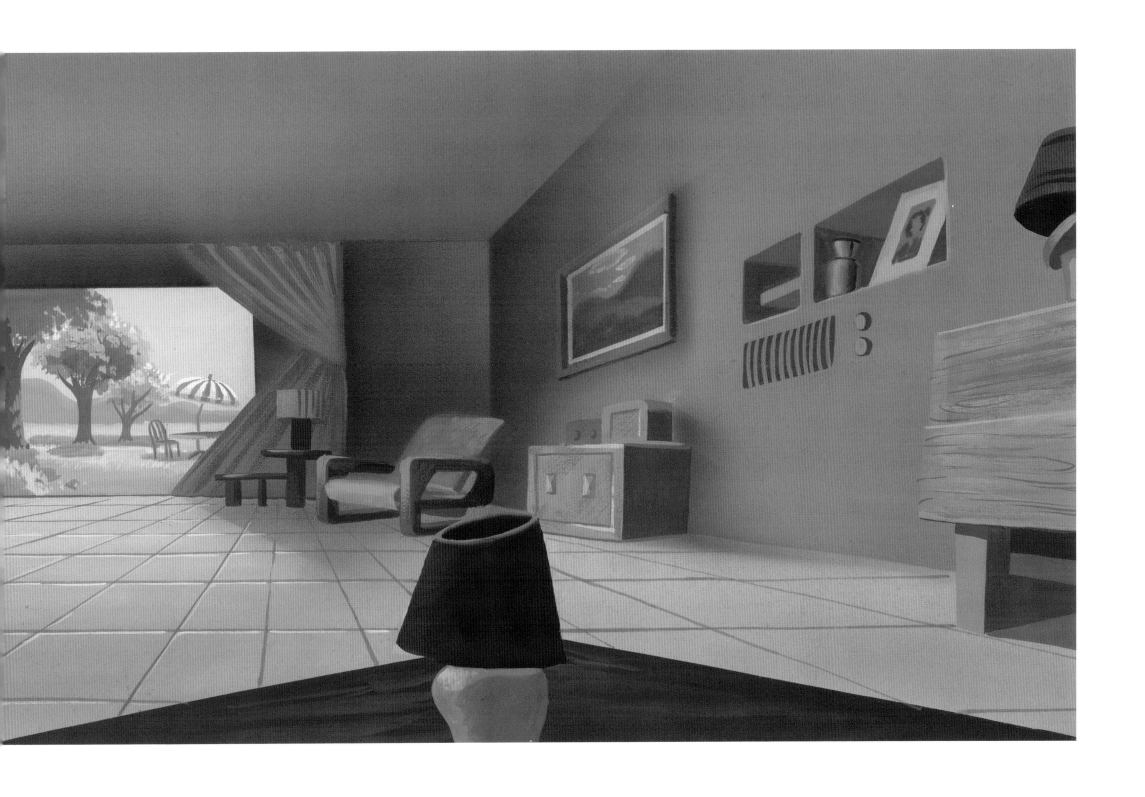

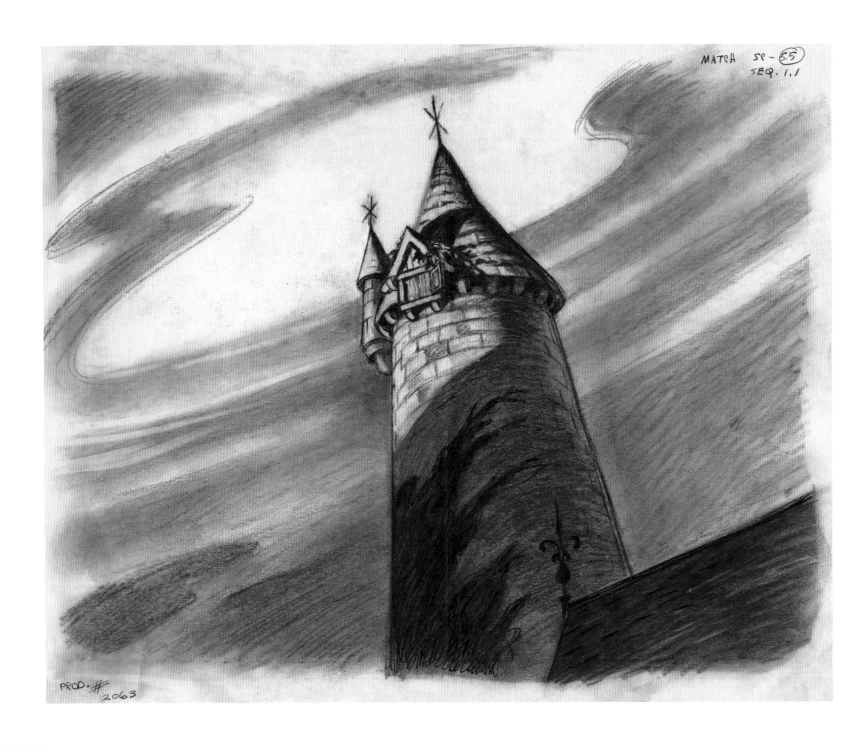

CINDERELLA 1950

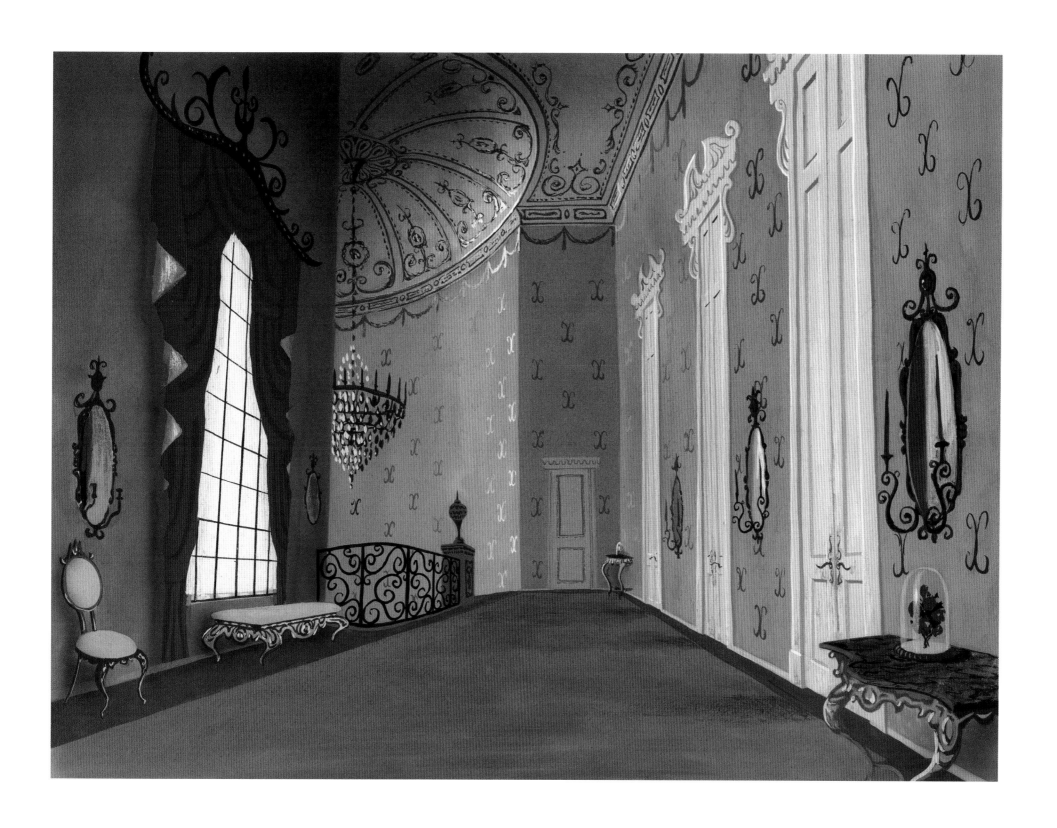

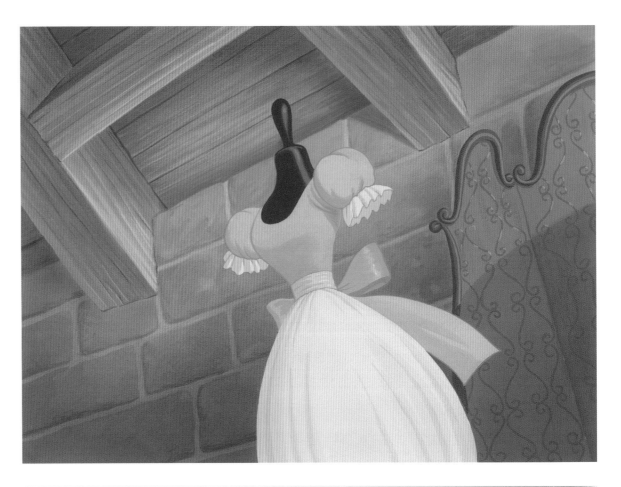

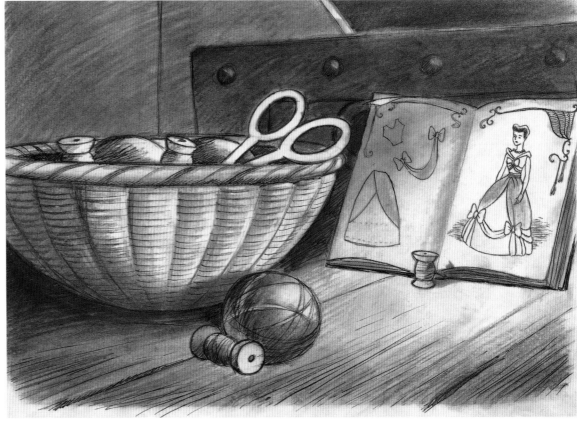

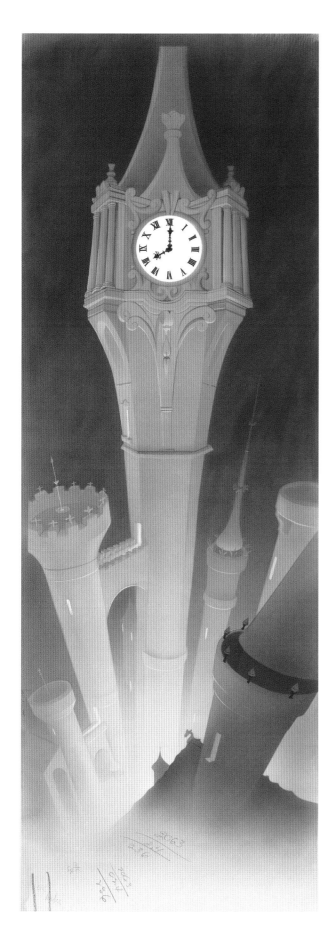

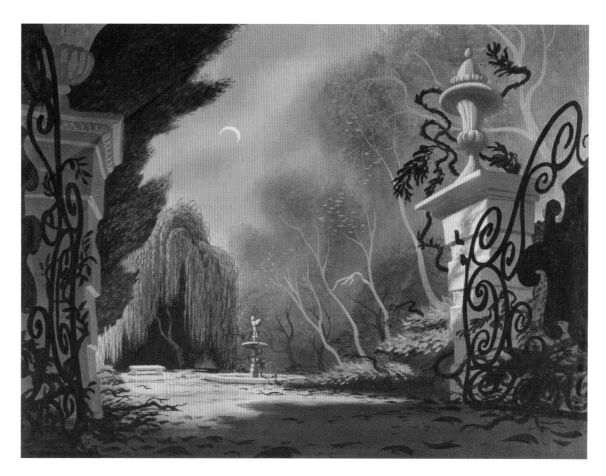

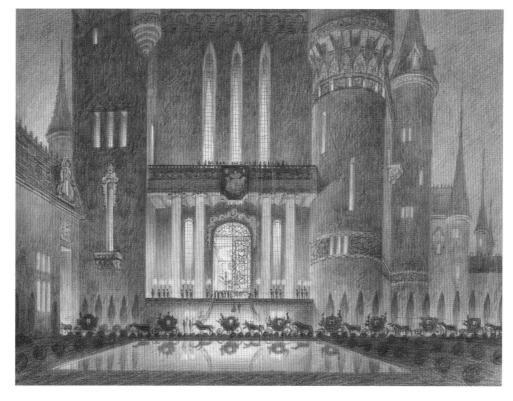

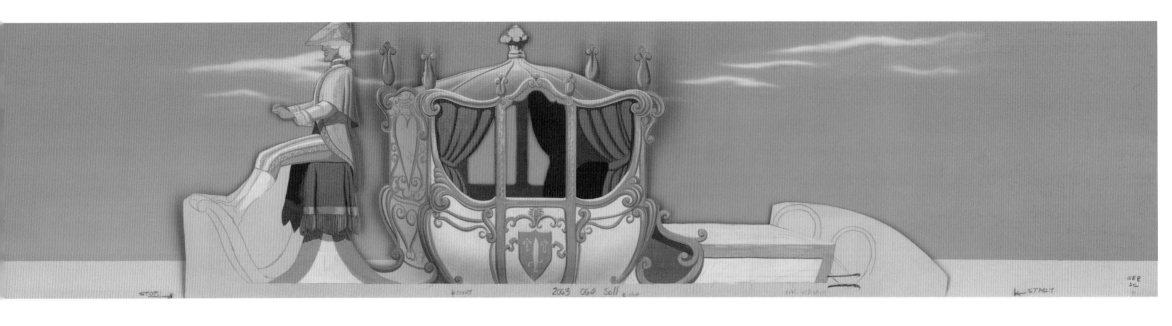

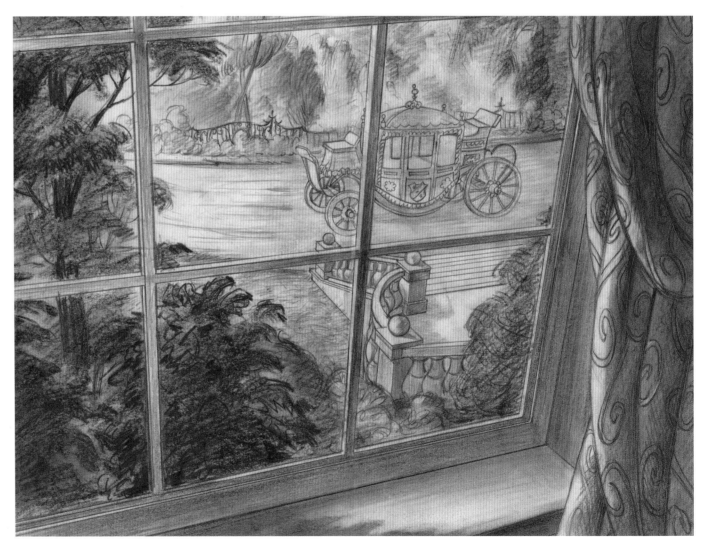

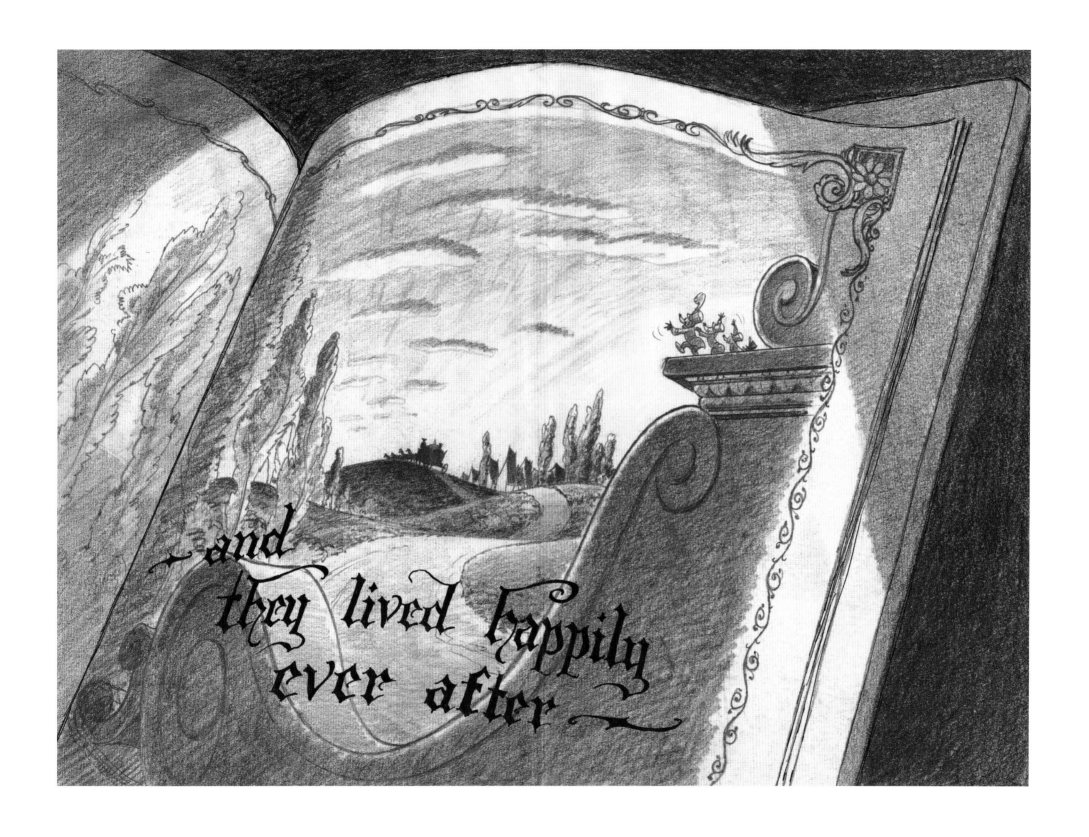

~and
they lived happily
ever after~

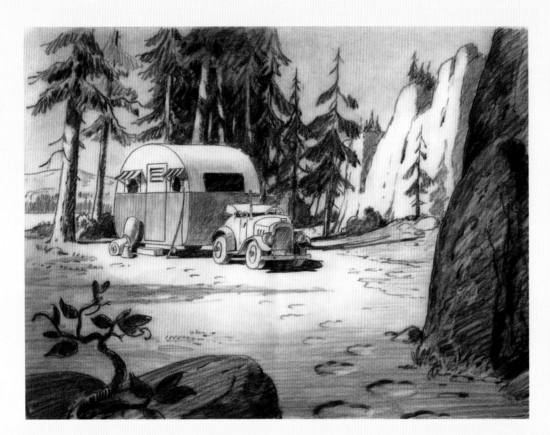 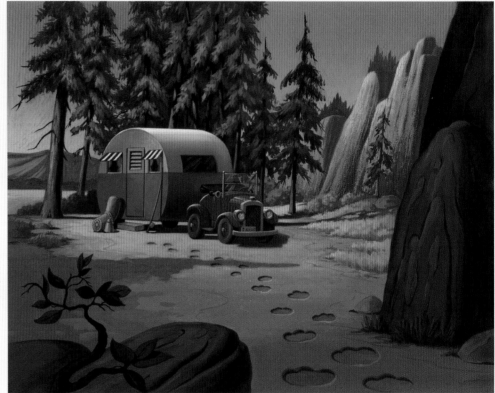

TRAILER HORN 1950

BEE AT THE BEACH 1950

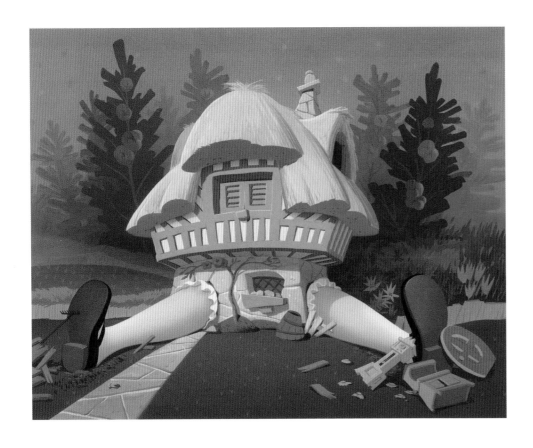

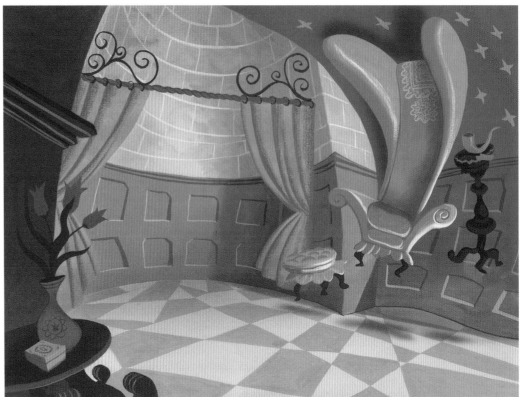

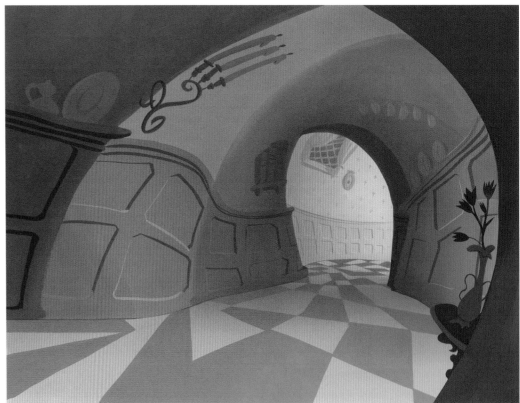

ALICE IN WONDERLAND 1951

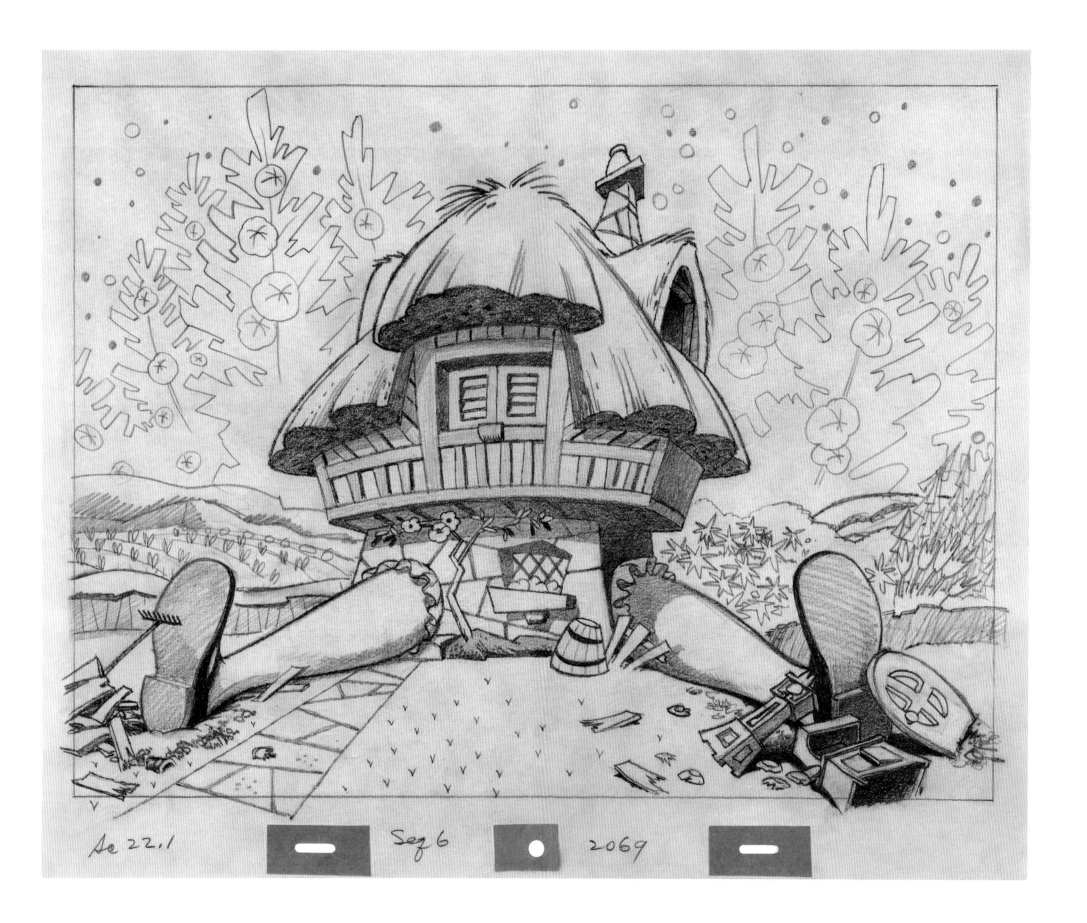

Ac 22.1 Seg 6 2069

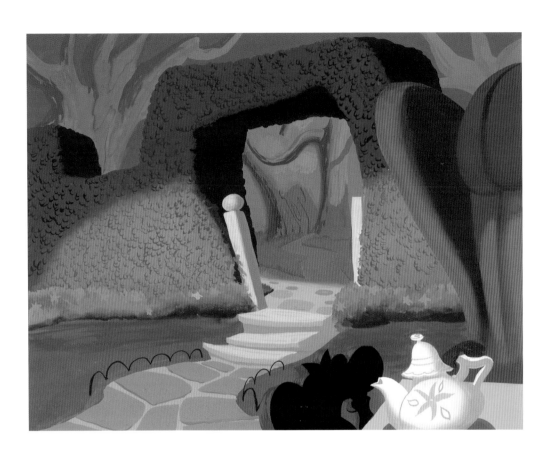

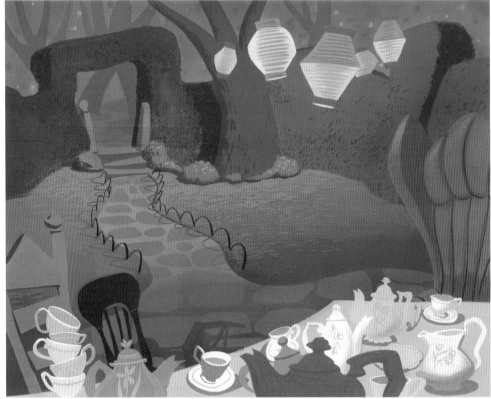

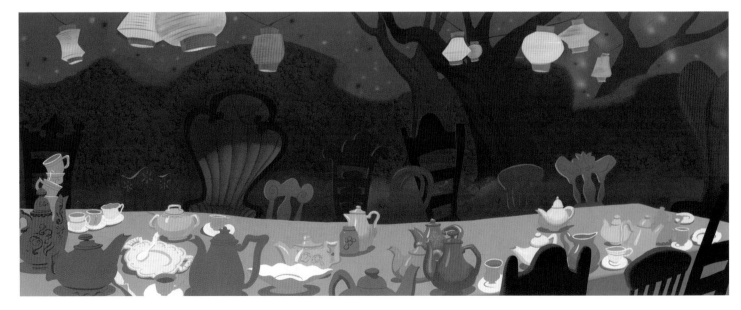

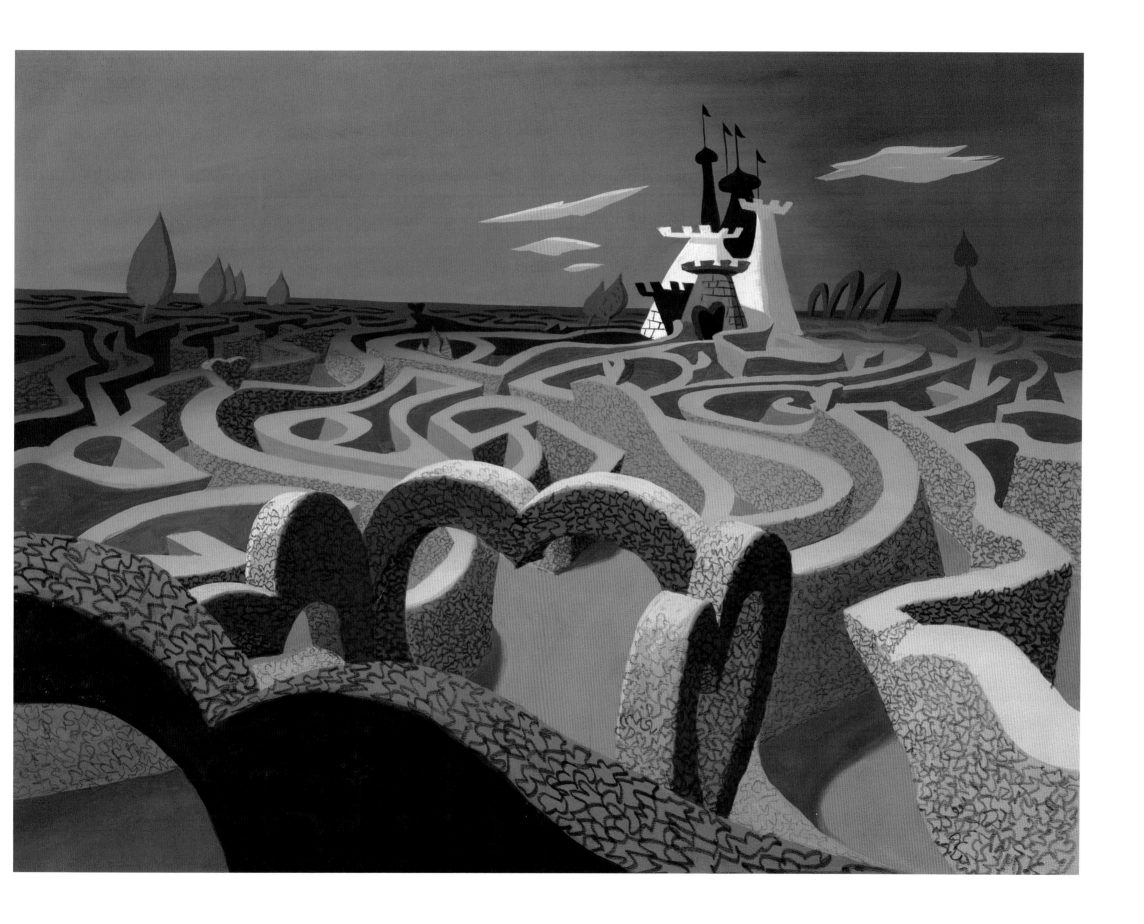

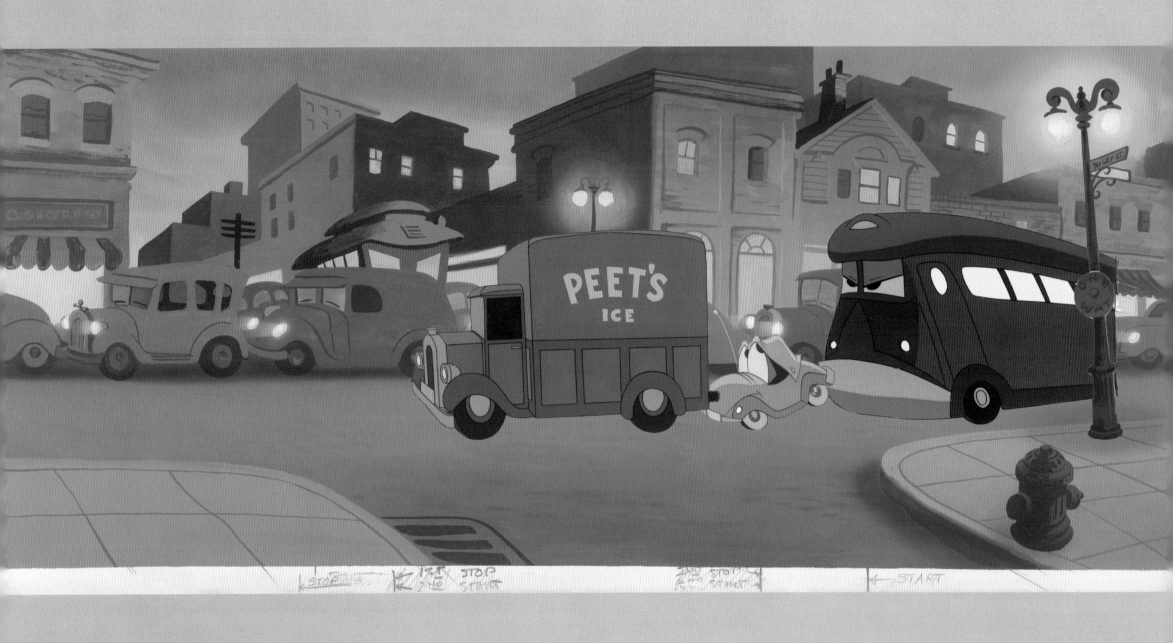

SUSIE, THE LITTLE BLUE COUPE 1952

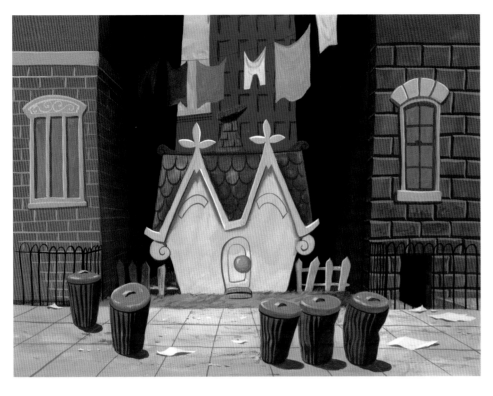

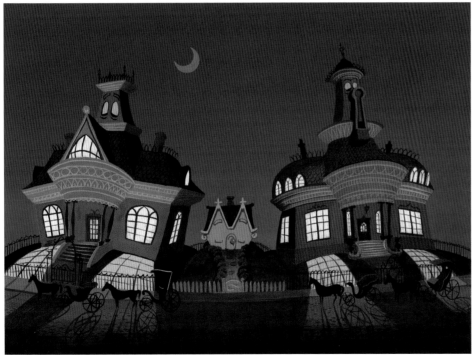

THE LITTLE HOUSE 1952

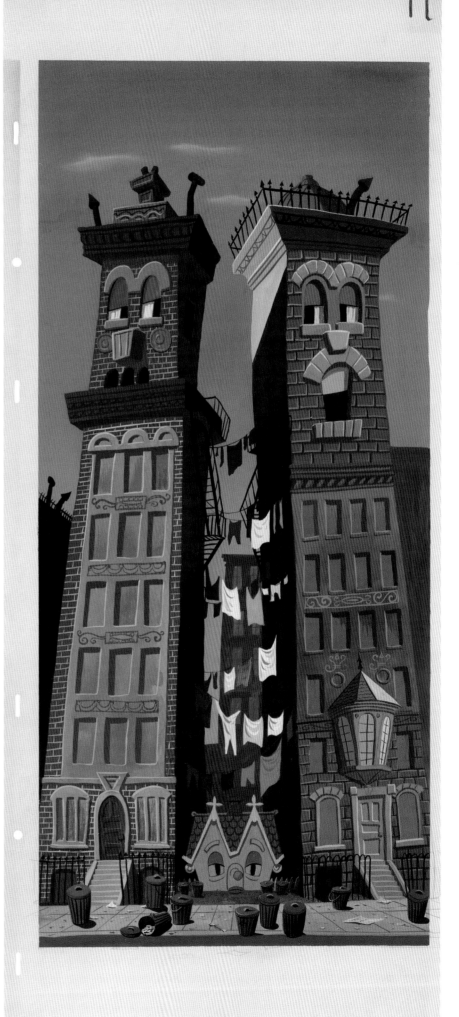

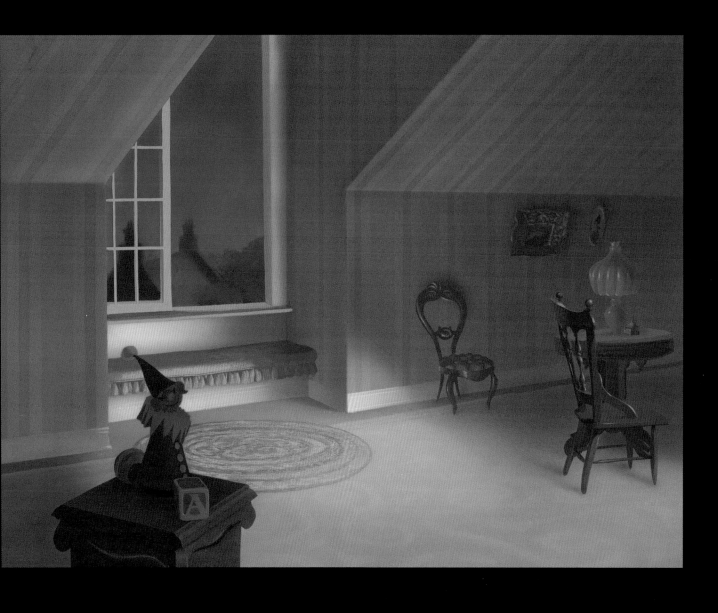

PETER PAN 1953

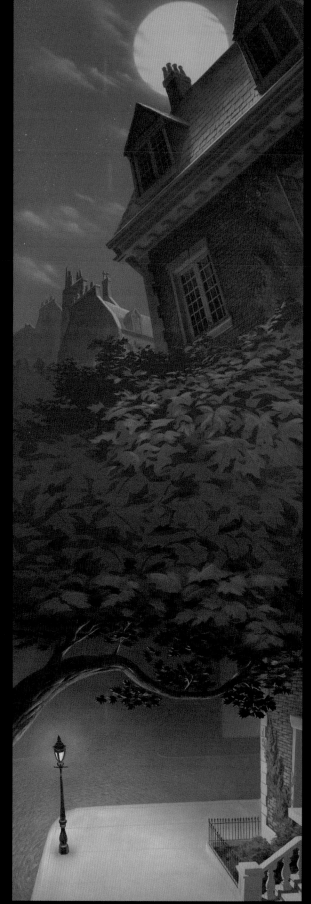

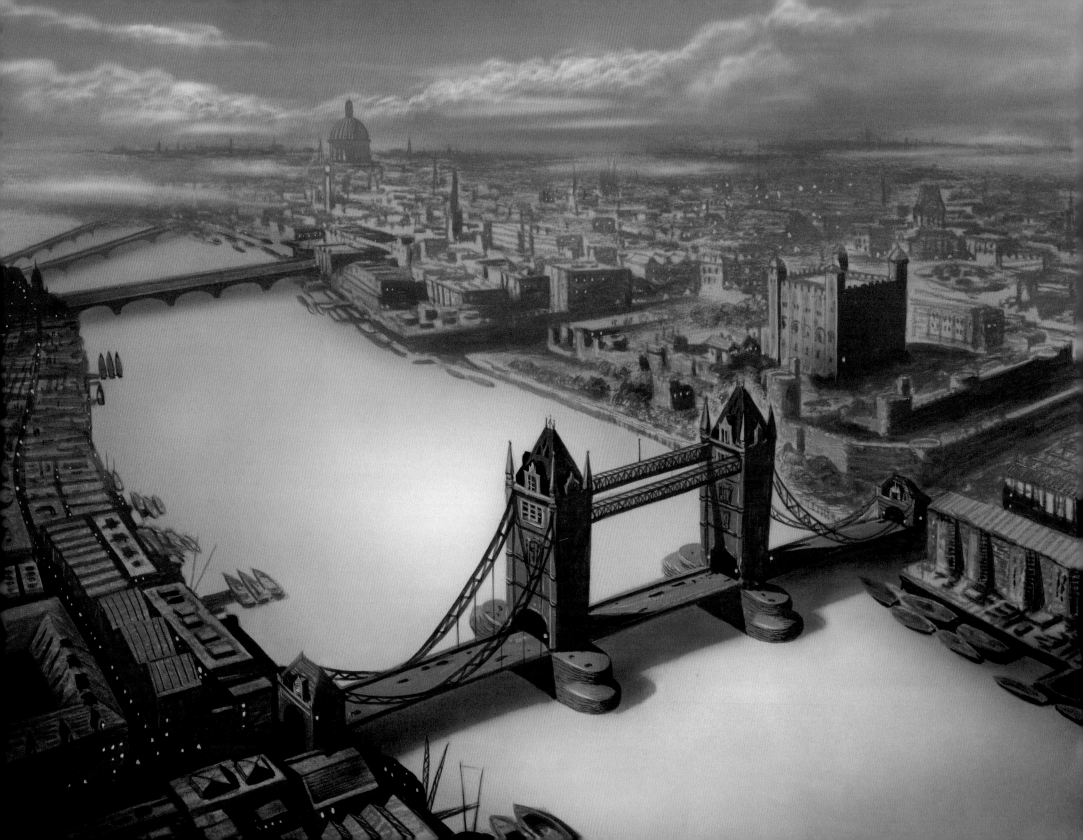

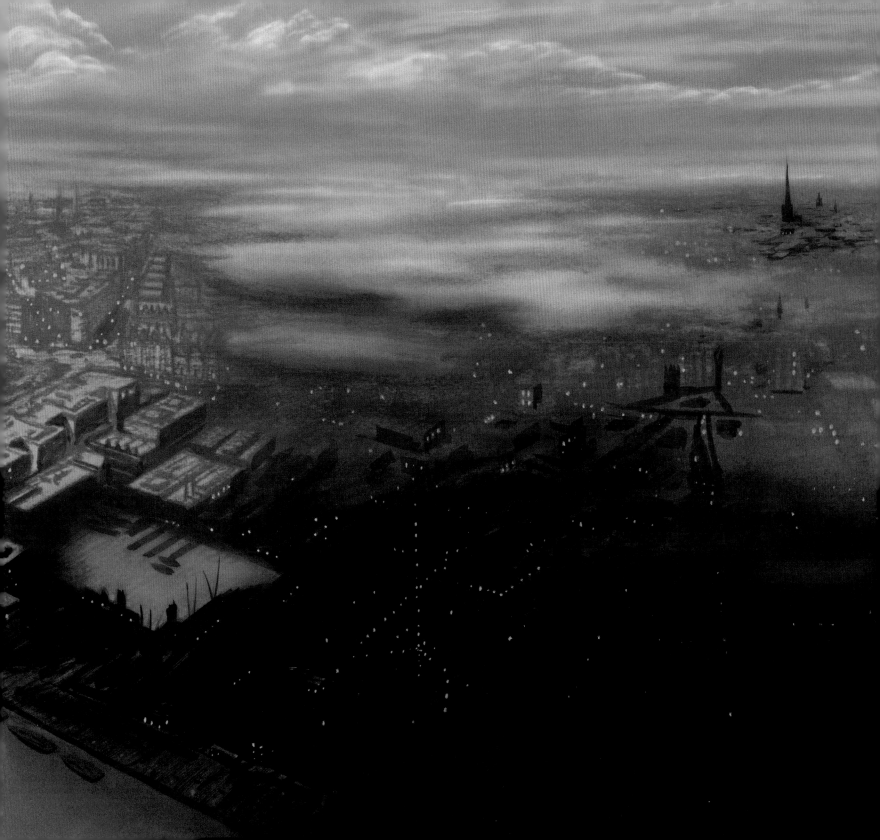

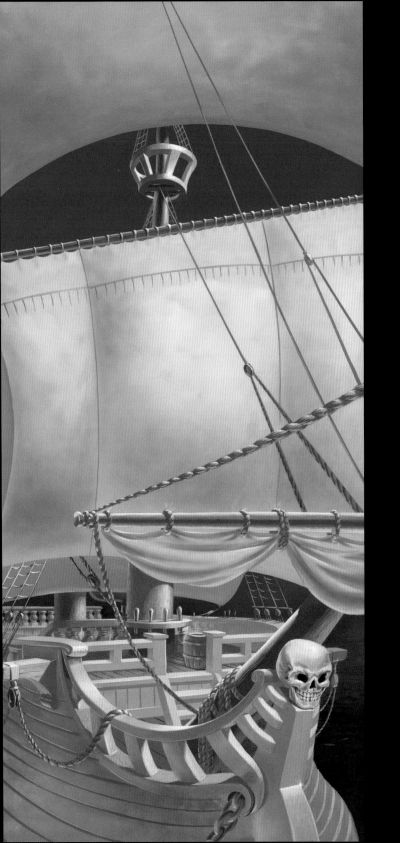
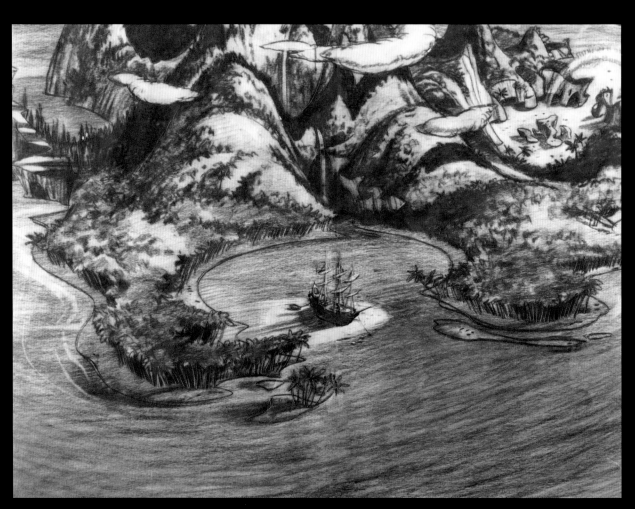

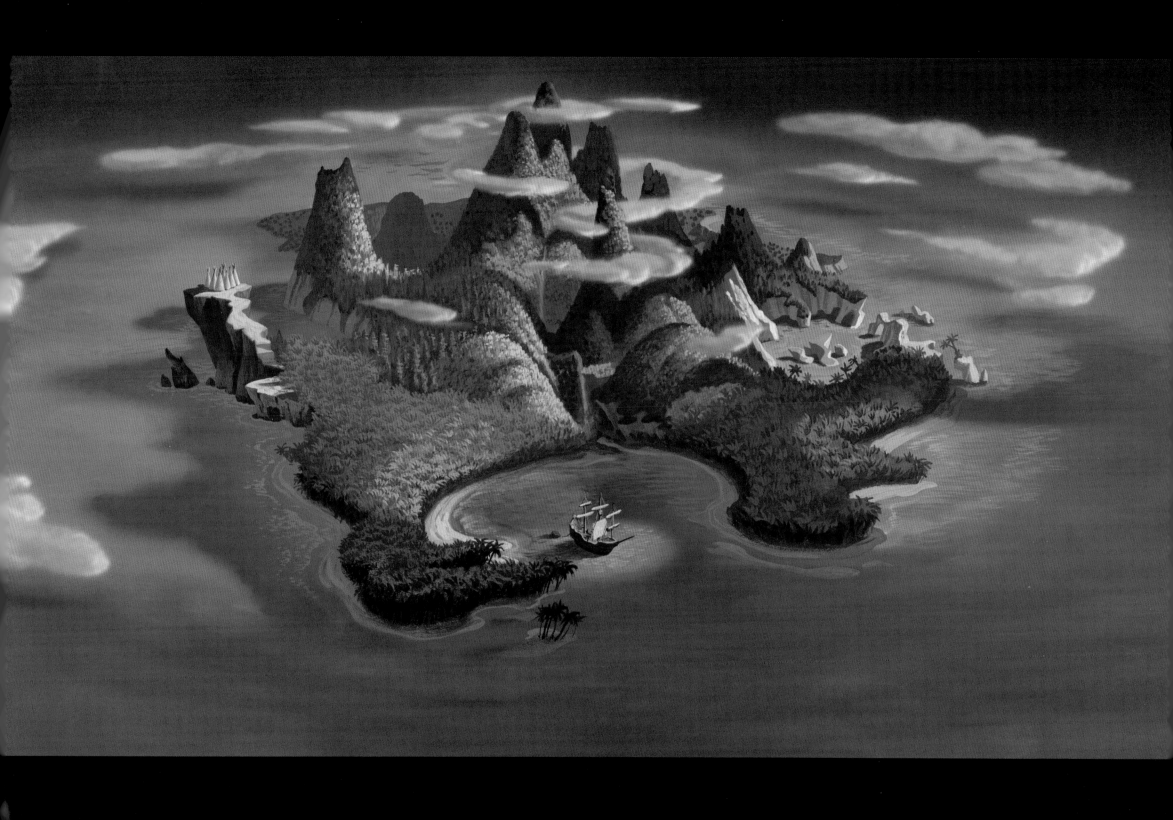

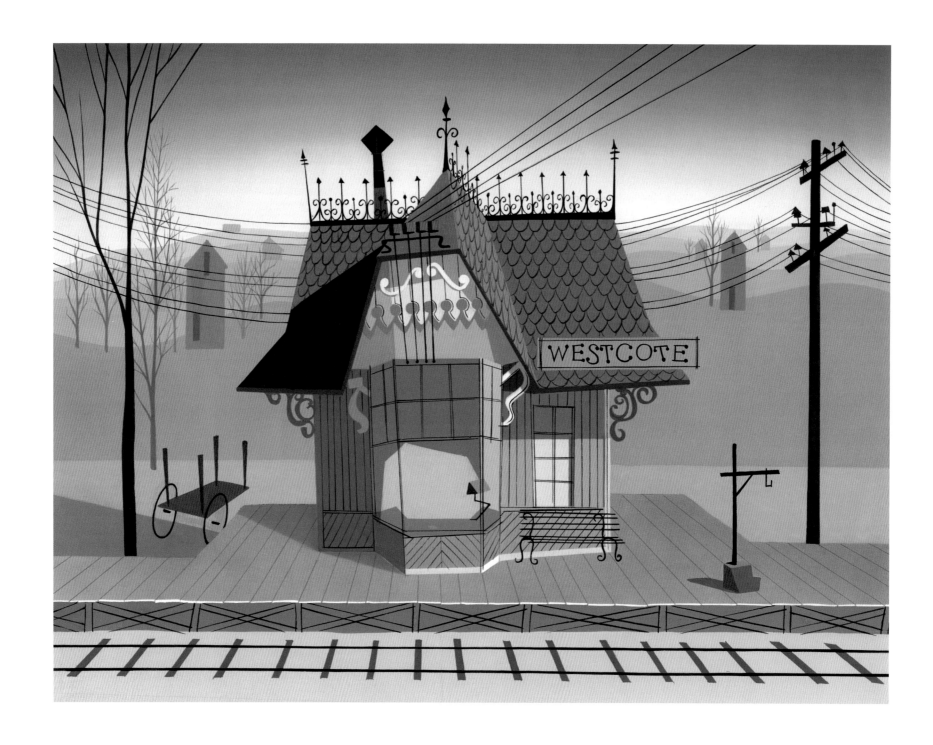

PIGS IS PIGS 1954

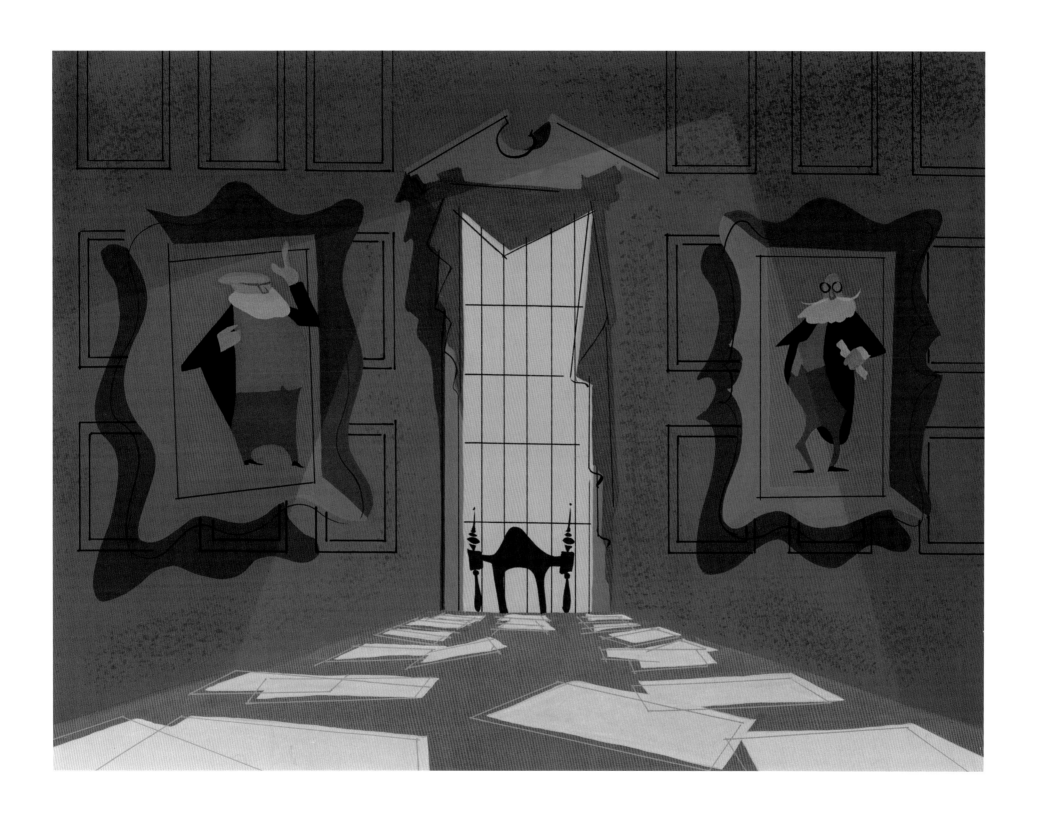

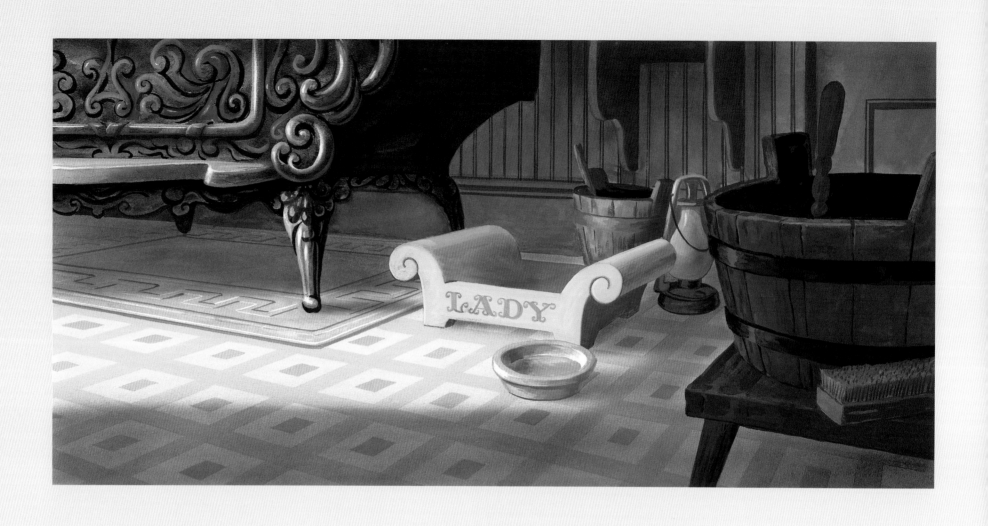

LADY AND THE TRAMP 1955

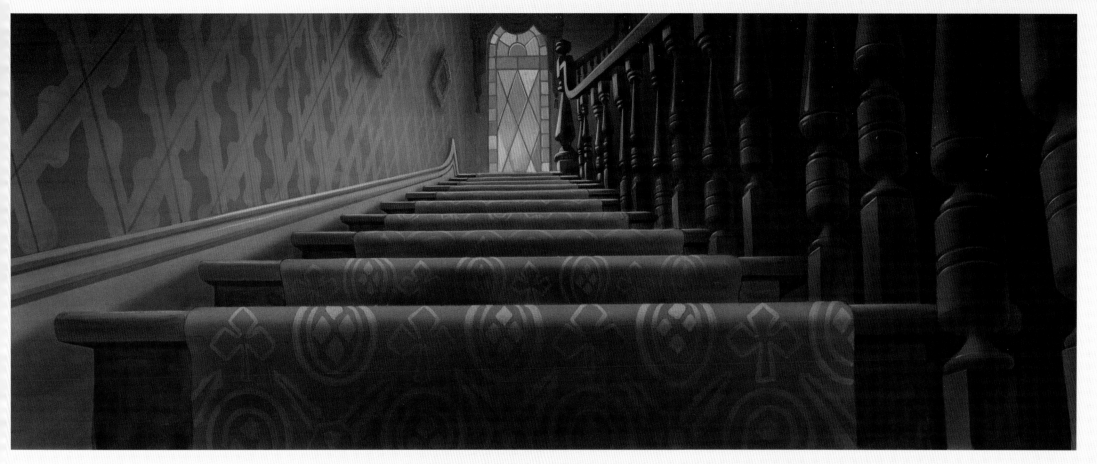

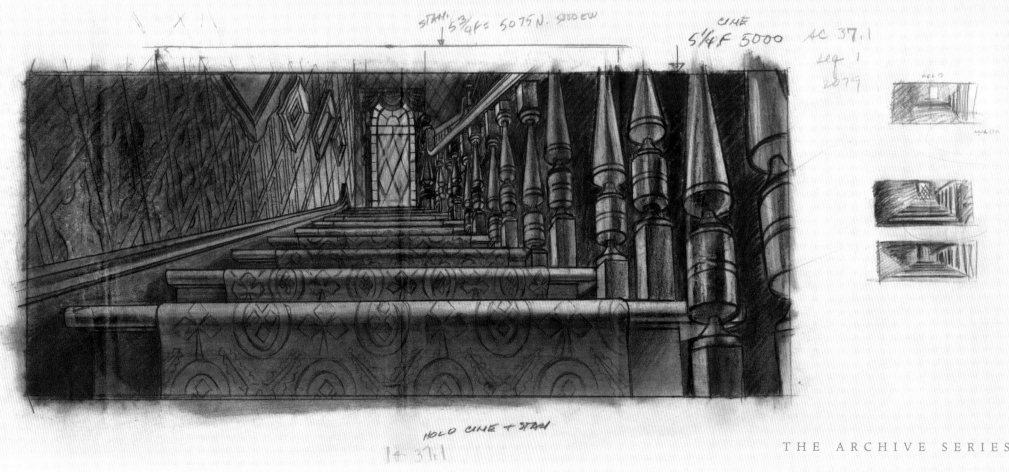

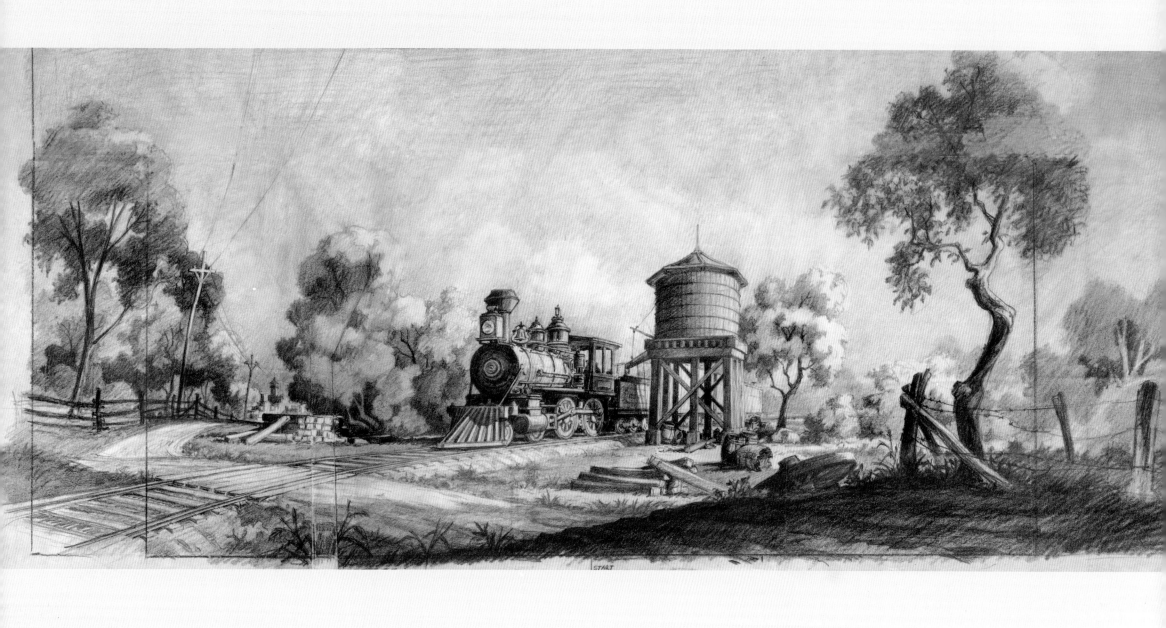

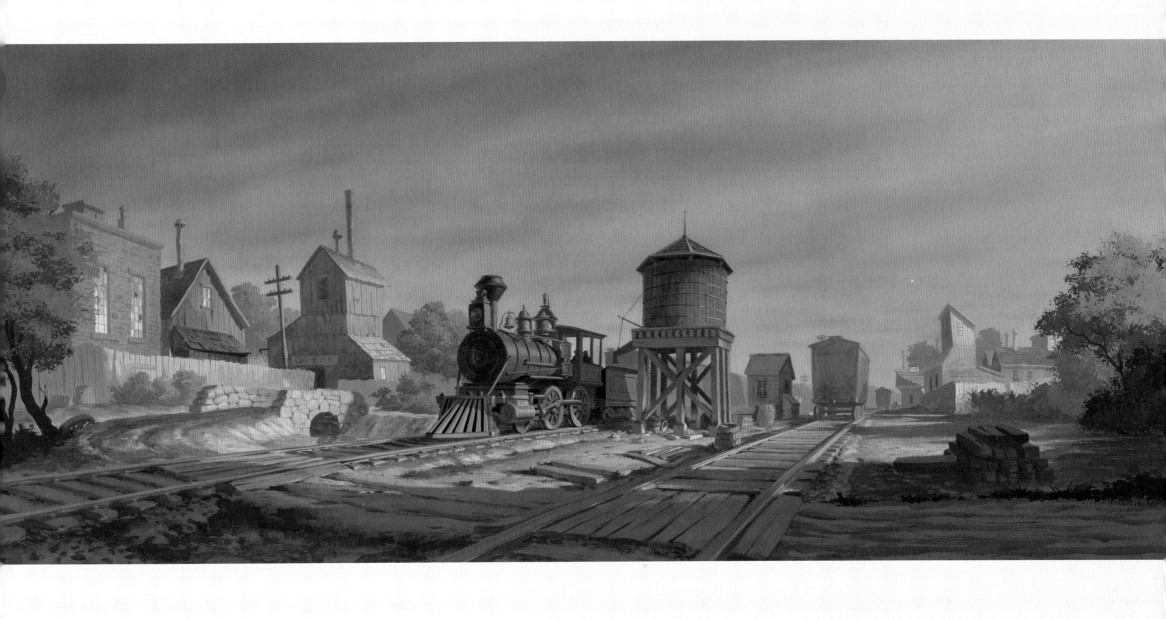

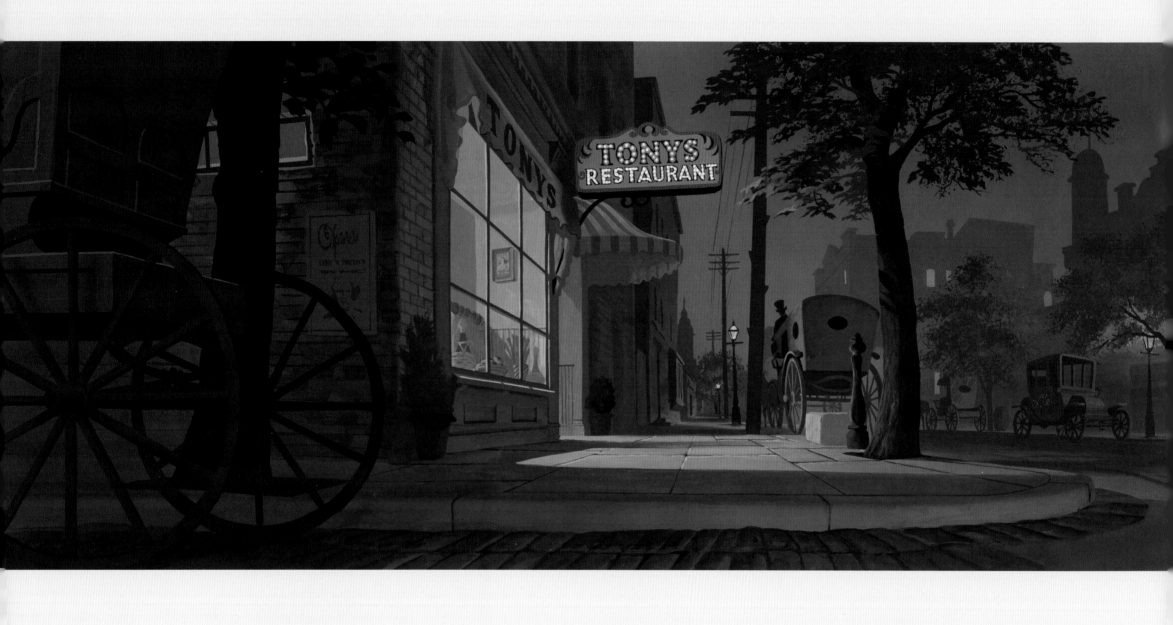

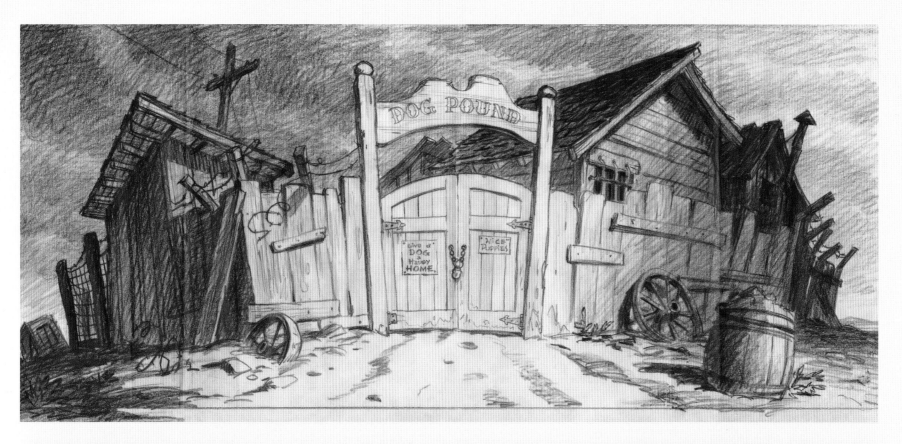

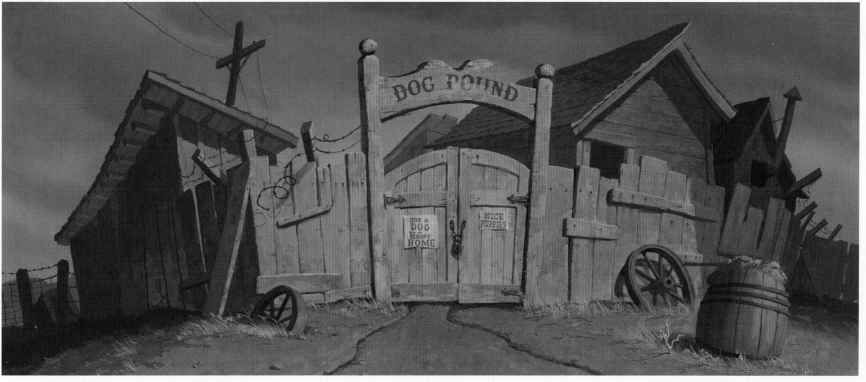

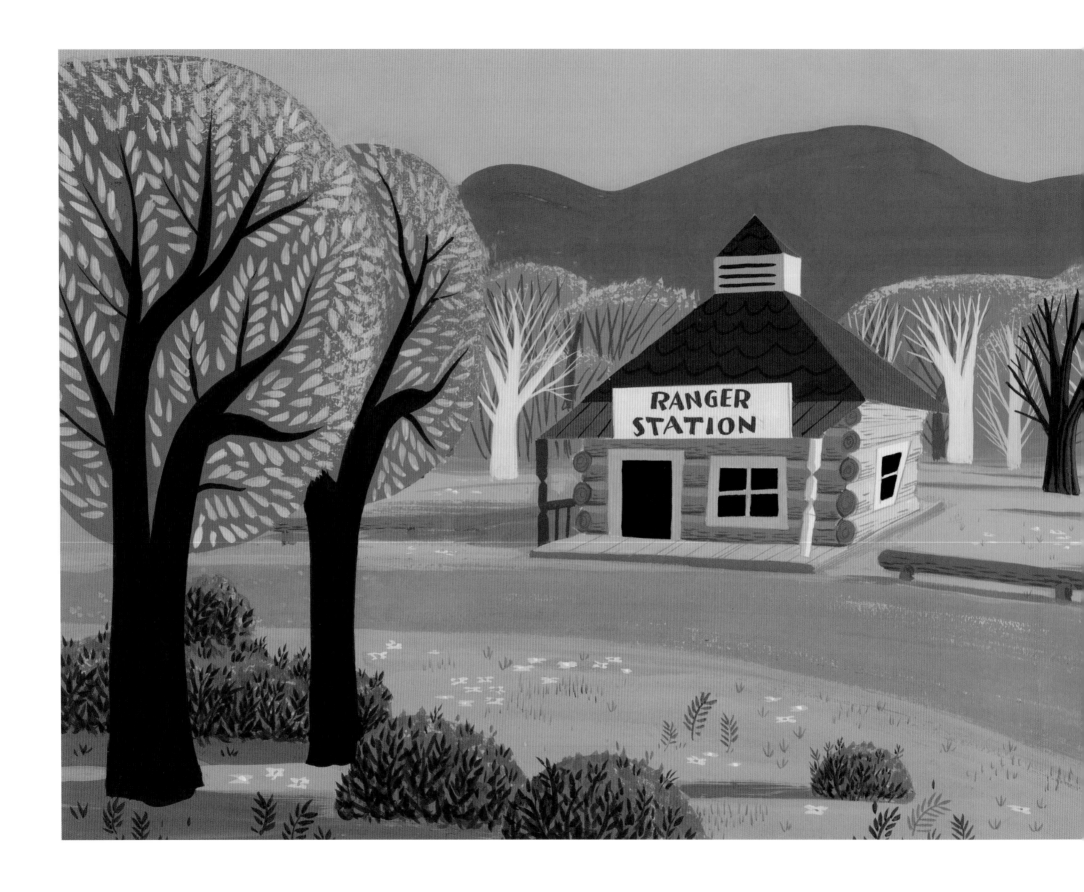

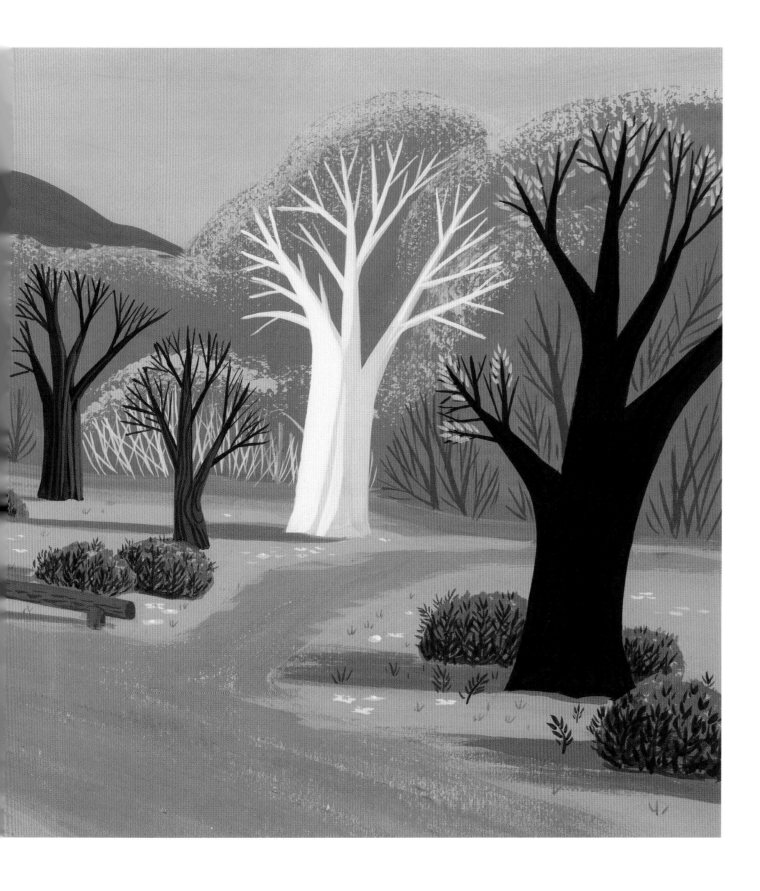

BEEZY BEAR 1955

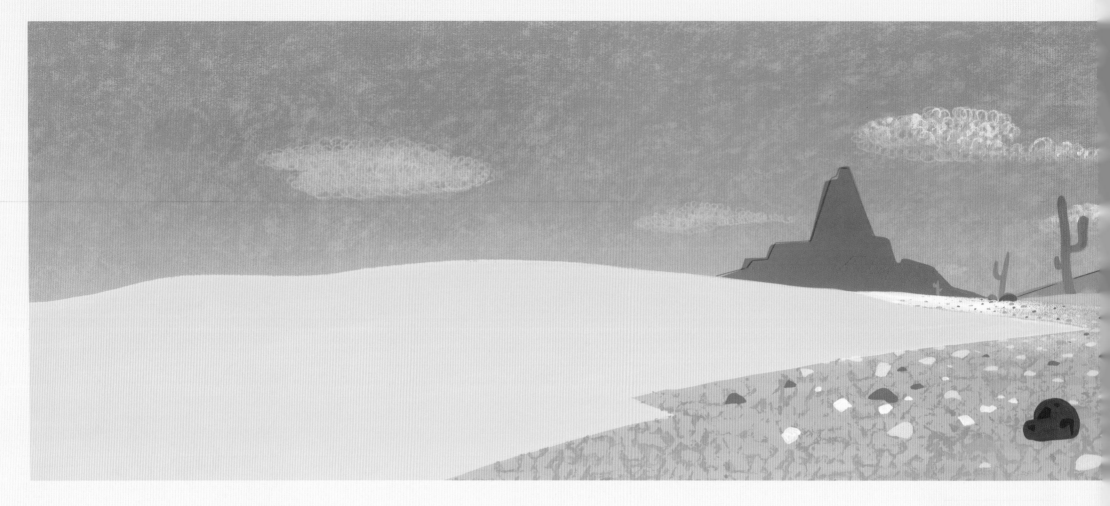

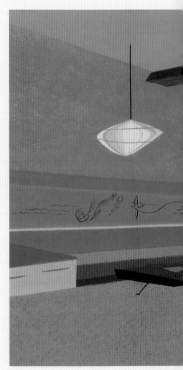

A COWBOY NEEDS A HORSE 1956

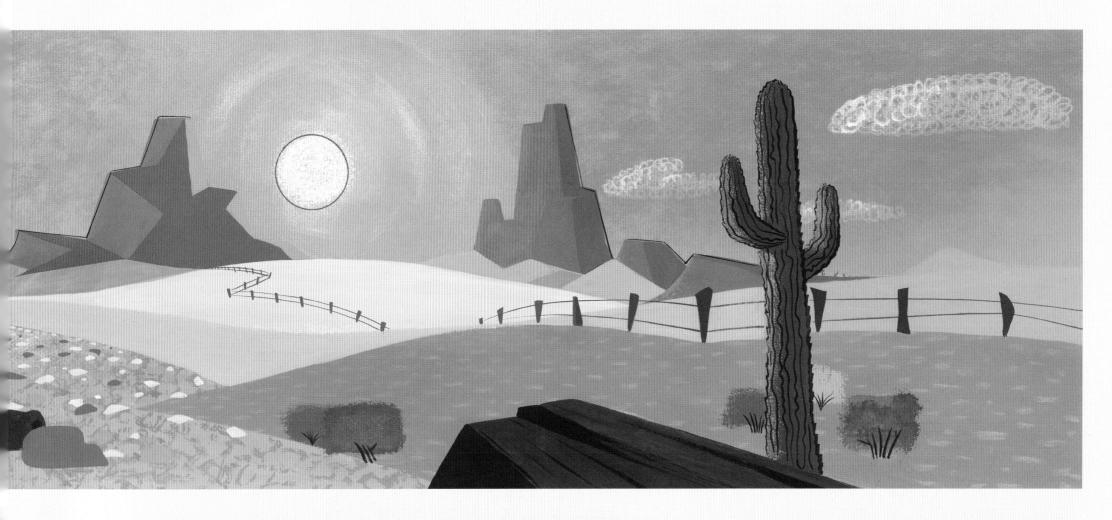

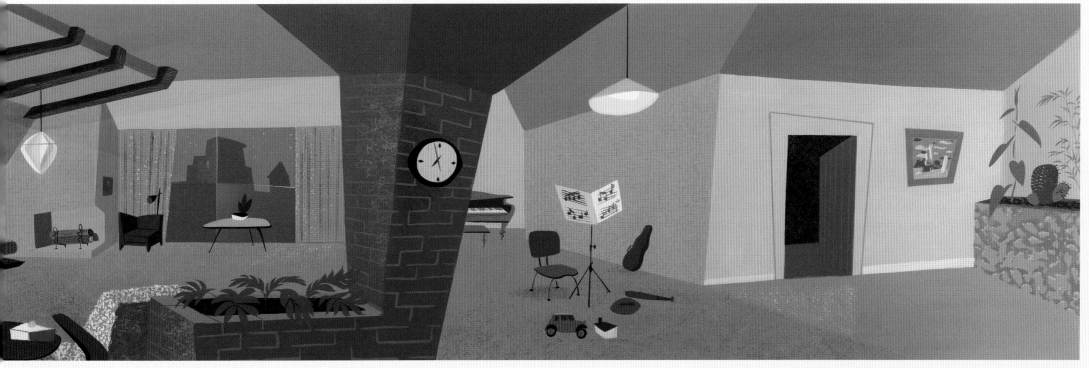

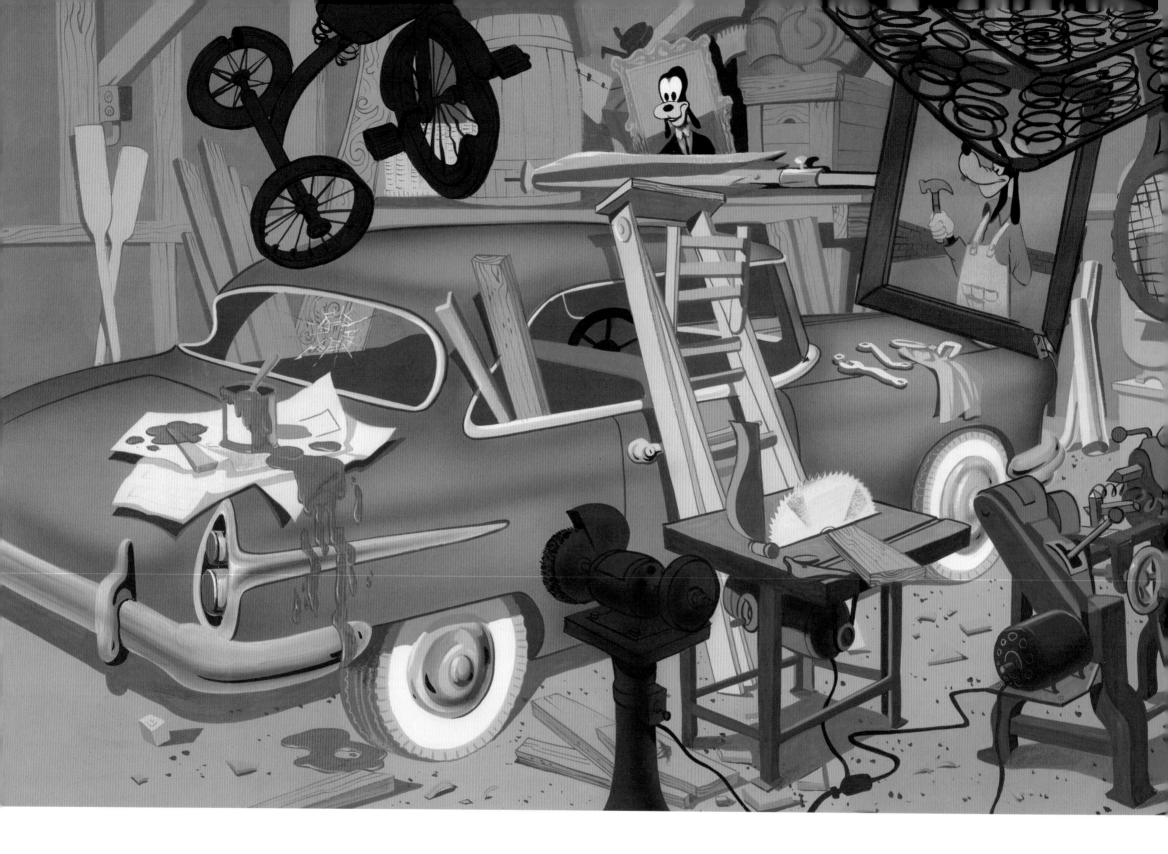

HOW TO RELAX 1957

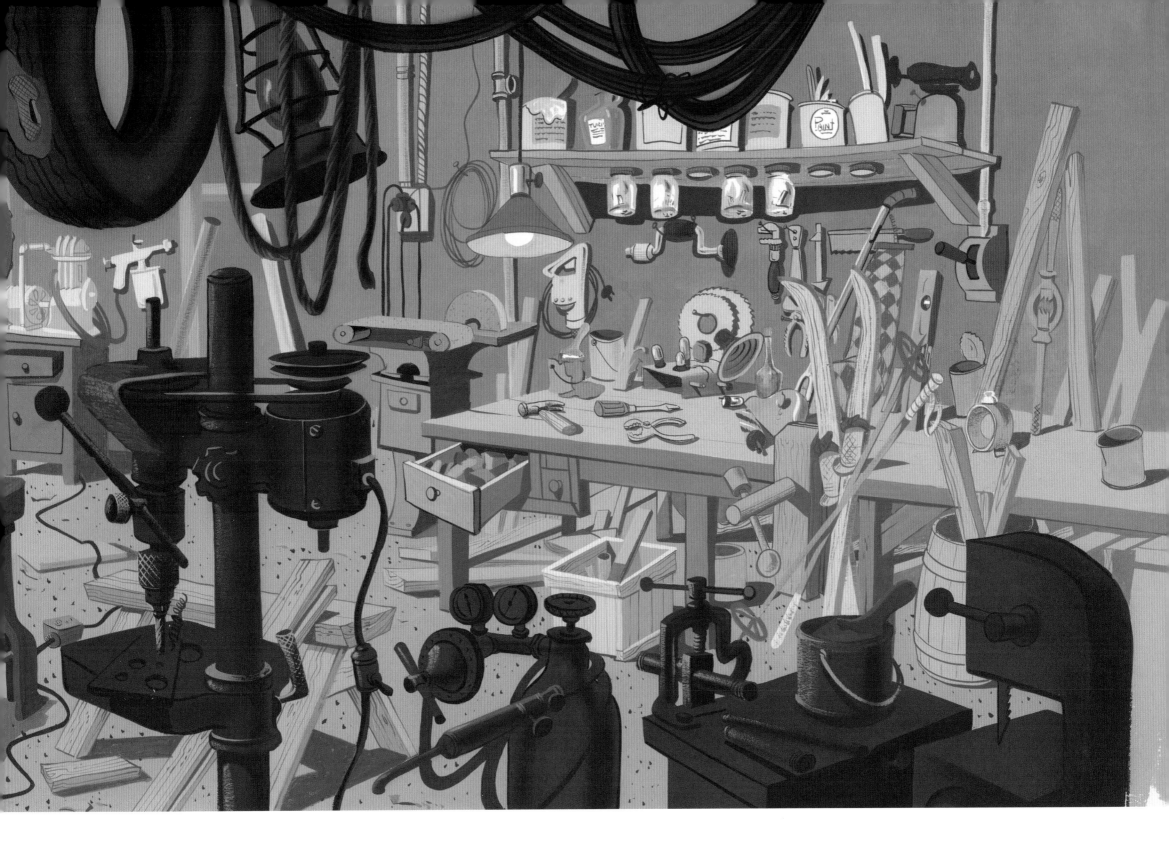

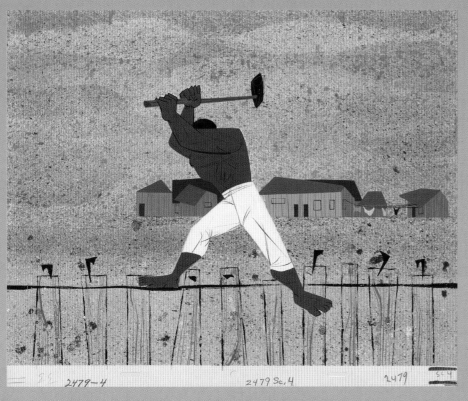

2479-4 2479 Sc. 4 2479

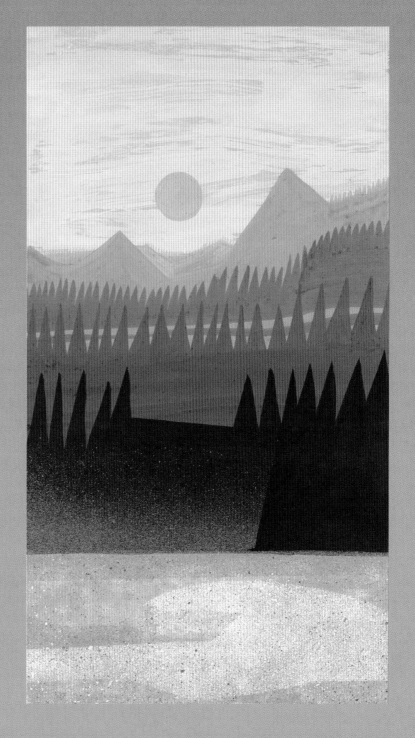

PAUL BUNYAN 1958

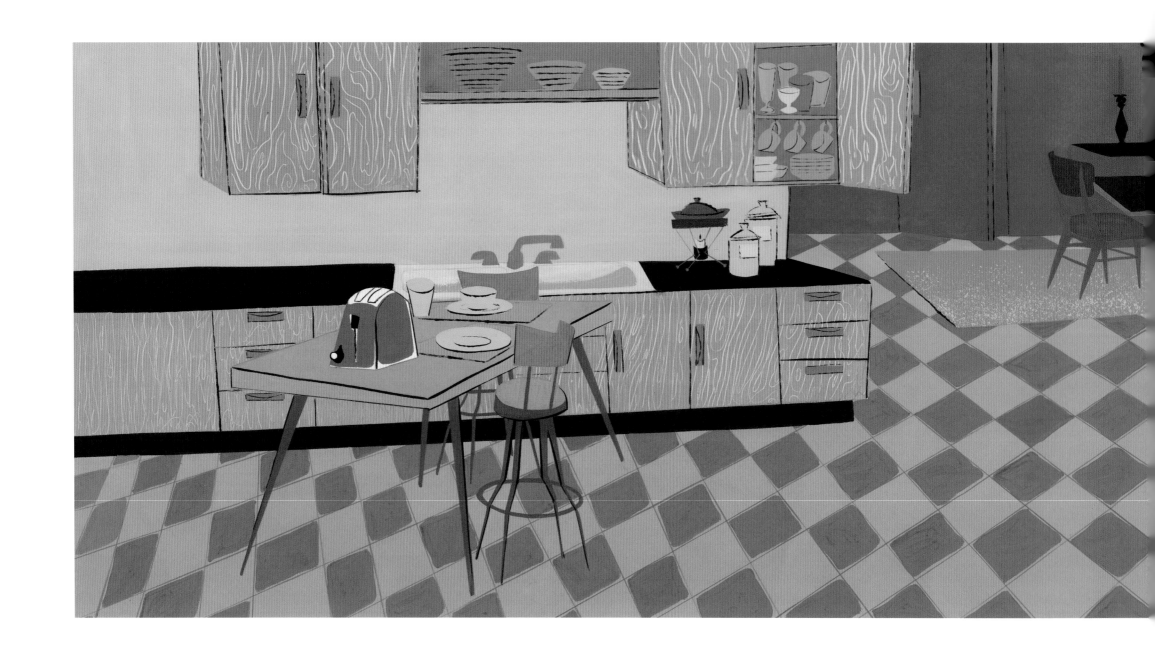

HOW TO HAVE AN ACCIDENT AT WORK 1959

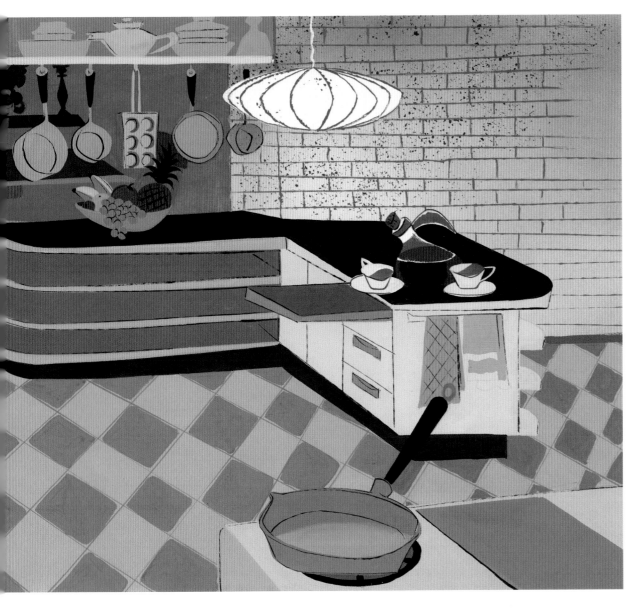

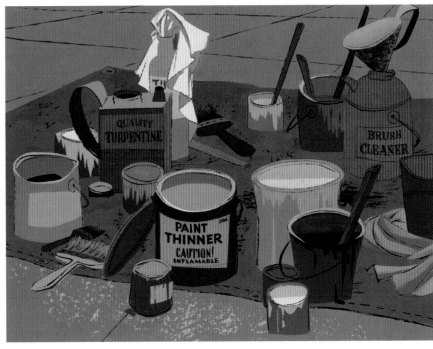

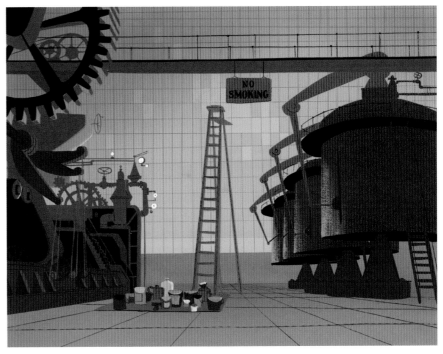

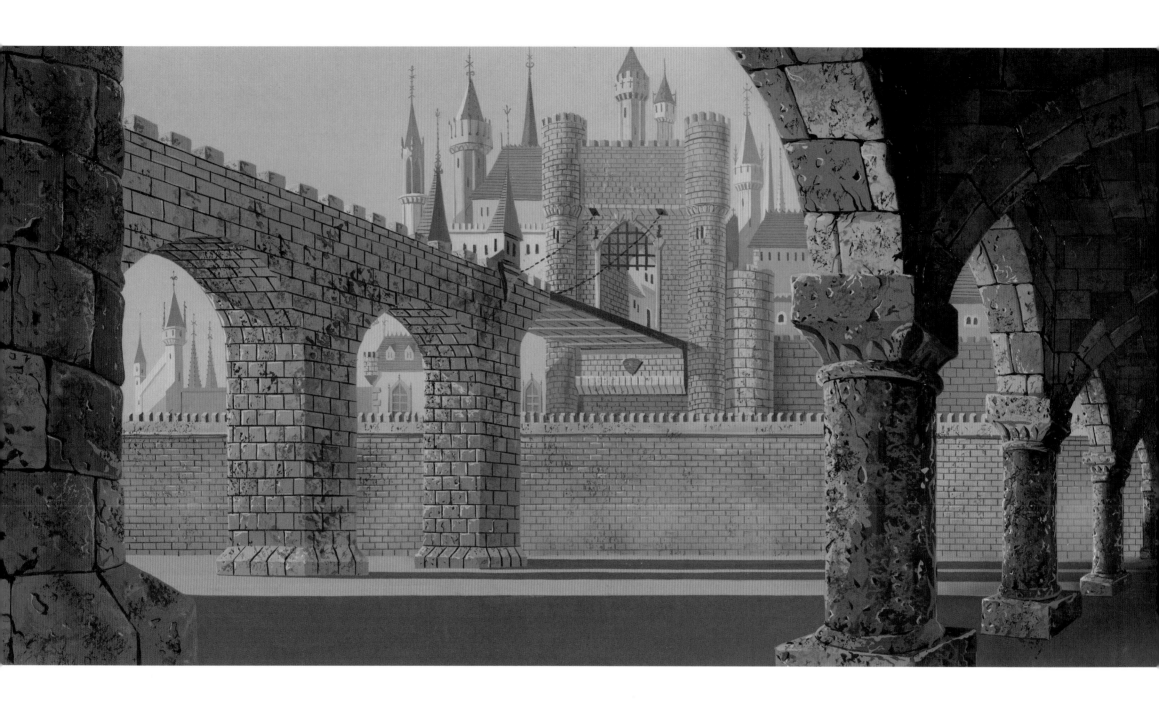

SLEEPING BEAUTY 1959

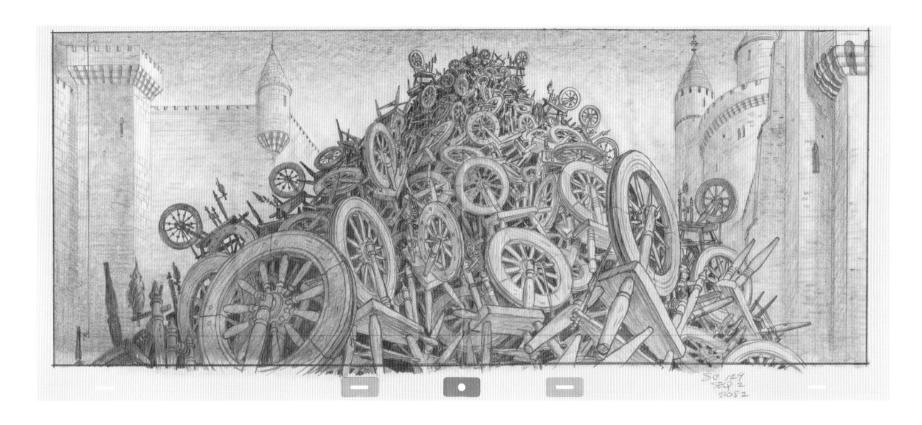

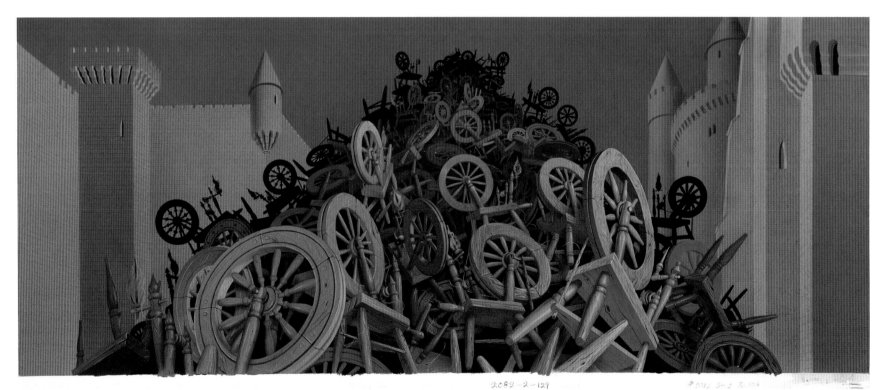

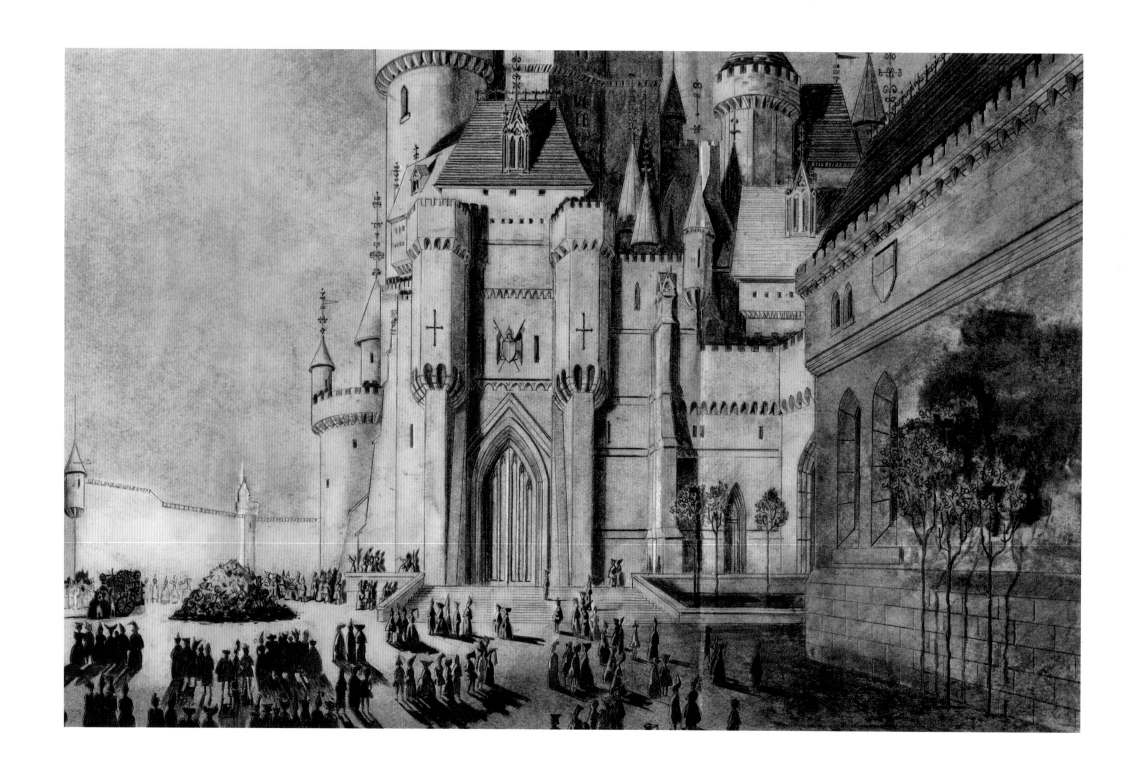

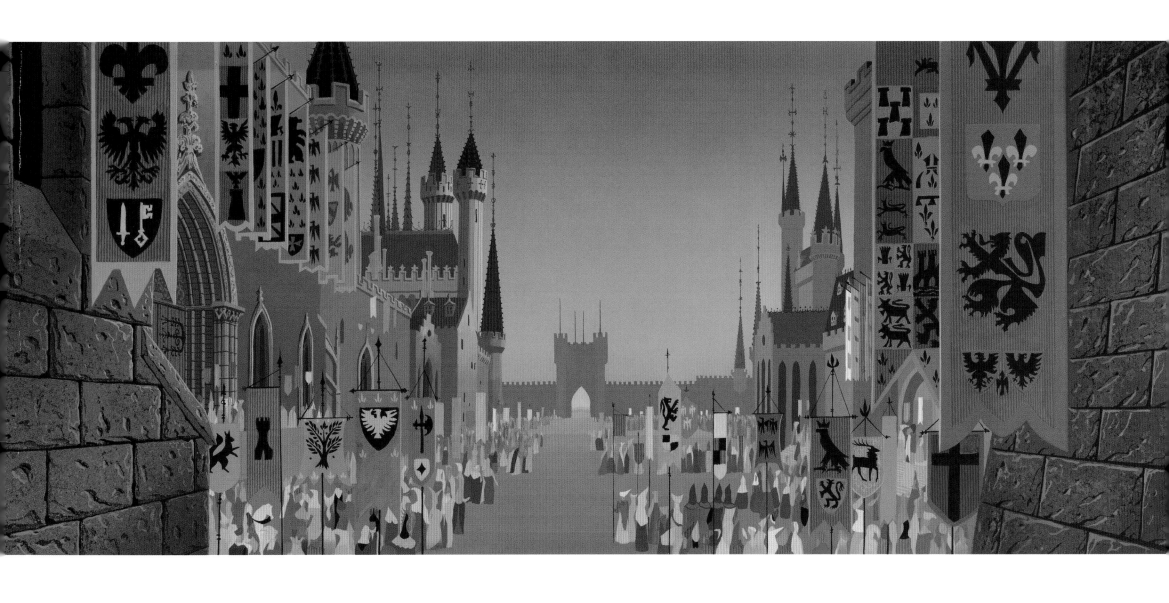

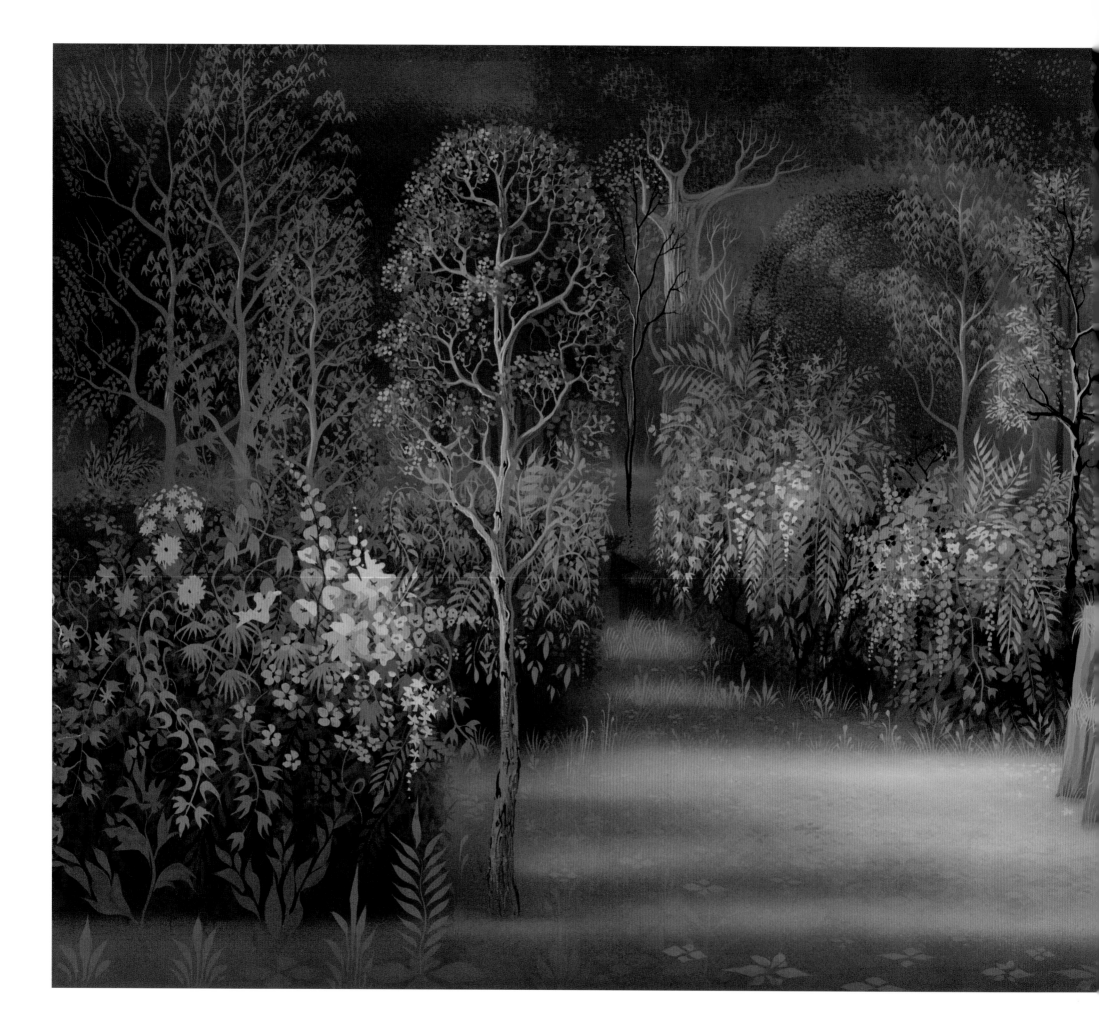

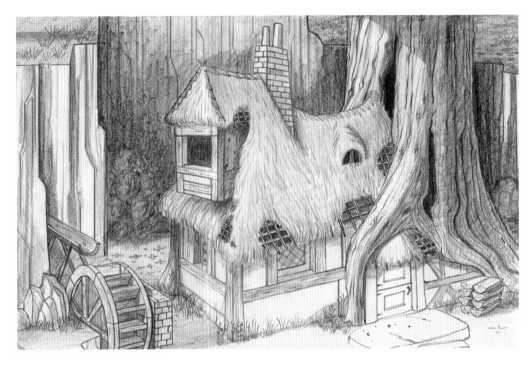

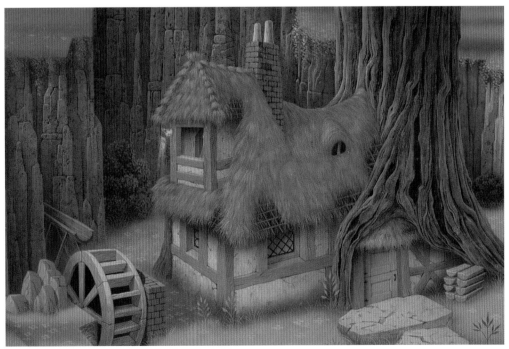

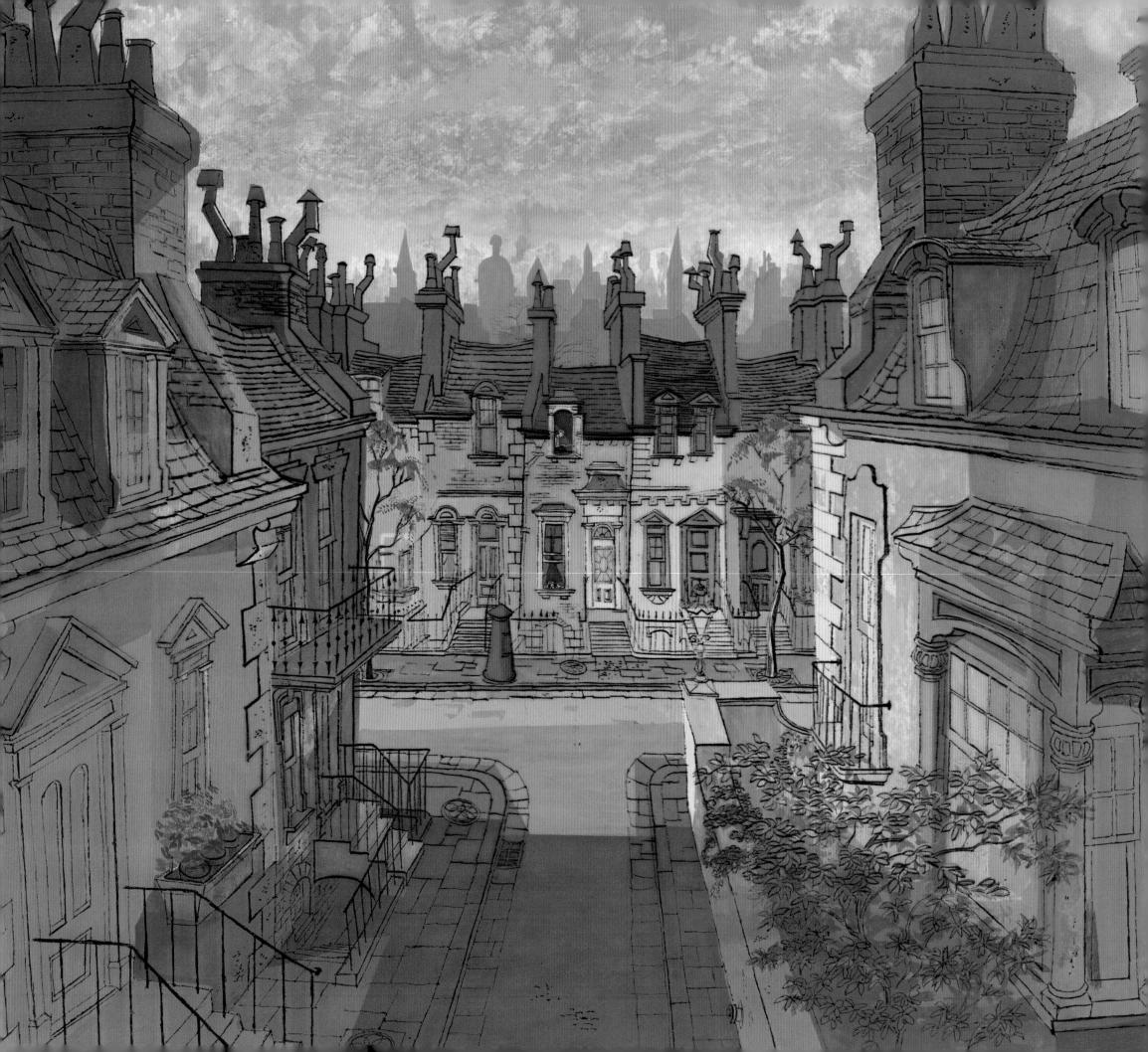

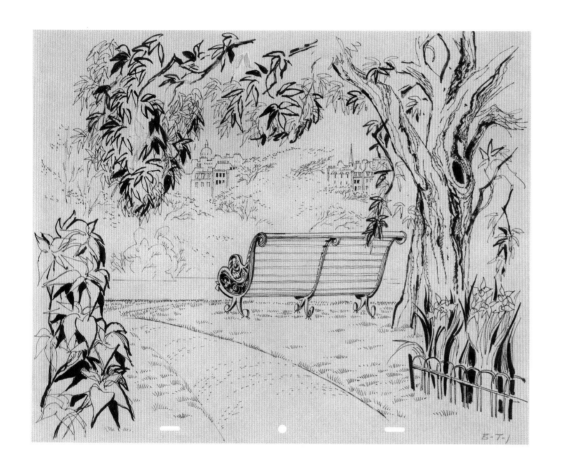

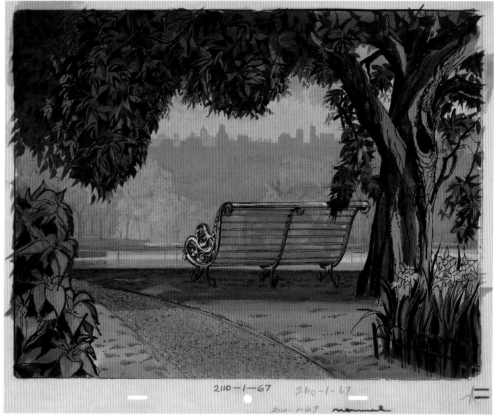

ONE HUNDRED AND ONE DALMATIANS 1961

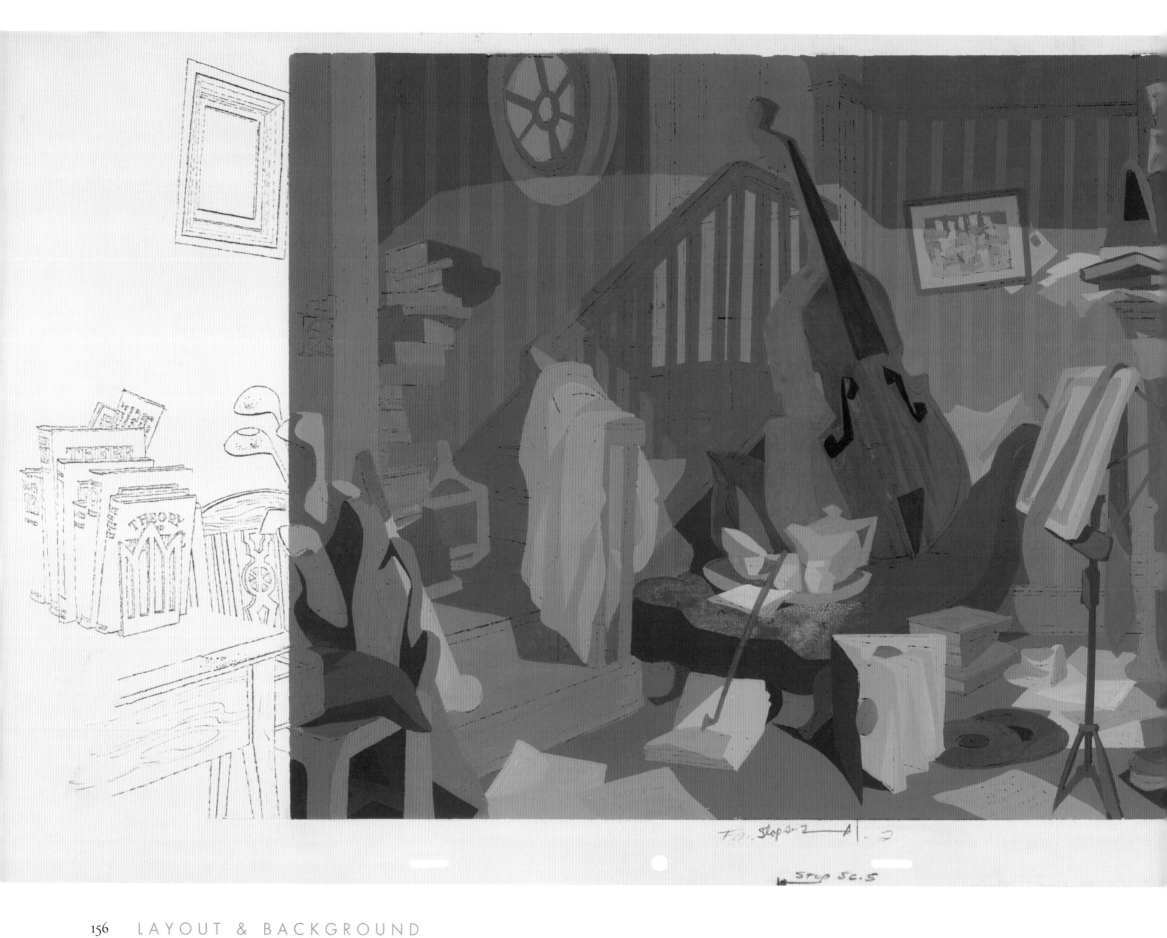

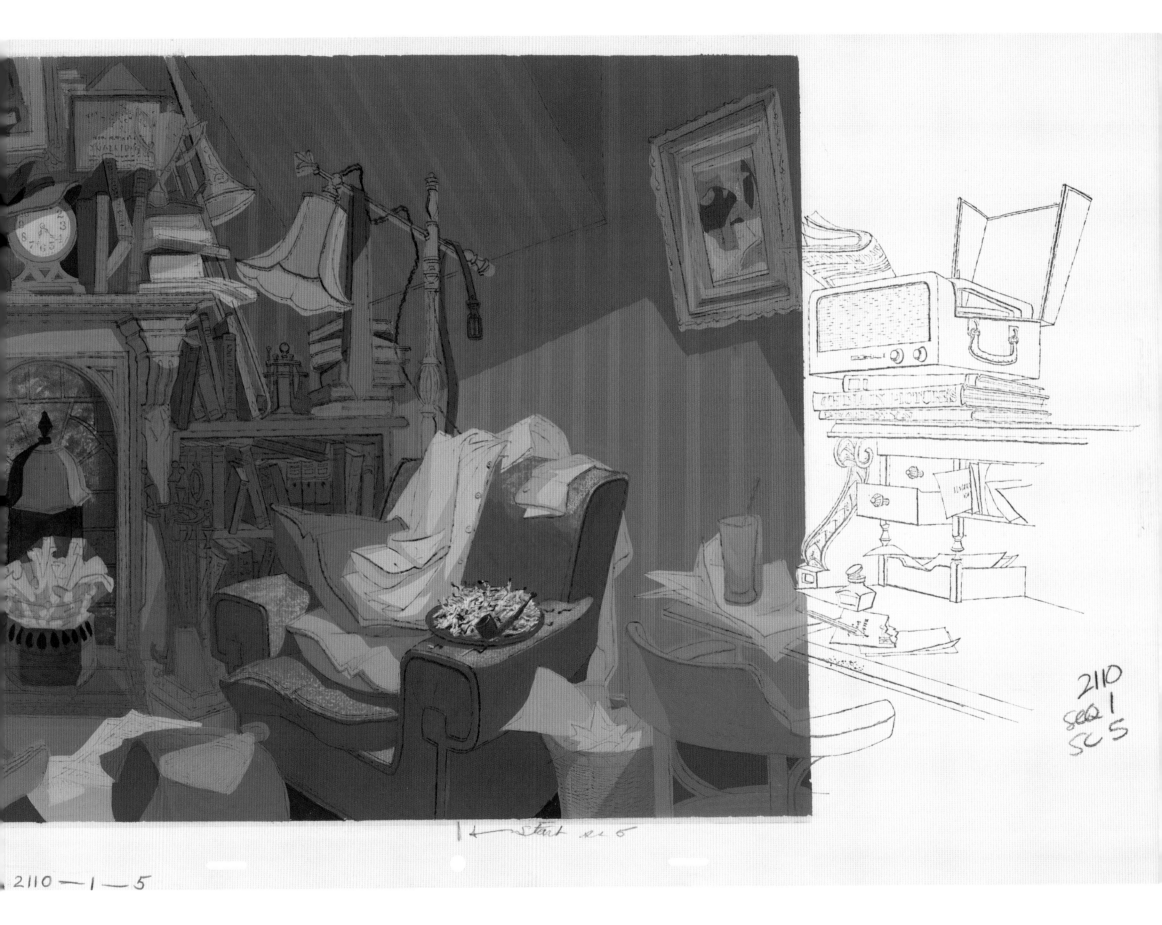

2110
seq 1
sc 5

start sc 5

2110—1—5

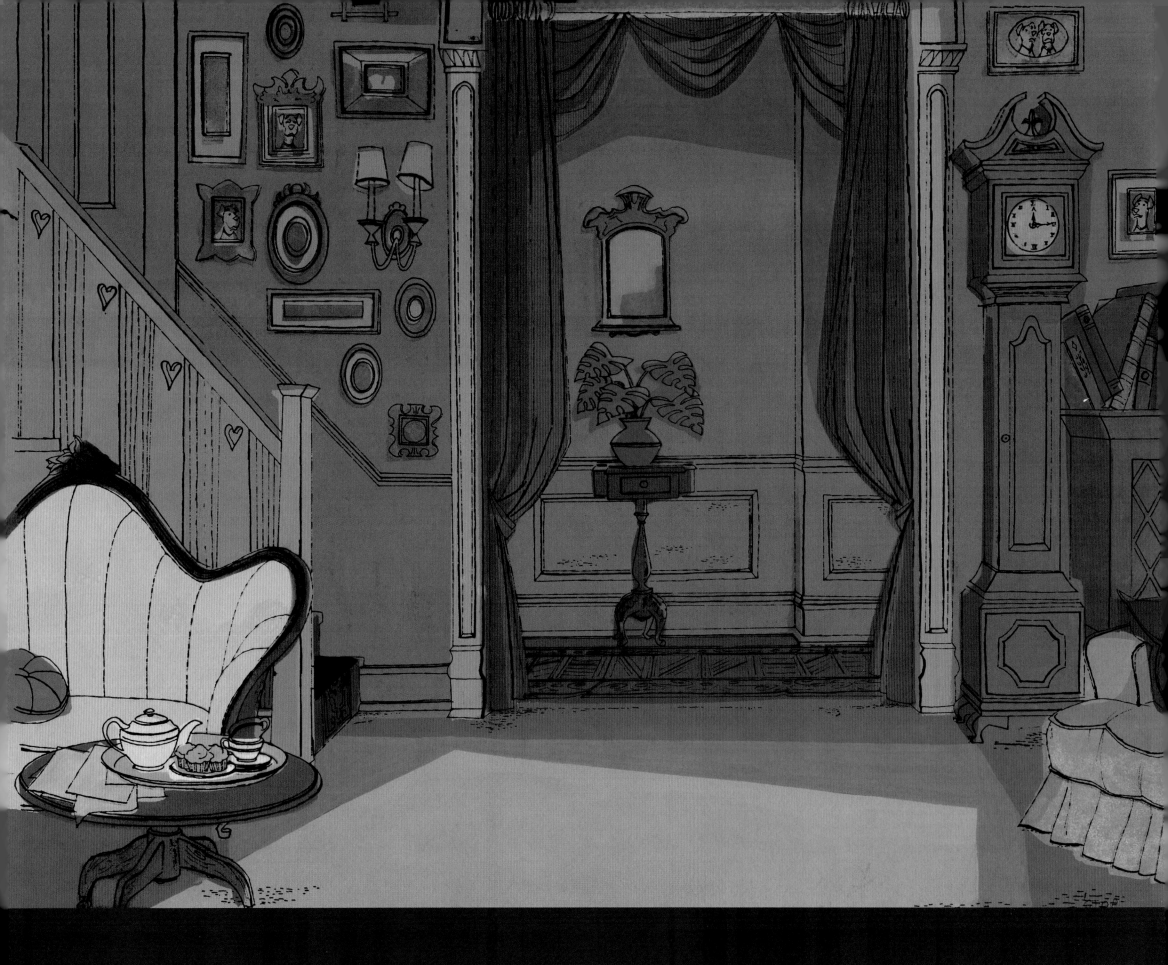

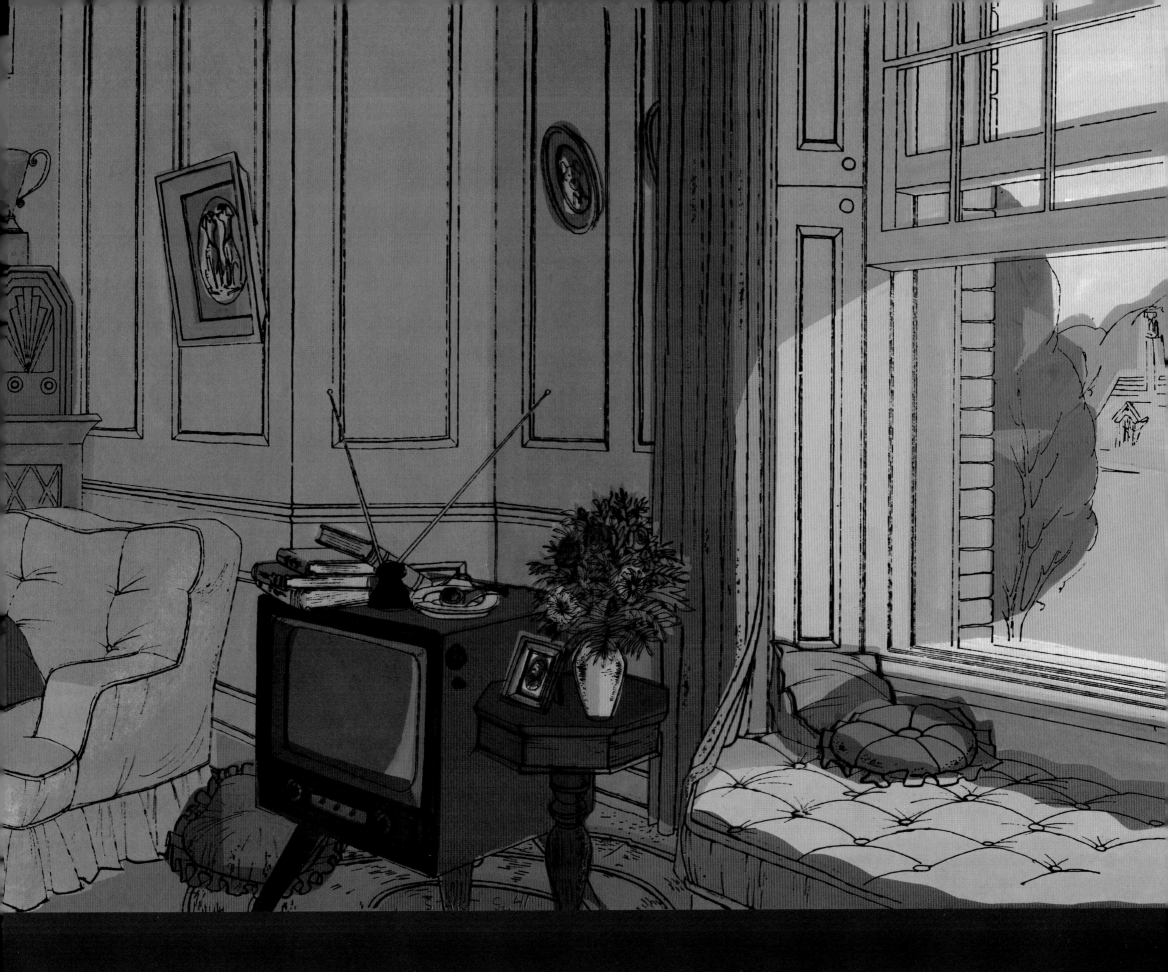

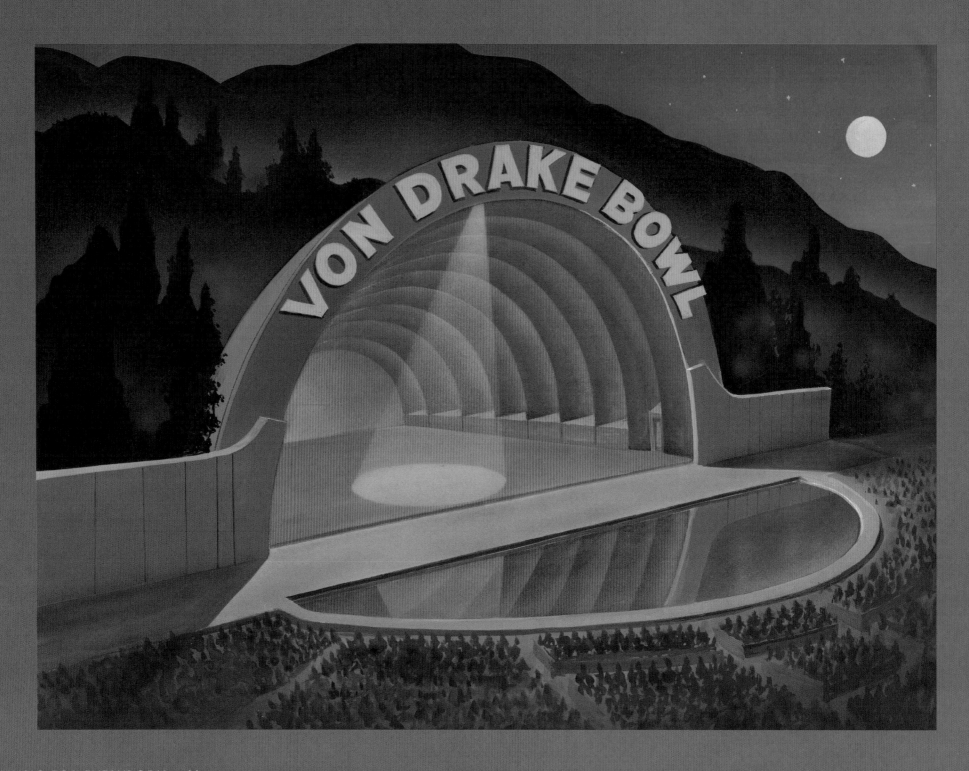

MUSIC FOR EVERYBODY 1966

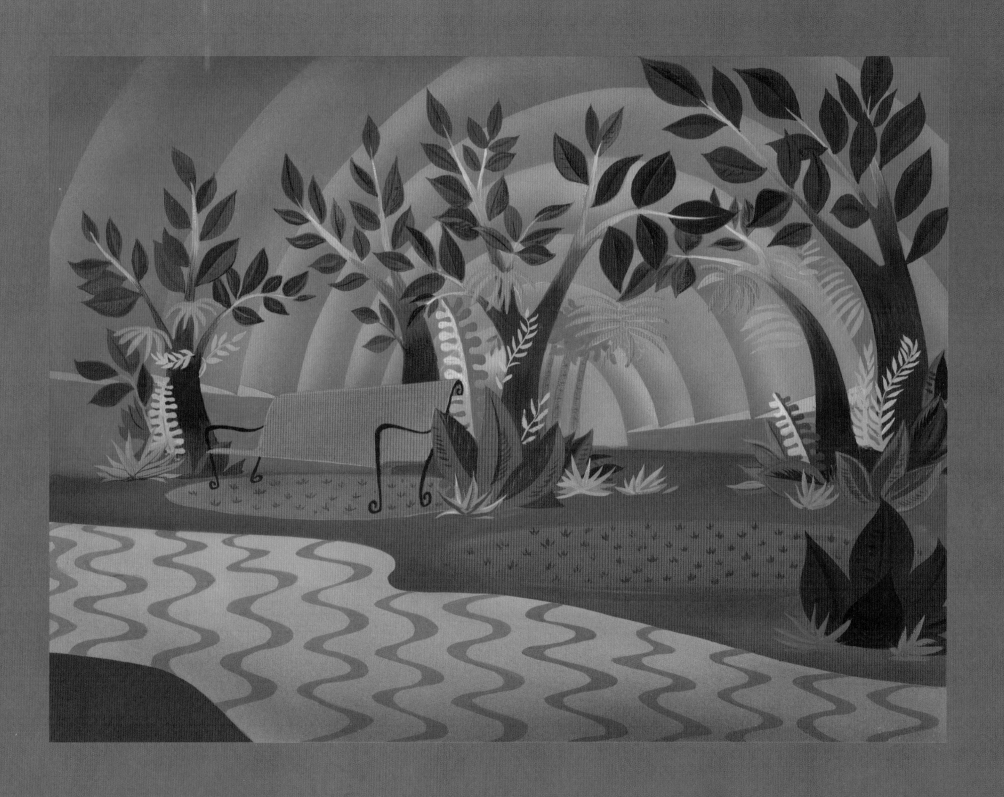

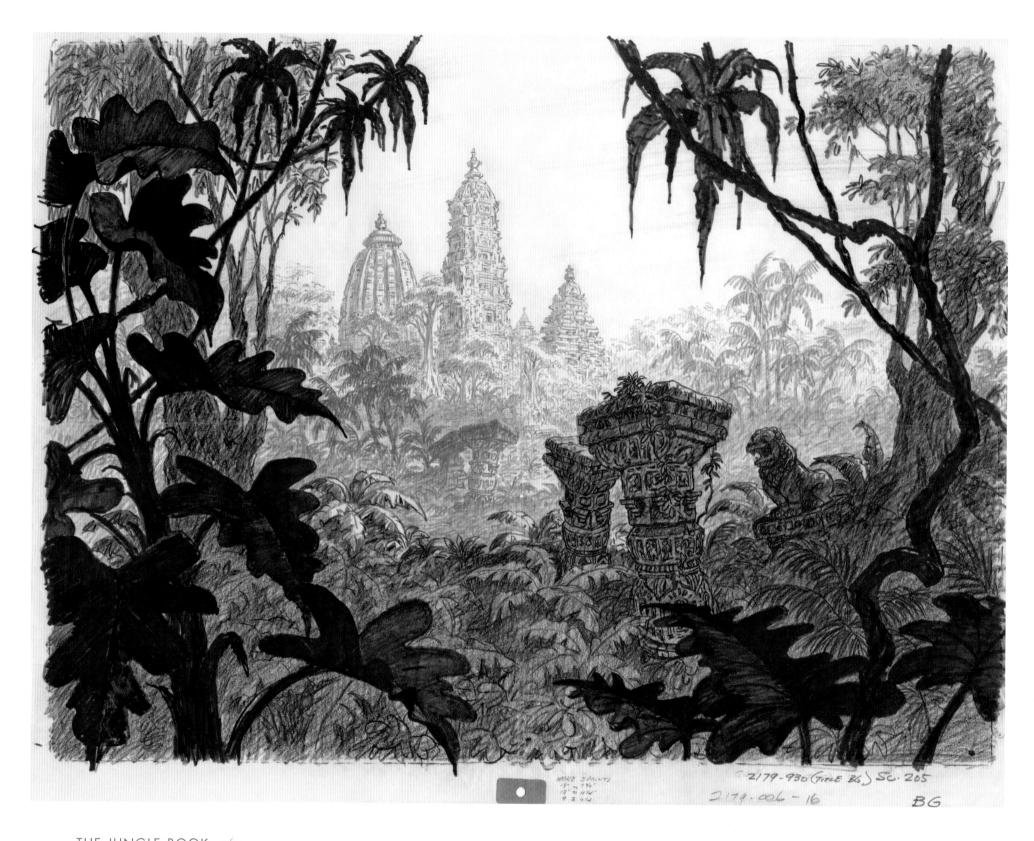

THE JUNGLE BOOK 1967

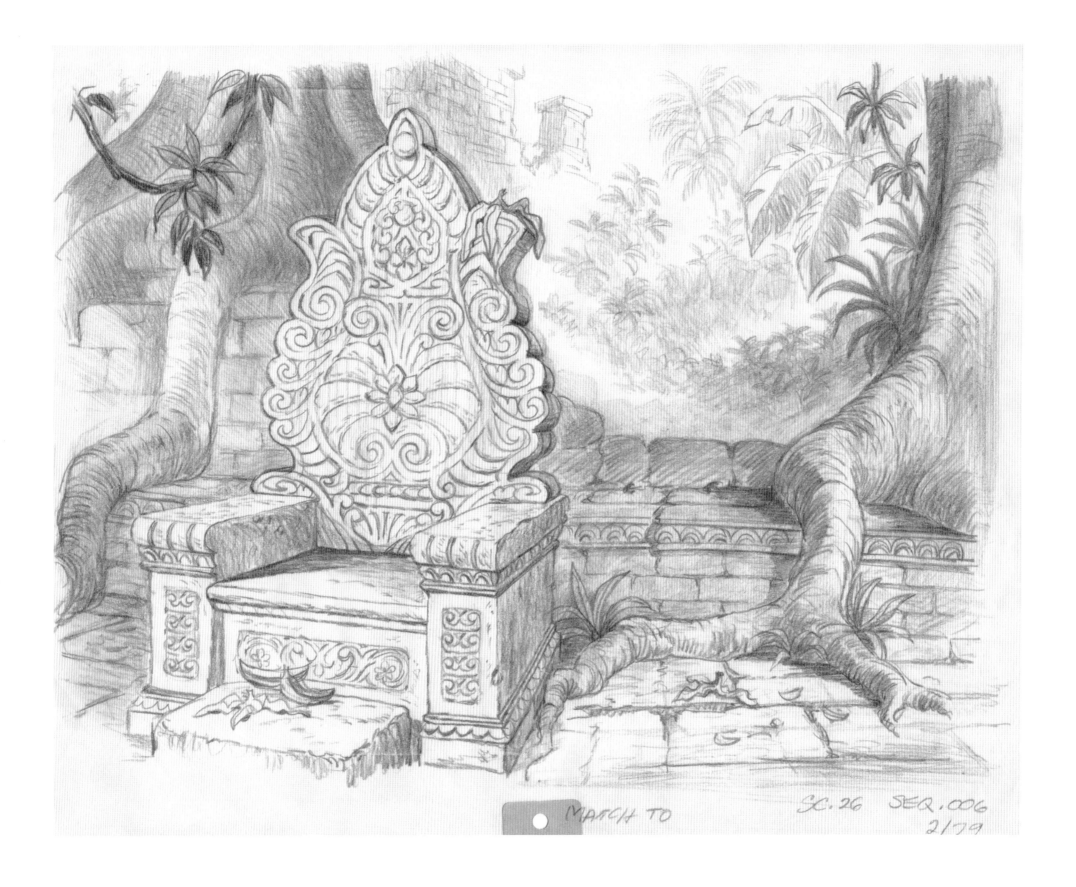

MATCH TO SC. 26 SEQ. OO6
2/79

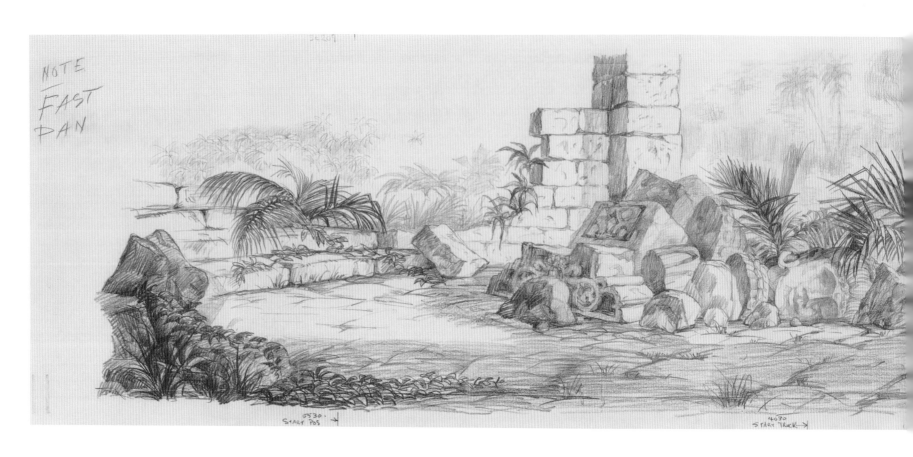

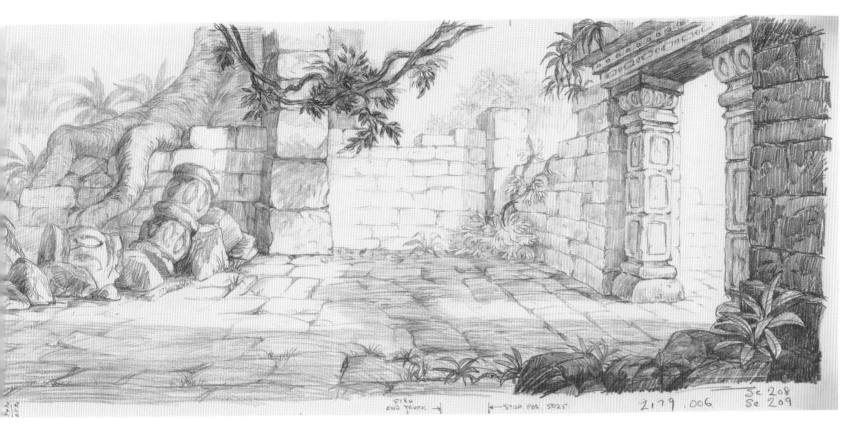

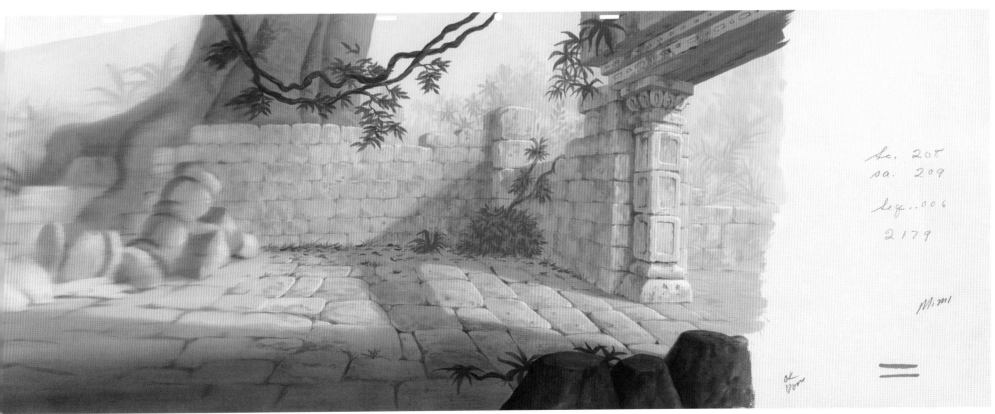

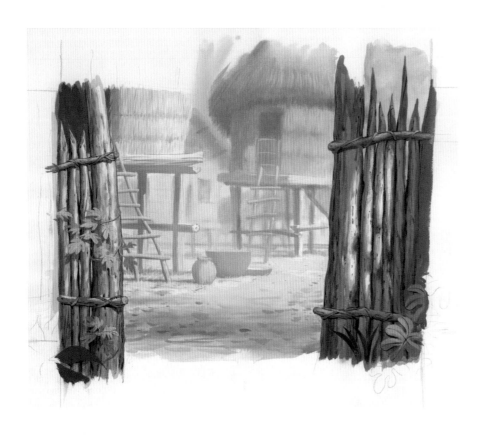

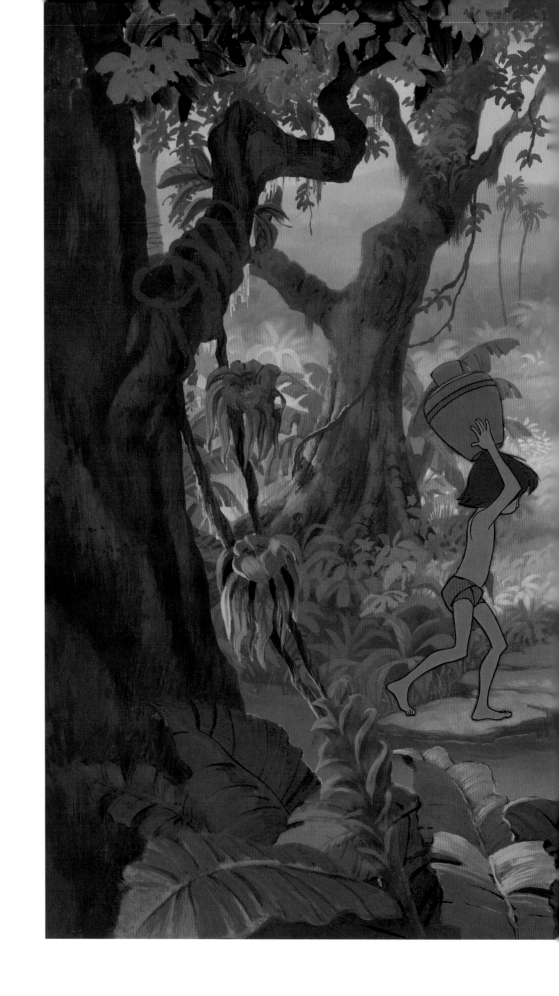

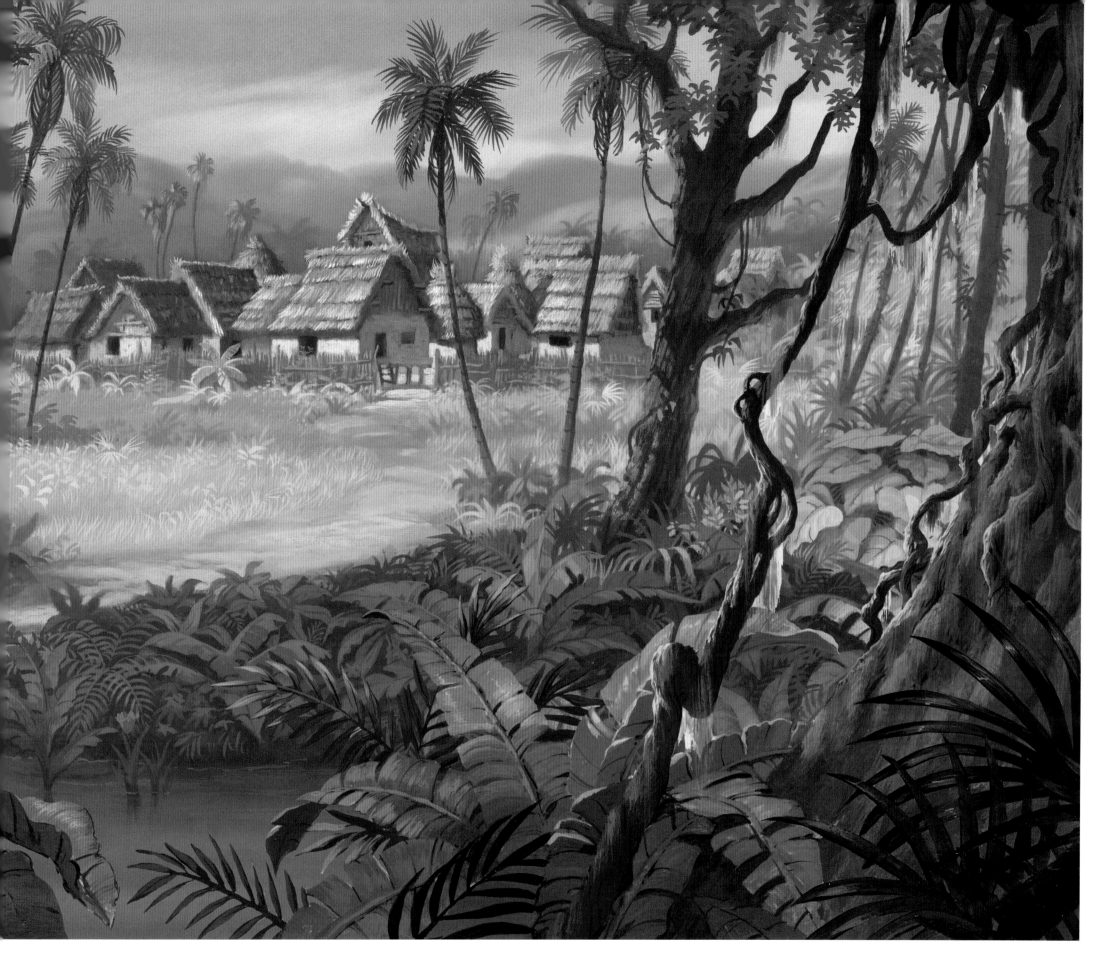

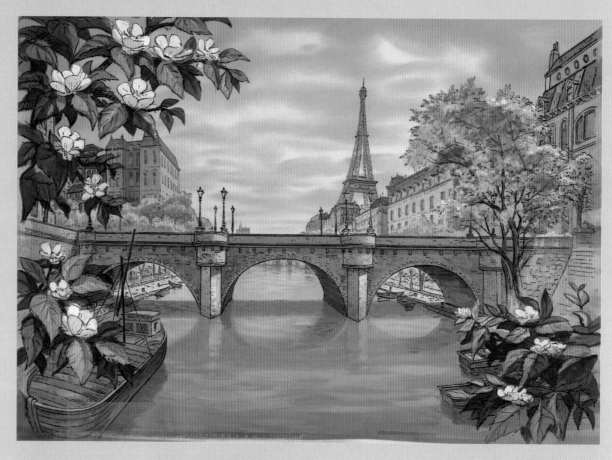

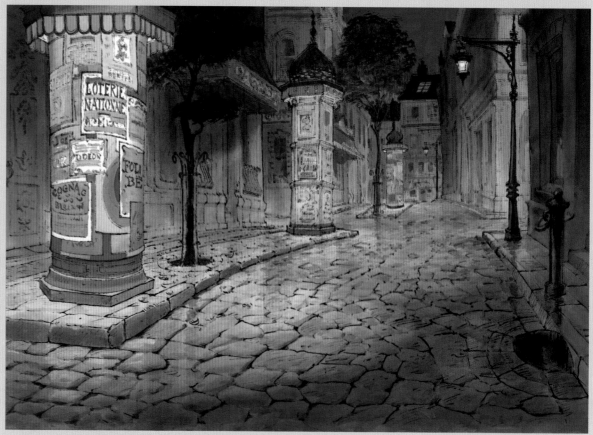

THE ARISTOCATS 1970

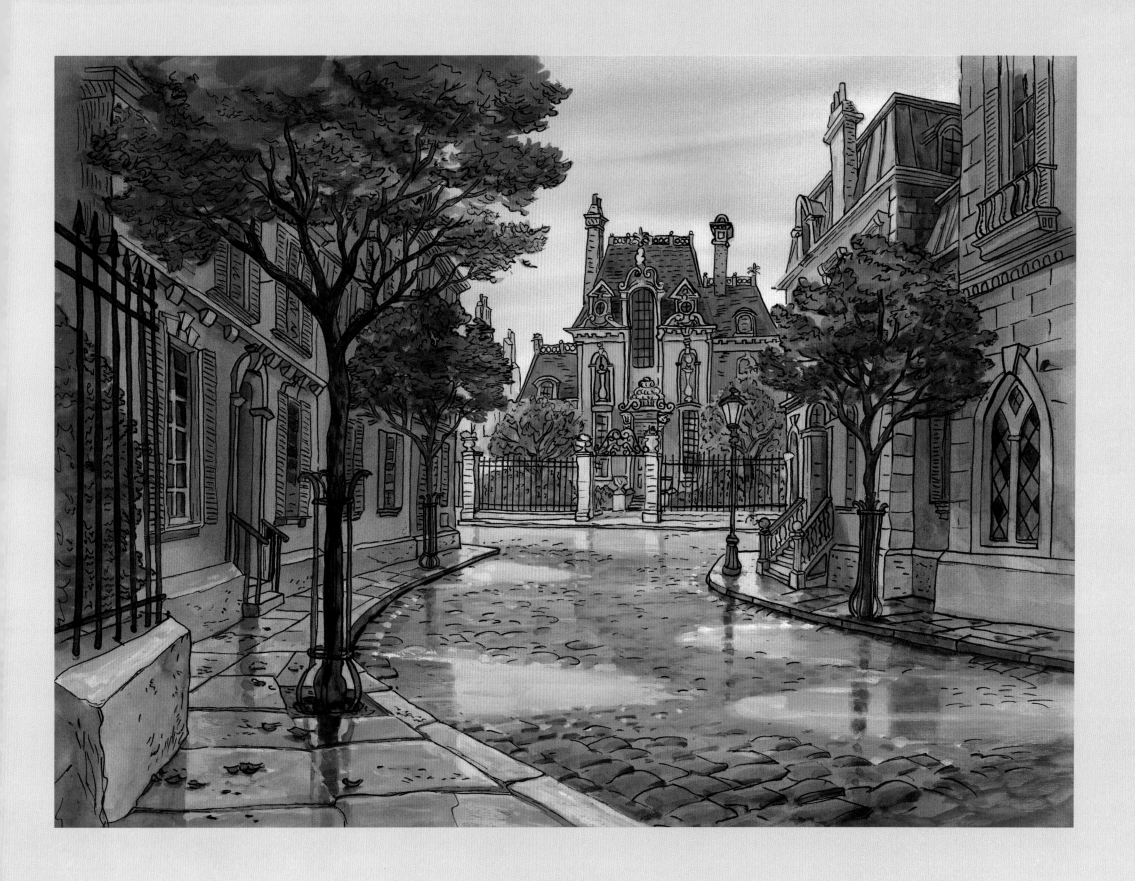

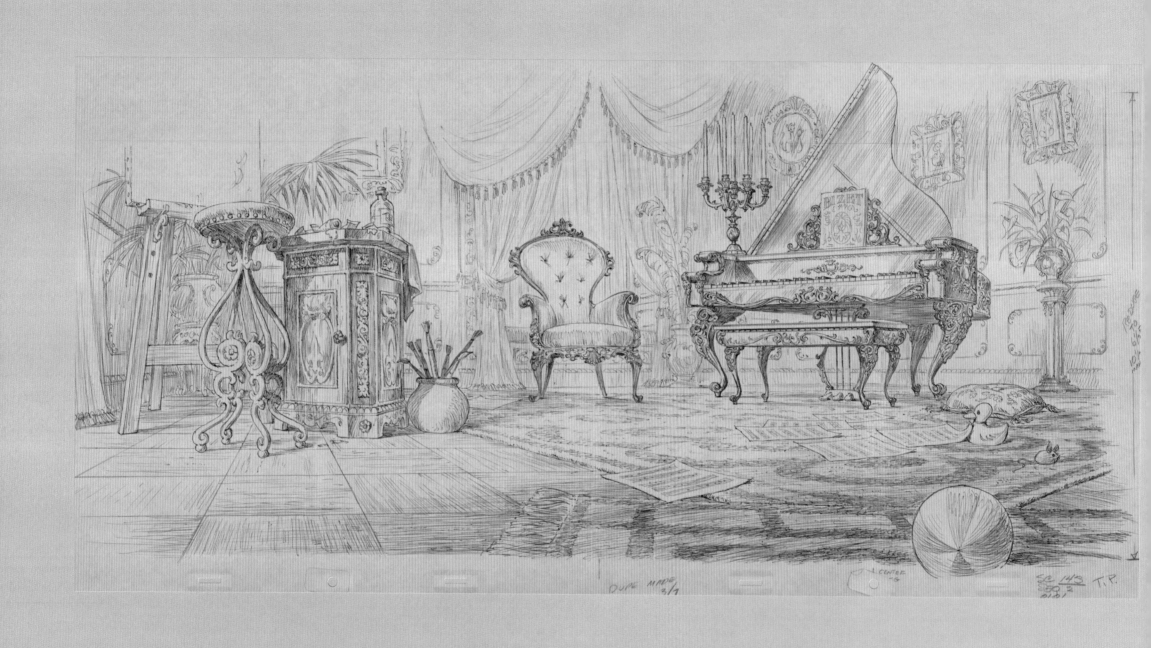

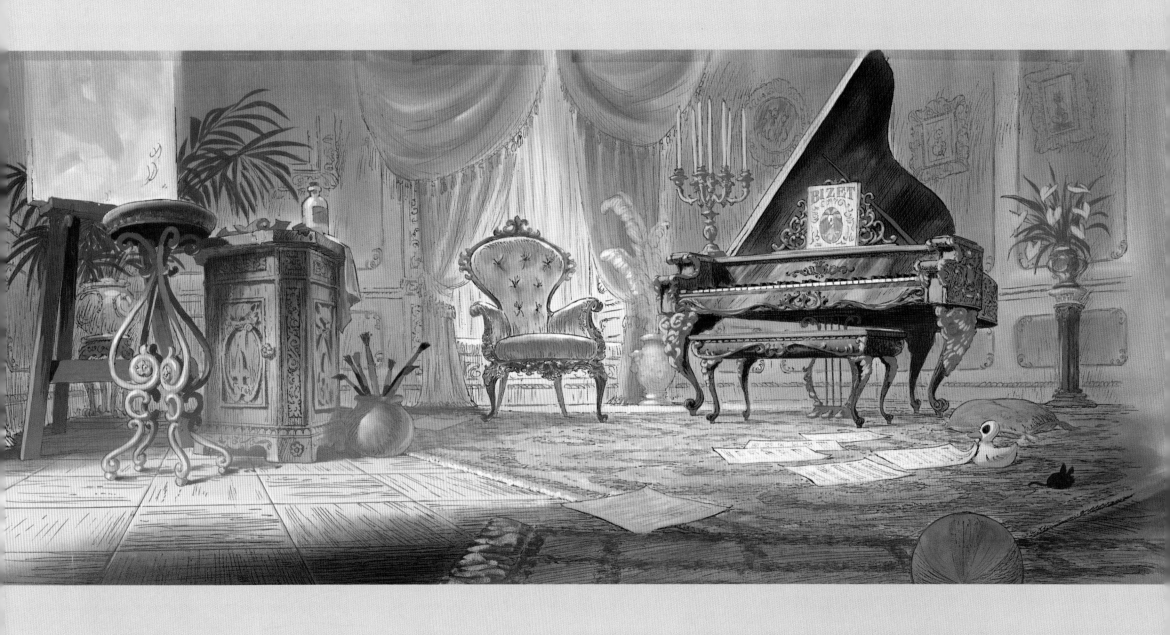

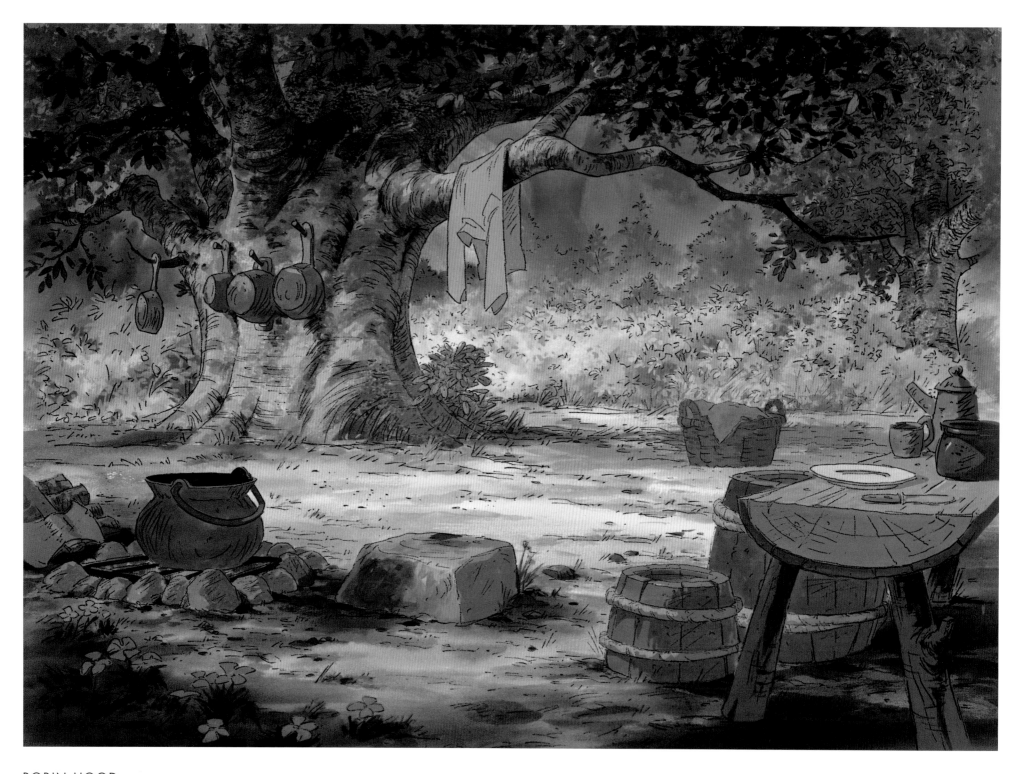

ROBIN HOOD 1973

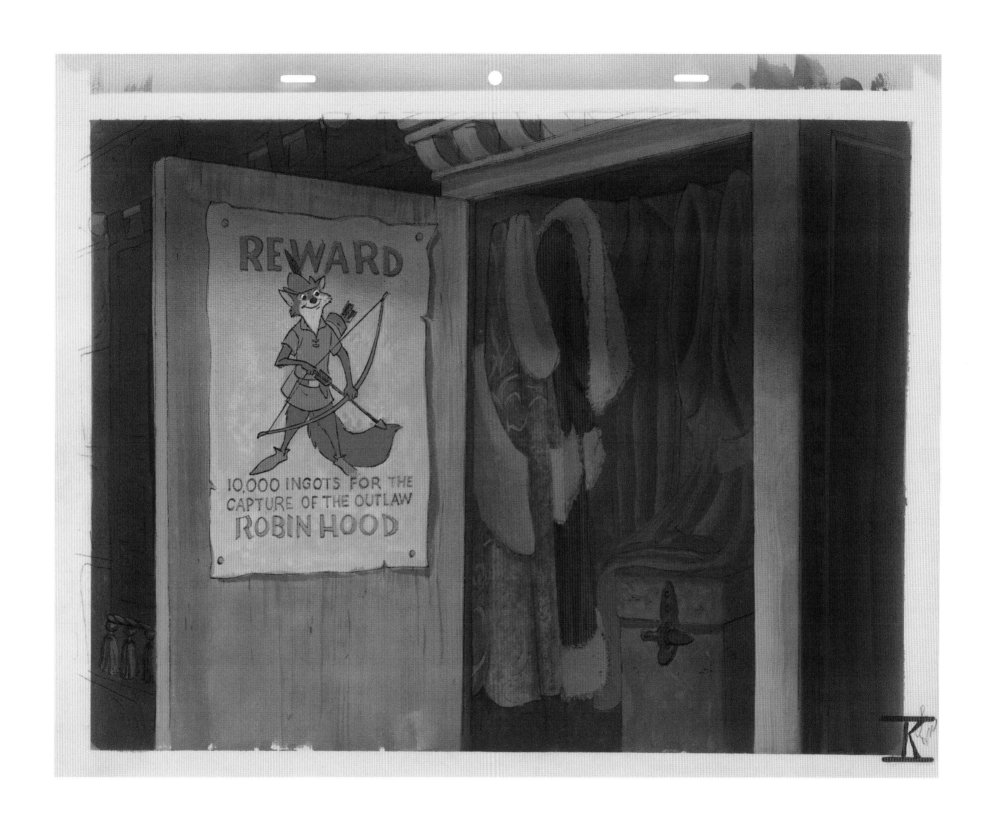

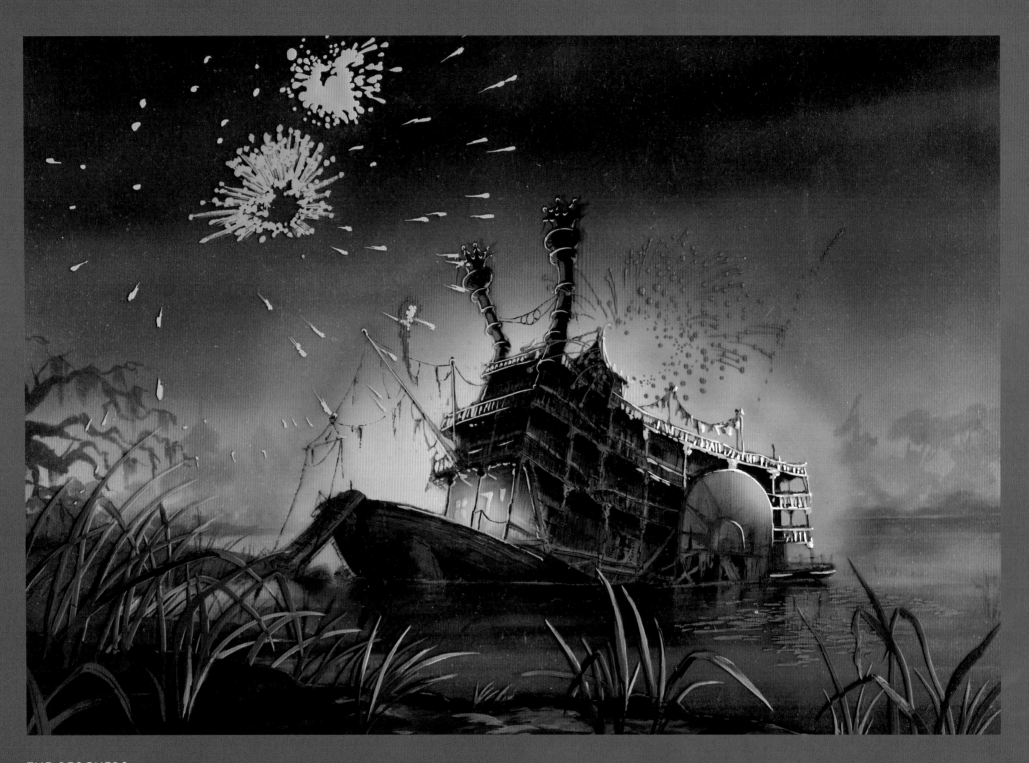

THE RESCUERS 1977

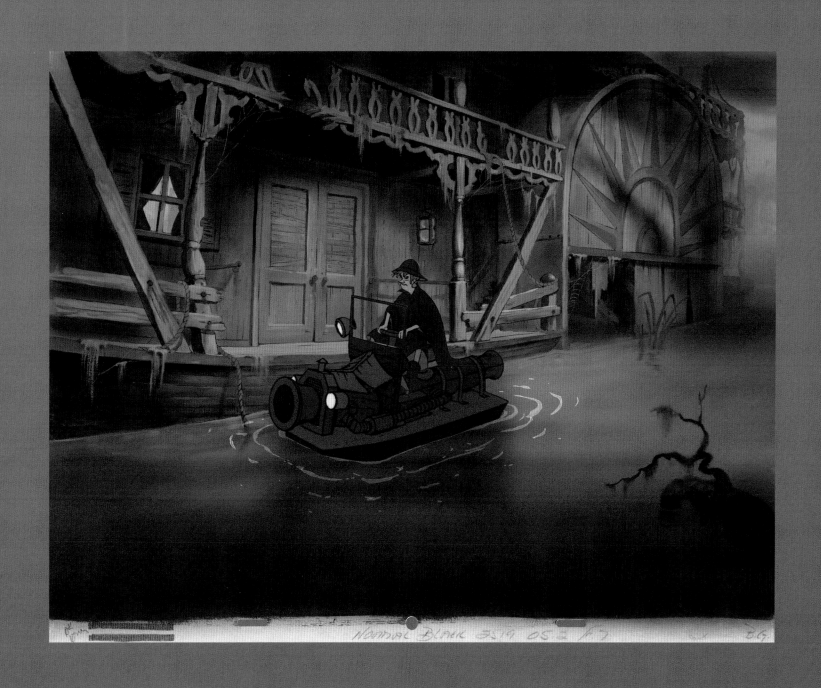

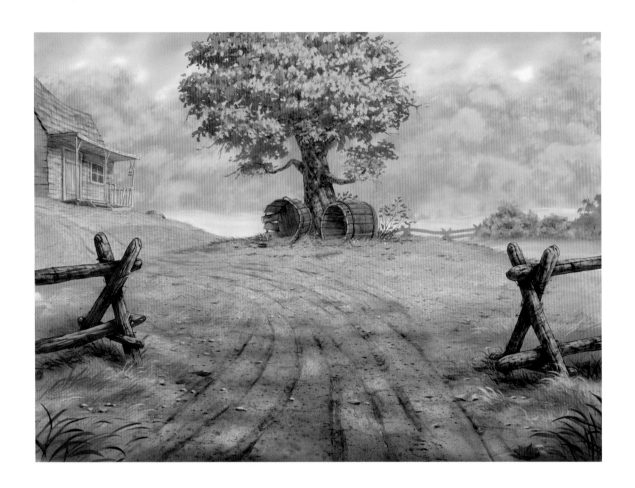

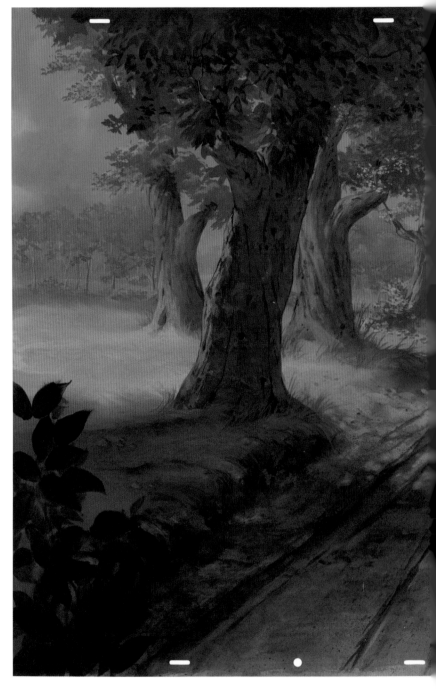

THE FOX AND THE HOUND 1981

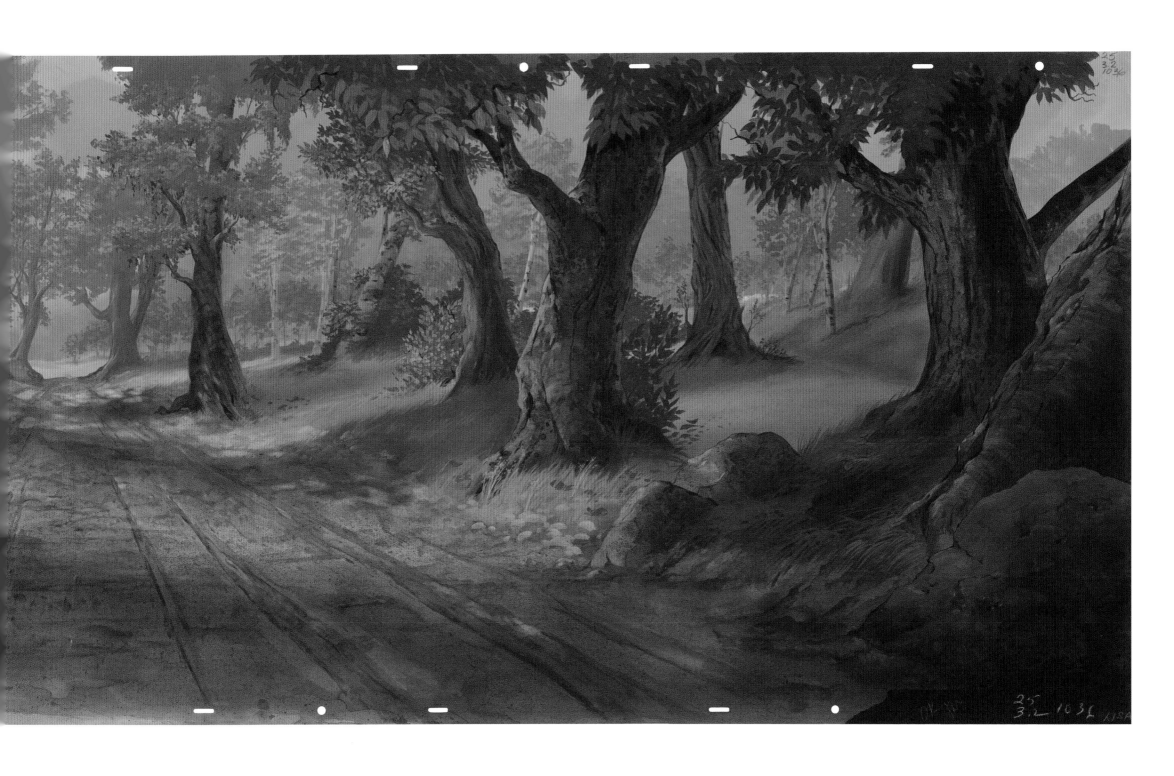

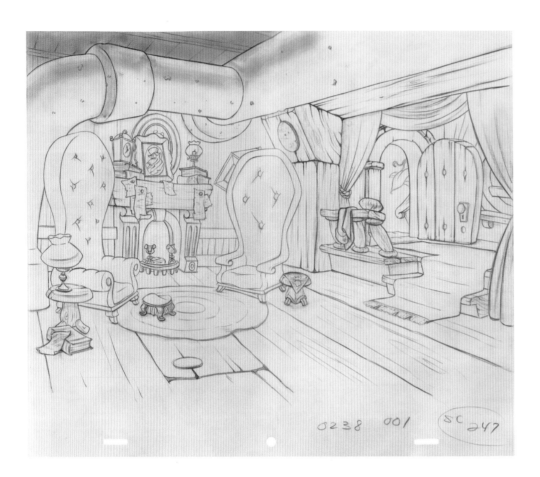
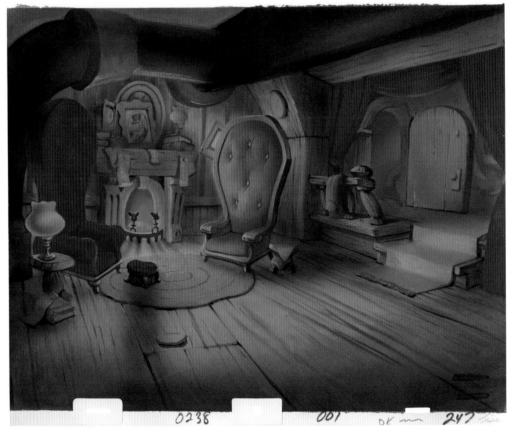

THE GREAT MOUSE DETECTIVE 1986

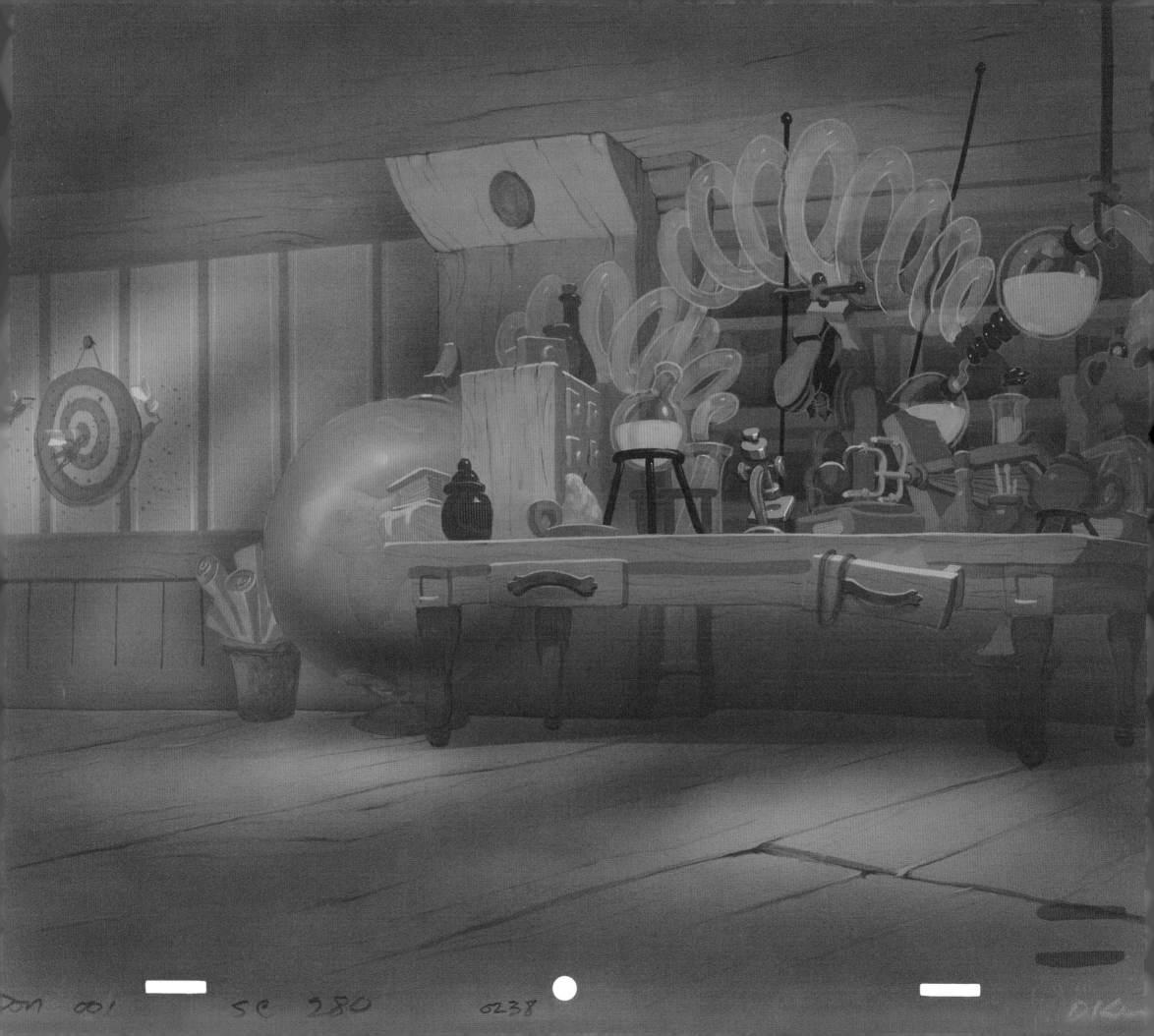

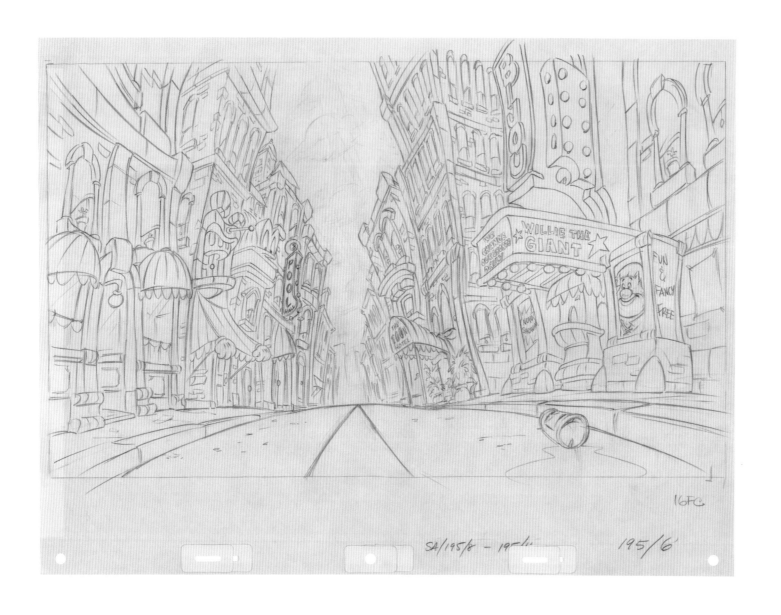

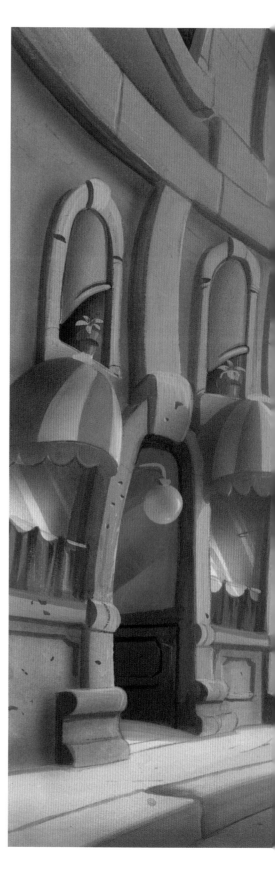

WHO FRAMED ROGER RABBIT 1988

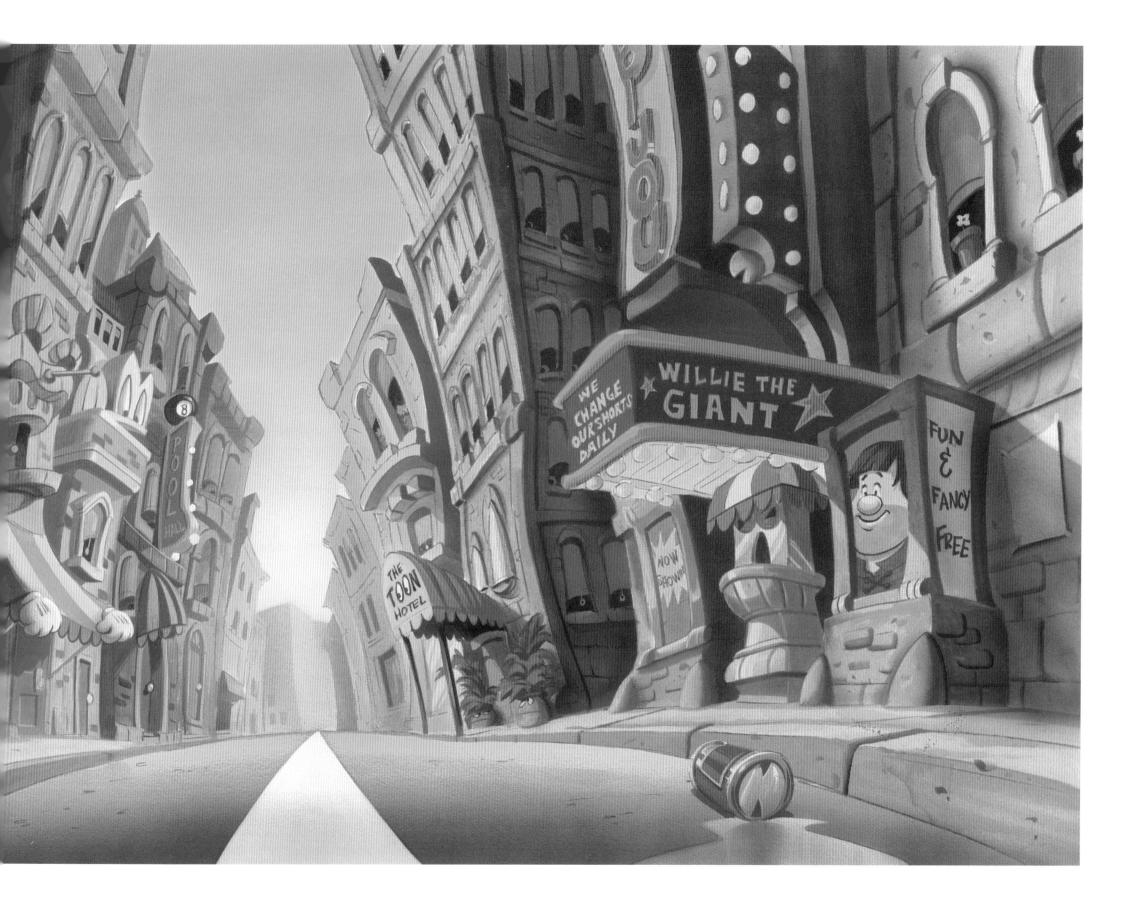

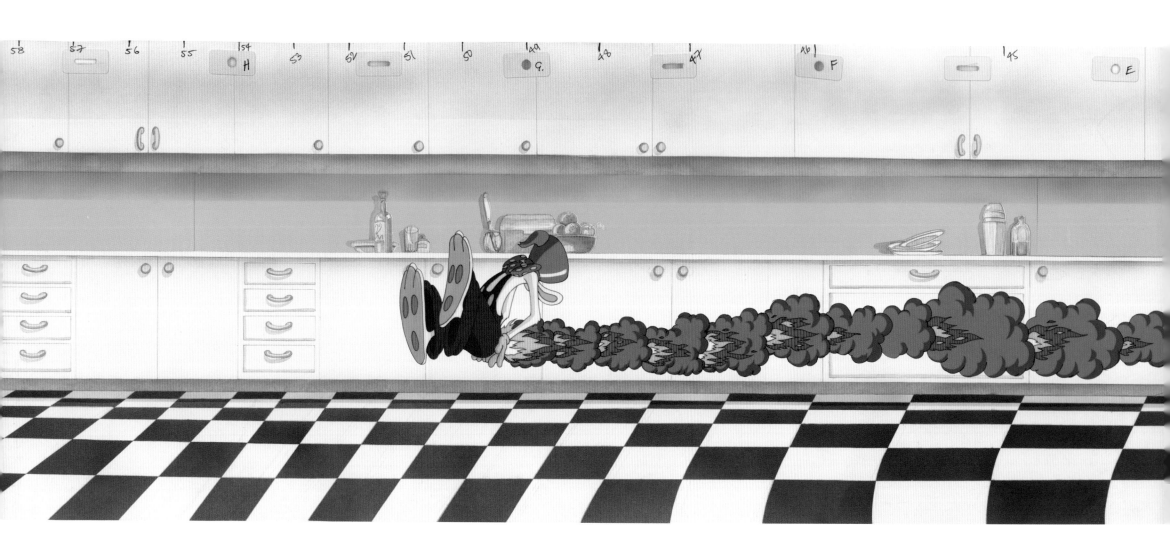

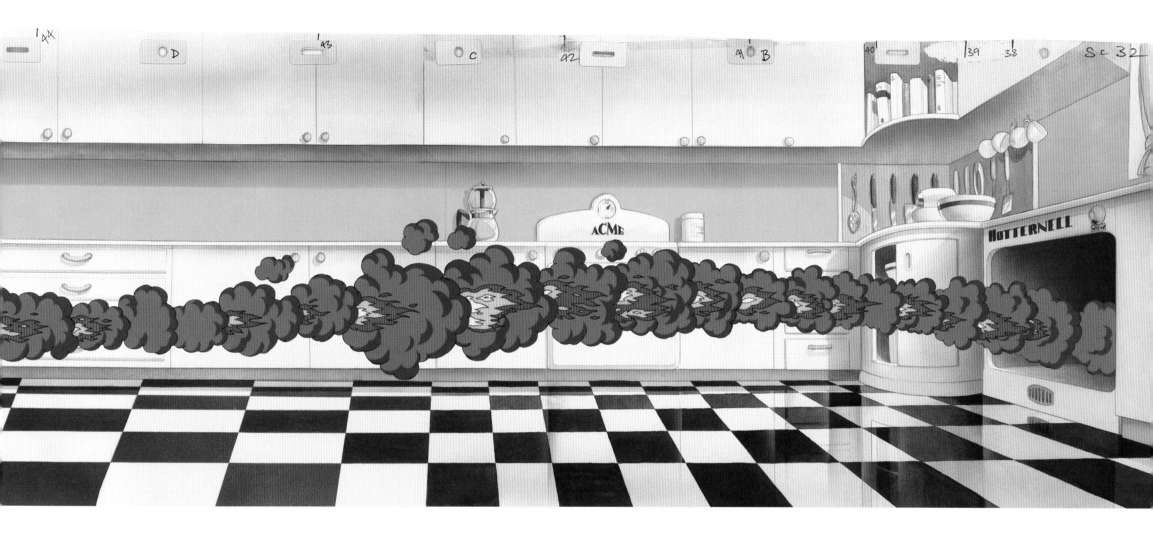

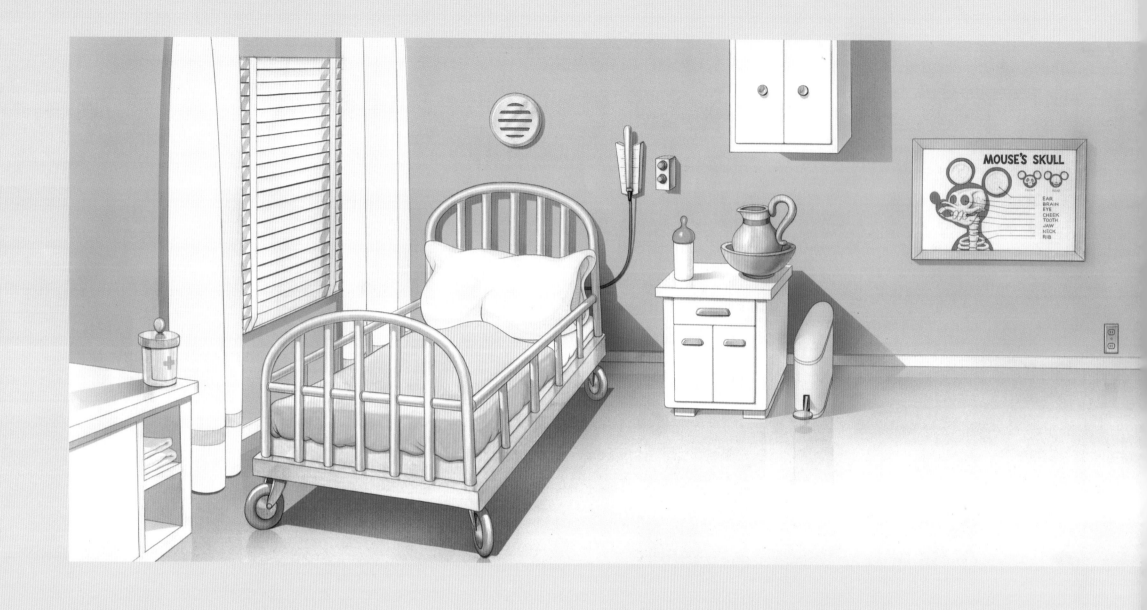

TUMMY TROUBLE 1989

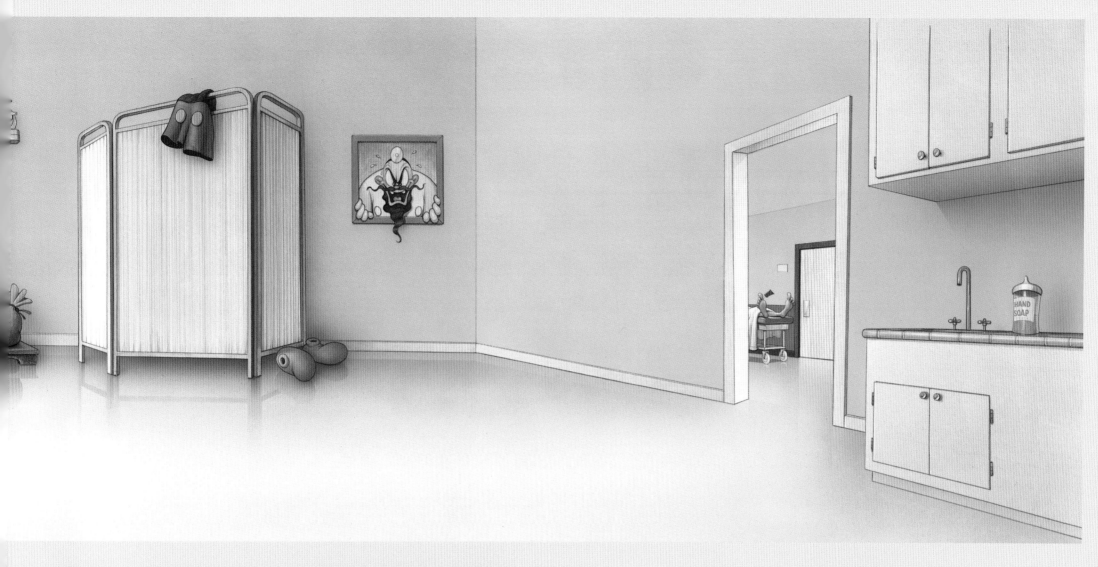

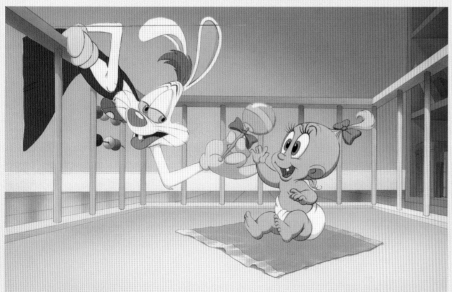

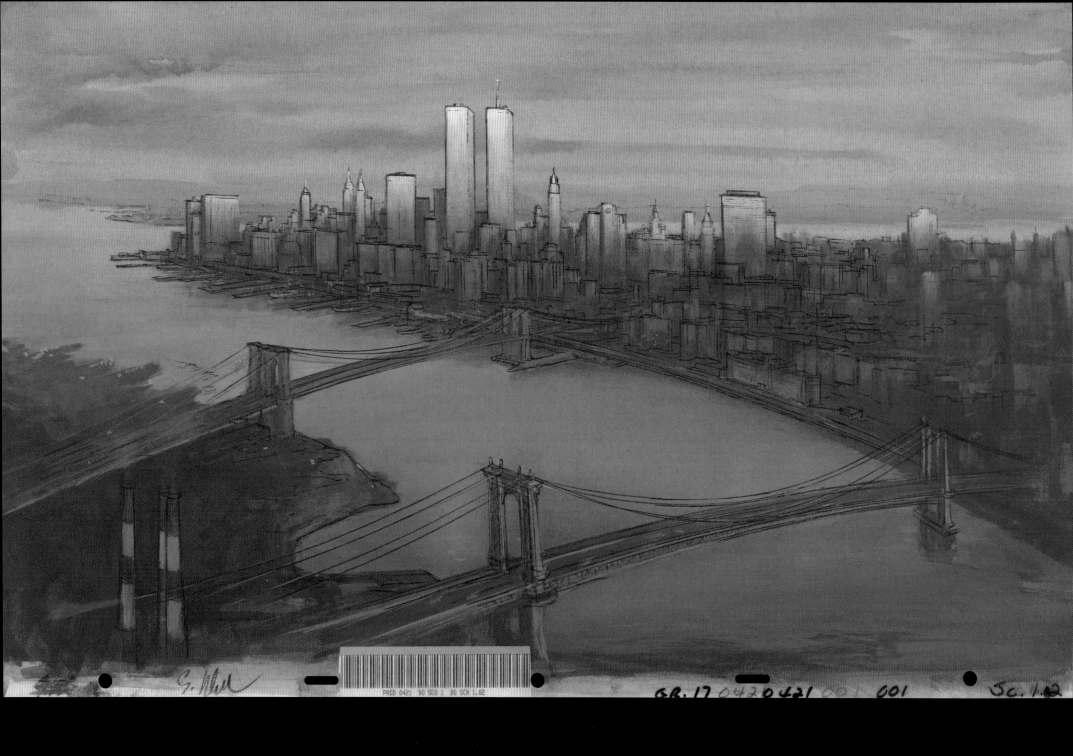

OLIVER & COMPANY 1988

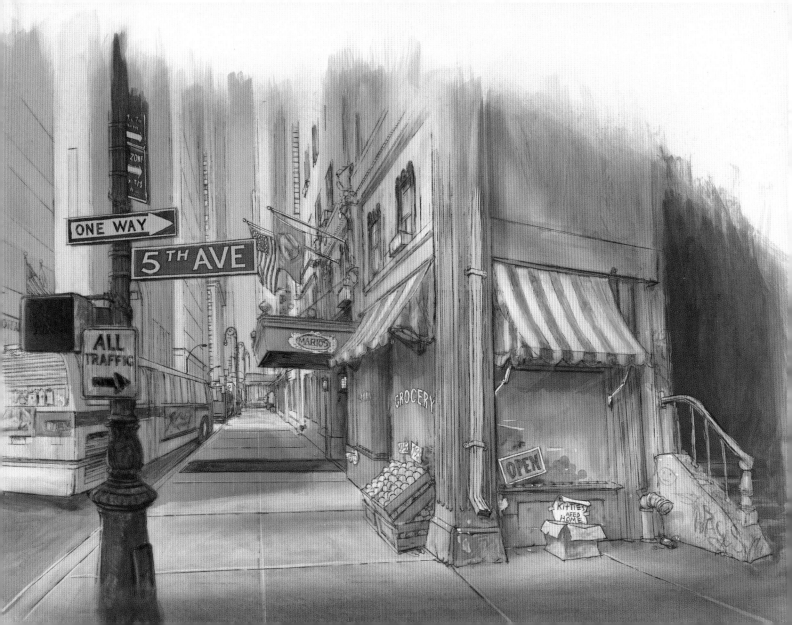

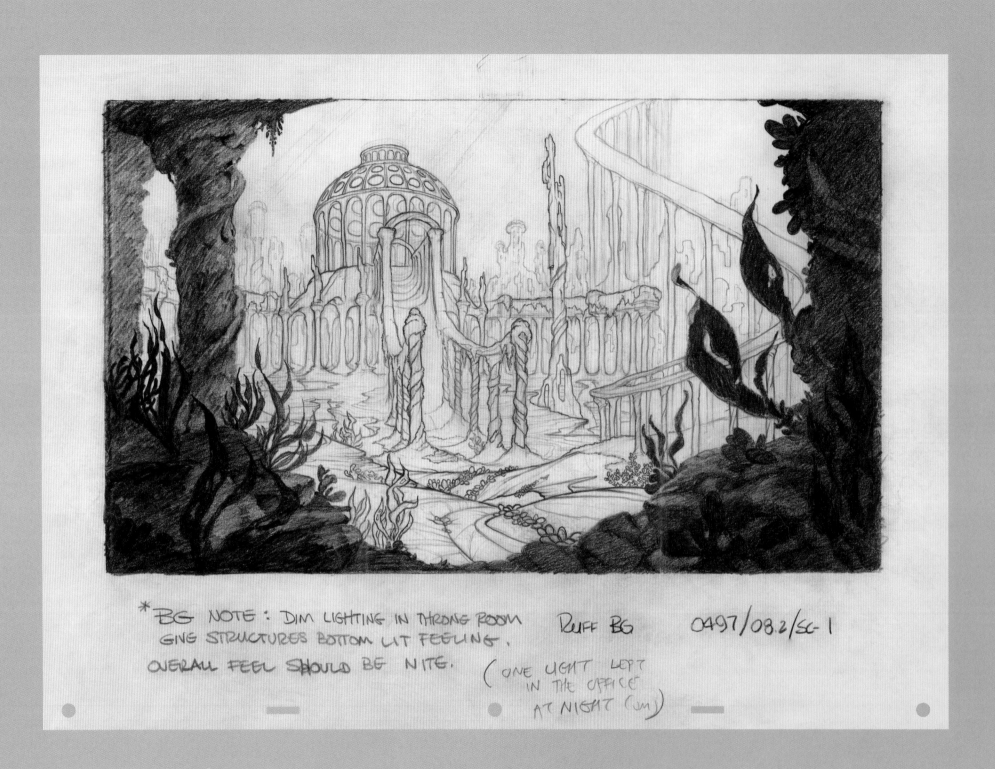

THE LITTLE MERMAID 1989

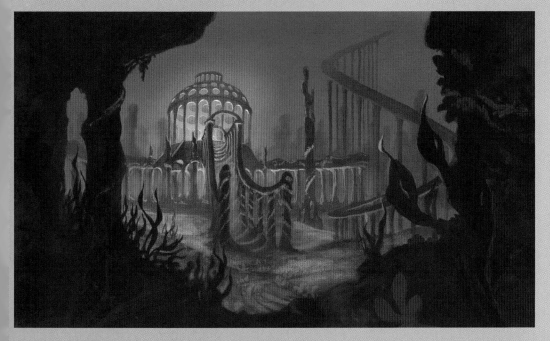
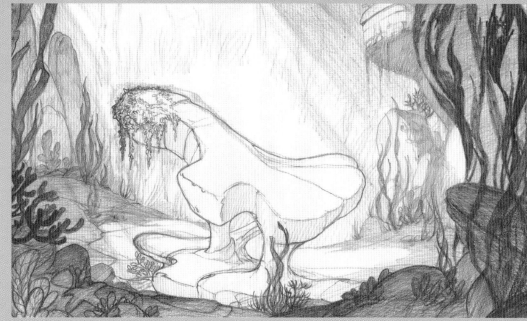
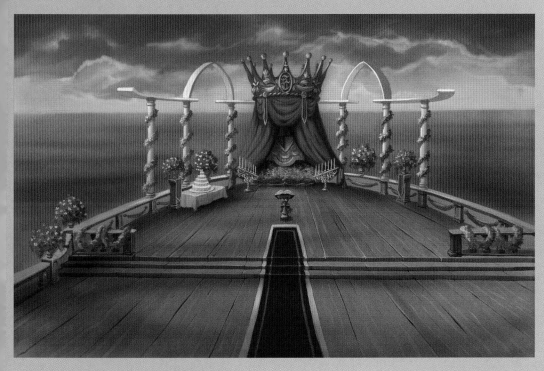
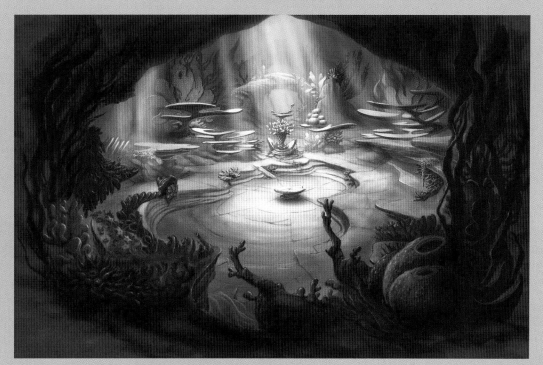

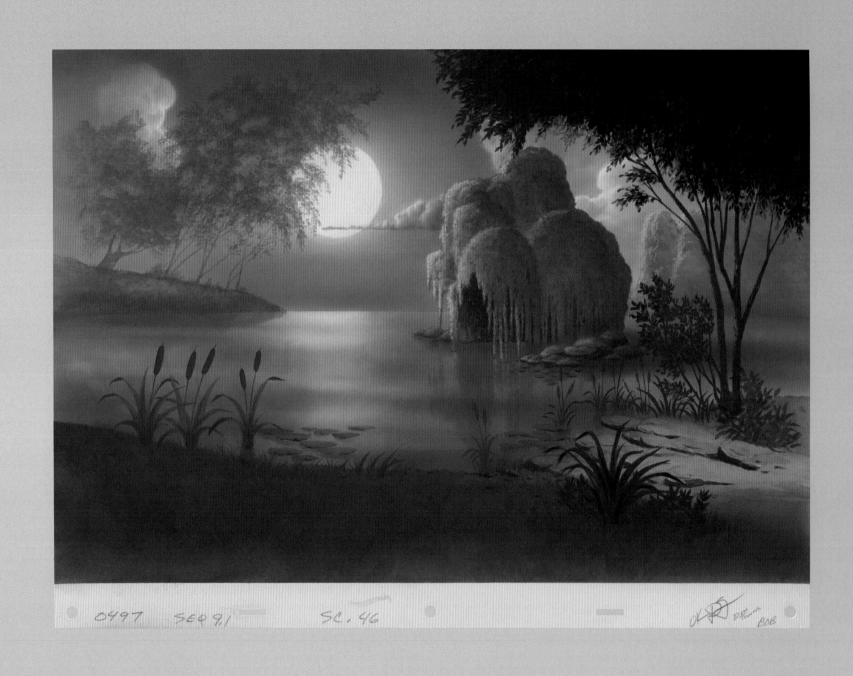

0497 SEQ 9.1 SC. 46

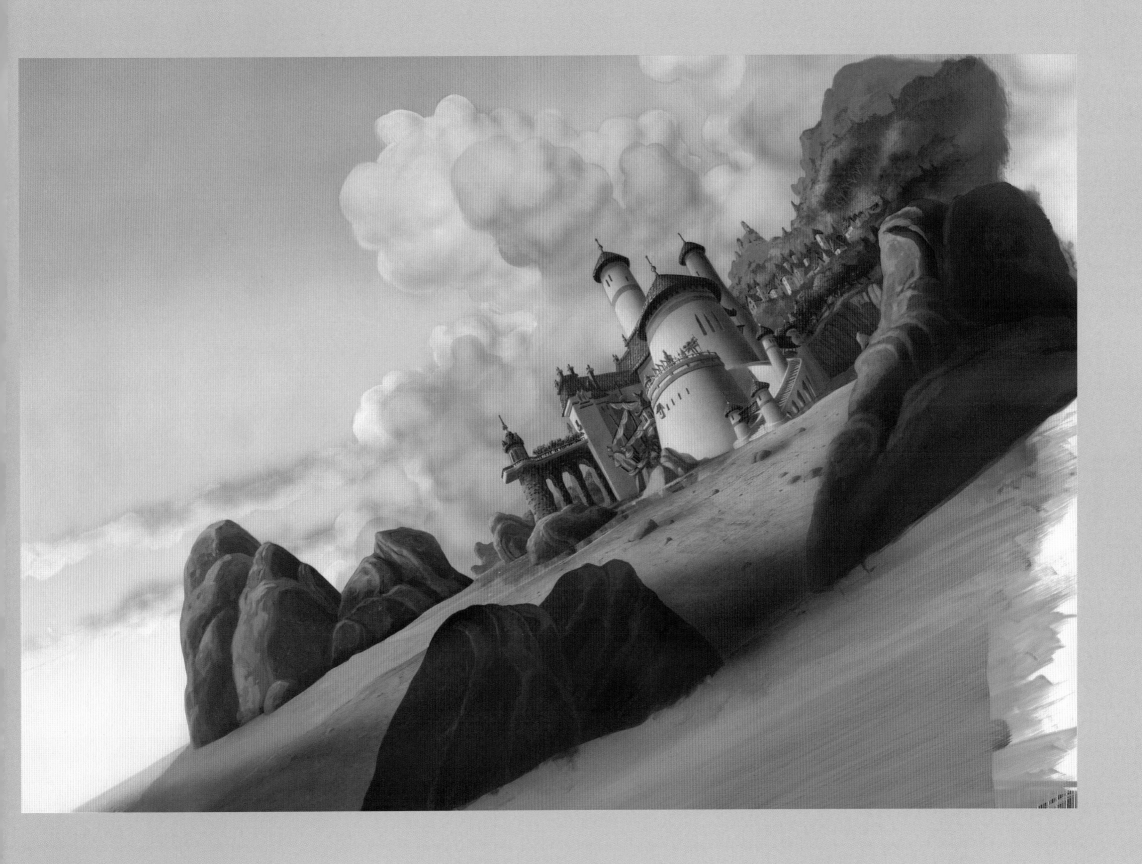

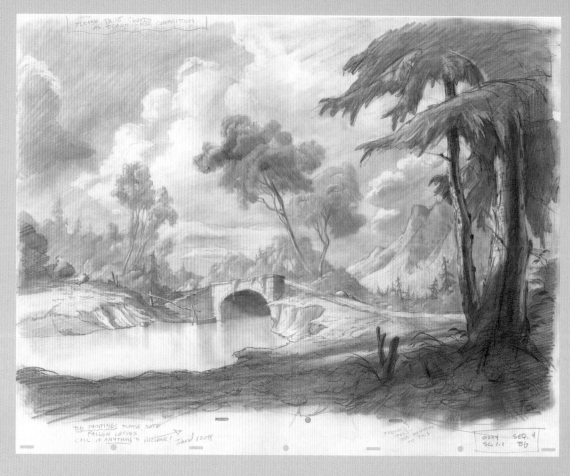

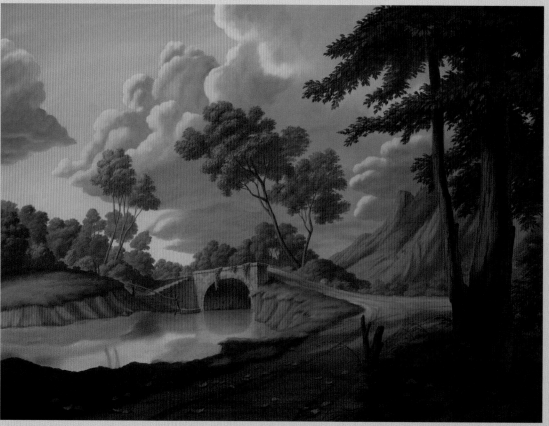

BEAUTY AND THE BEAST 1991

LAYOUT & BACKGROUND

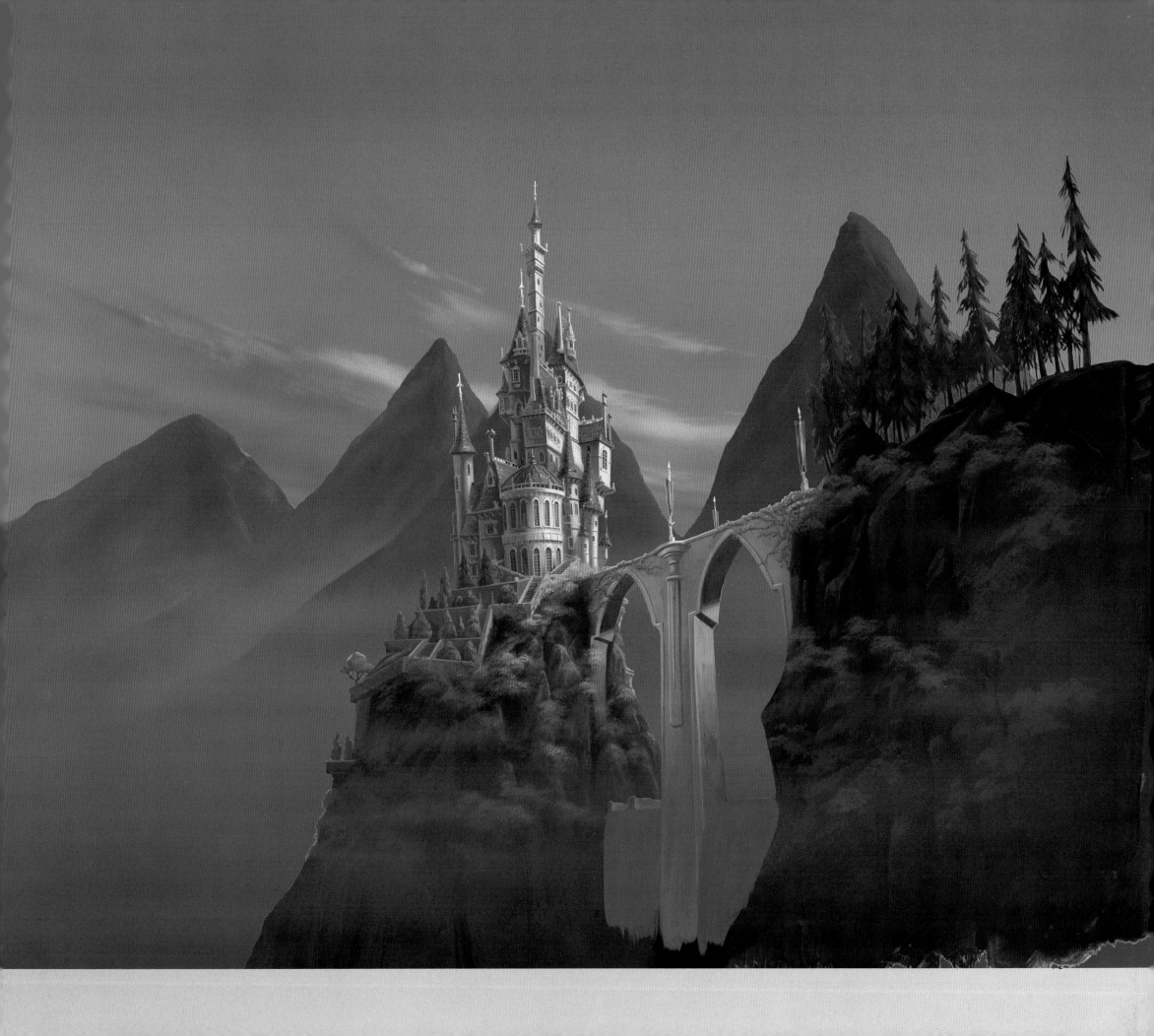

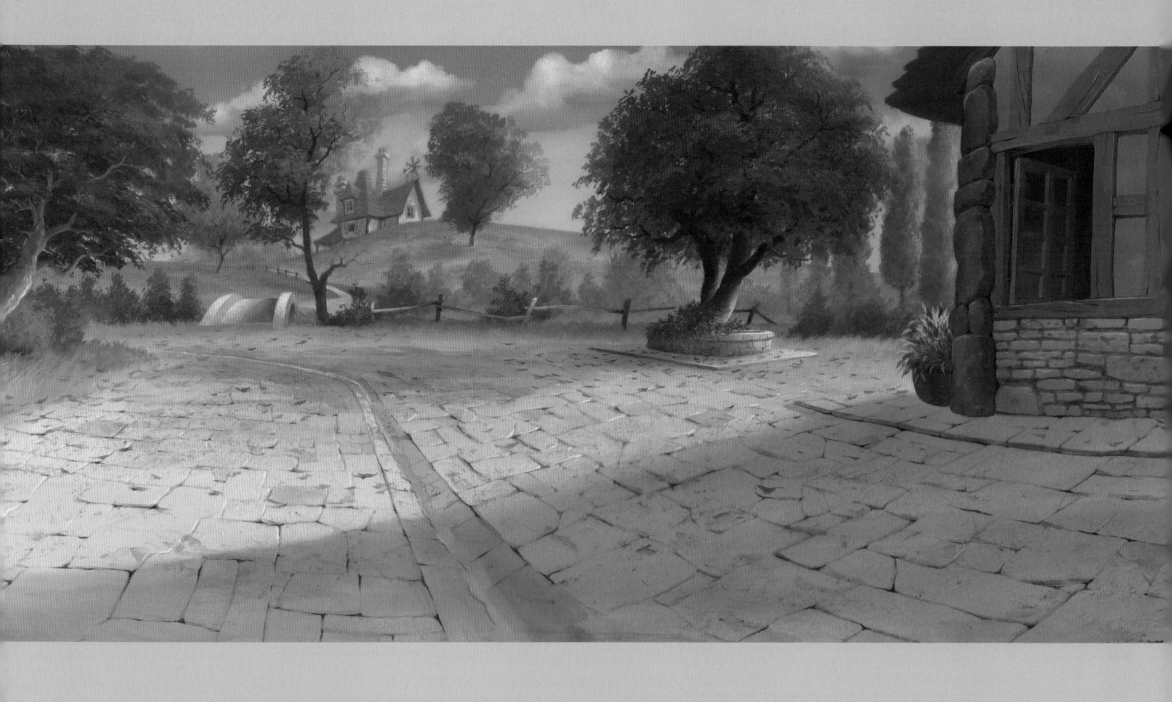

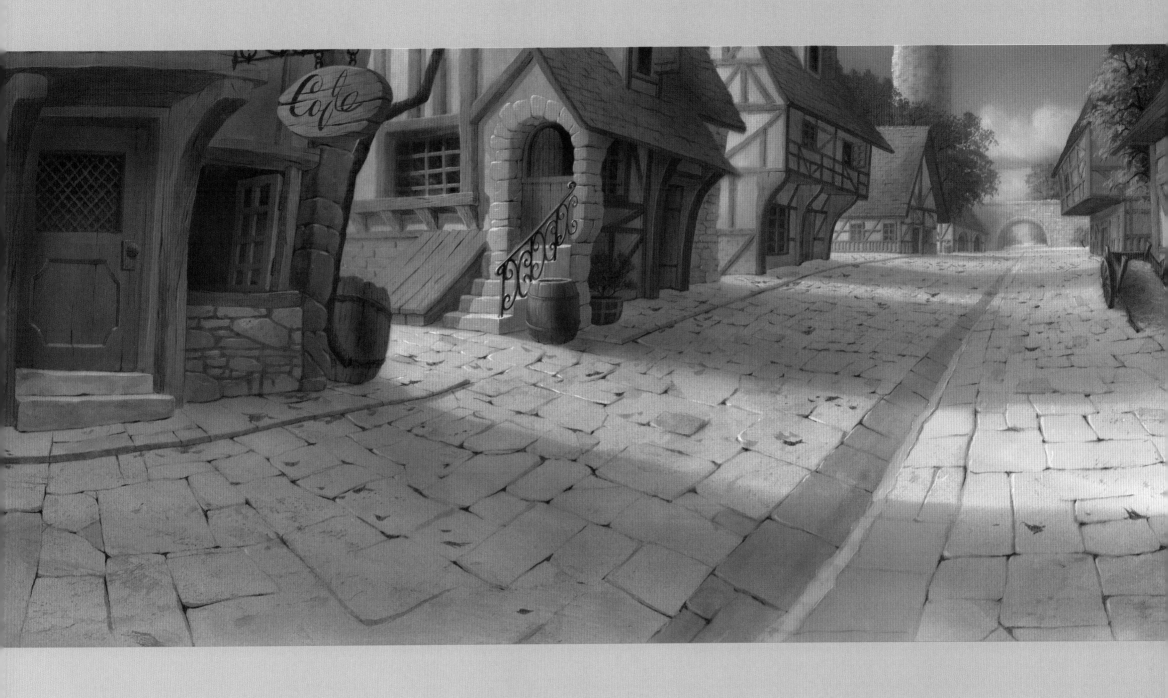

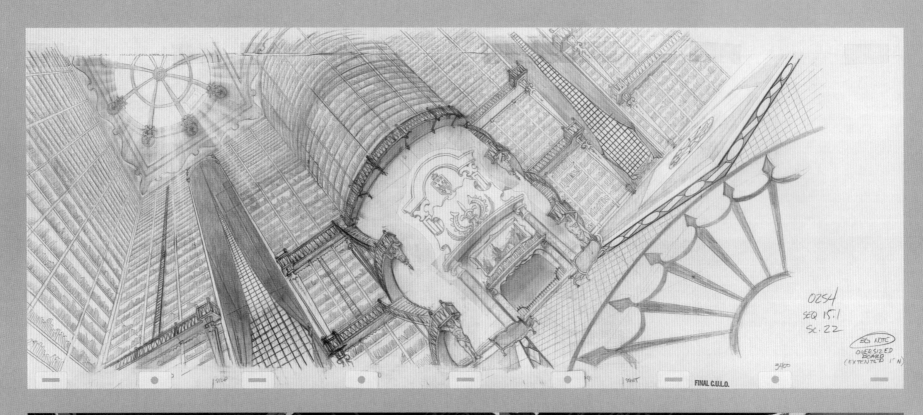

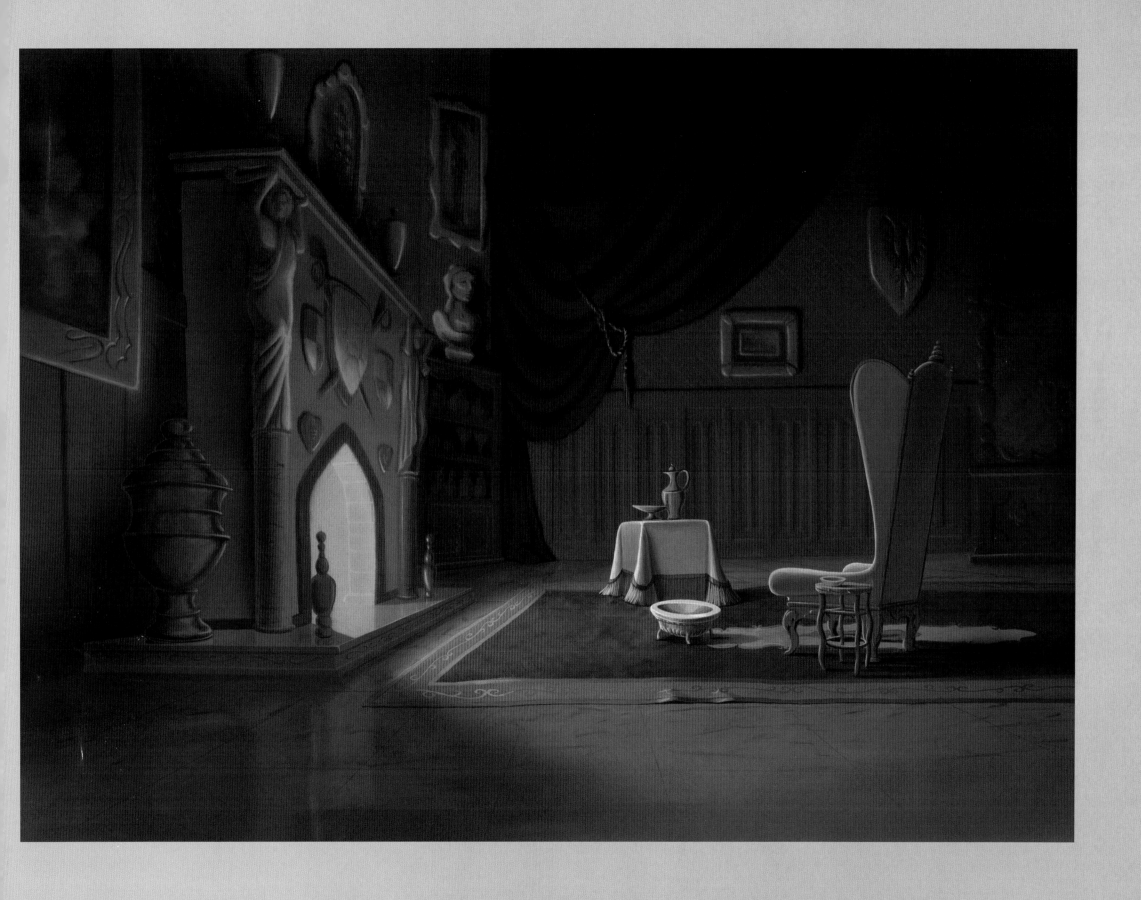

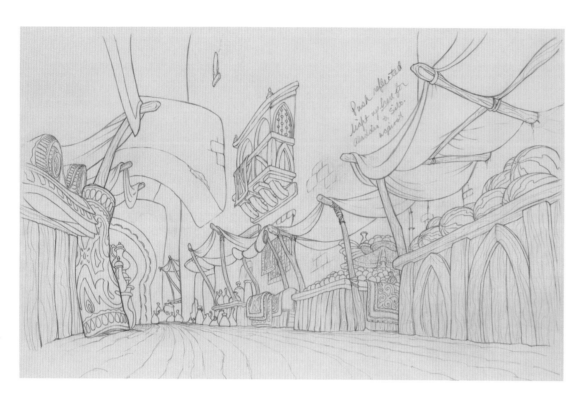
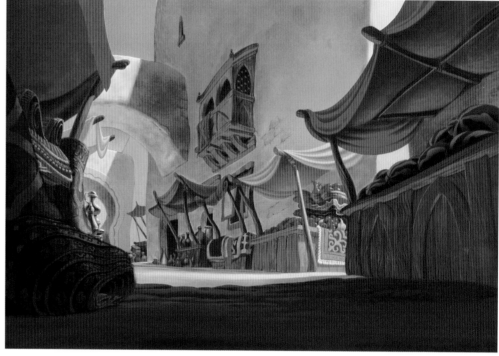

ALADDIN 1992

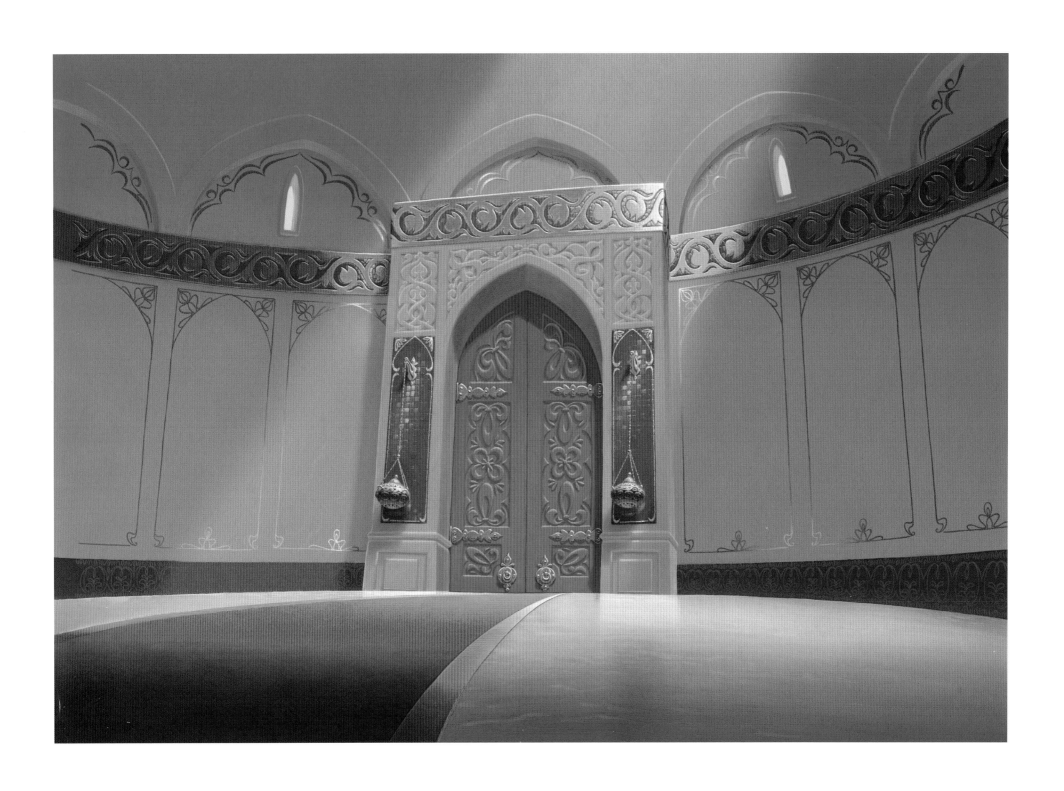

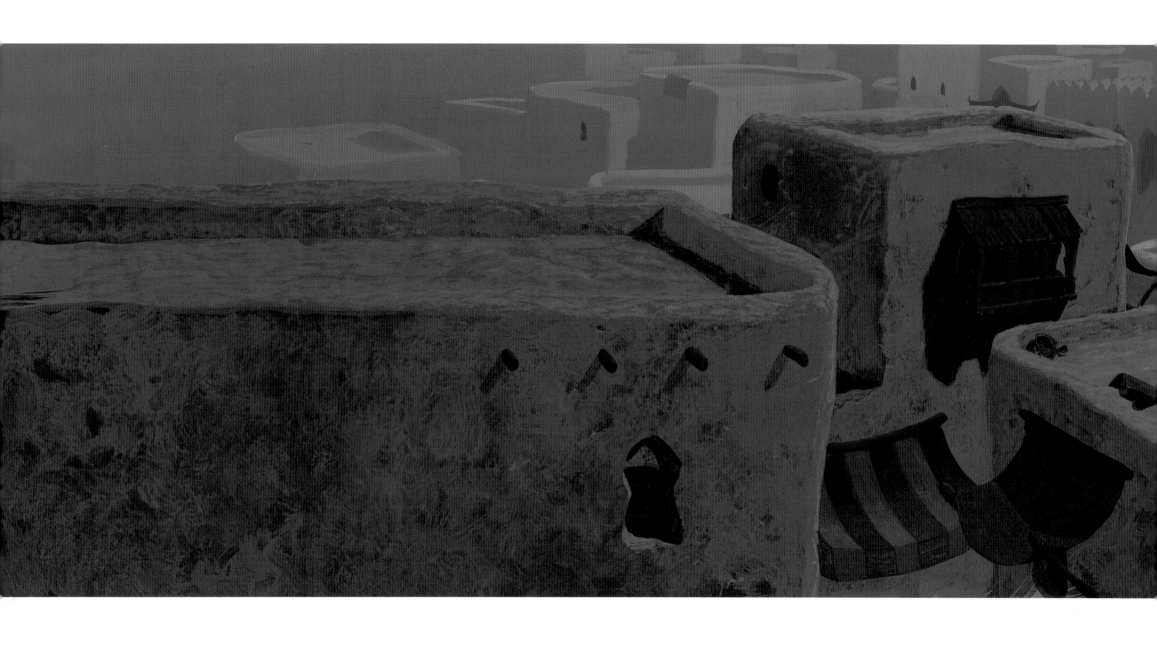

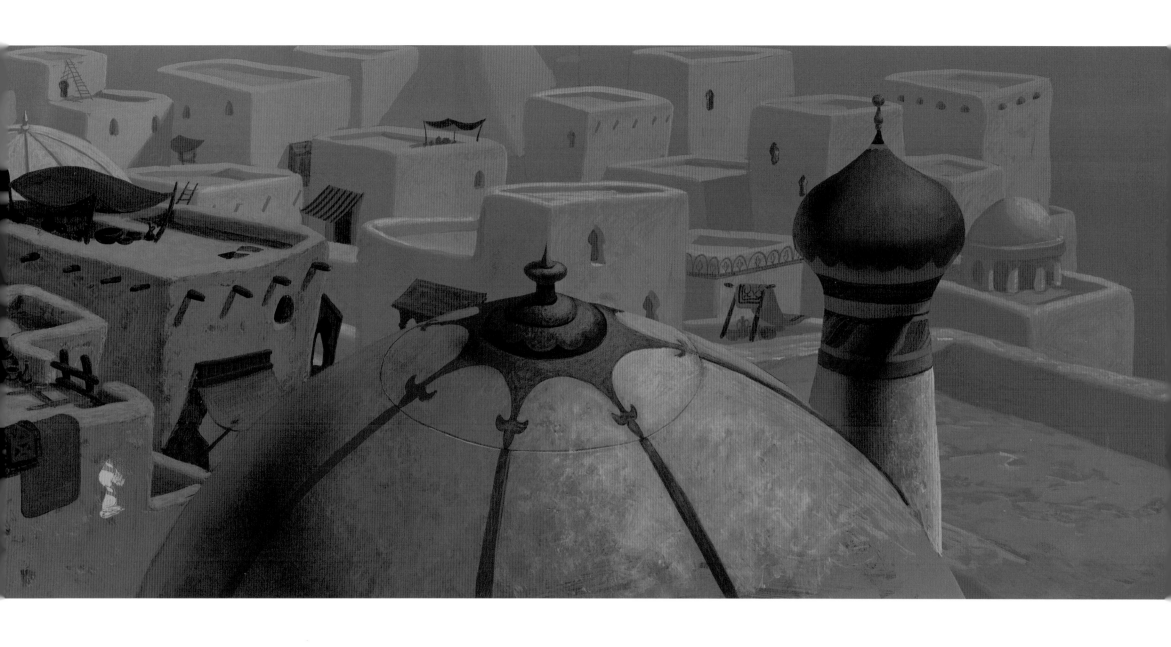

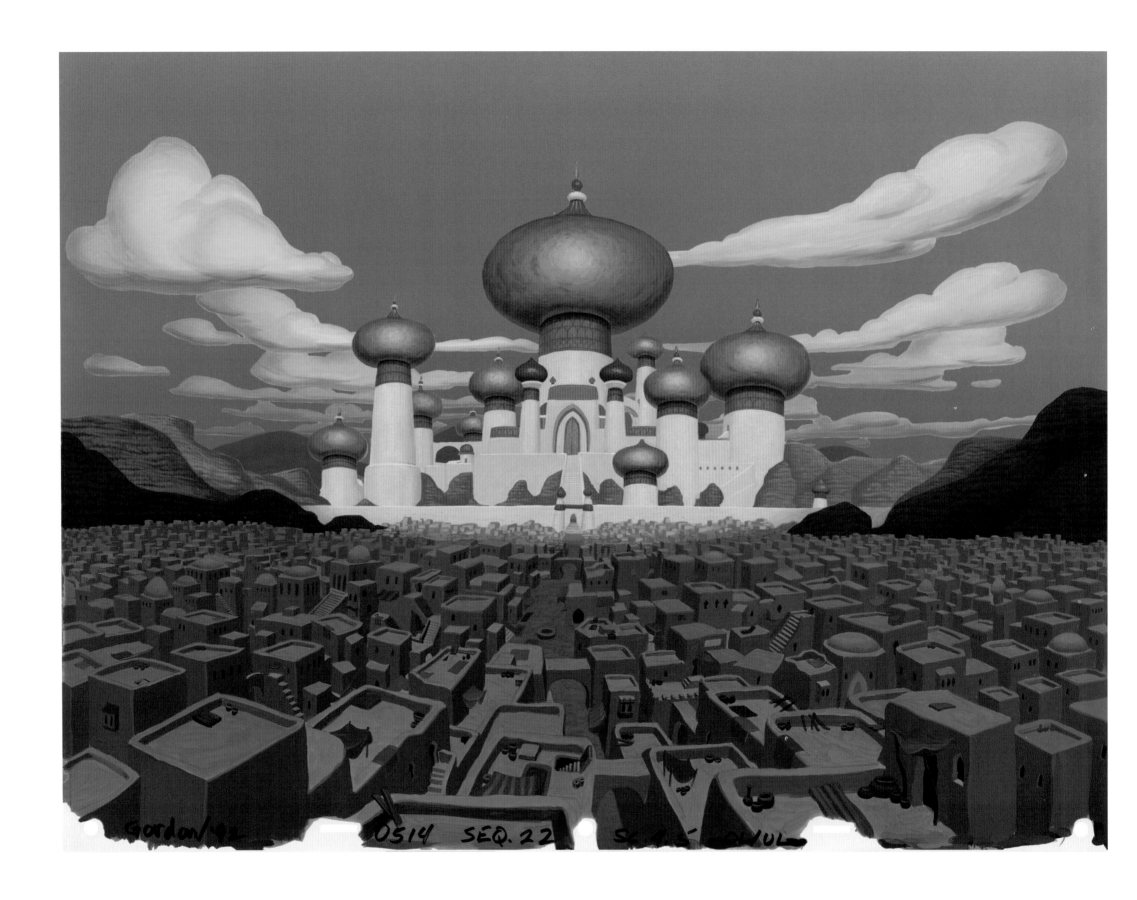

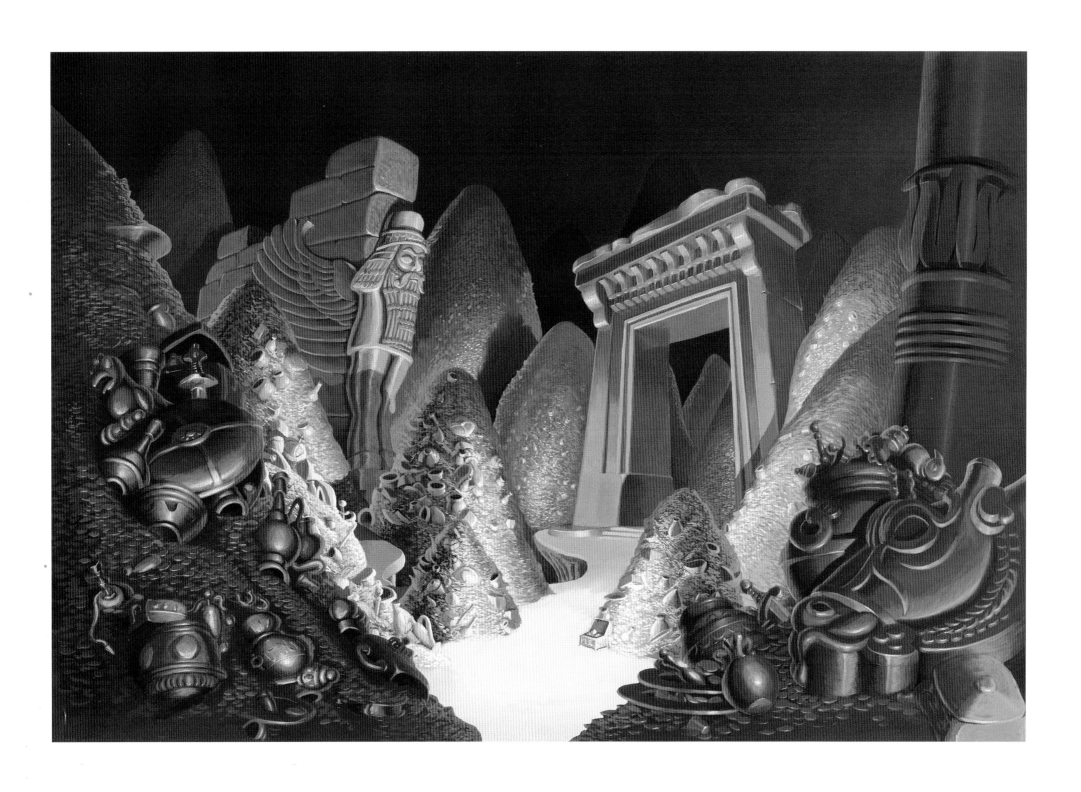

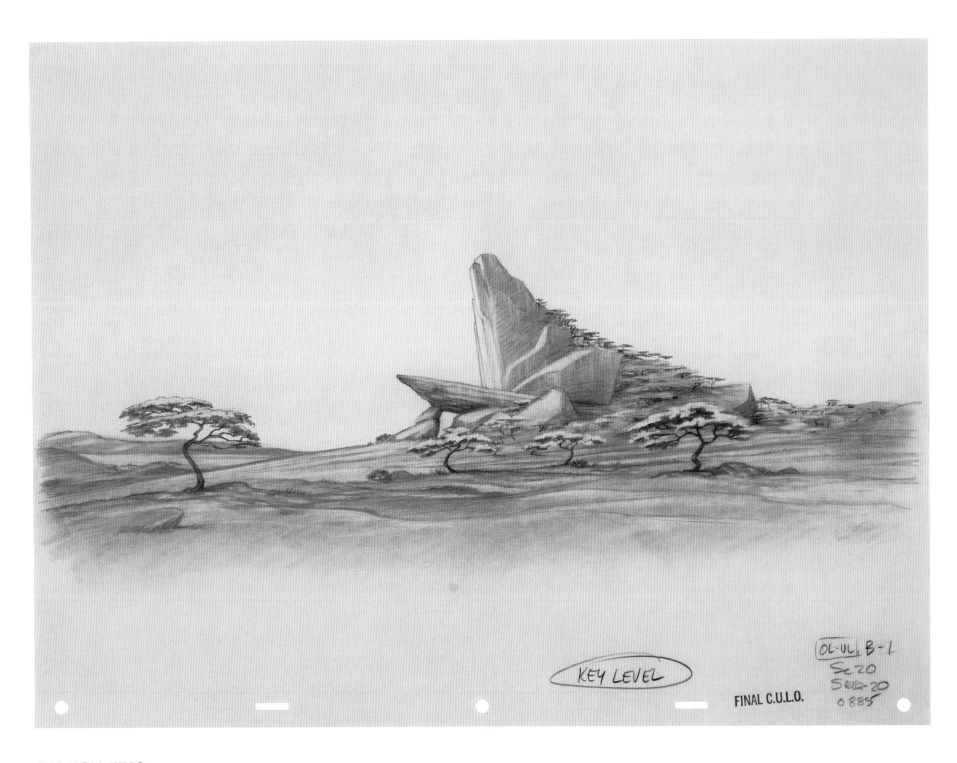

KEY LEVEL

FINAL C.U.L.O.

OL·UL, B-L
Sc20
SEG-20
0885

THE LION KING 1994

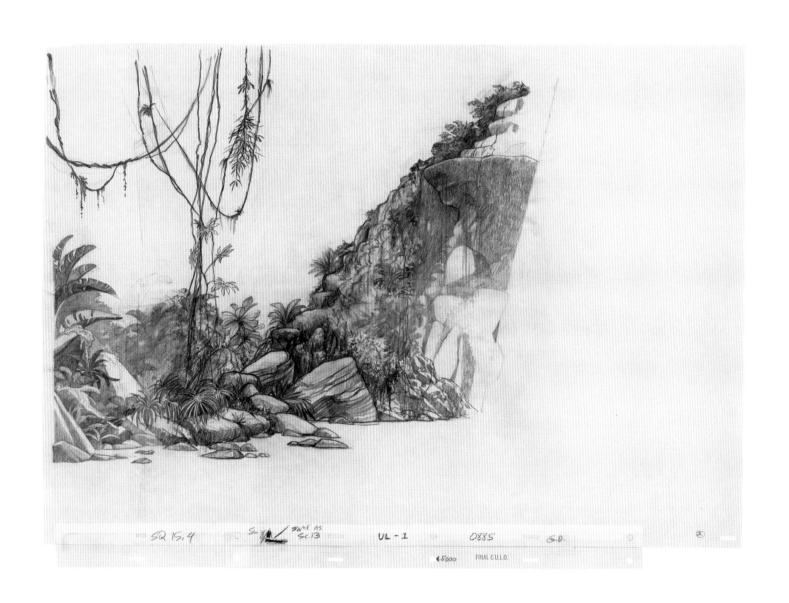

SQ 15.4 SAME AS UL - 1 0885 G.D.
 SC.13
 5000 FINAL C.U.L.O.

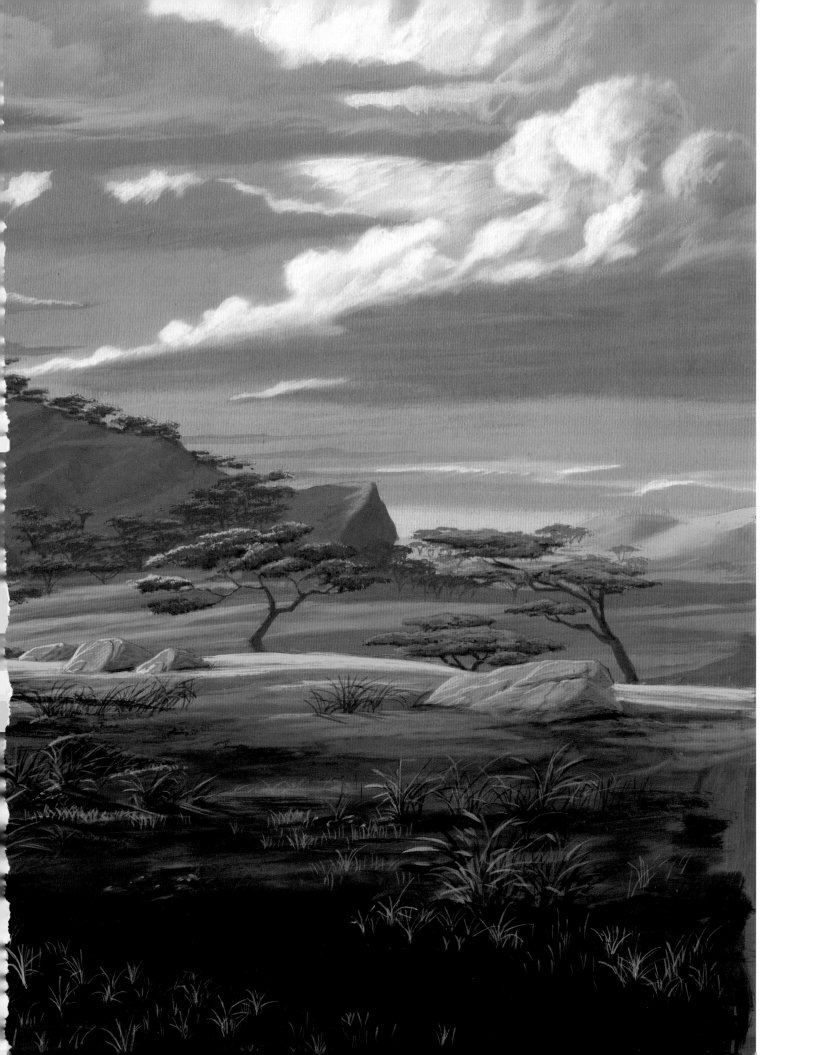

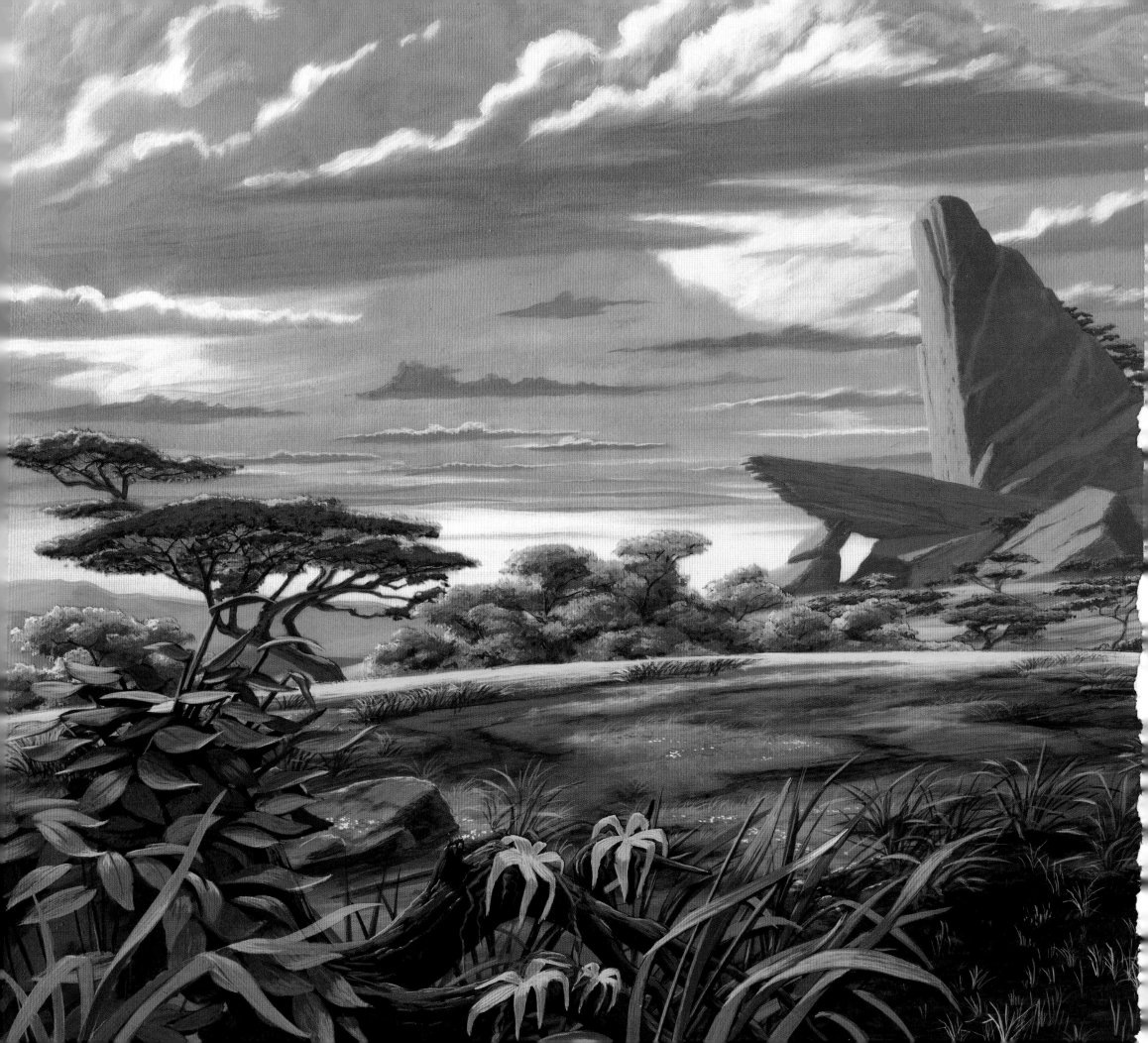

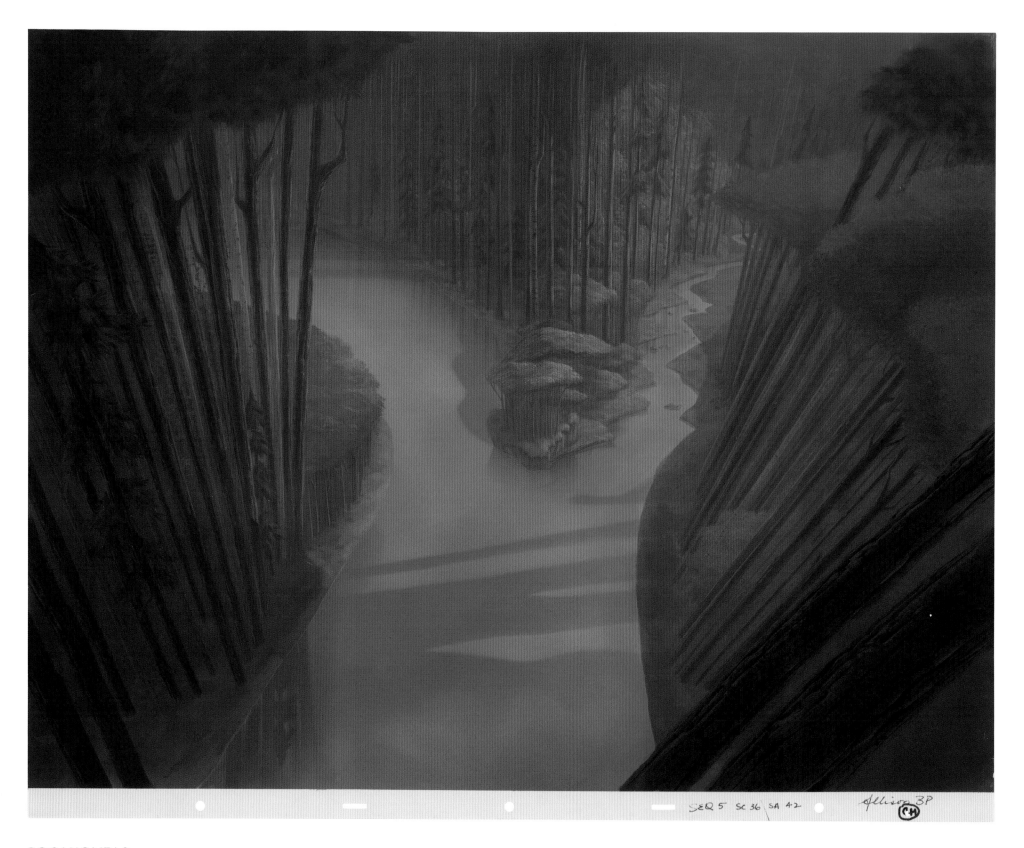

SEQ 5 SC 36 SA 42

POCAHONTAS 1995

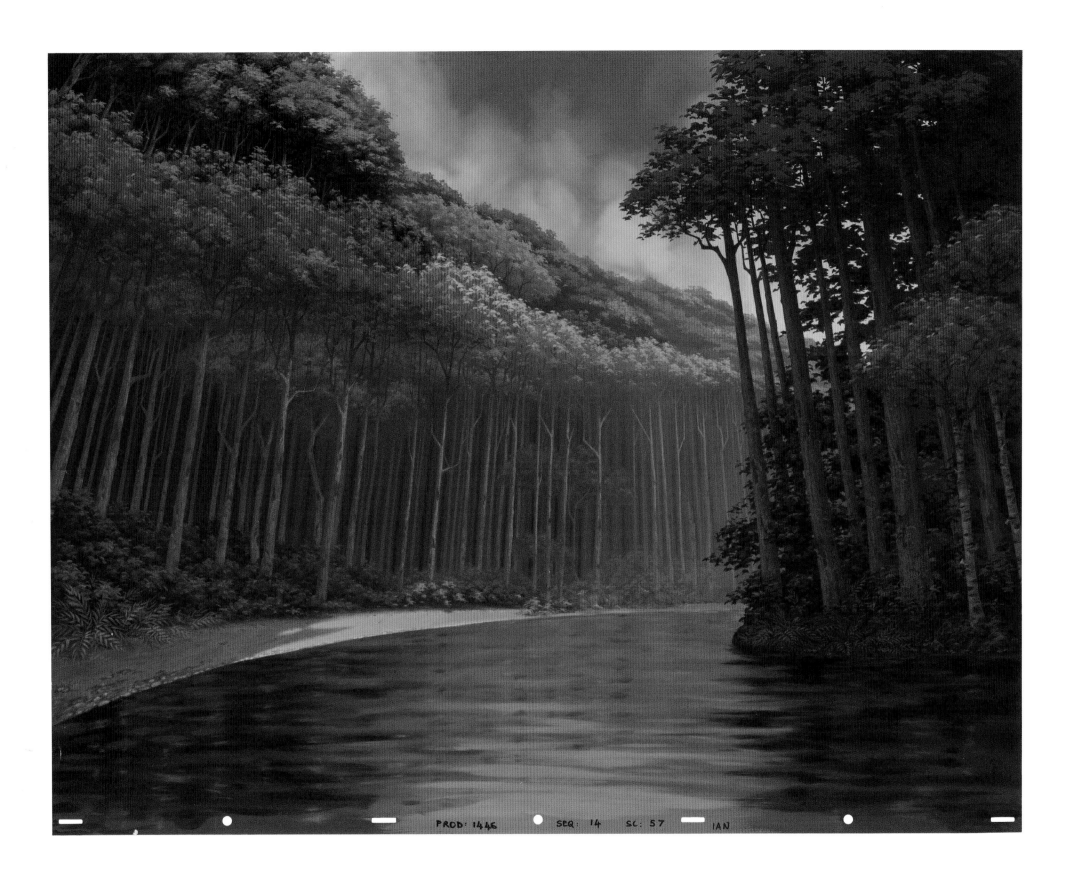

PROD: 1446 SEQ: 14 SC: 57 IAN

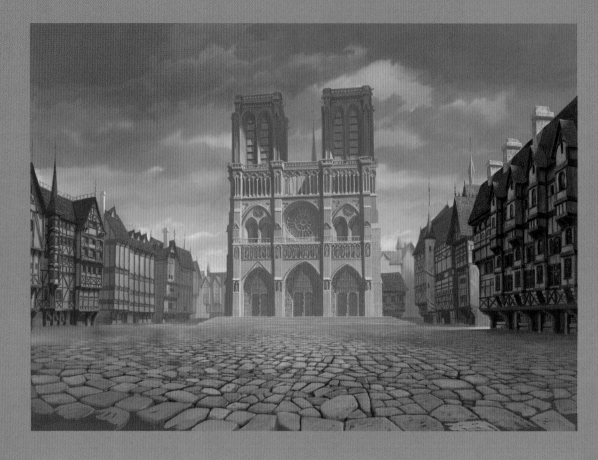

THE HUNCHBACK OF NOTRE DAME 1996

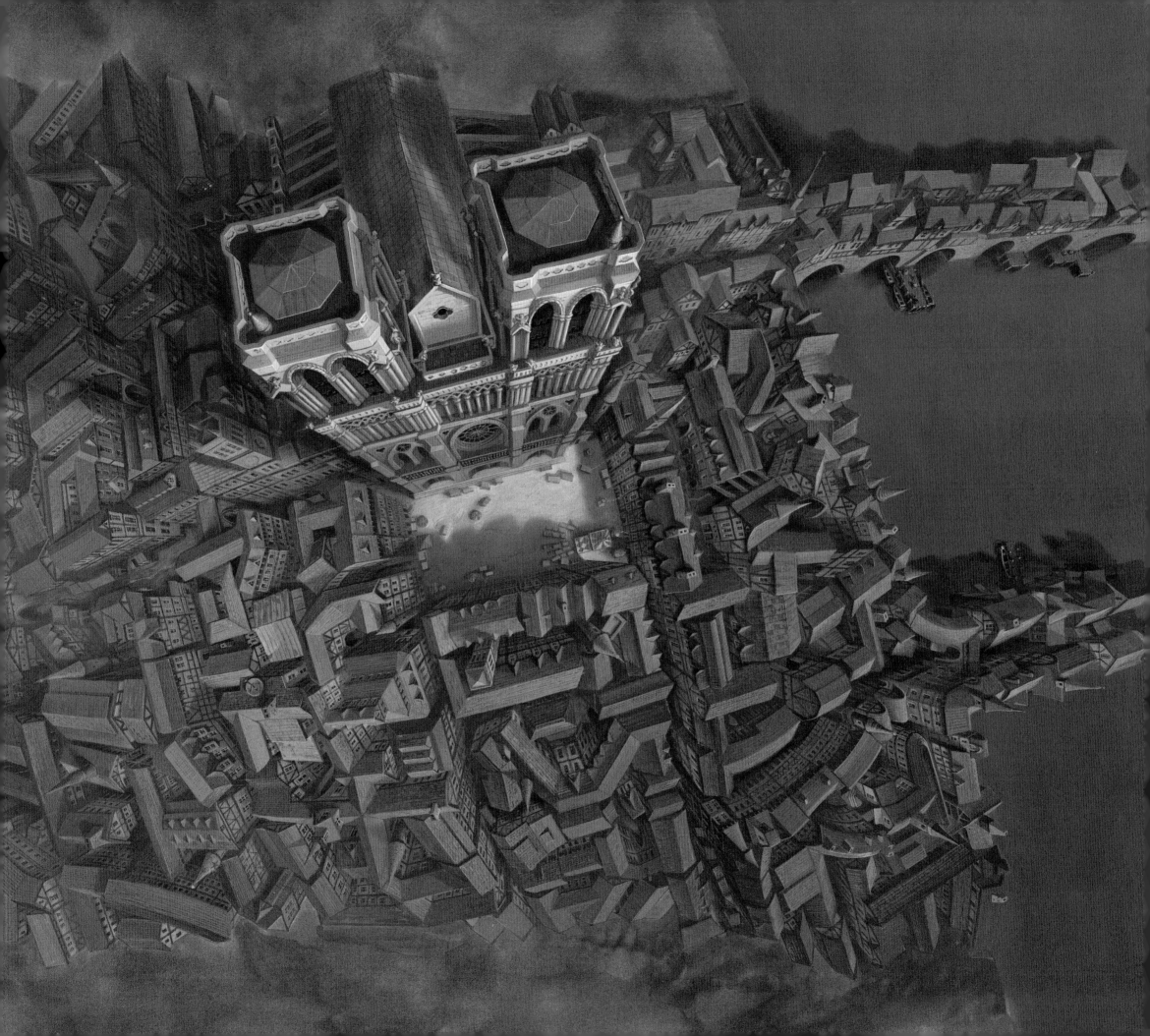

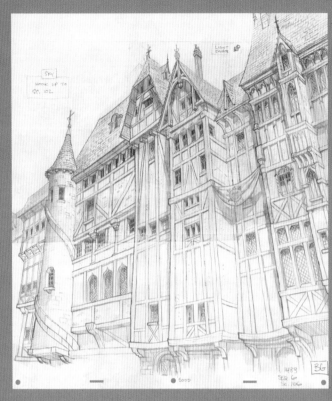

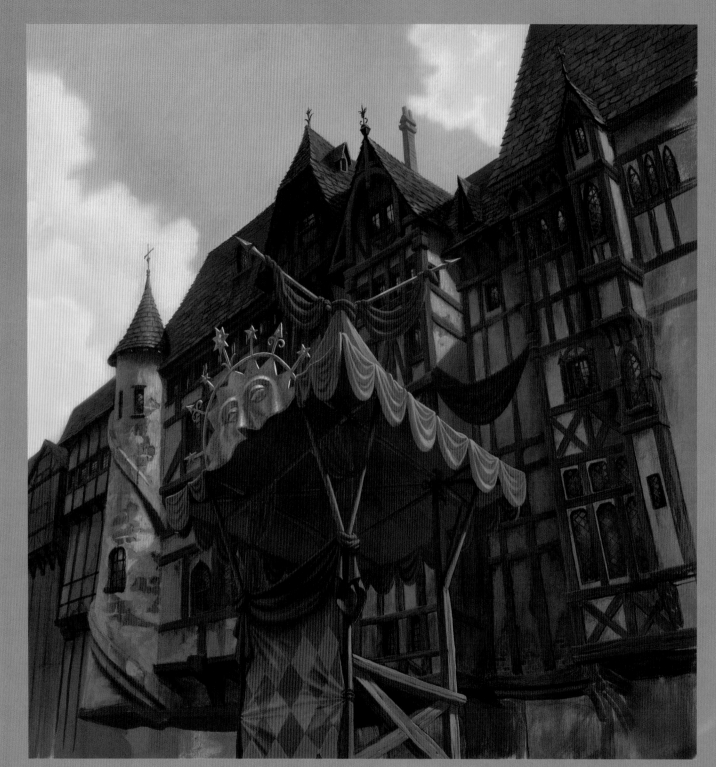

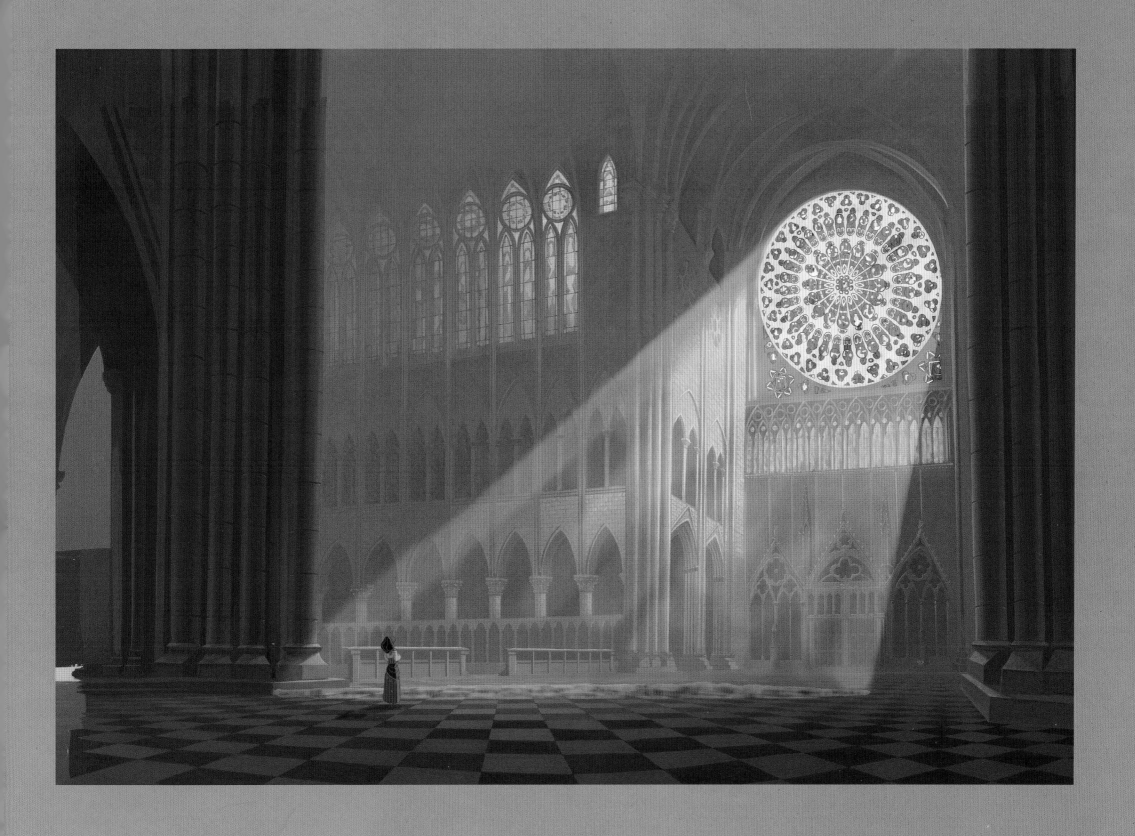

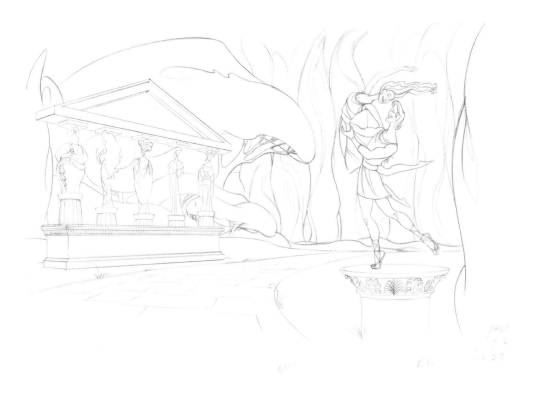

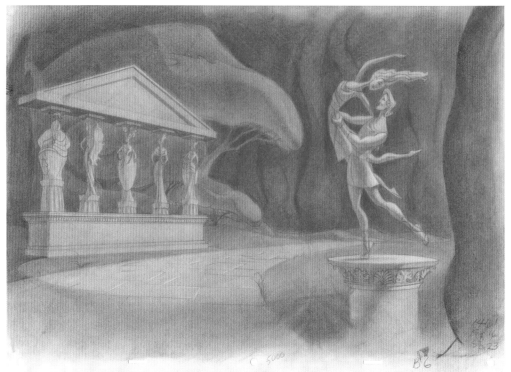

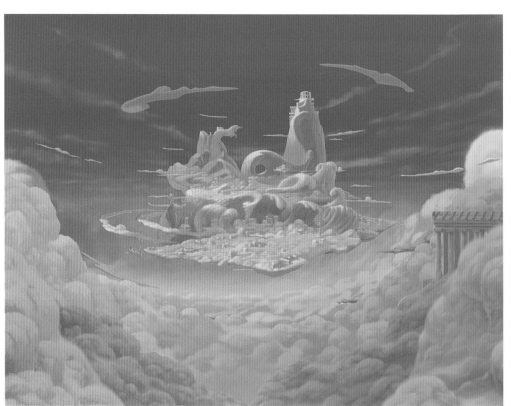

HERCULES 1997

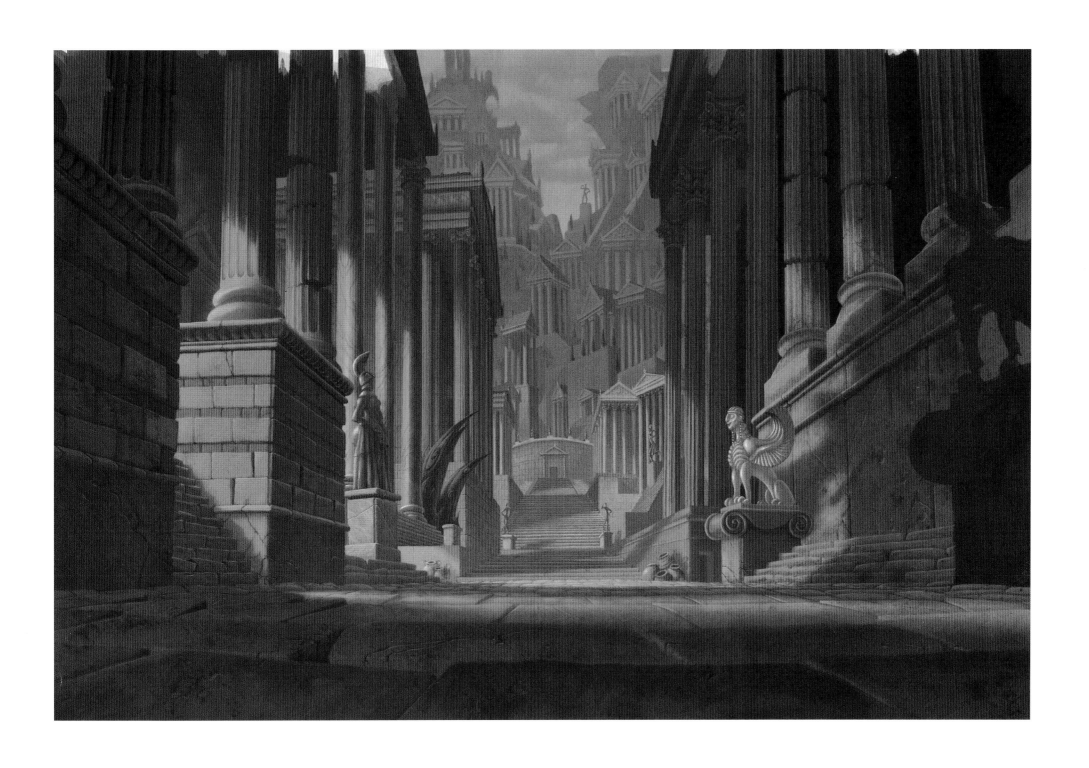

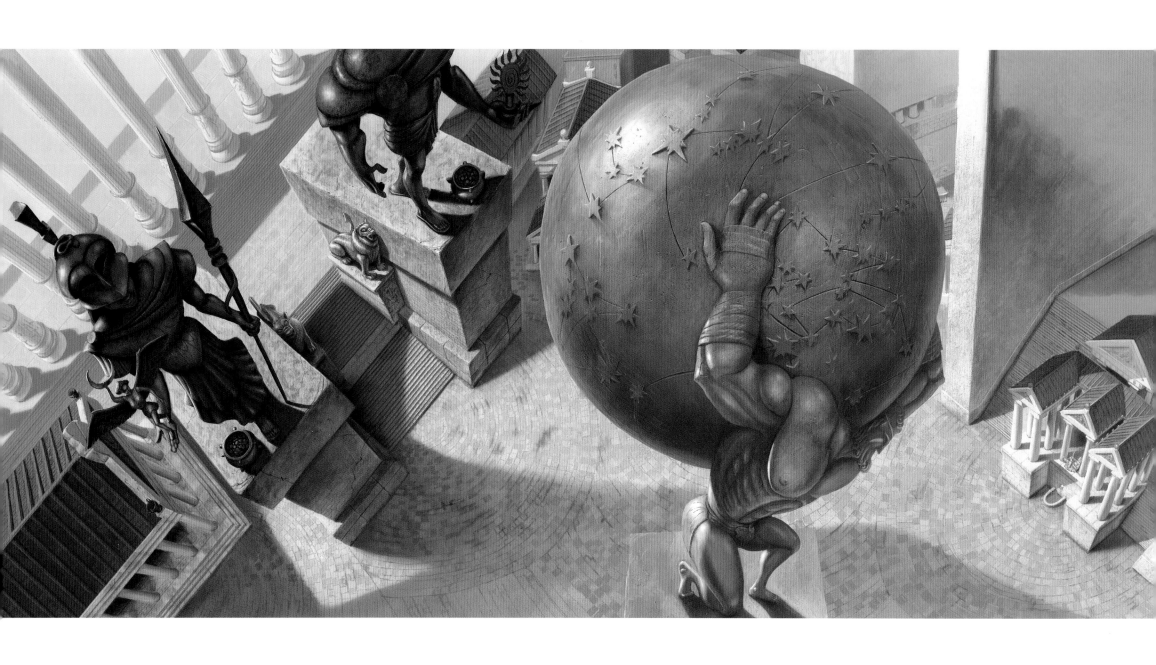

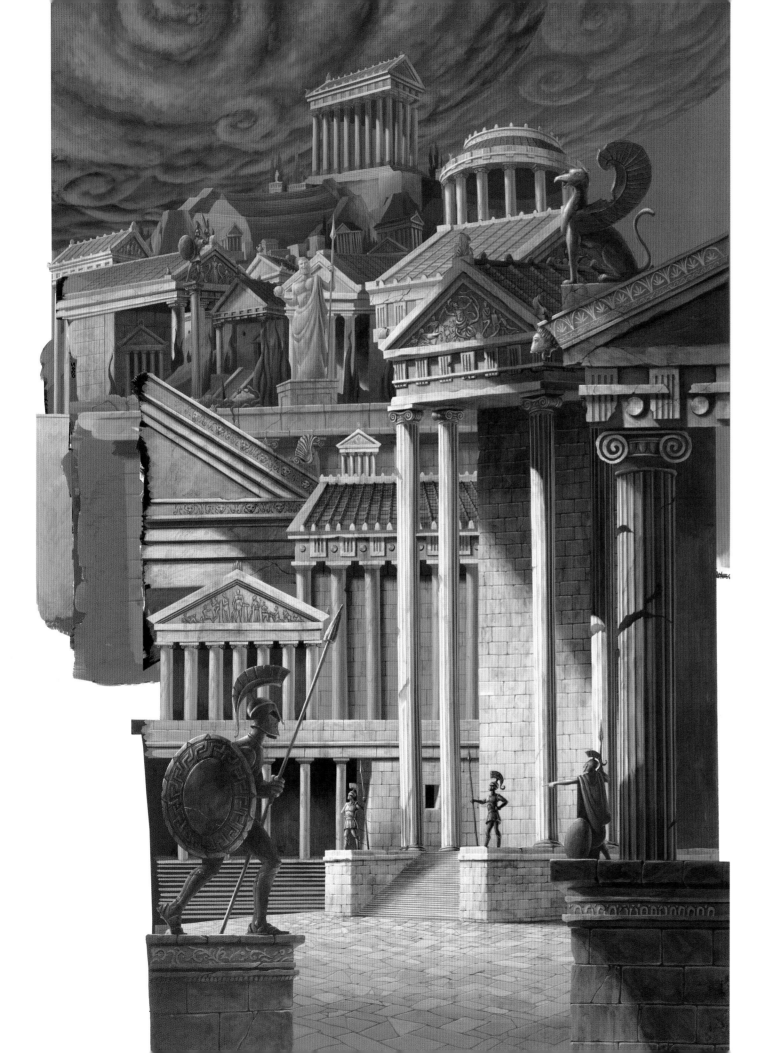

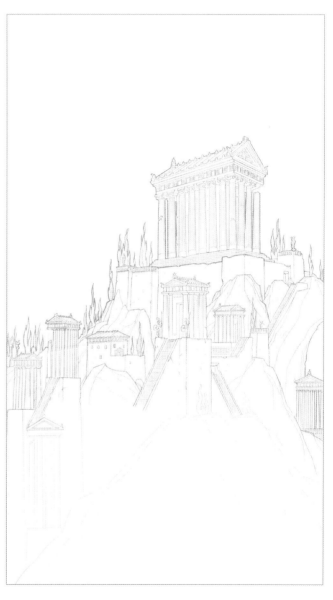

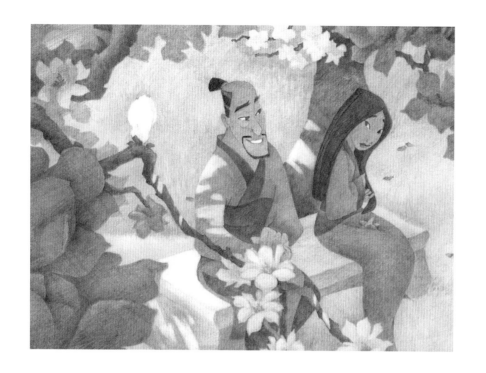
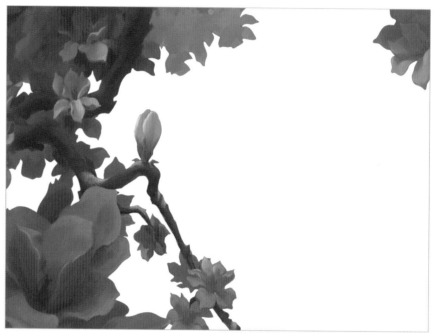
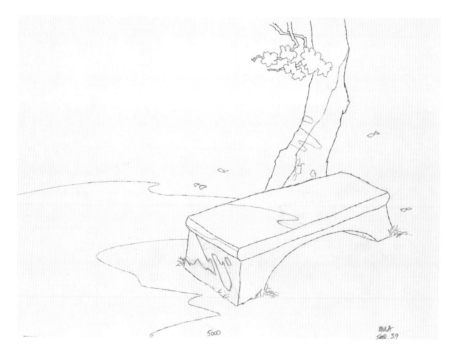
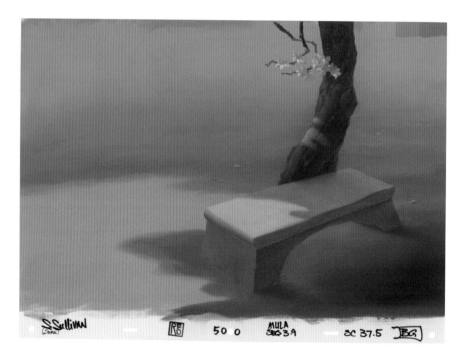

MULAN 1998

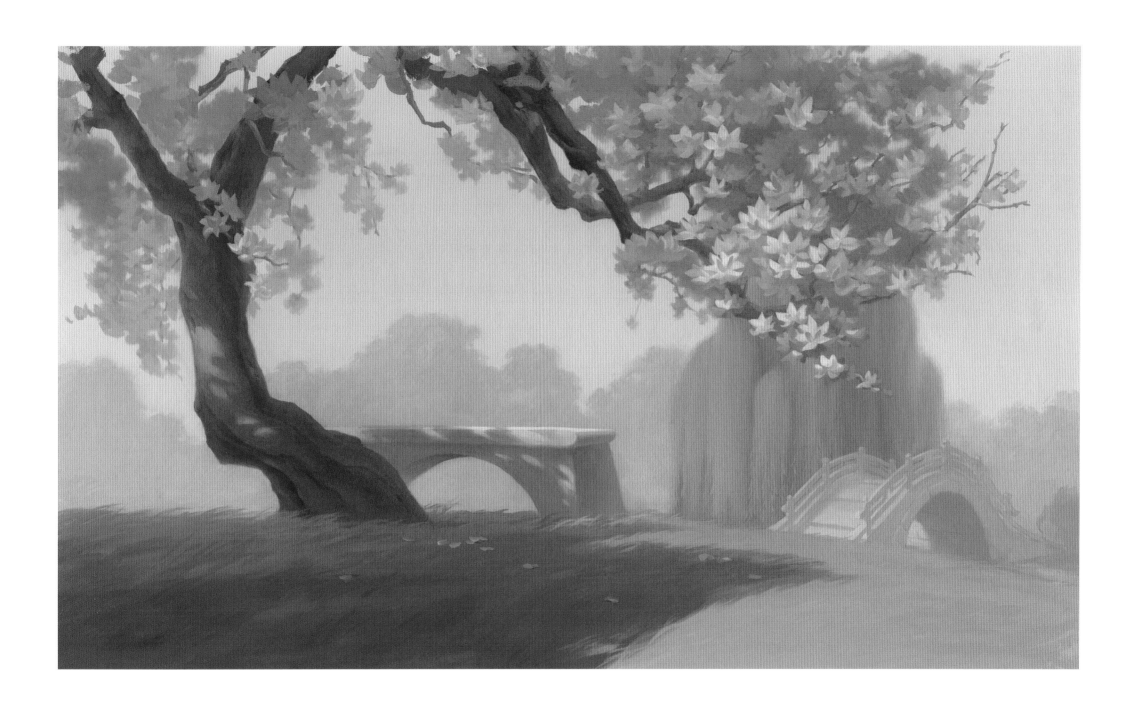

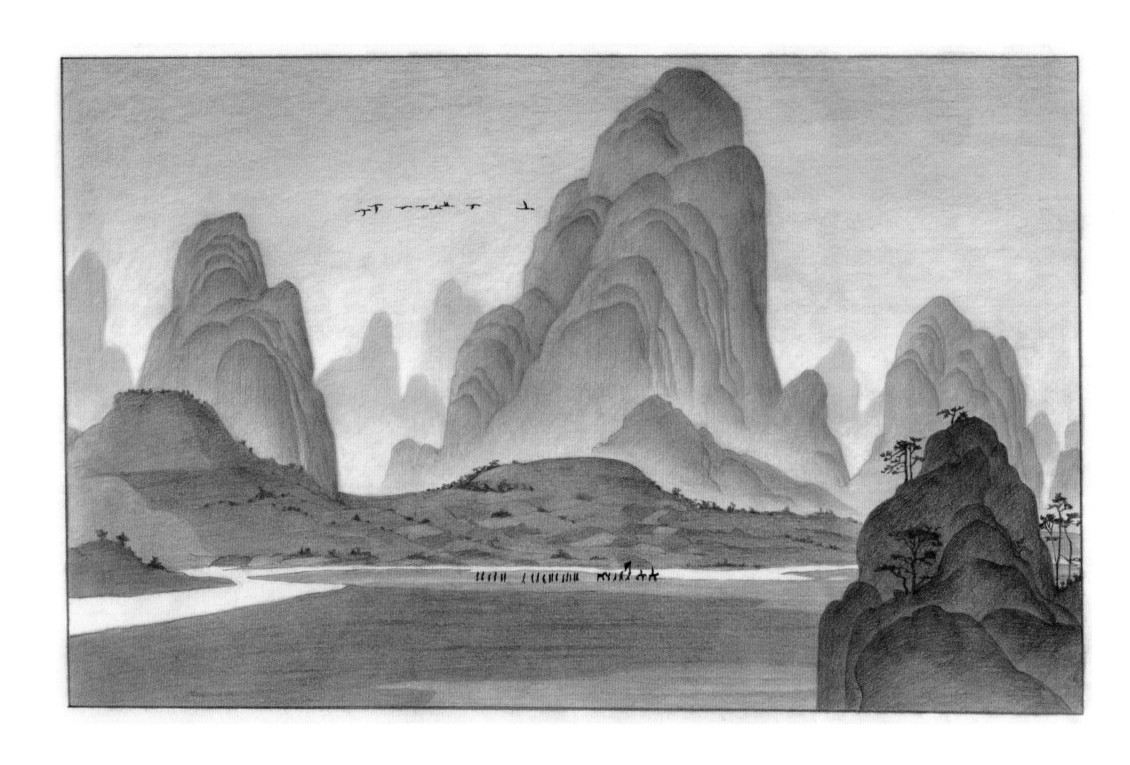

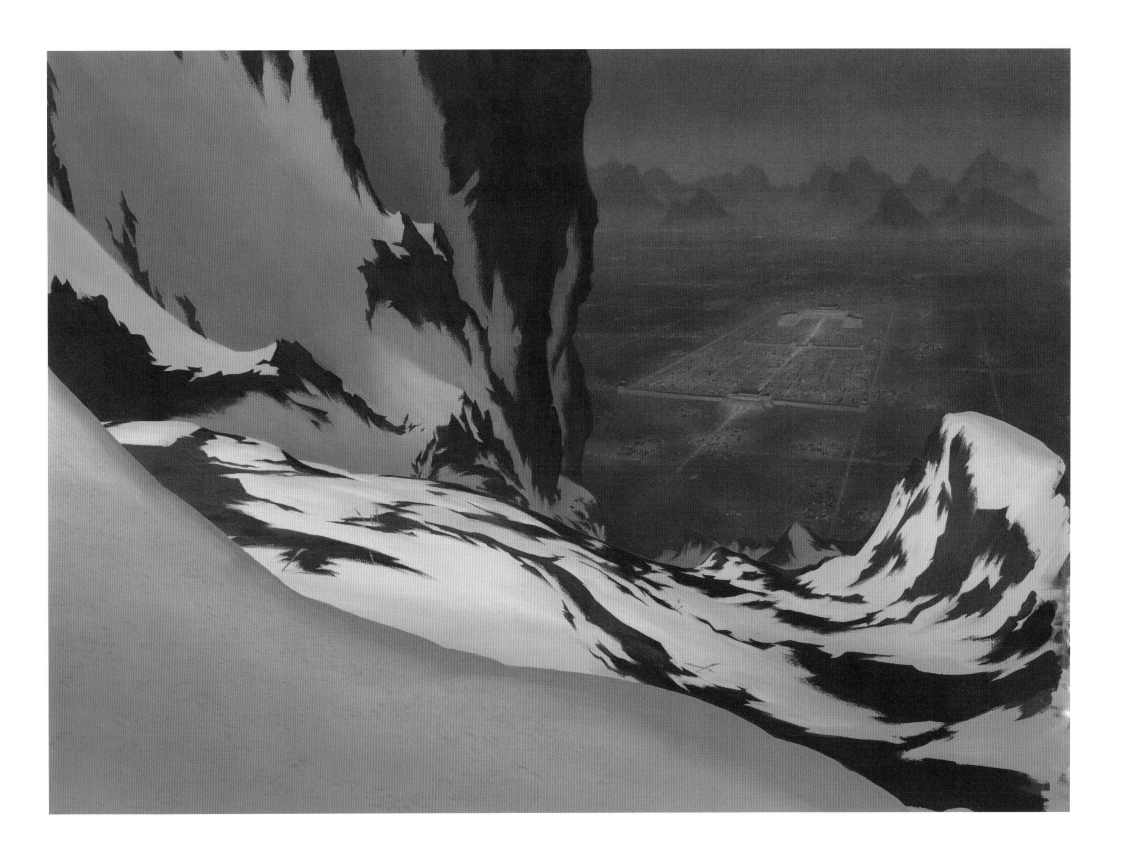

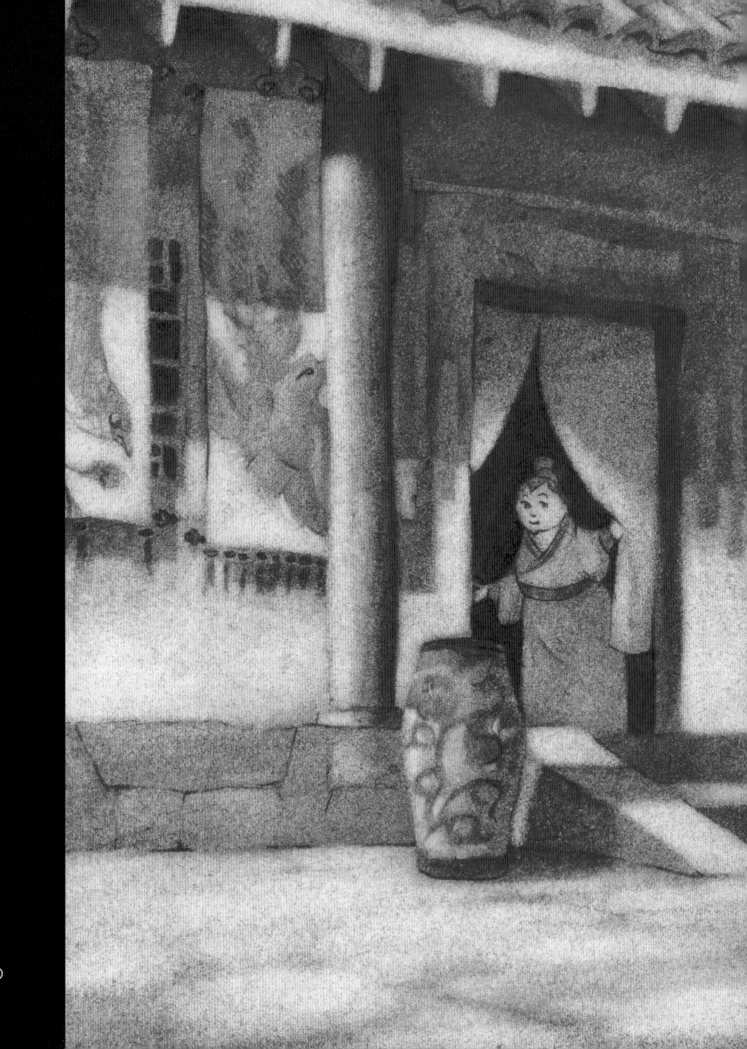

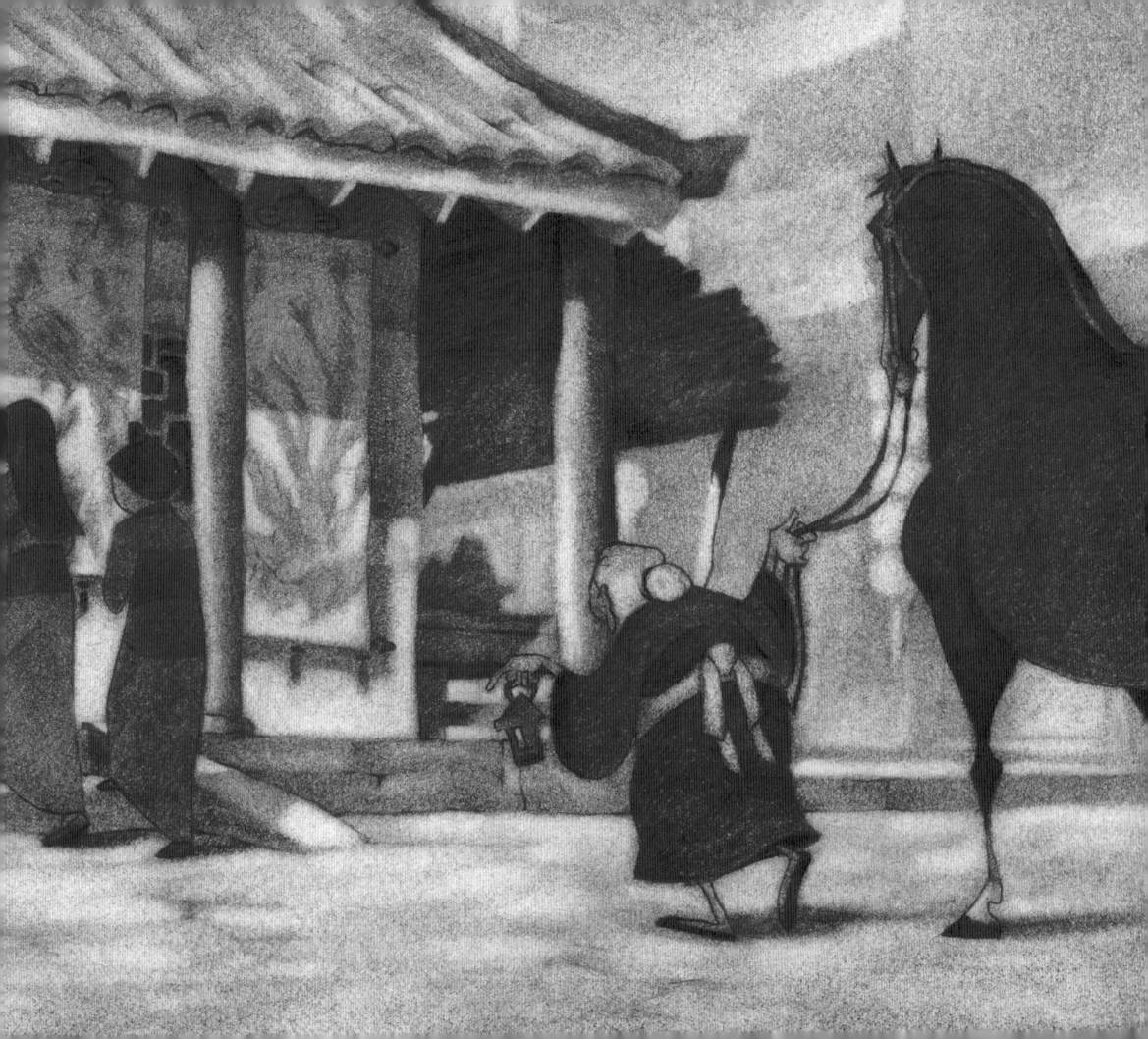

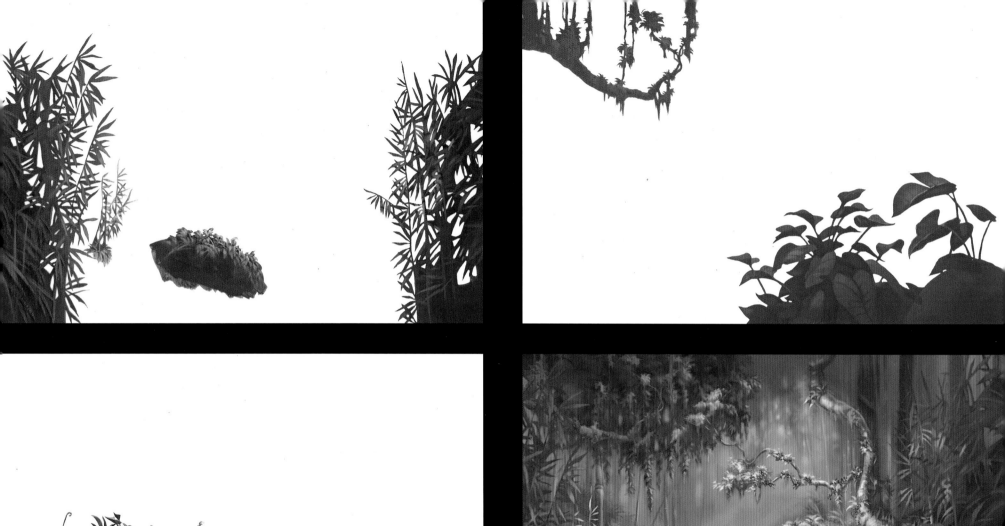

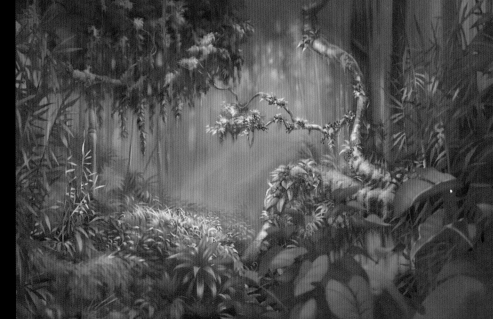

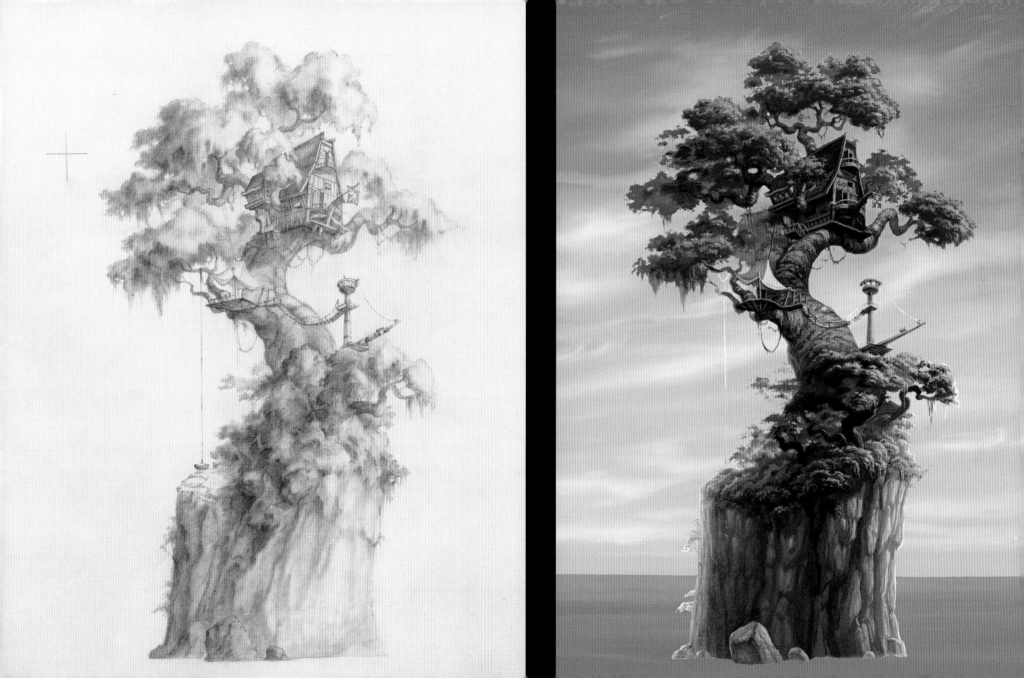

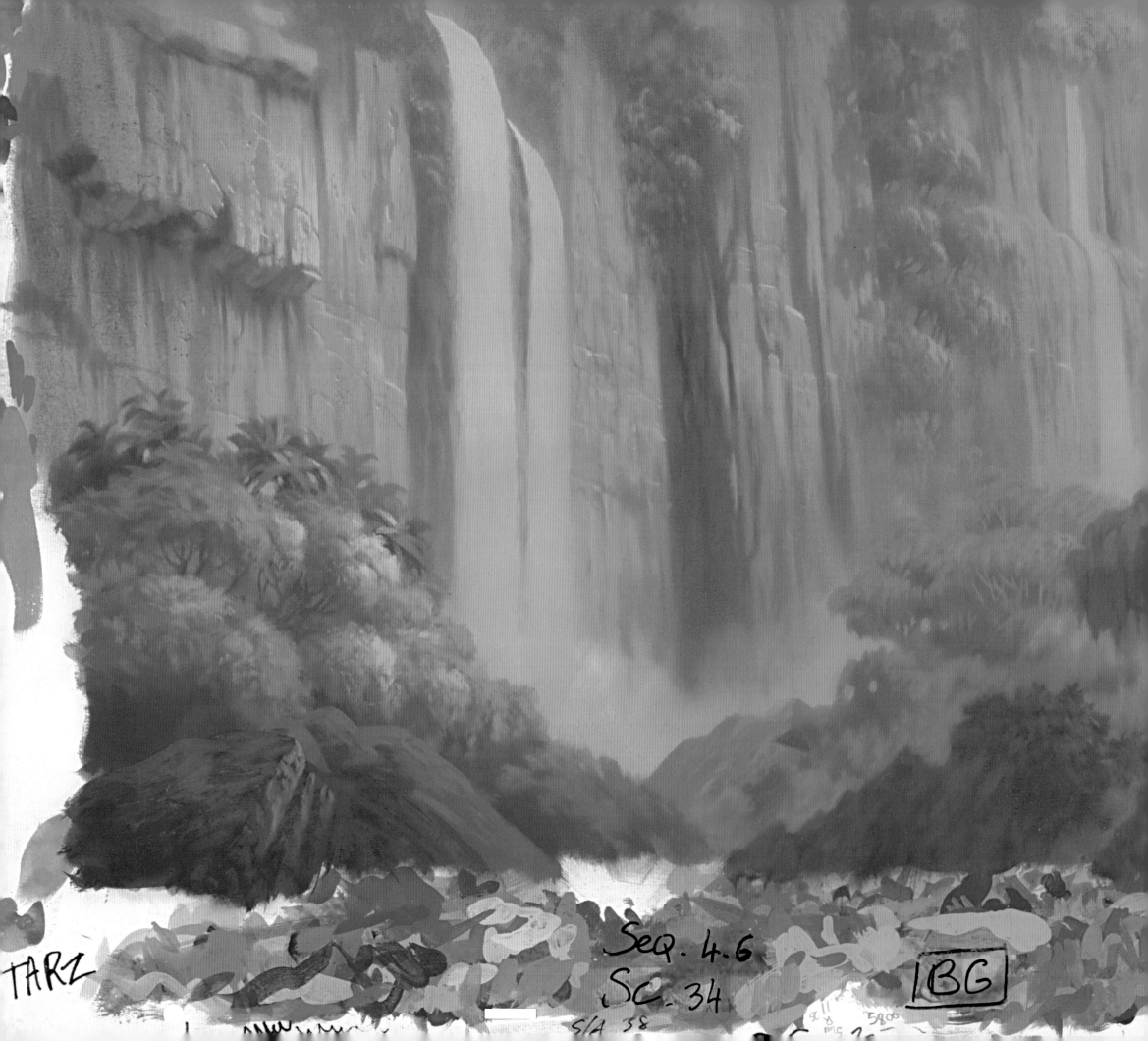

TARZ Seq. 4.6
SC. 34 BG
S/A 38

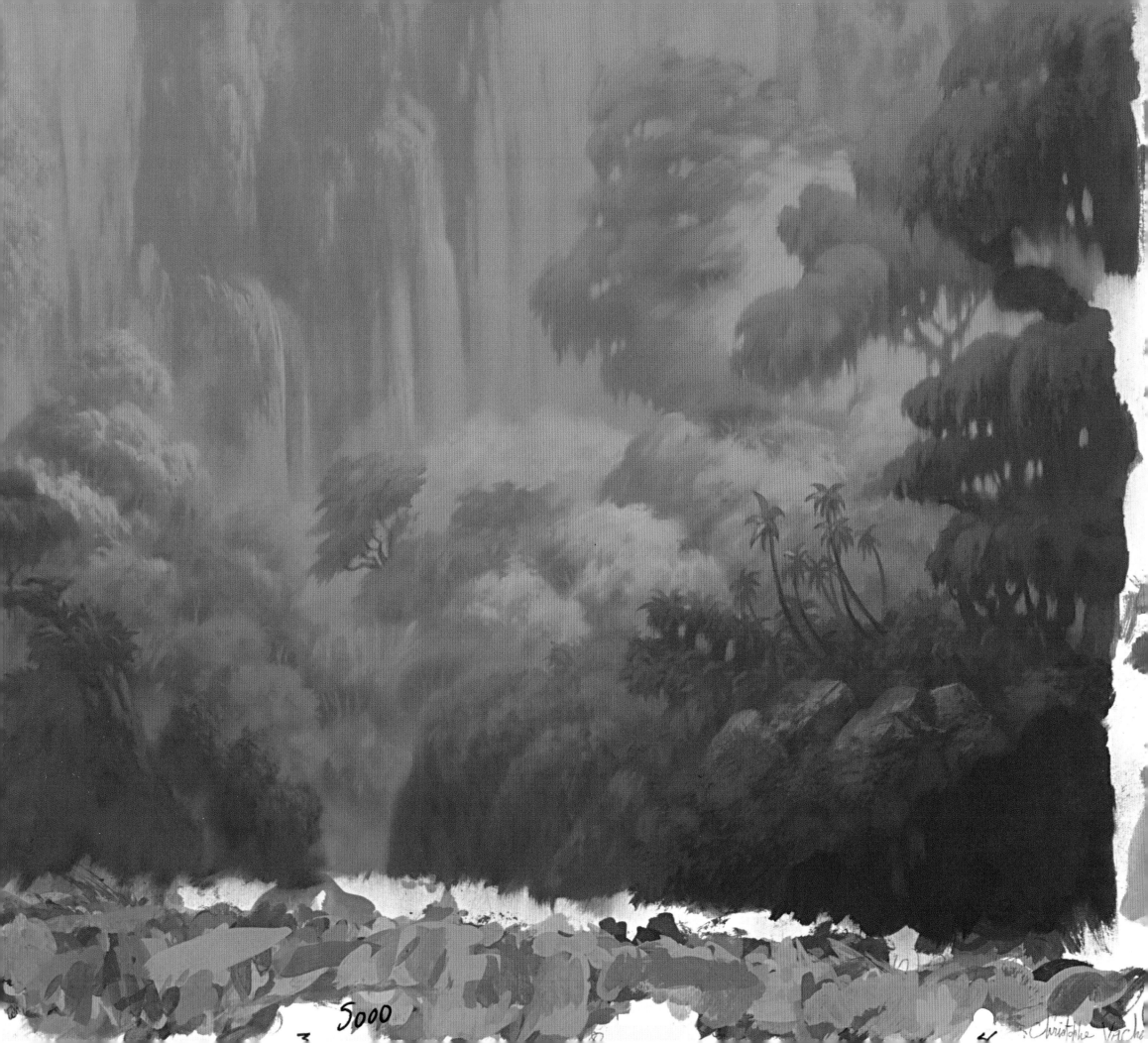

OK
MHUNT
YASUDA

FANTASIA/2000, "SYMPHONY NO. 5" 2000

- PASTELS -
224-P 245-P
275-P 234-P
285-P

BG-2
Scene 11

BEES
SEQ 2
Scene 11

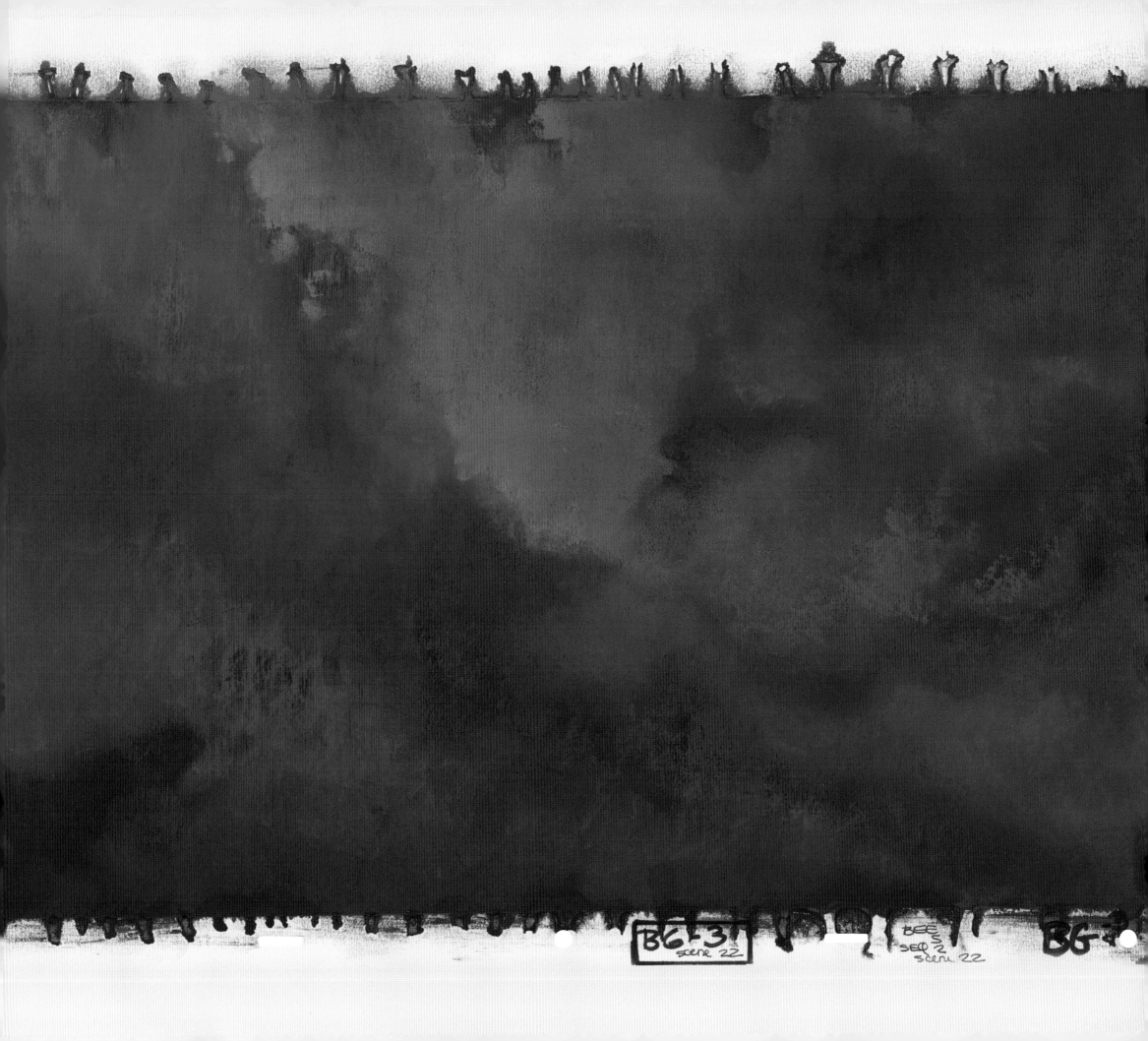

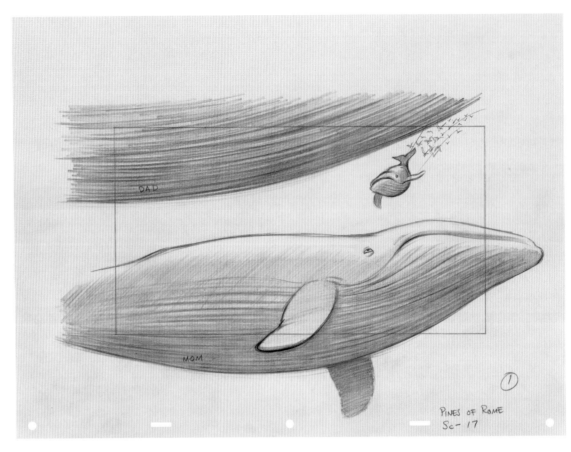

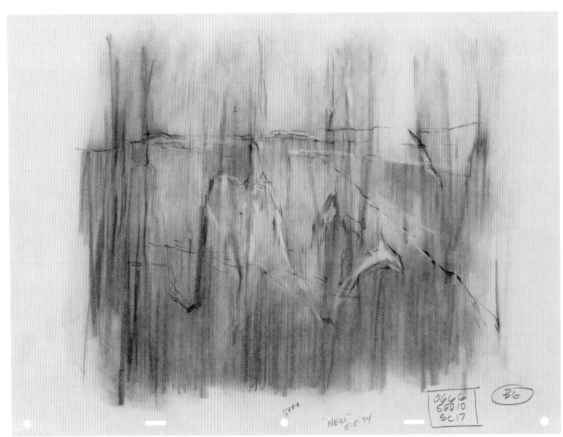

FANTASIA/2000, "PINES OF ROME" 2000

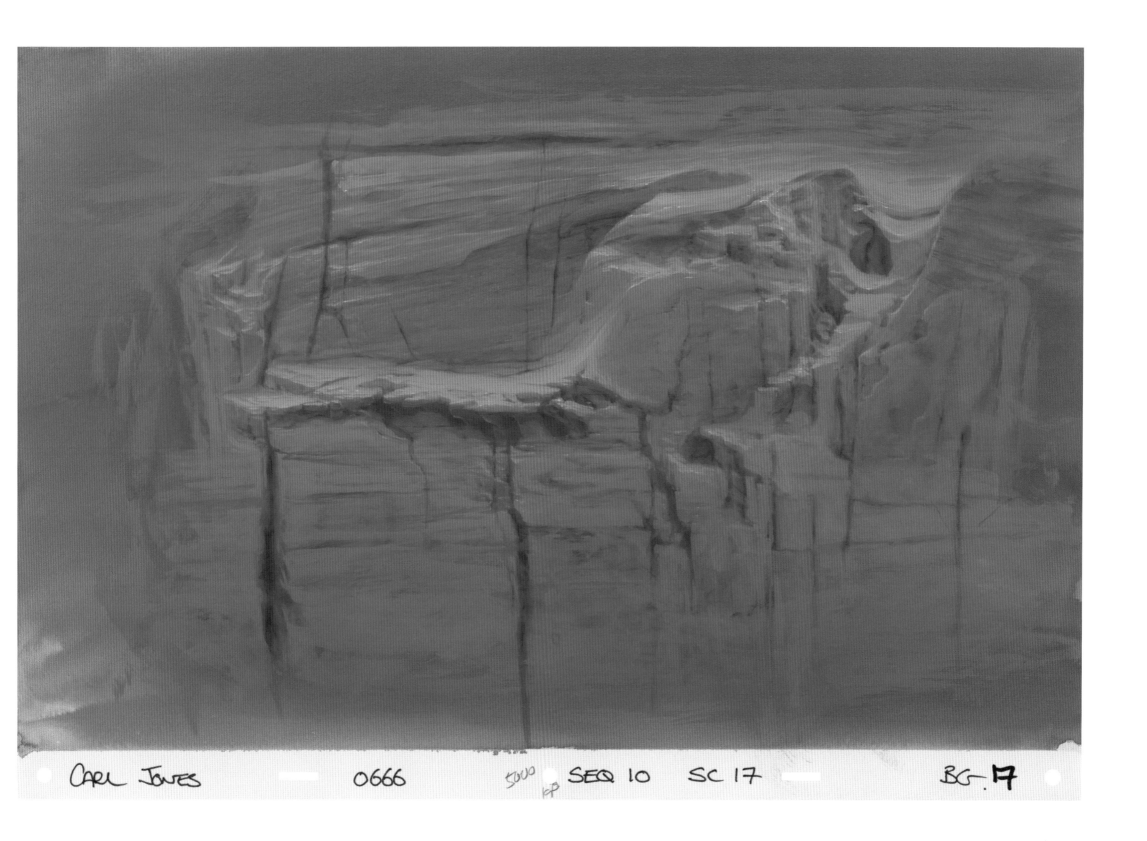

Carl Jones 0666 5000 kp SEQ 10 SC 17 BG. 17

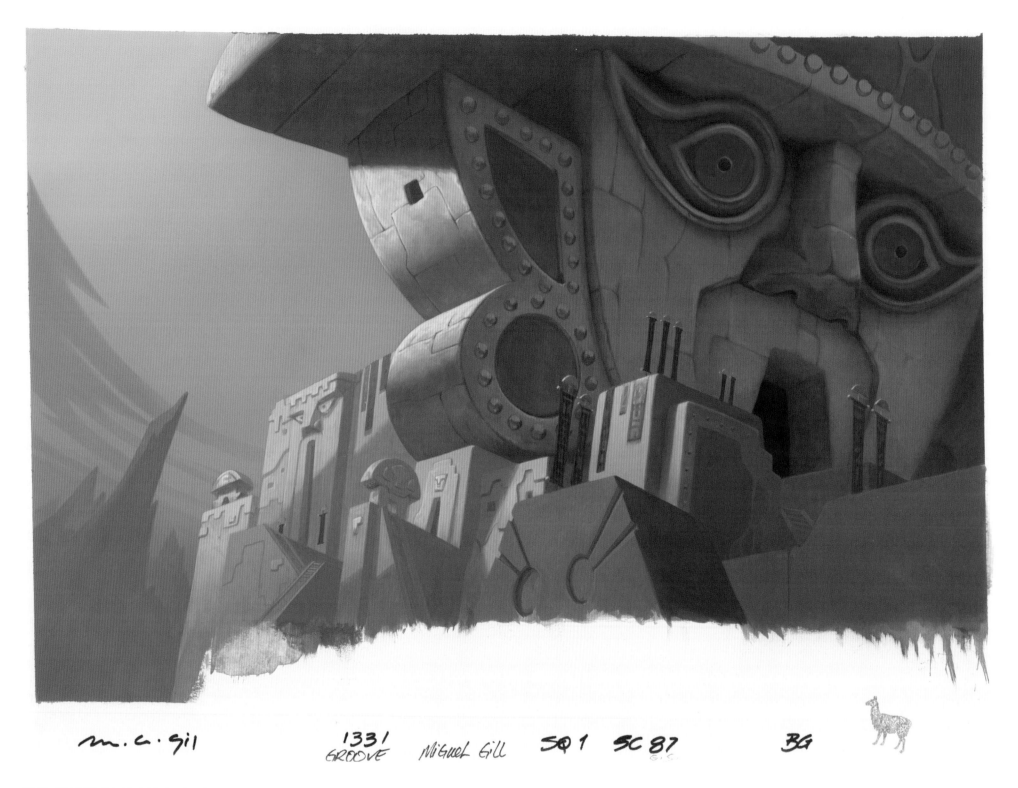

m. G. gil

1331
GROOVE Miguel Gill SQ 1 SC 87 BG

THE EMPEROR'S NEW GROOVE 2000



232 LAYOUT & BACKGROUND

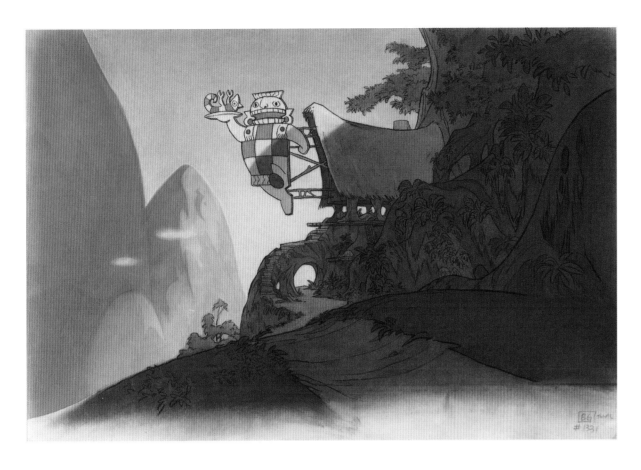

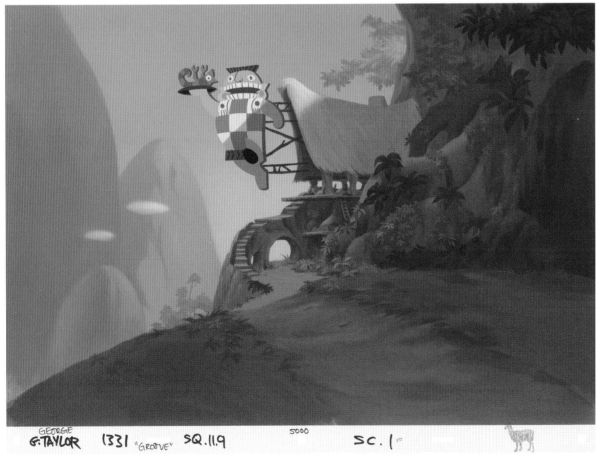

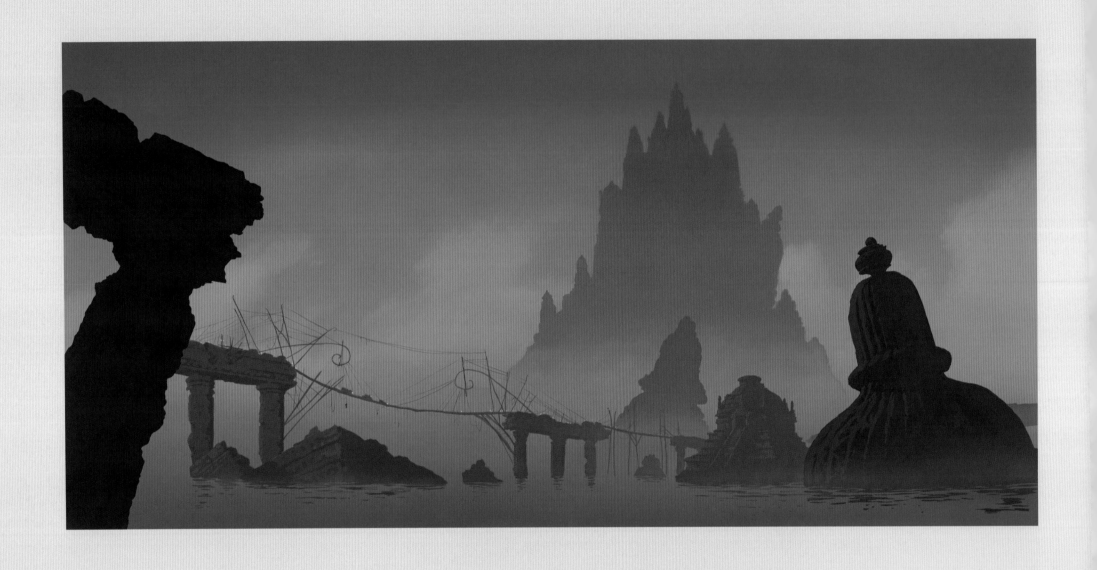

ATLANTIS: THE LOST EMPIRE 2001

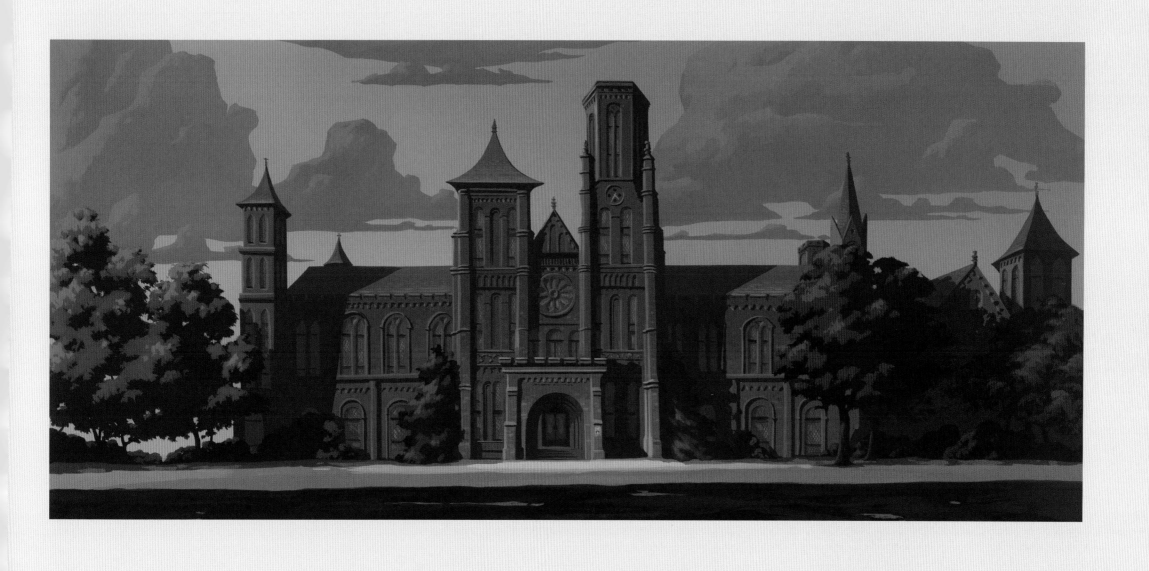

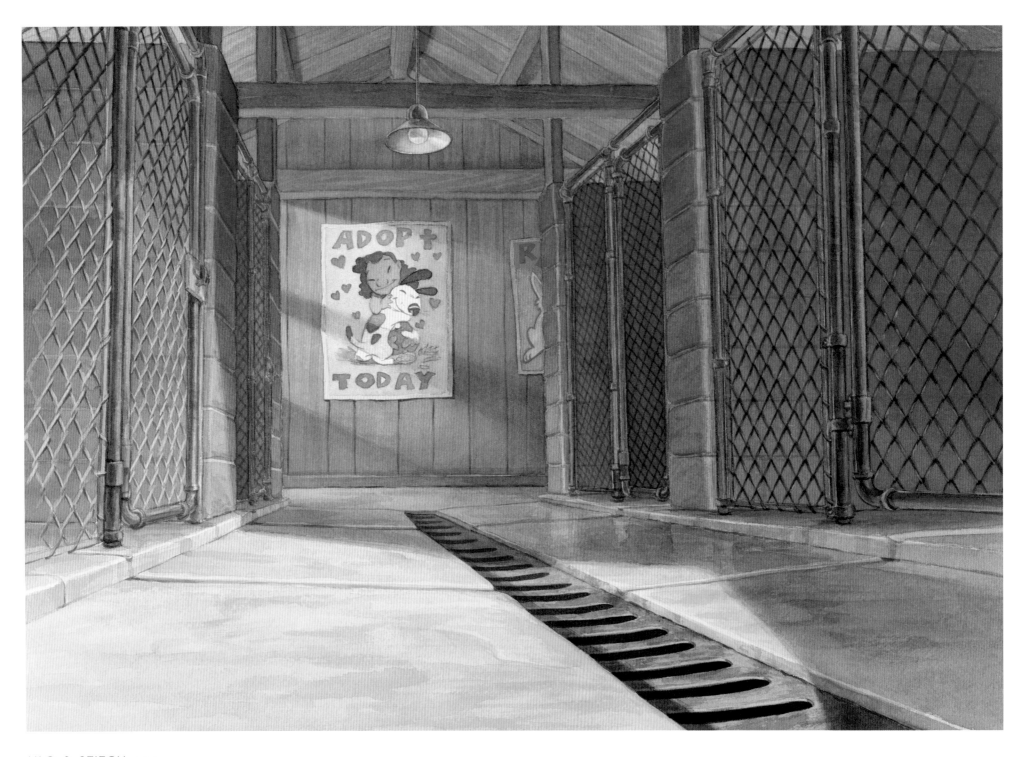

LILO & STITCH 2002

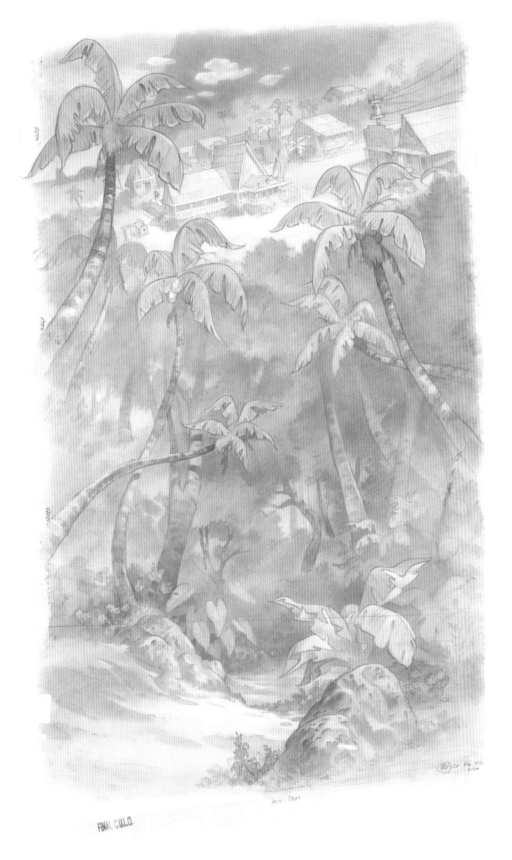

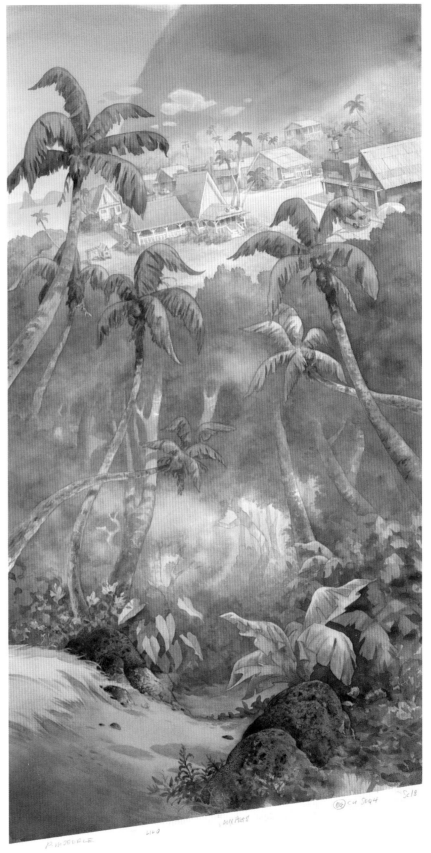

THE ARCHIVE SERIES 237

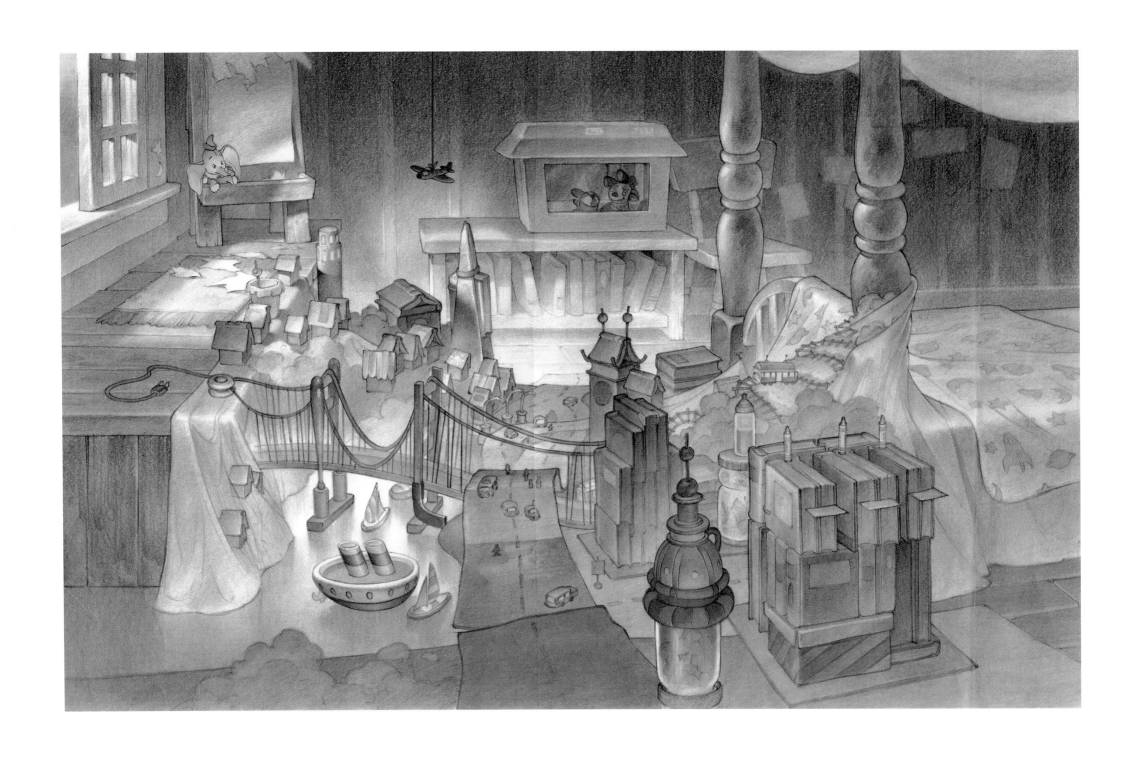

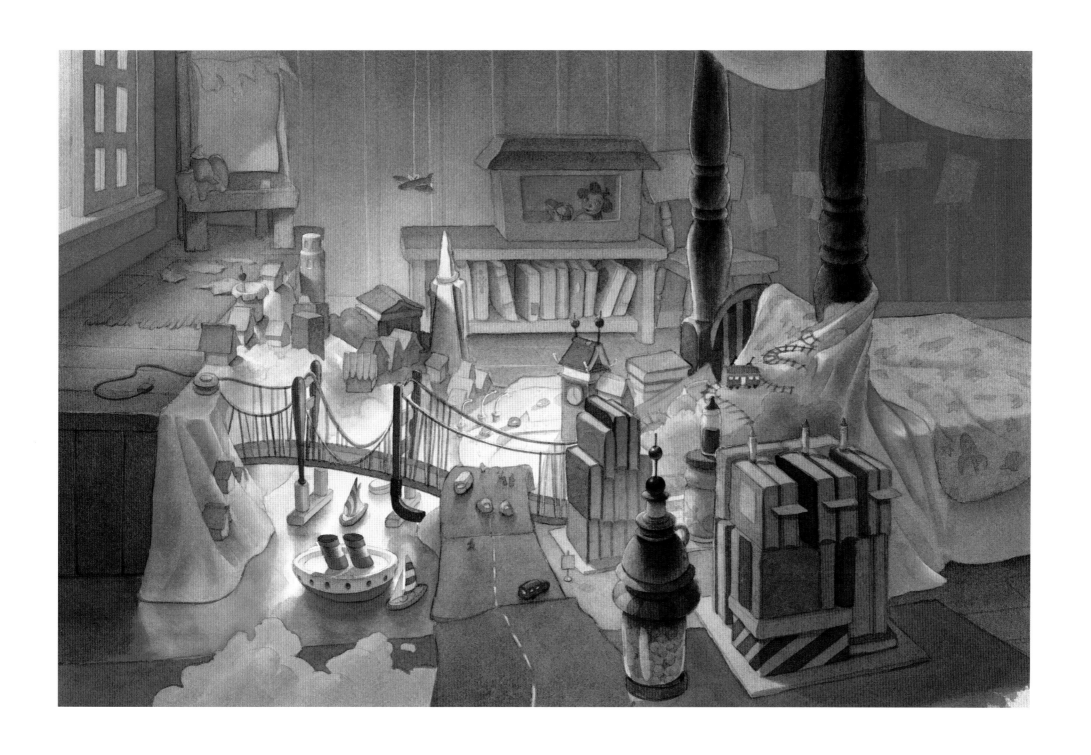

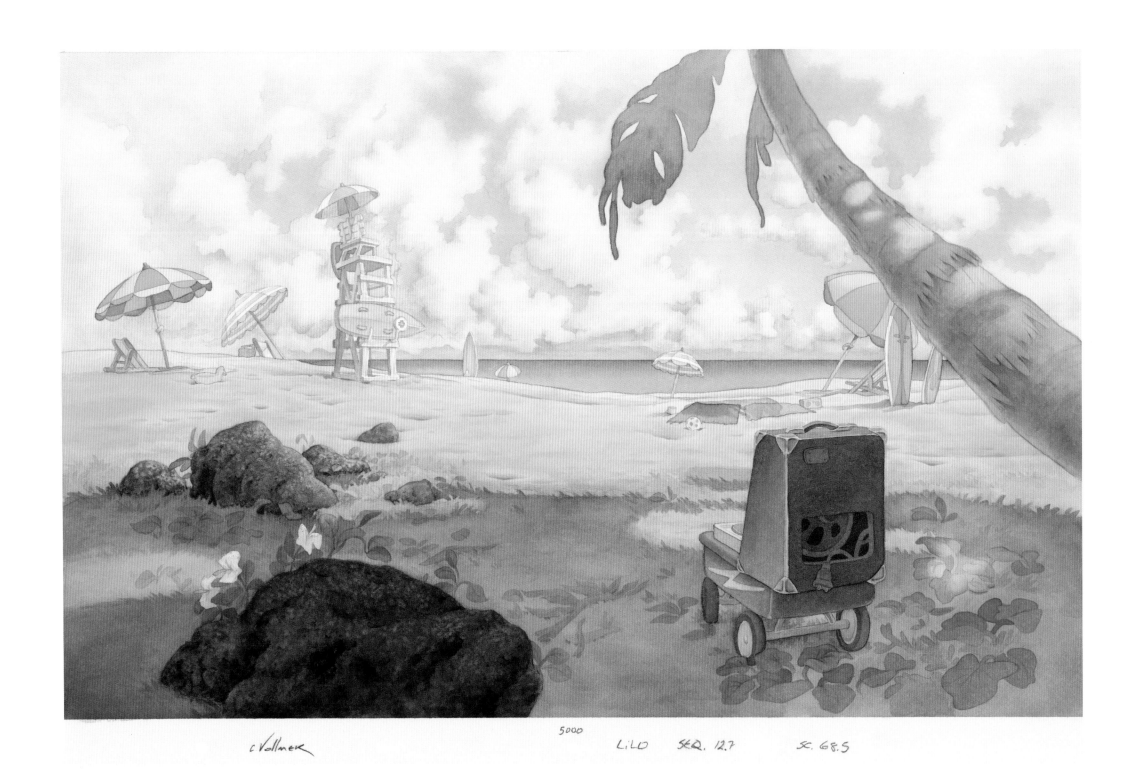

c Vollmer

5000

LiLO SEQ. 12.7 SC. 68.5

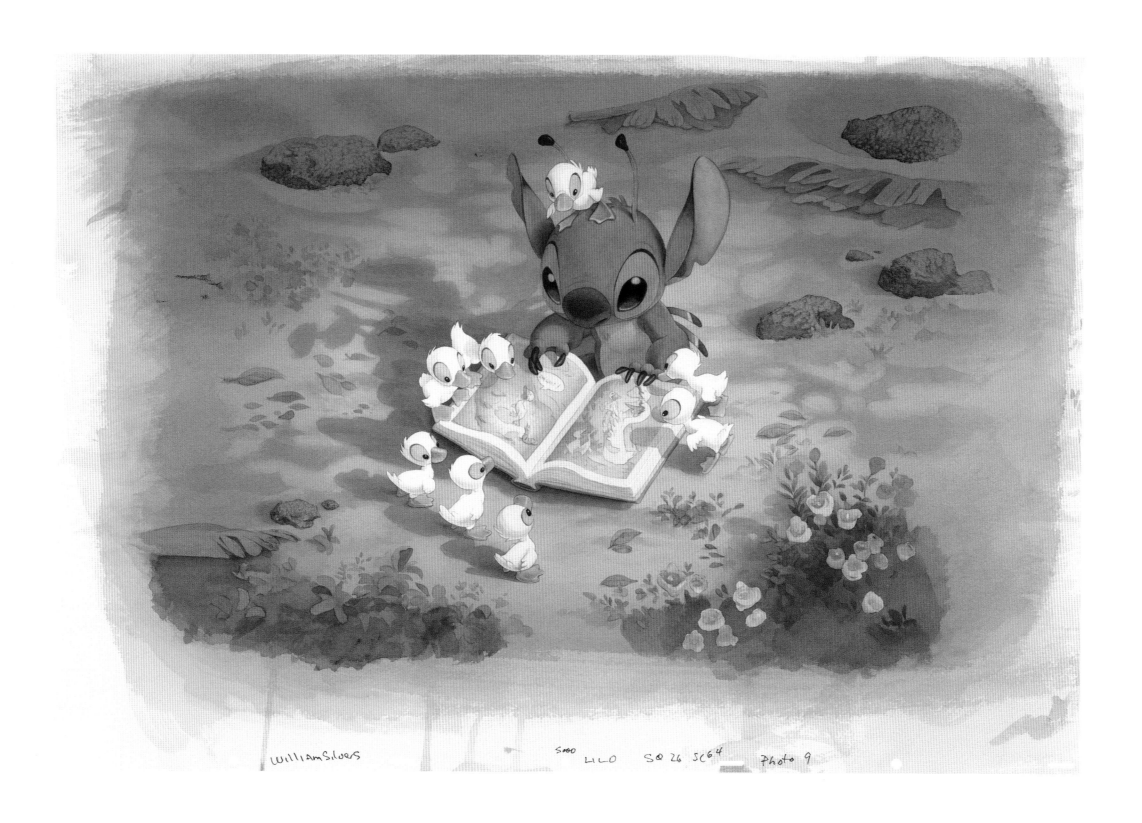

WilliamSilvers · S000 · LILO · SQ26 SC64 · Photo 9

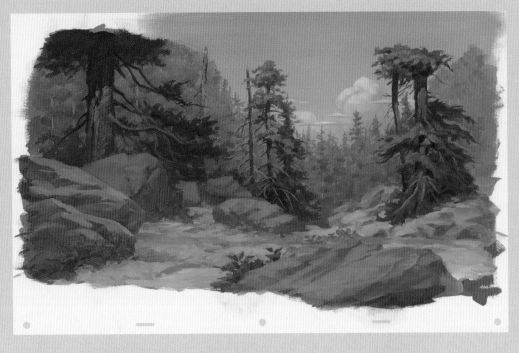

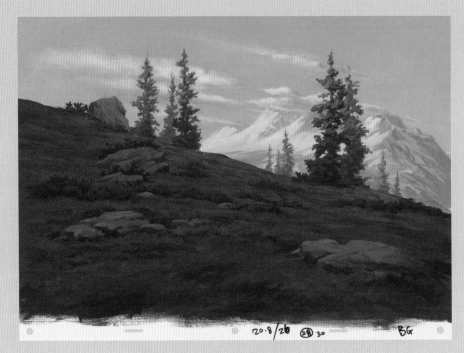

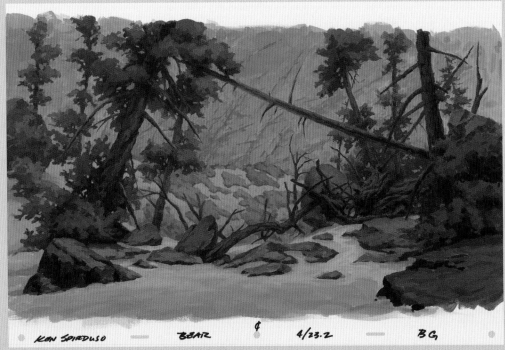

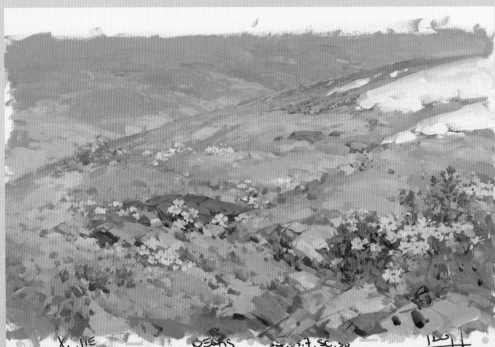

BROTHER BEAR 2003

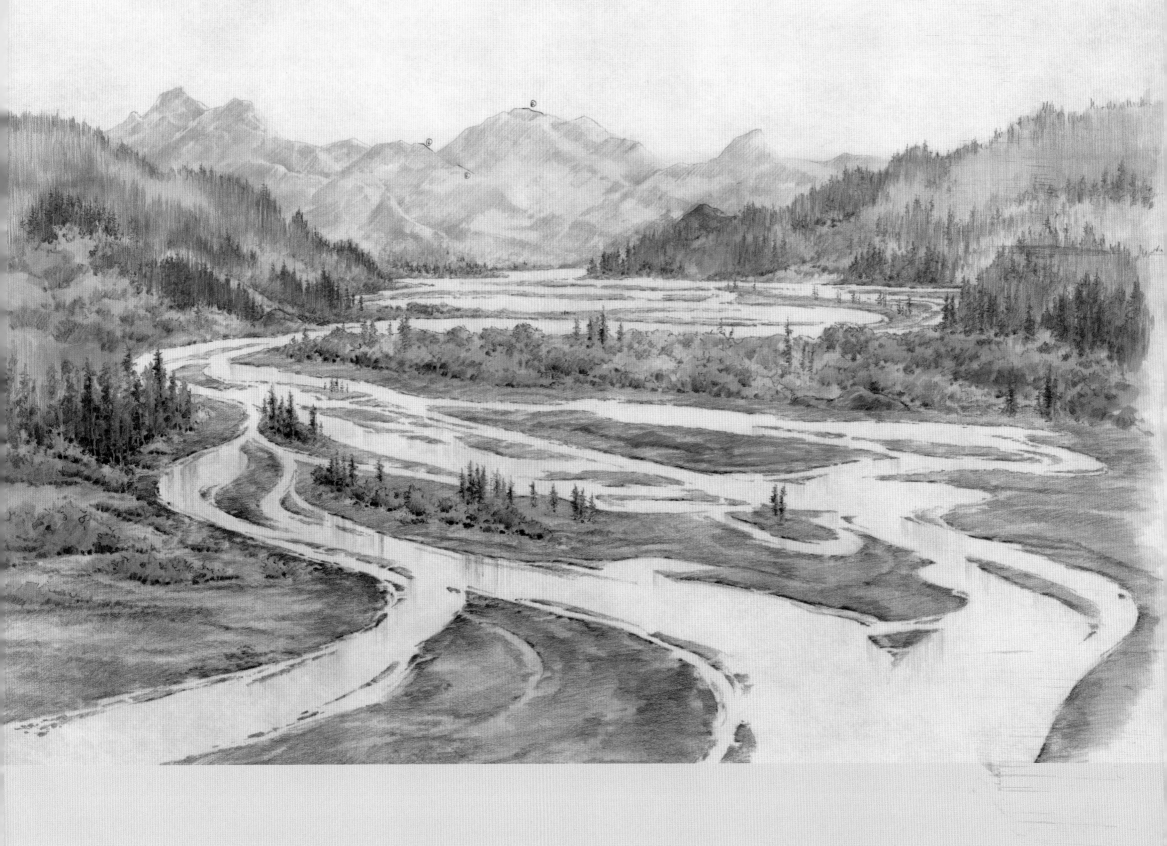

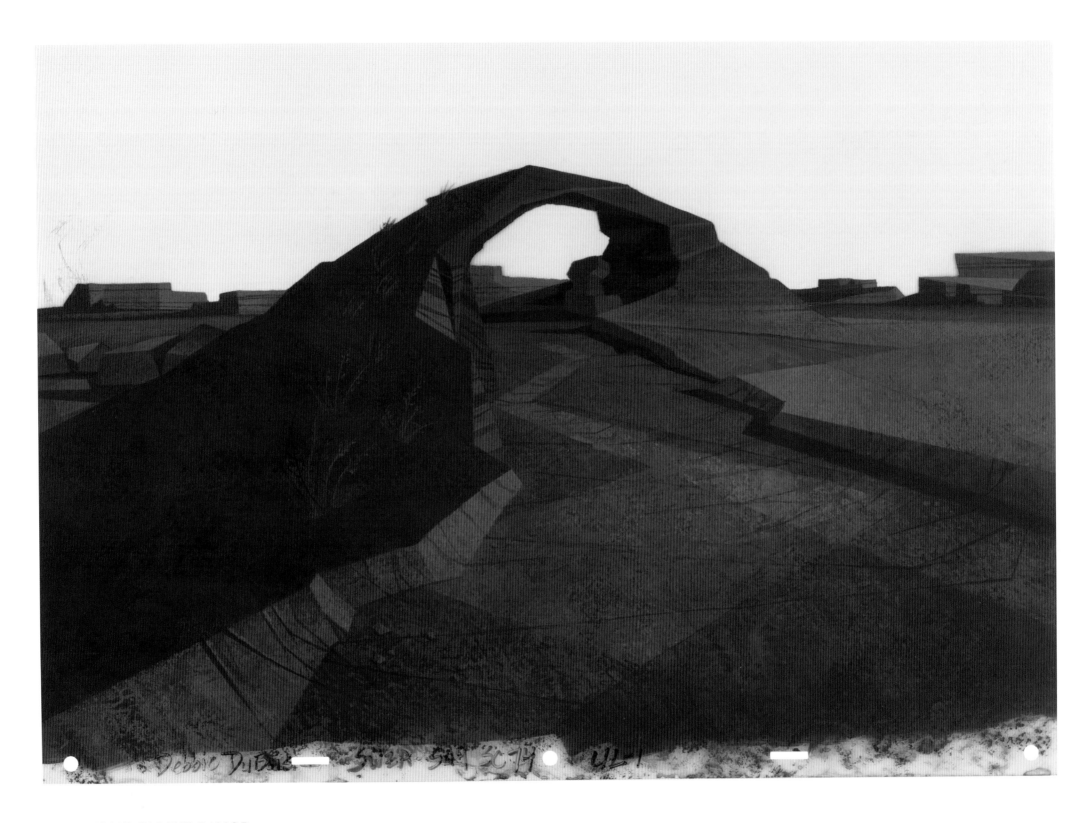

HOME ON THE RANGE 2004

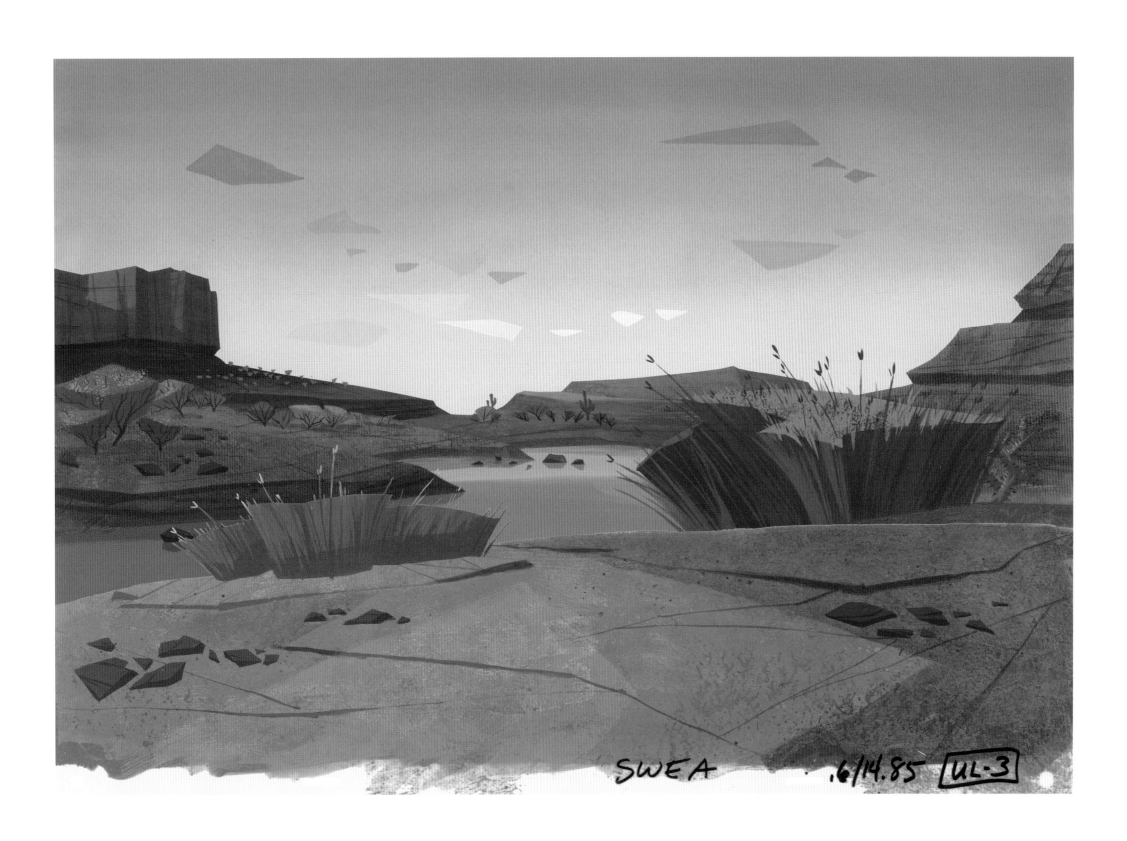

SWEA · 6/14.85 UL-3

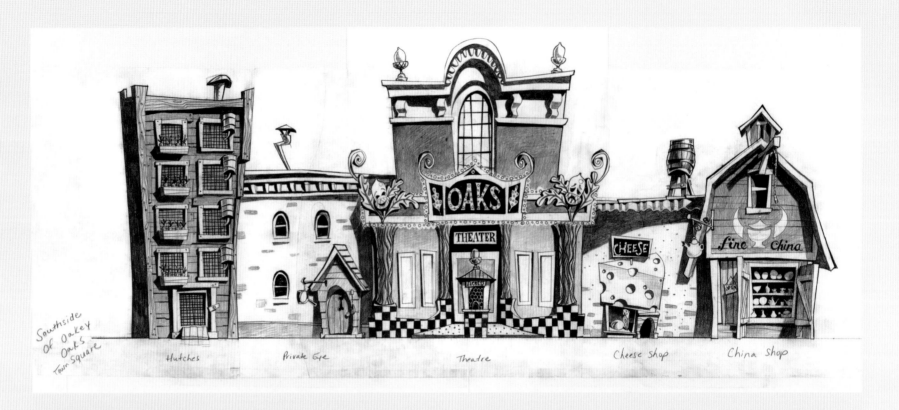

Southside
Of Oakey
Oaks
Town Square

Hutches Private Eye Theatre Cheese Shop China Shop

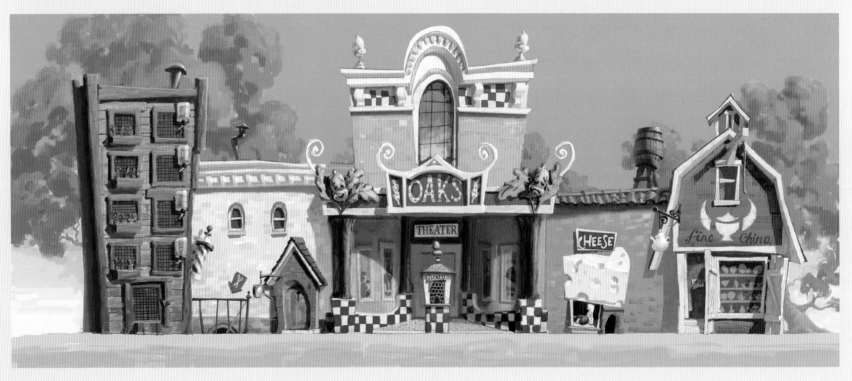

CHICKEN LITTLE 2005

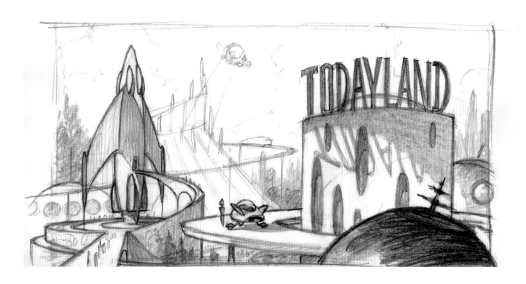

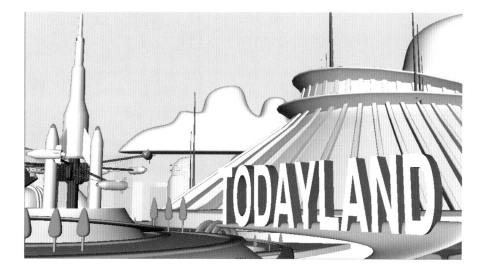

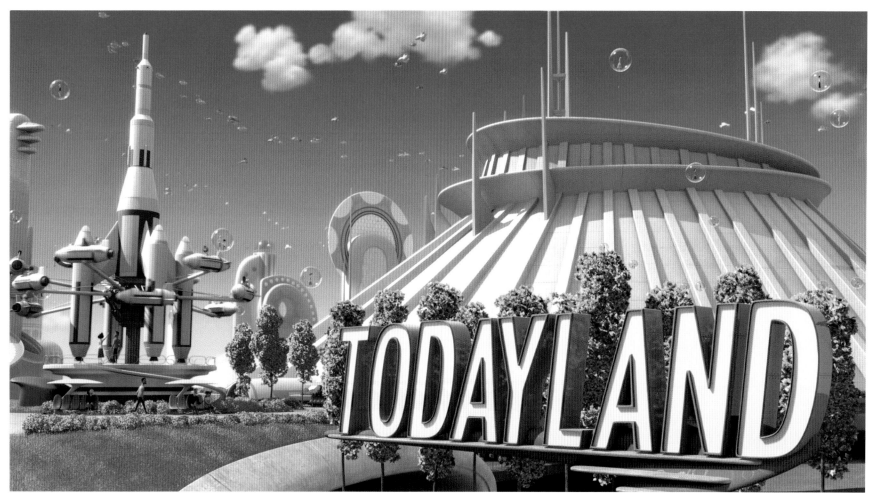

MEET THE ROBINSONS 2007

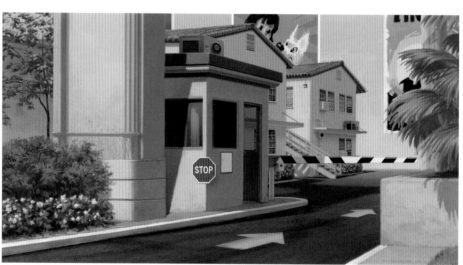

BOLT 2008

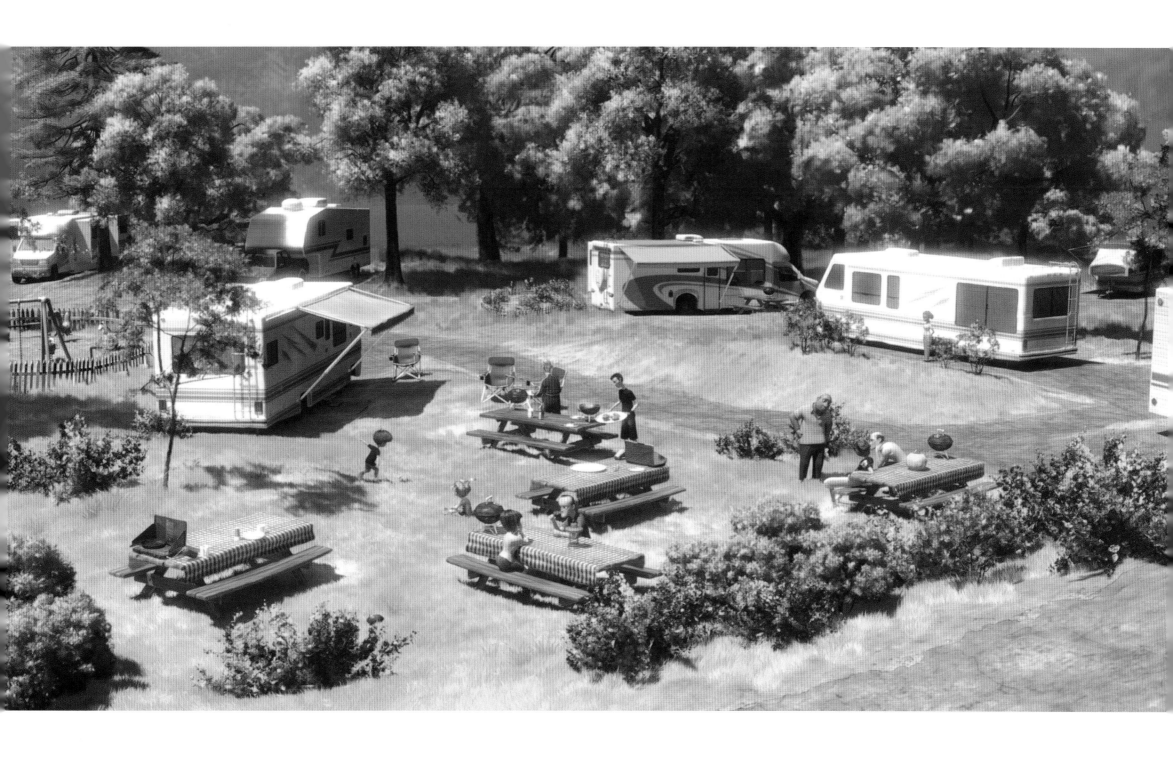

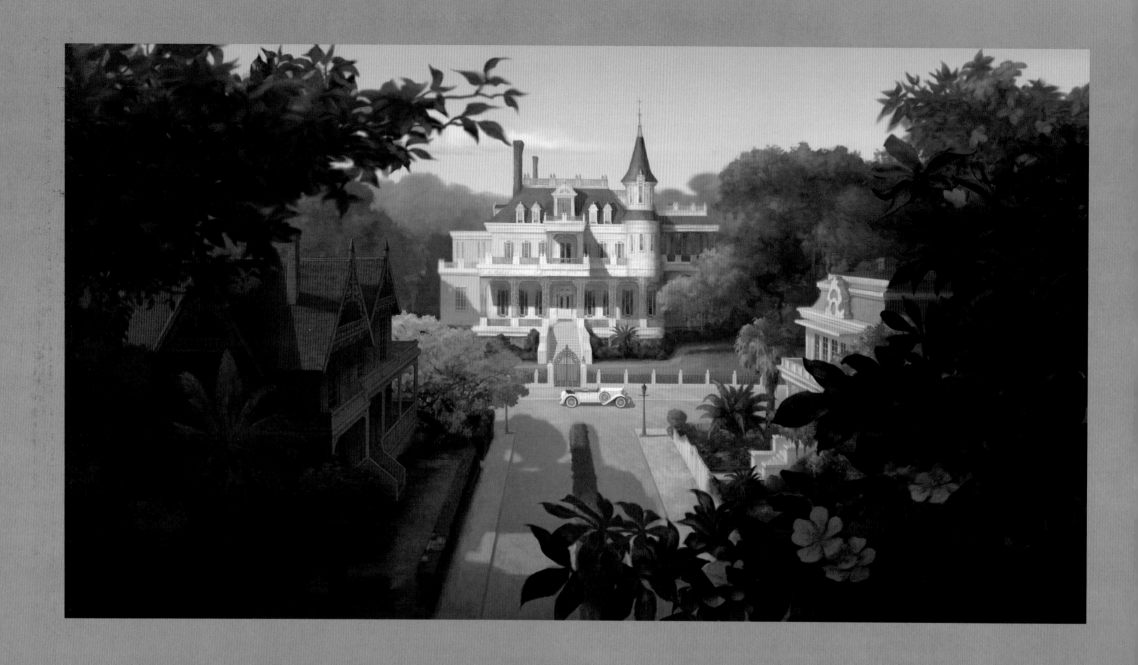

THE PRINCESS AND THE FROG 2009

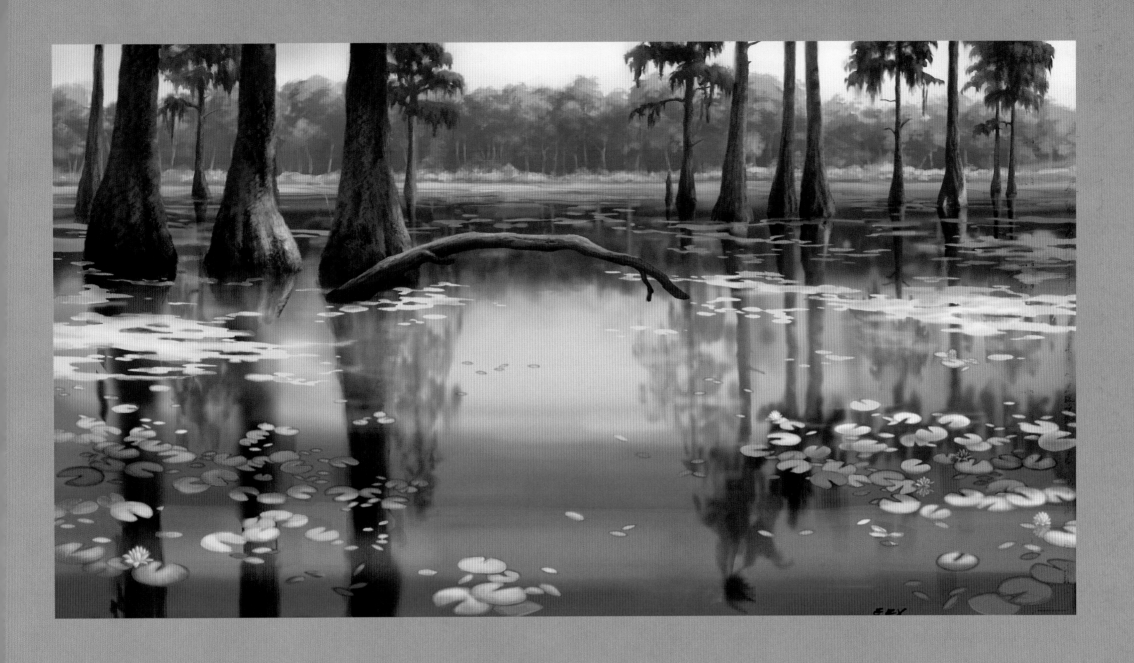

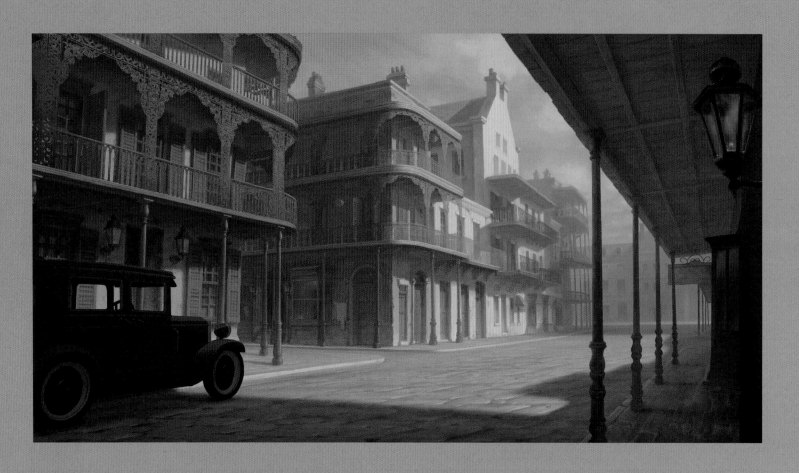

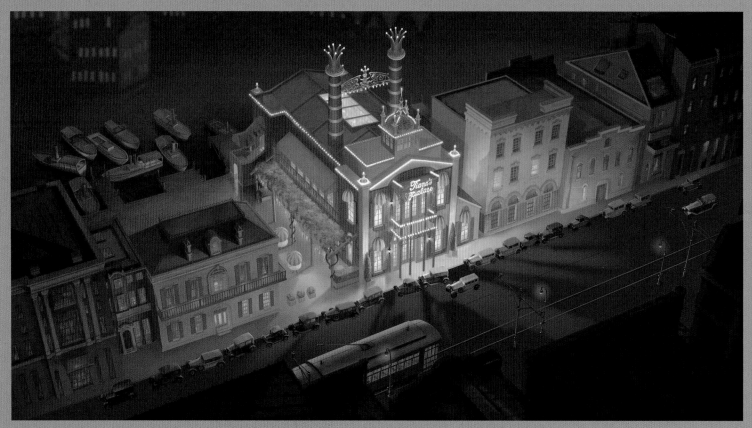

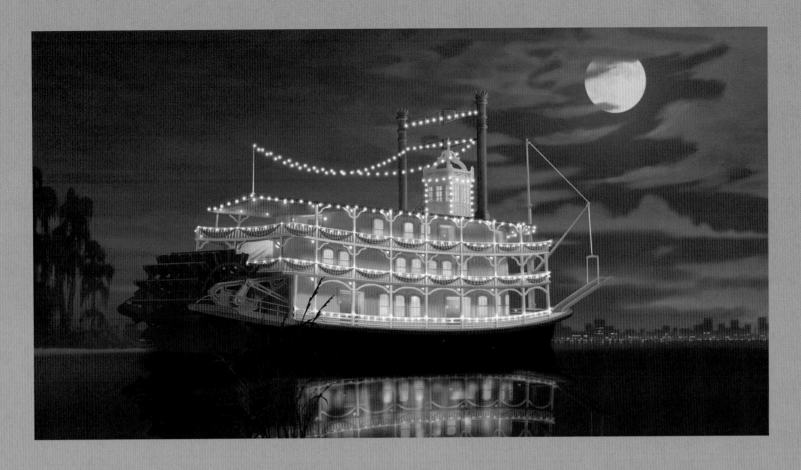

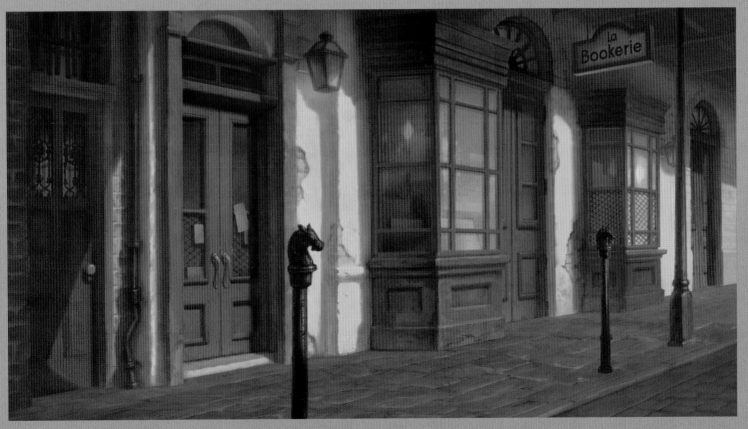

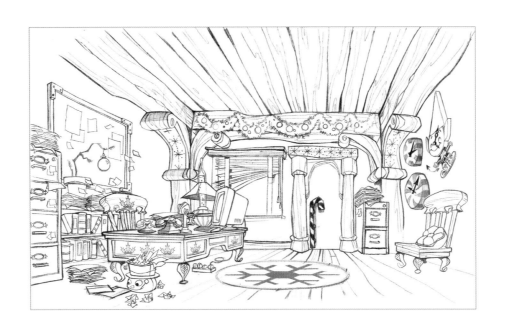

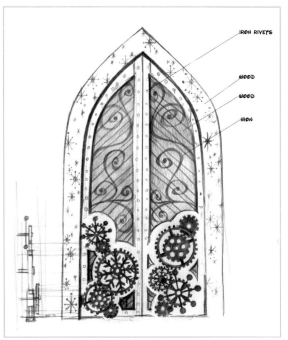

IRON RIVETS

WOOD

WOOD

IRON

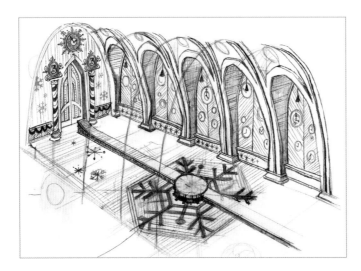

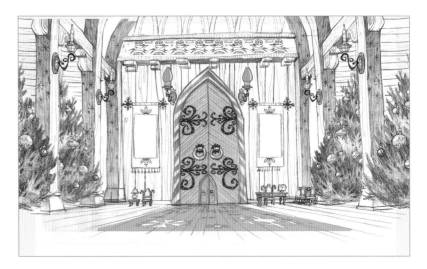

PREP & LANDING 2009

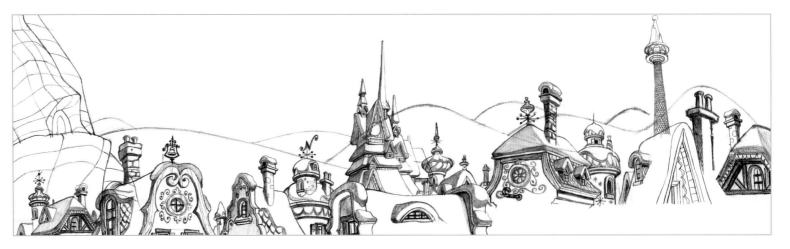

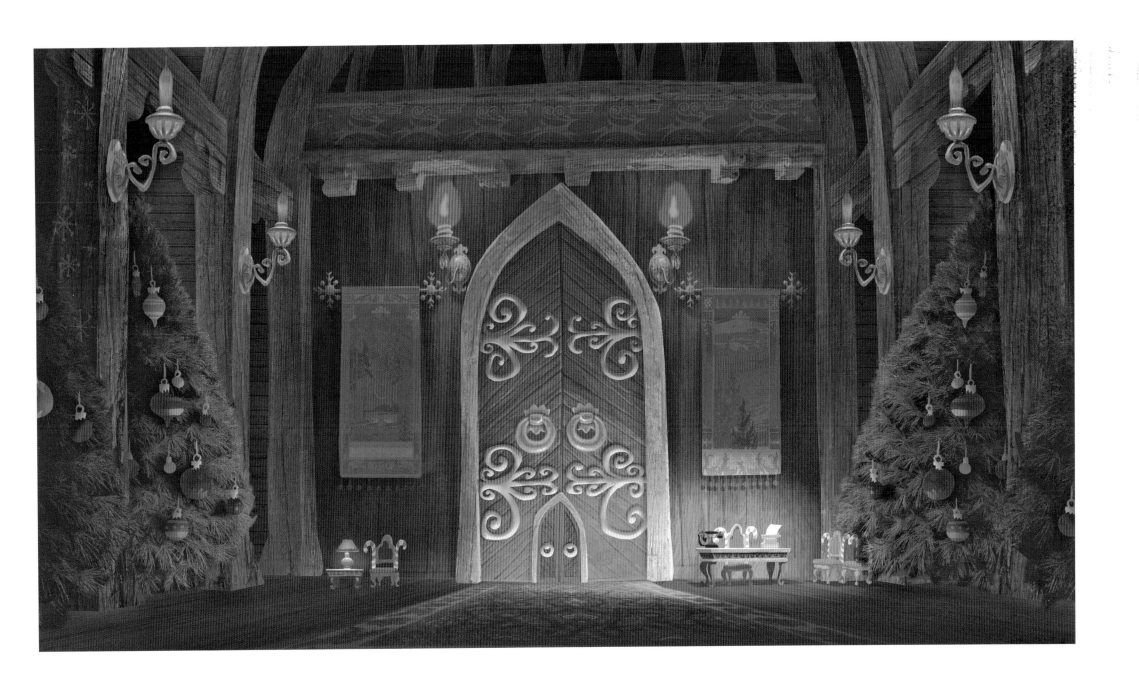

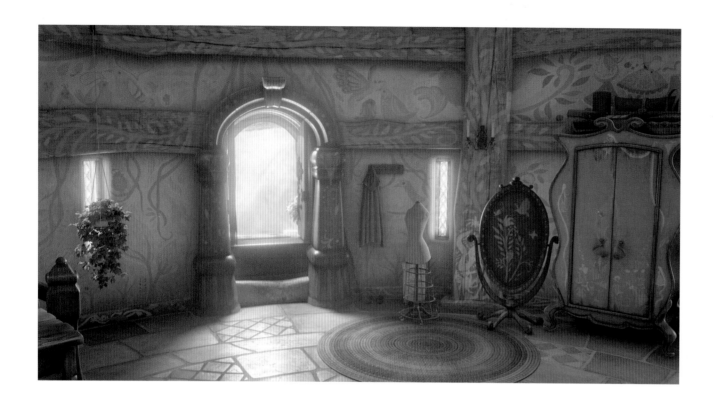

TANGLED 2010

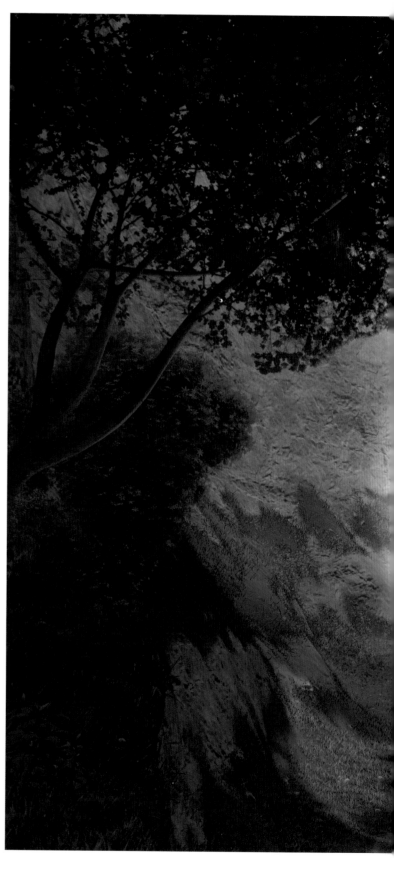

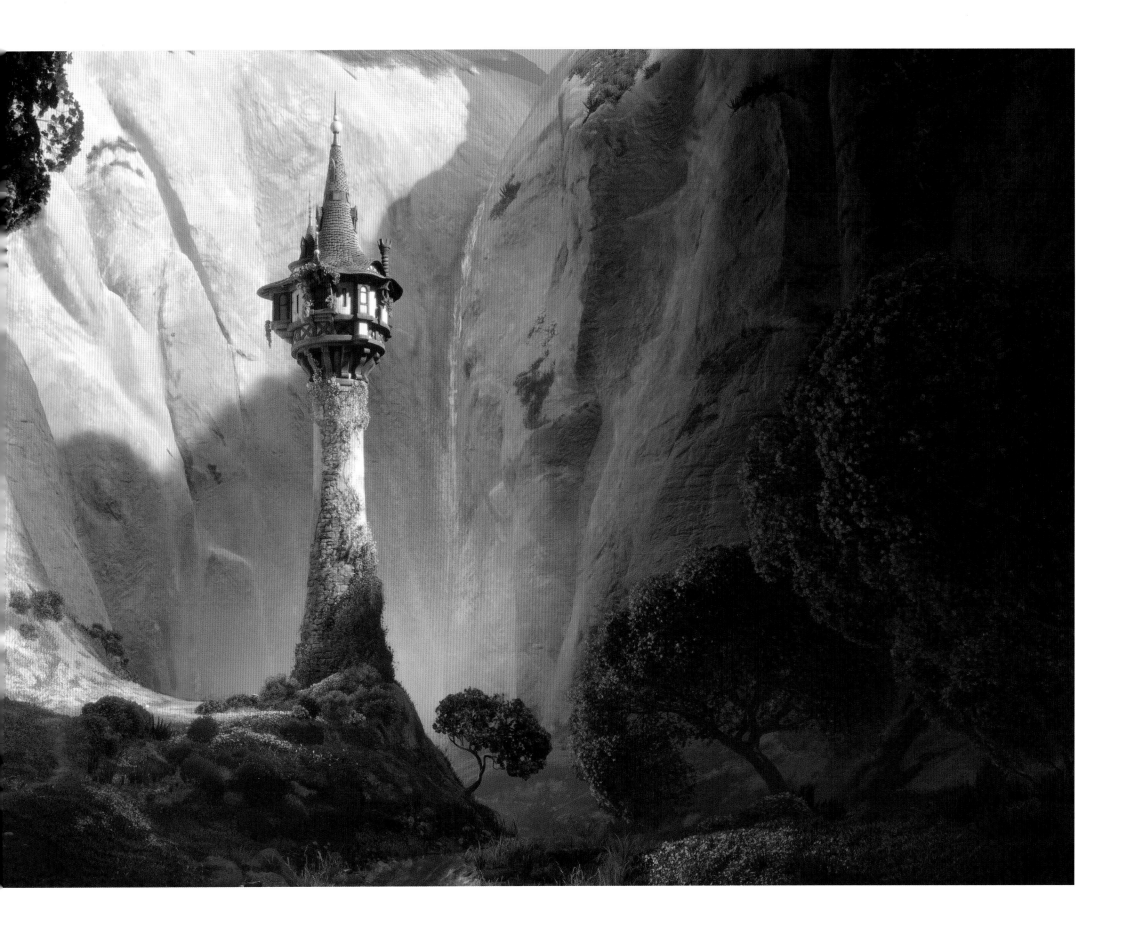

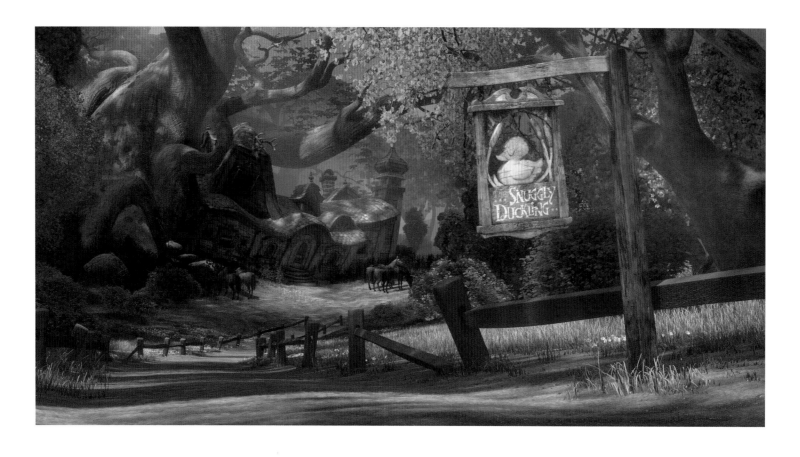

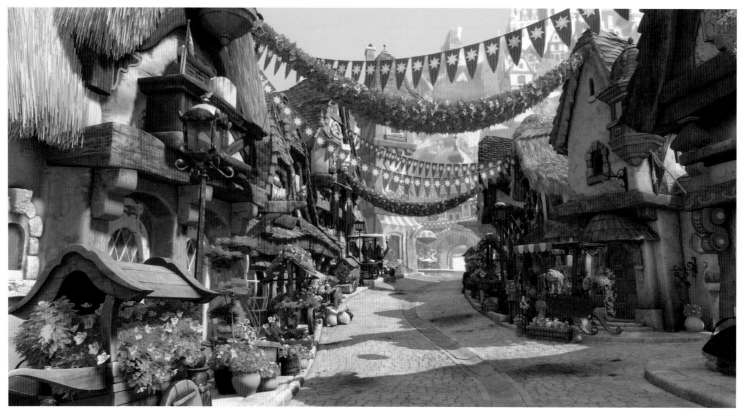

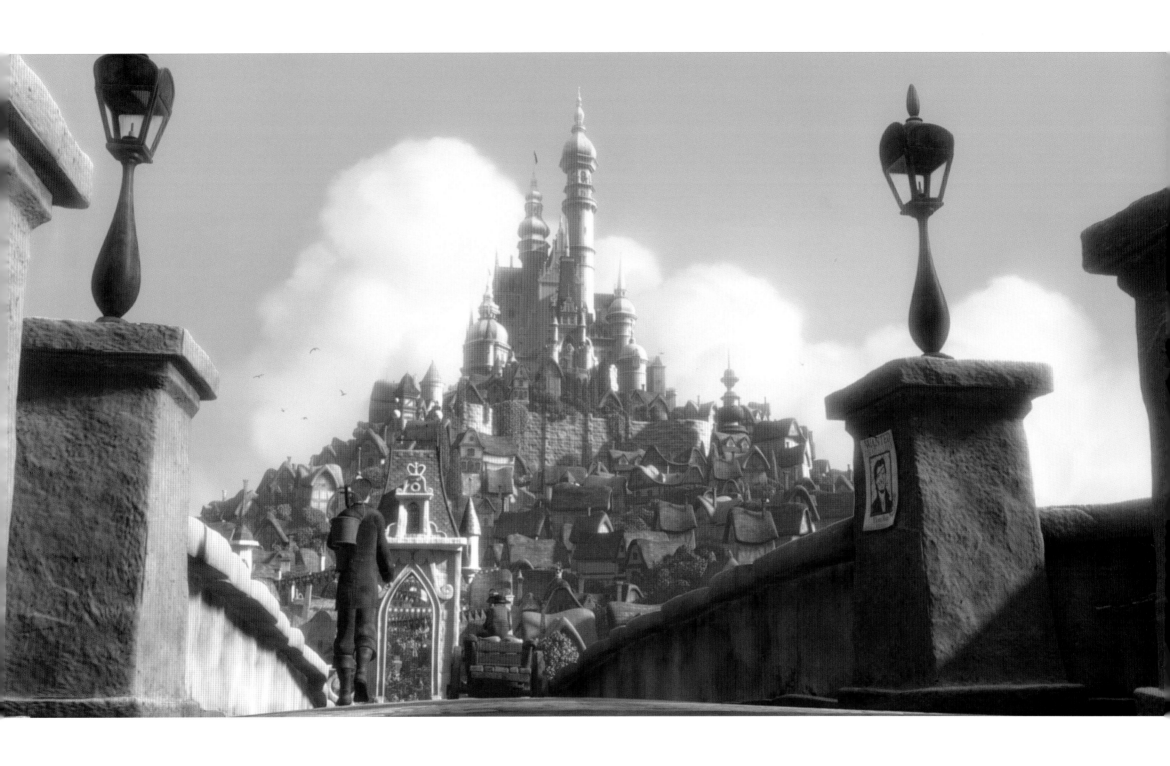

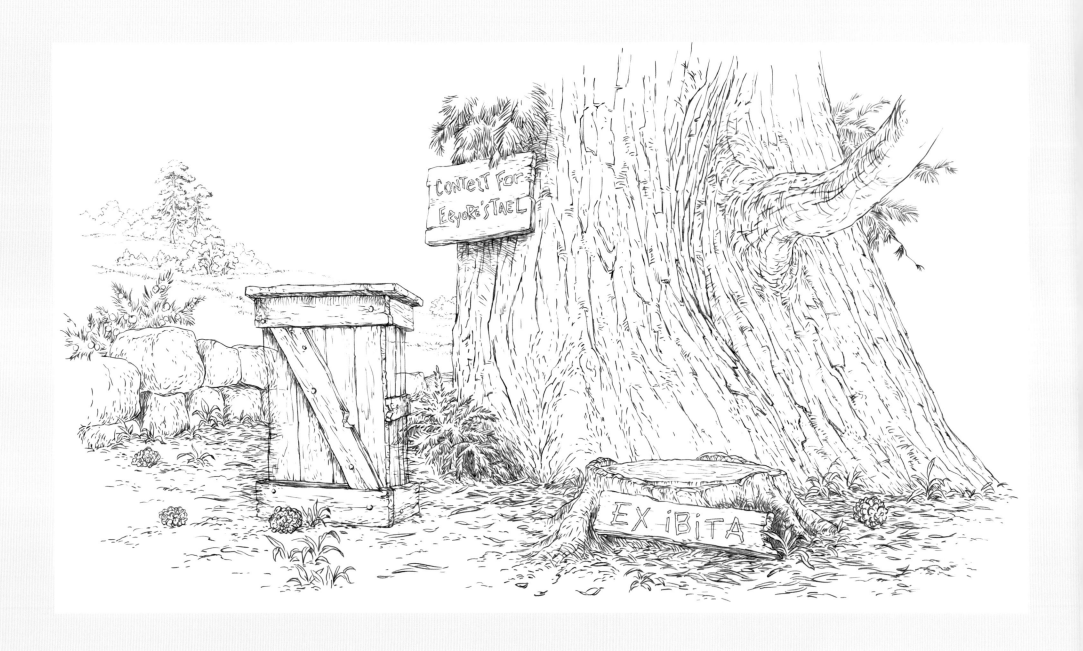

WINNIE THE POOH 2011

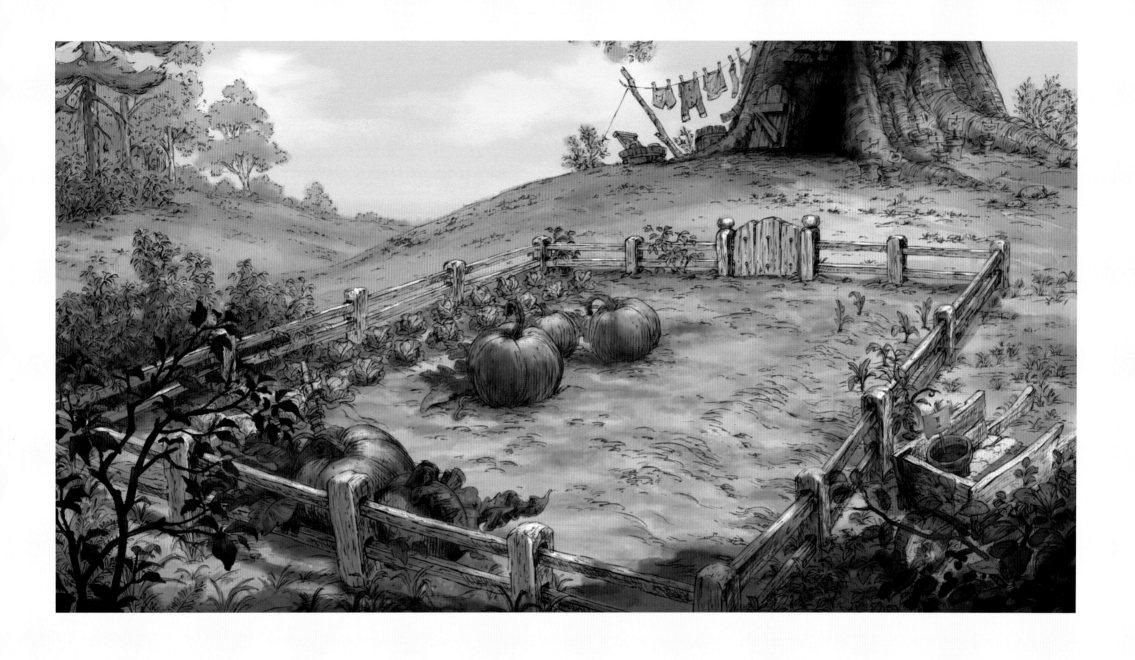

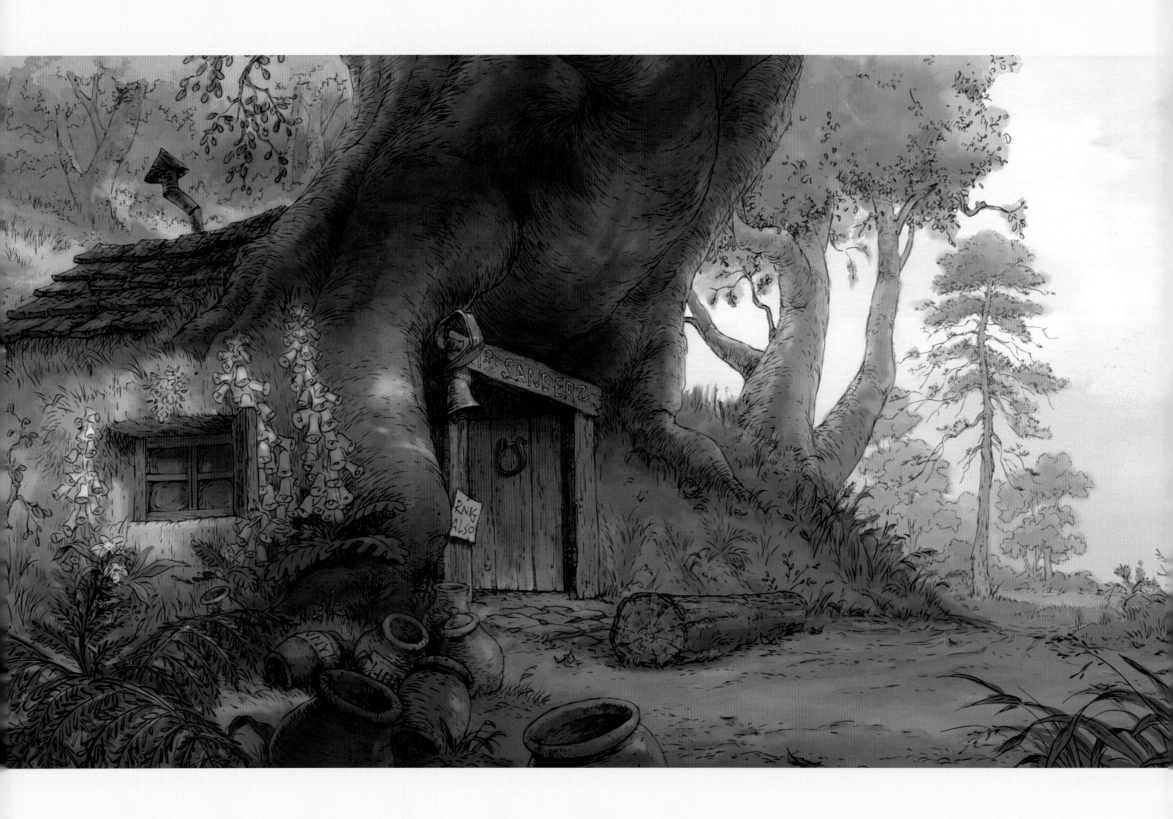

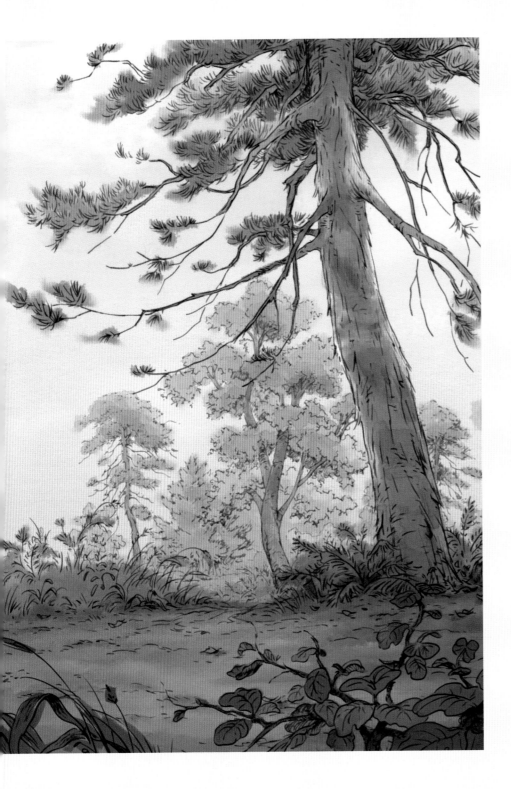

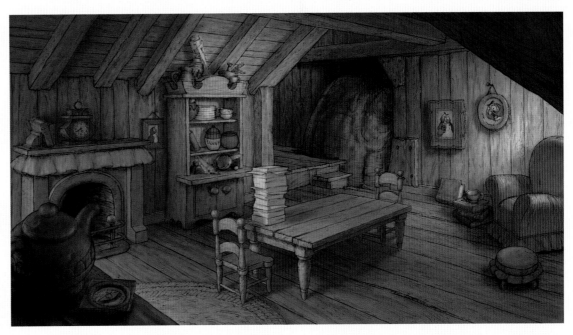

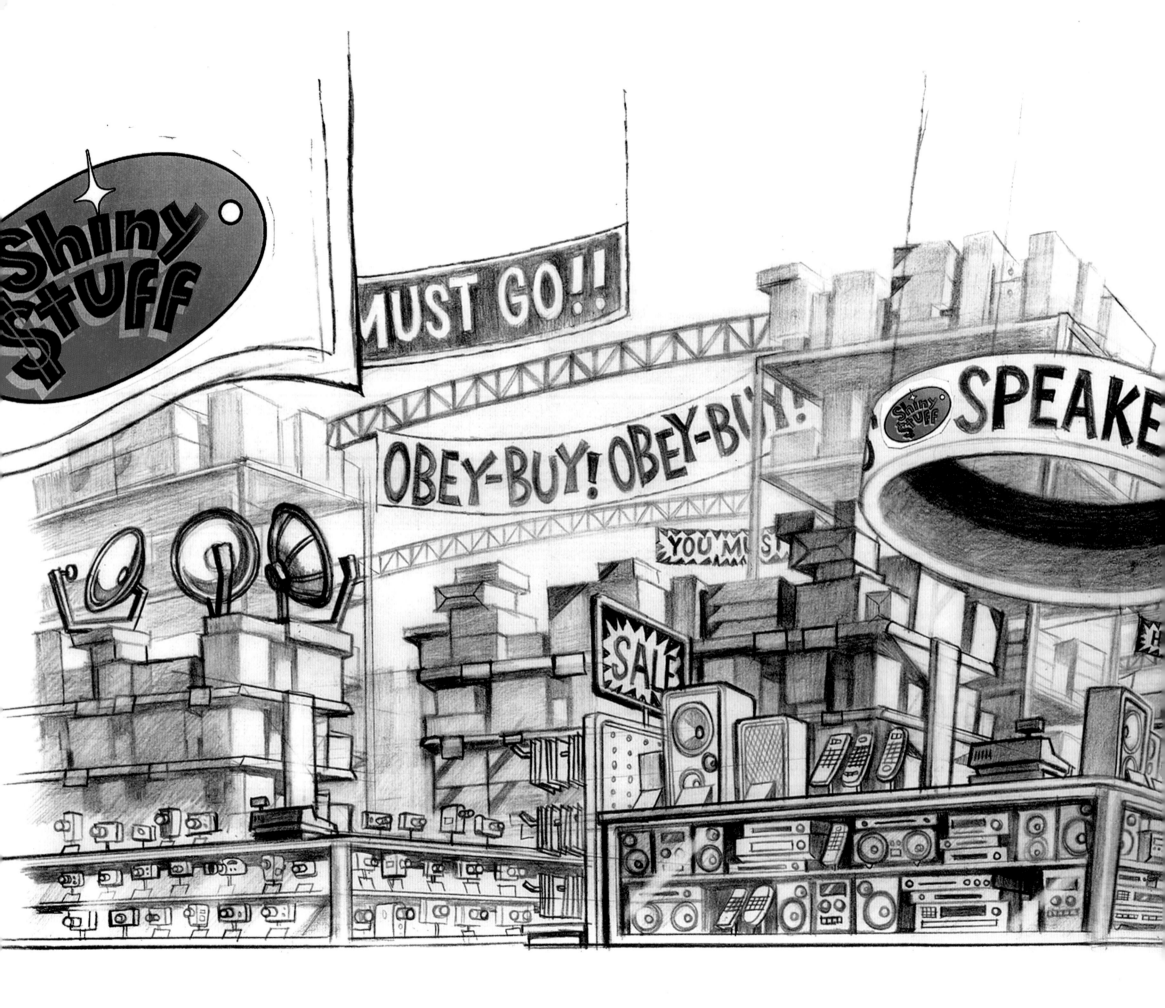

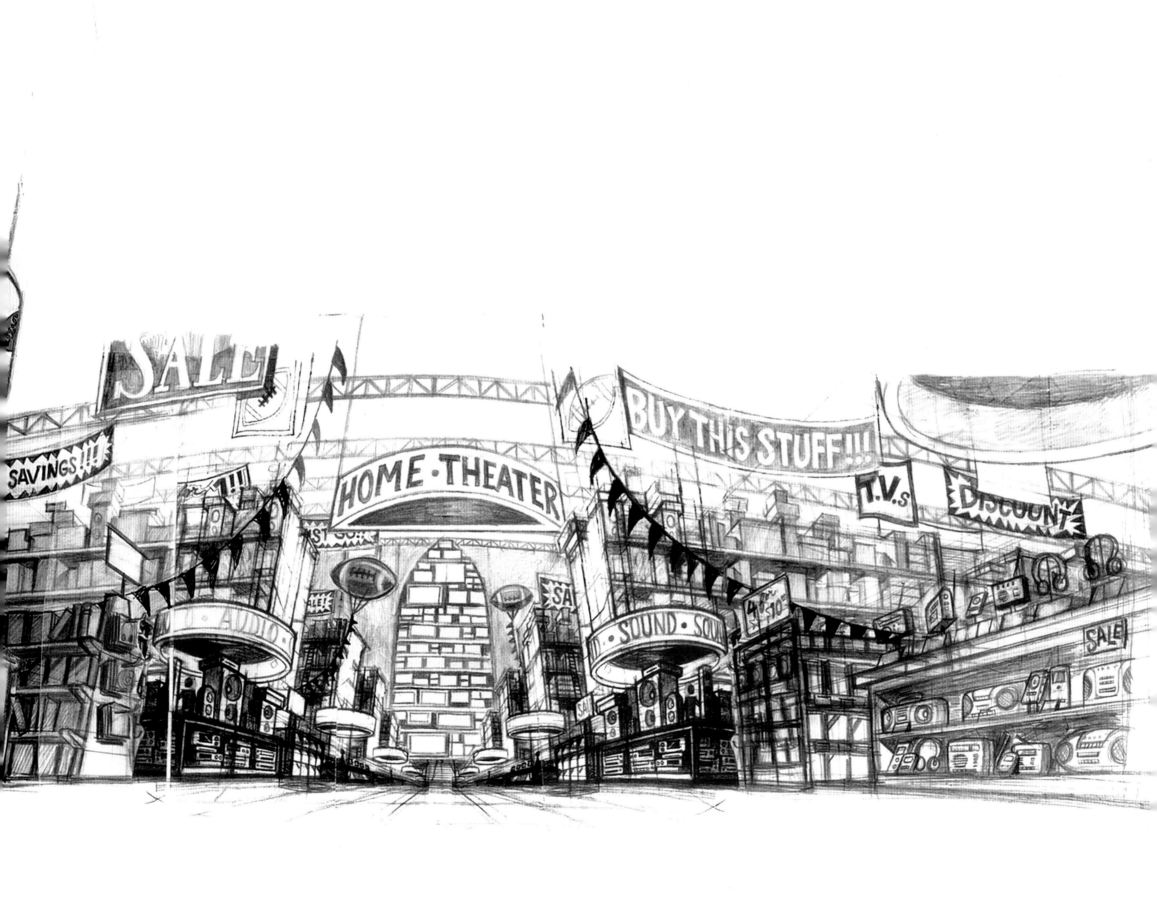

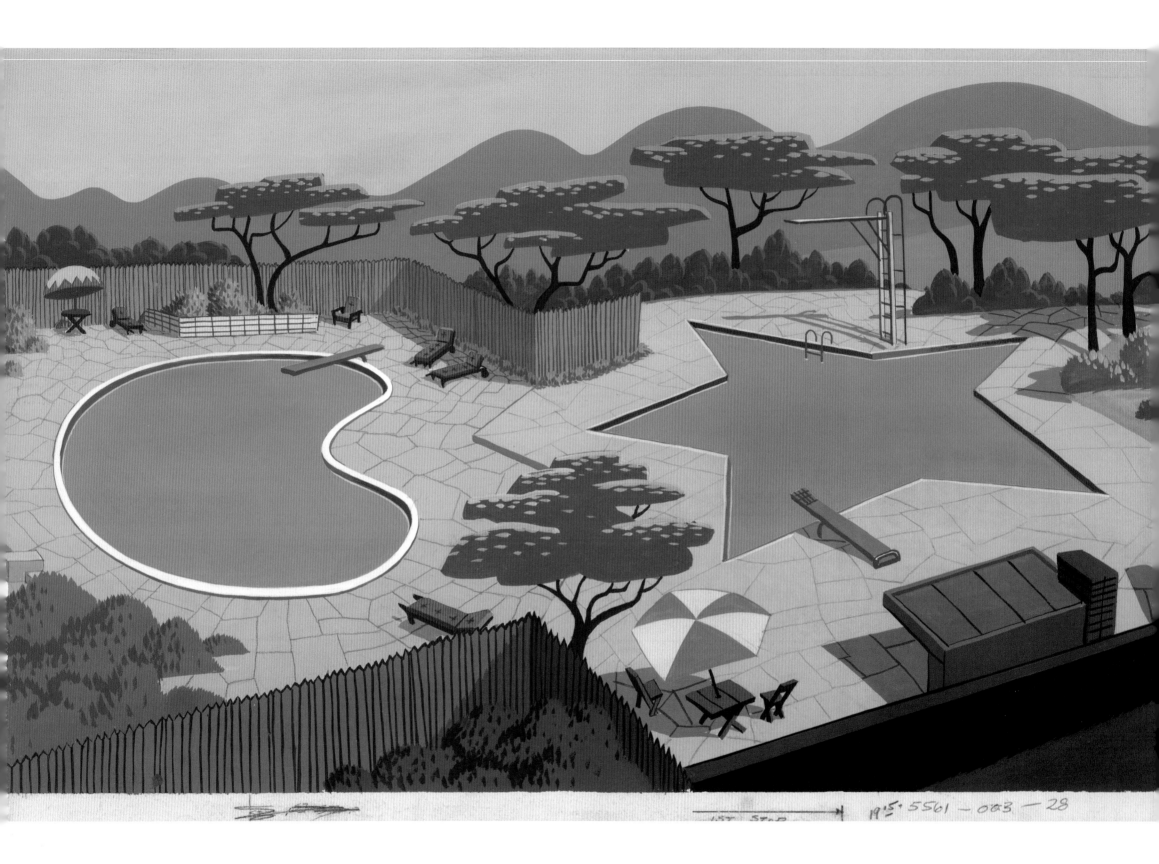

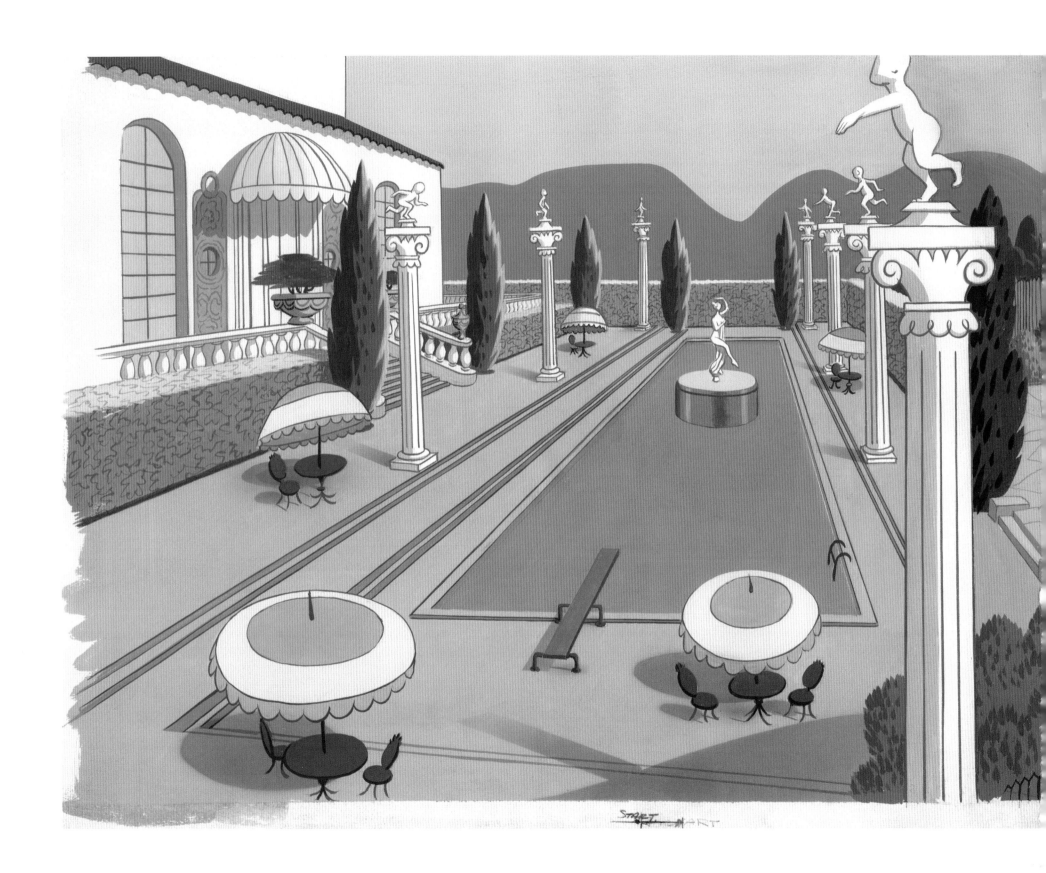

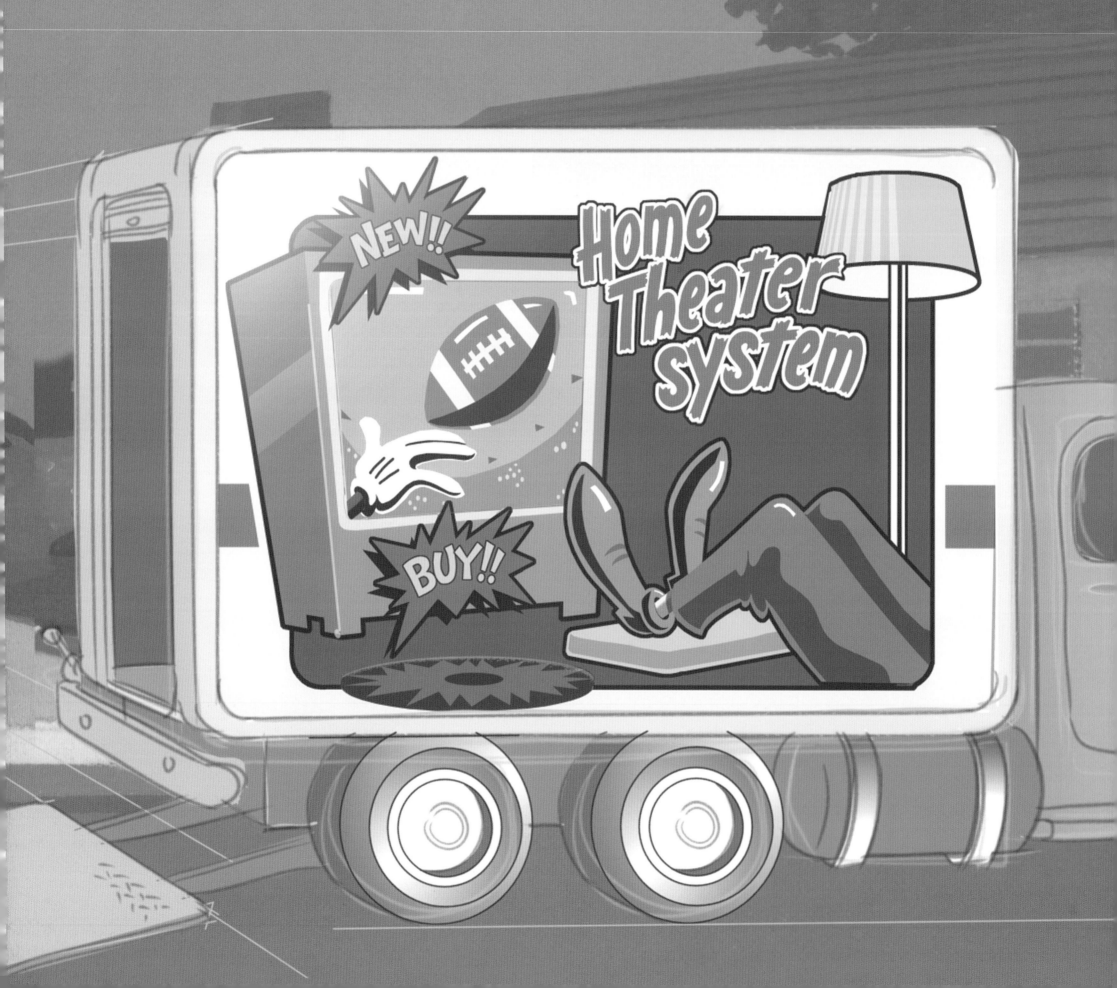

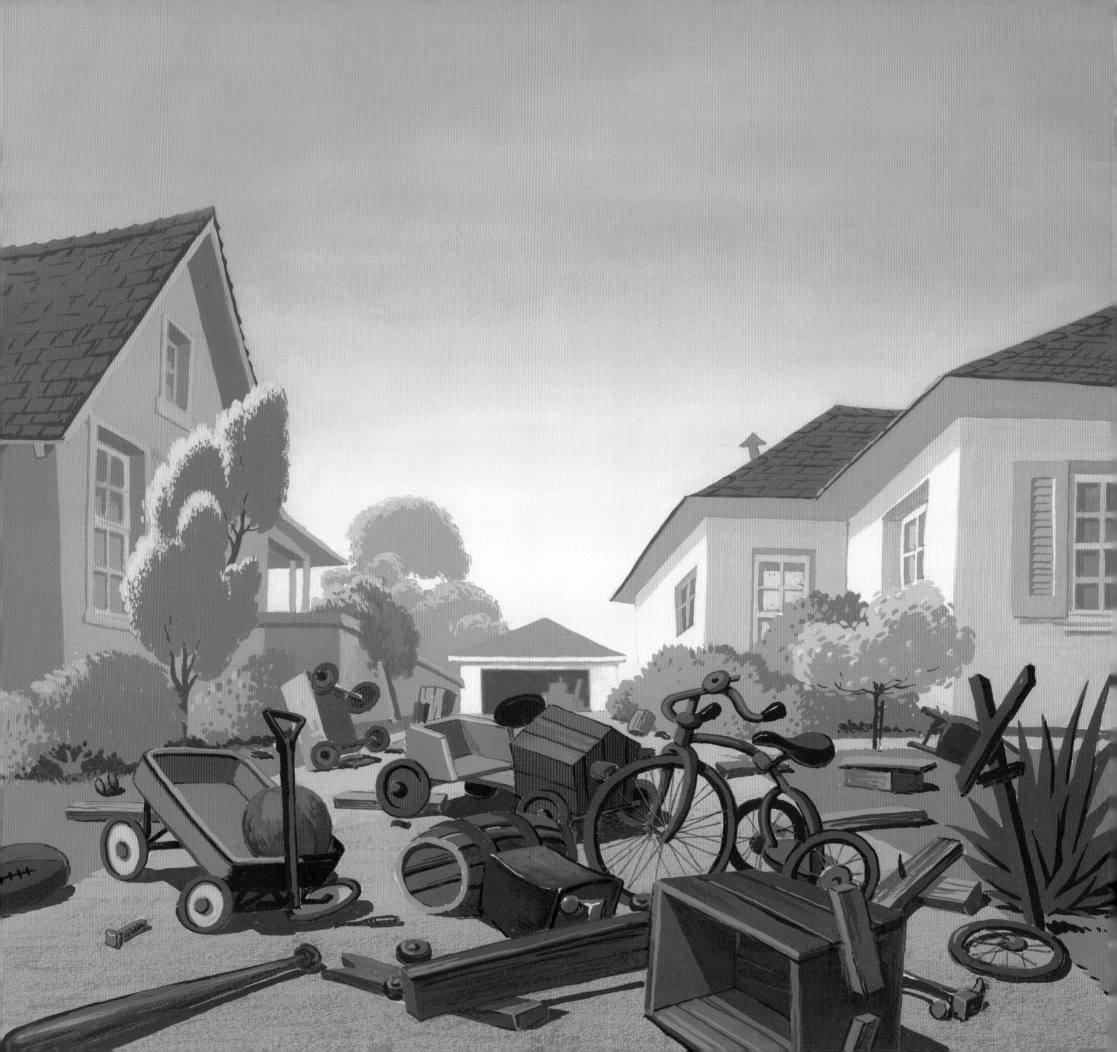

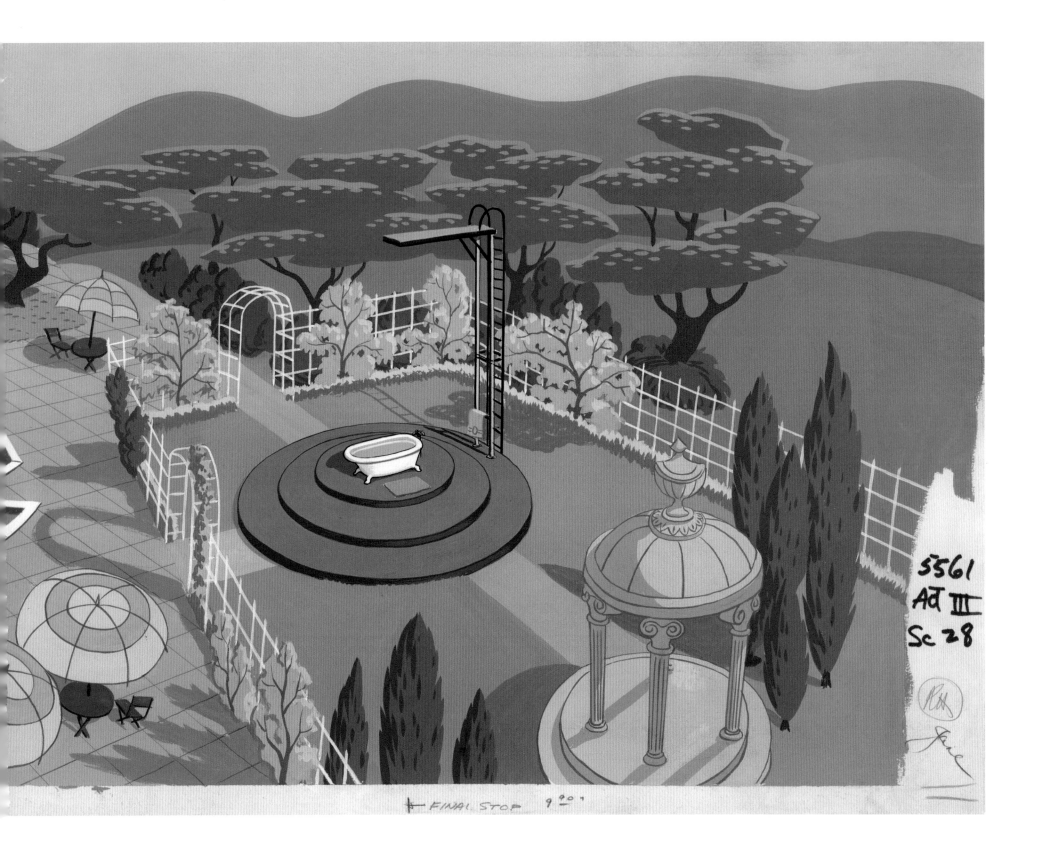

5561
Act III
Sc 28

FINAL STOP 9 90

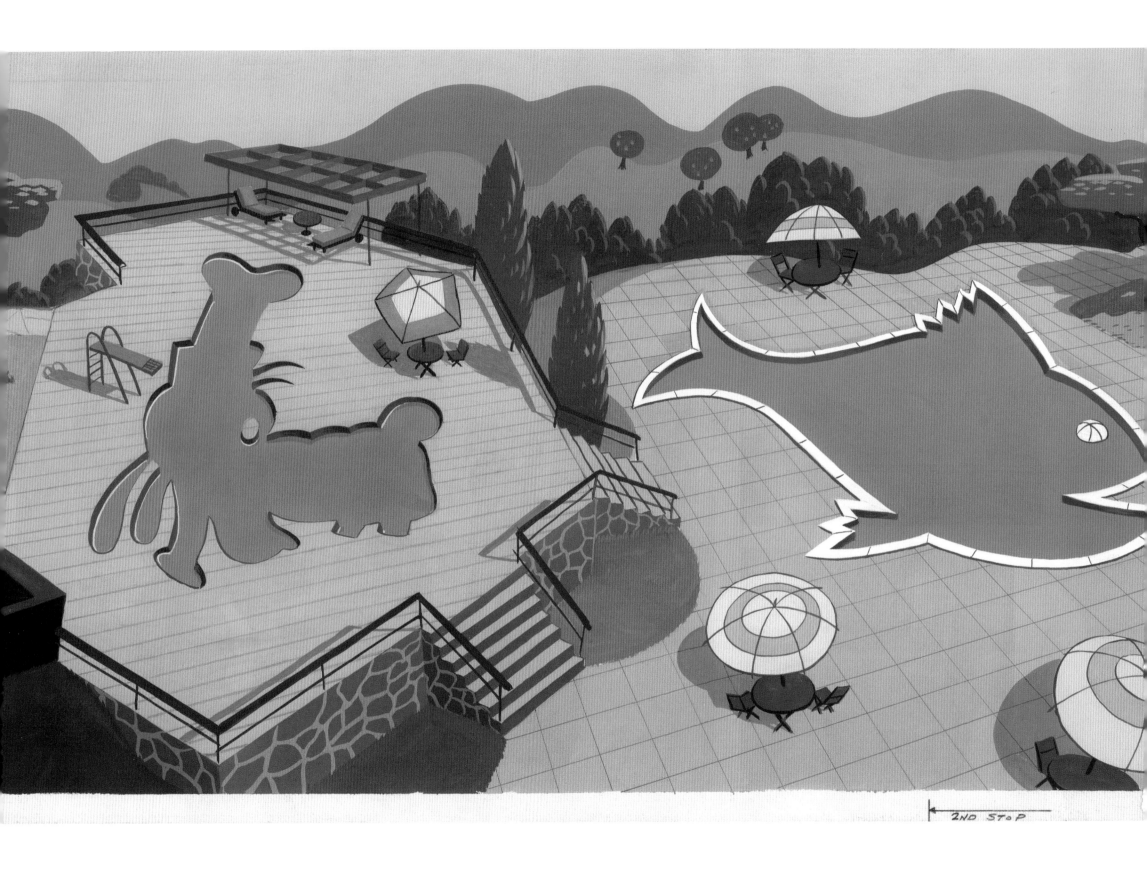

ABOVE: THE GOOFY SUCCESS STORY 1955; OVERFLAP LEFT: HOW TO HOOK UP YOUR HOME THEATER 2007; OVERFLAP RIGHT: FATHERS ARE PEOPLE 1951

CLOCKWISE FROM TOP LEFT:
Al Dempster; Ralph Hulett; Joe Hale;
a group session — left to right, Dick
Lucas, Woolie Reitherman, Betsy Gossin,
John Sibley, Don Griffith, and Basil
Davidovich; Art Riley, and Walt Peregoy

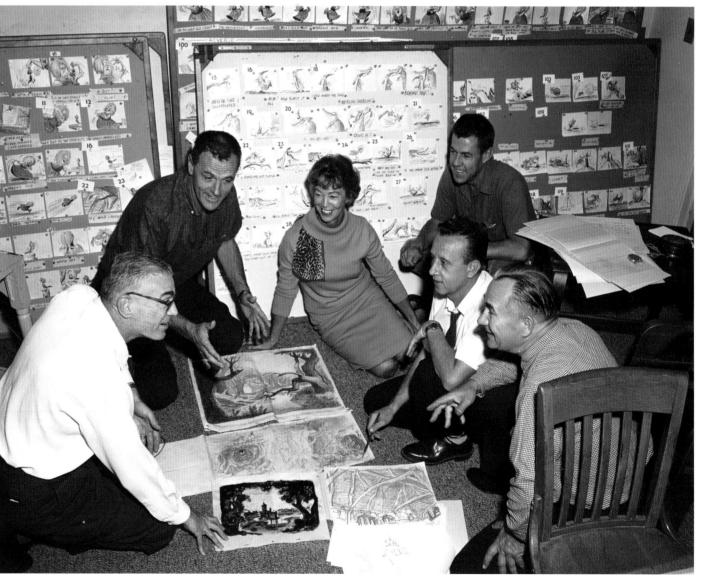

CLOCKWISE FROM TOP LEFT: Doug Walker, Bill Perkins, Lisa Keene, Rasoul Azadani, David Womersley, Mac George, Sunny Apinchapong, James A. Finch, Doug Ball (middle)

ART CREDITS

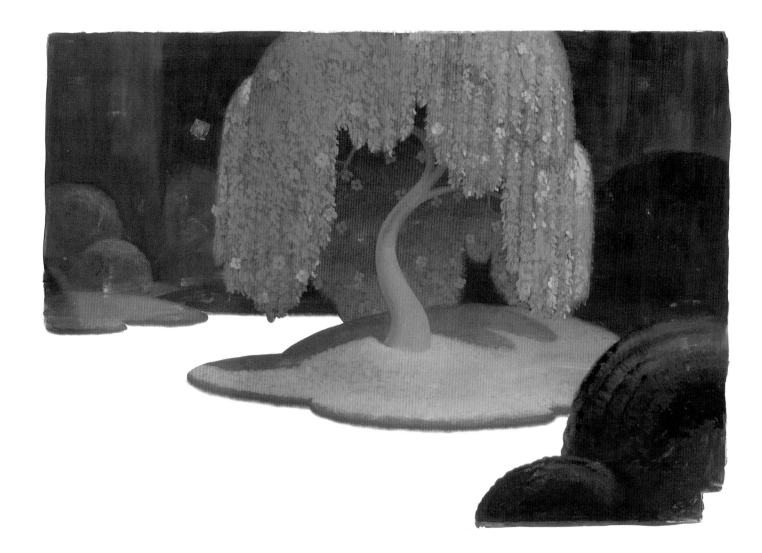

FANTASIA, "THE PASTORAL SYMPHONY" 1940

INDEX

MAGIC HIGHWAY, U.S.A. 1958

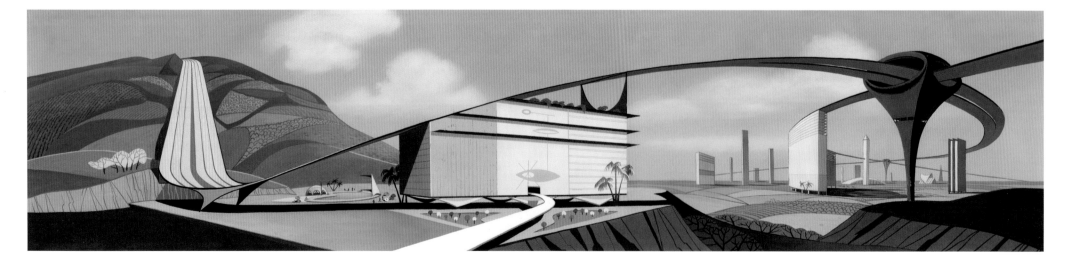

ONE HUNDRED AND ONE DALMATIANS 1961